ARTISTIC FORM AND YOGA IN THE SACRED IMAGES OF INDIA

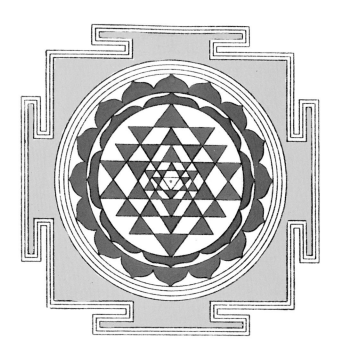

HEINRICH ZIMMER

Artistic Form and Yoga in the Sacred Images of India

TRANSLATED FROM THE GERMAN
AND EDITED BY
Gerald Chapple AND
James B. Lawson
IN COLLABORATION WITH
J. Michael McKnight

PRINCETON UNIVERSITY PRESS

Copyright © 1984 by Princeton University Press
Published by Princeton University Press, 41 William Street,
Princeton, New Jersey 08540
In the United Kingdom: Princeton University Press,
Guildford, Surrey

All Rights Reserved
ISBN 0-691-07289-2
Library of Congress Cataloging in Publication Data will be
found on the last printed page of this book

Publication of this book has been aided by a grant from the
Paul Mellon Fund of Princeton University Press

Translated from *Kunstform und Yoga im indischen Kultbild*,
Frankfurter Verlags-Anstalt AG, Berlin, 1926;
Suhrkamp Verlag, Frankfurt am Main, 1976

Clothbound editions of Princeton University Press books
are printed on acid-free paper, and binding materials are
chosen for strength and durability. Paperbacks,
while satisfactory for personal collections,
are not usually suitable for library rebinding

Printed in the United States of America by
Princeton University Press
Princeton, New Jersey

For
Christiane Zimmer

Contents

List of Plates

NOTE

An asterisk (*) indicates that a new photograph of the same object
has been substituted for Zimmer's plate.
A dagger (†) indicates a new plate added to this volume.
A double dagger (‡) indicates a new plate that has been substituted
for one of Zimmer's plates.

Foreword

REFLECTING at this time, forty years after Heinrich Zimmer's death at the age of fifty-three (1890–1943), on the majesty of the great theater of ideas into which everyone who ever heard him speak was transported through the magic of his eloquence, I can now appreciate more objectively than I could when directly under his spell the historic importance of his genial recognition of the one life and humanity in the arts, mythologies, and metaphysical intuitions of both the Orient and the West. As noticed in a memorial read at a meeting in the spring of 1949 of the New York Oriental Club: "Dr. Zimmer stood alone, forming a class by himself, not only for the wide range of subjects he was proficient in, but also for his unique genius of interpretation. . . . Zimmer strove to understand both Eastern and Western ideas from universal conceptions lying at the root of spiritual and psychological developments everywhere."

Kunstform und Yoga im indischen Kultbild was the fundamental work through which, in 1926, Zimmer introduced to Western scholarship his first insight into the spiritual foundations of a tradition of religious art where the aim is not to arrest the eye but to effect in both the artist and the worshiper a psychic transformation. Carl Jung immediately recognized the relationship of this insight to the findings of his own science, and there ensued from 1933 to the year of Zimmer's death an interchange that is reflected in the writings from those years of both masters. The four decades since have been marked by a significant increase of interest throughout the West, both in the arts and life of the Orient, and in the psychology of C. G. Jung. And to this development the early contribution of Heinrich Zimmer to Jung's own realization of the relevance of an understanding of Indian philosophy and cult-practice to the interpretation of occidental as well as of oriental symbolic forms was (as Jung himself on several occasions declared) an essential factor.

The crucial moment was of Jung's reading of Zimmer's *Kunstform und Yoga*. And that this work now appears in an English edition, sixty years after its publication in German yet still of relevance to current thought, speaks, not only for the validity of Zimmer's insight into the conscience of Eternal India, but also for the vitality and importance of an ever-increasing Indian contribution to the life, the arts, and the philosophical enrichment of the modern West. The book is as vital today as it was the year it was written, still unmatched for the eloquence of its recognition and celebration of this inspiration of Indian art.

Joseph Campbell

Honolulu, Hawaii
December 1983

Preface

Kunstform und Yoga im indischen Kultbild was published in 1926 by the Frankfurter Verlags-Anstalt in Berlin. Exactly fifty years later, a second edition, edited and with an introduction for the general reader by Friedrich Wilhelm, appeared in the Suhrkamp Verlag, Frankfurt am Main.[1] In this translation, it at last takes its place alongside four other works by Zimmer, all edited by Joseph Campbell, that have appeared in the Bollingen Series.[2]

Before we approach the work itself, it seems appropriate to look both backward and forward—backward to a story told at the end of *Myths and Symbols in Indian Art and Civilization*, and forward to the account of the genesis of *Kunstform und Yoga* which appears in the Appendix of this volume.

At the end of *Myths and Symbols*, Zimmer tells a story that illustrates why he wanted to bring esoteric material from the East before the widest possible audience in the West. It is the story of Rabbi Eisik, son of Rabbi Jekel of Krakow, who dreamed three times of treasure buried under the bridge leading to the king's castle in Prague, and was determined to go and dig it up. He traveled to Prague and found the bridge, and although it was heavily guarded, he returned daily, hoping for an opportunity to dig for the treasure. Finally the captain of the guard asked him why he was loitering there and Rabbi Eisik told him of his dream. The captain mocked the rabbi for believing in dreams, and told one of his own to

[1] An index of Sanskrit terms was appended to both editions, but the thirty-six plates of the first edition were not included in the second one.

[2] *The Art of Indian Asia: Its Mythology and Transformations*, Bollingen Series XXXIX, 2 vols. (1955; 2nd ed. 1964; paperback reprint, Princeton: Princeton University Press, 1982); *The King and the Corpse: Tales of the Soul's Conquest of Evil*, Bollingen Series XI, 2nd ed. (Princeton: Princeton University Press, 1956); *Myths and Symbols in Indian Art and Civilization*, Bollingen Series VI (Princeton: Princeton University Press, 1946); *Philosophies of India*, Bollingen Series XXVI (Princeton: Princeton University Press, 1951.

show how ridiculous it was to pay attention to dreams: he himself had dreamed of treasure hidden in Krakow, in the house of a Jewish man called Eisik, son of Jekel; it was supposed to be buried in a dirty corner behind the stove. The rabbi thanked the captain, and quickly returned home, where he found the treasure where it was supposed to be. Zimmer commented on the inner significance of this tale:

> The real treasure, to end our misery and trials, is never far away; . . . it lies buried in the innermost recess of our own home, that is to say, in our own being. And it lies behind the stove, the life-and-warmth giving center of the structure of our existence, our heart of hearts—if only we could dig." He went on to comment that "there is the odd and persistent fact that it is only after a faithful journey to a distant region, a foreign country, a strange land, that the meaning of the inner voice that is to guide our quest can be revealed to us. And together with this odd and persistent fact there goes another, namely, that the one who reveals to us the meaning of our cryptic inner message, must be a stranger, of another creed and a foreign race.[3]

After twenty years of studying Indian art and thought, Zimmer was reflecting that we must venture far to discover what we have had at home all along.

Two decades earlier, as Zimmer wrote in the autobiographical notes that appear in the Appendix of this volume, Zimmer's own search had led him to the writing of *Kunstform und Yoga*, his first published book. He was persuaded by Alfred Salmony, founder of the journal *Artibus Asiae*, to write an article for that journal. The article, in the writing, grew into this book. And after the book was published, it was in that same journal that A. K. Coomaraswamy gave evidence of Zimmer's success:

> No more valuable book for the understanding of Indian art, the answering of the fundamental problem "Why is

[3] Zimmer, *Myths and Symbols*, pp. 219–21.

it what [it] is?", has yet been published. One might go
further, and point out that no history of art, or of aes-
thetic theory, which does not take into account the Hindu
point of view here so clearly expounded, can be regarded
as at all complete.[4]

As Coomaraswamy recognized, *Kunstform und Yoga* served to
change the direction of the study of Indian art in the West.
Zimmer's revelations of the inner significance and instru-
mentality of sacred images cleared the way for a new appre-
ciation of Eastern art in general.

One example of this influence is the study of the great
Buddhist monument at Borobudur in central Java. Although
Zimmer had never visited the site and had but limited access
to the texts dealing with the subject, his perception of Bo-
robudur as a mandala of monumental proportions, whose
purpose was to guide the spiritual seeker, subsequently in-
spired a number of fruitful studies. Most notably, the French
archaeologist and art historian Paul Mus based his approach
to the subject on Zimmer's explication in *Kunstform und Yoga*.[5]

In addition to his influence on the study of Indian art, Zim-
mer had a significant impact on the work of C. G. Jung and
other depth psychologists. Before he met Zimmer, Jung had
read *Kunstform und Yoga*, and he later reminisced about his
early encounter with the young scholar:

> I first met Heinrich Zimmer at the beginning of the
> thirties. I had read his fascinating book *Kunstform und Yoga*
> and long wished to meet him in person. I found him to
> be a man of lively temperament, a man of genius. He
> talked a great deal and spoke very rapidly, but he could
> also be an excellent, attentive listener. We spent several
> fine days together in wide-ranging conversations that for
> me at least proved extraordinarily stimulating. Indian

[4] A. K. Coomaraswamy, review in *Artibus Asiae*, IV:1 (1930–1932), 78–
79. See also the Appendix to this volume.

[5] Paul Mus, "Barabudur, esquisse d'une histoire du bouddhisme fondée
sur la critique archaeologique des textes," *Bulletin de l'École Française d'Extrême
Orient*, XXXII, XXXIII, XXXIV (1933–1935).

mythology was the chief topic of our conversations. He took the occasion to tell me of his first reaction to *The Secret of the Golden Flower*, the book Richard Wilhelm and I had edited. (At the time I was writing it, Zimmer's *Kunstform und Yoga* was unfortunately unknown to me, which meant that I had not had access to material I would have found most valuable—a matter of great regret.) He told me that in leafing through the book, he became so infuriated at my psychological commentary that he threw the book at the wall.

I was not surprised by his reaction, for it was typical of many others who had read the book—or so I had heard indirectly. Zimmer was the first to tell me this to my face. Like many others, he had reacted to the word 'psychological' like a bull to the red flag. "Surely," so went his thoughts, "'psyche' is out of place in a text that is only of historical interest. The whole notion is simply a flight of fancy, not the least bit scholarly."

After giving it some calmer thought and regaining his scholarly composure, his curiosity made him ask himself whether psychology might not have something of importance to contribute to a book like this after all. He picked it up and began to study it in earnest. Outstanding connoisseur of Indian literature that he was, he could not fail to see a whole host of interesting parallels; and here his decidedly artistic powers of vision and his rare intuitive sense stood him in good stead. With no little irony, he put it in the following words, "What struck me then, was the sudden insight that my Sanskrit texts were not simply a collection of grammatical and syntactical problems, but that they also actually contained a substantial body of meaning!"

Although this statement should, as a hyperbole, be taken *cum grano salis*, I still find this self-revalation of Zimmer commendable. There is a singular and refreshingly honest ring to it, especially if we call to mind these *dii minorum gentium* who are always ready to assure us, with barely concealed *ressentiment*, that they had long

been aware of what you thought you had just discovered.[6]

Zimmer, for his part, recalled his initial meeting with Jung:

I had never imagined to see his like. I had realized the unique chance to be privileged to offer him the results of my research, to read to him my deciphering of the pictorial script of the Hindu genius by which I was spellbound. In fact, so had I done before without knowing. Six years before I met him, in 1926, I had published my first book which, dealing with Hindu art, was the first to pay attention to mandalas and similar drawings and to point out that Hindu idols should be interpreted on their lines. Quite unconsciously I had hit upon a thing which had preoccupied Dr. Jung since many years.[7]

Zimmer came, indeed, to find in depth psychology the possibility that the West could develop a science of the soul comparable to the techniques of spiritual development he was finding in India:

We are thus given a new outlook over our present-day psychological situation, and we begin to see a great many possibilities and tasks in which Western psychotherapy will engage itself in the future and which may have a very far-reaching effect. Perhaps one of these paths into the future will lead to the development of the soul; and from the analysis and observation and collection of psychological facts we may evolve a method somewhat similar to the Indian one, which would grow up from our own Western soil and material into a kind of synthetic dietetics of the psyche.[8]

[6] C. G. Jung, *Erinnerungen Träume Gedanken von C. G. Jung*. Edited by Aniela Jaffé (Zurich: Rascher, 1962), pp. 385–86.

[7] H. Zimmer, "The Impress of Dr. Jung's Teachings on My Profession," transcript of talk to the Analytical Psychology Club of New York, 1942. An edited version of this talk appeared in *Spring*, 1941.

[8] H. Zimmer, "Indian Views on Psychotherapy," *Prabuddha Bharata*, 41:2 (February 1936), 189.

Just as dietetics of the body deals with the science of nutritional planning, "dietetics of the psyche" deals with nutritional planning for the growth of the Self. Zimmer found in the relationship between art and yoga a highly refined array of "dietetics" used in the Hindu tradition, for *yantras* can properly be viewed as utensils of conscious transformation that enable the meditating devotee to realize unity with the object of devotion. As Zimmer phrased it in a later work, "The form has to function technically, that is to say, in the actual crisis of a psychological transference."[9] The benefit of actualizing levels of the psyche that are normally unconscious is to transform the potentially destructive forces of the unconscious into "helpful spirits."[10] If the West were able to develop its own methodology of transforming these dark forces, we might be able to liberate ourselves from the specter of global warfare.

There is a remarkable consistency and continuity in all Zimmer's writings from the publication of *Kunstform und Yoga* in 1926 down to his work in progress at the time of his death in 1943. Among Zimmer's final papers is the unfinished manuscript of *The Mahatmas—An Introduction to India's Wisdom*, which was planned as one of the initial volumes of the Bollingen Series. The manuscript contains only an outline of chapter headings, and a preface that could almost serve as an introduction to his first book. His concerns are the same, though he had begun to write in the English language and had become more direct in making his points:

> We Westerners have our own heritage and are caught in its mold . . . as much as the Hindu are in their own. There is no swapping horses or changing shoes; in the main we have to go on like a star in its orbit, following its own gravity, but by the law of gravitation the orbits influence each other and are forming a changing pattern. We cannot readily dress in Indian wisdom without becoming monkeys or dilettante actors. But, in viewing India's basic attitudes and spiritual propensities, we

[9] Zimmer, *Art of Indian Asia*, I, 320.
[10] H. Zimmer, "Indian Views on Psychotherapy," p. 188.

might gain insight of two things: of the subtle and inextricable web in whose meshes the Hindu spider abides and is caught . . . and, thus, we might realize to a fuller extent in what self-timbered framework of ideas we abide and are caught ourselves.[11]

Zimmer had not lost hope that Westerners might avert further catastrophes of war and suffering by taking an inner "journey to the East." He strongly believed that we must go beyond the realm of ideas and conceptualizations to arrive at Truth. One of his final notes to himself was, "Truth is not a bundle of ideas, but the very essence of things, the law governing life in man and the universe."[12] It can be achieved only through a "transmutation of man's nature or substance" that would enable us to reflect in some measure ever-present Truth. For this leap to occur—for us to learn to know ourselves as we are so we can be aware of the higher law governing all life—we can find it helpful to have an archimedic point of support outside our own culture. Zimmer found this point in the "other ocean" of traditional India.[13]

THE search that Zimmer was pursuing at the end of his life, and the hopes that the insights he gained there could guide us in the West to our own self-discovery, were first, and brilliantly, evident in *Kunstform und Yoga*. All the power, the subtlety, and complexity of his thought find expression in this book, whose translation has presented us with challenges that should be commented on at the outset.

To our knowledge, no manuscript of *Kunstform und Yoga* has survived; according to Zimmer's widow, the manuscript

[11] H. Zimmer, "Mahatmas," unfinished manuscript, p. 5. This work is alluded to in a memorandum from Ximena De Angulo to the editorial board of the Bollingen Foundation dated February 25, 1942. In the listing of prospective works, "The Mahatmas" is described as: "Book to be based on lectures at Columbia on Indian Philosophy. The main theme is to be the intrinsic and essential unity of thought and Yoga experience. The book is to be 'strictly scientific and strictly for everybody', covering the basic ideas of Indian philosophy and wisdom. MS could be ready by Xmas."

[12] Personal note found among Zimmer's final papers.

[13] See Appendix, p. 248.

has been missing since the family was forced to leave Germany. We have thus based this translation on the first edition, which contains relatively few errors in typography and punctuation.

The main challenges in translation lay in transferring Zimmer's powerful and idiosyncratic style into an equally vigorous but "un-Germanic" English. A reader coming either from Zimmer's other early writings in German, from his later narration of myths, or from English translations, is immediately struck by the unique style of the present volume. Convoluted, taut, at times extravagantly rhapsodic, even dithyrambic, it is above all stylistically *very* German. This first book is obviously bound up with his personal search for his own critical voice and method. It was the suggestion of Zimmer's first translator, Joseph Campbell, that we try to capture the persuasive liveliness of Zimmer's voice. Zimmer once told Campbell that the style of this particular book had been consciously chosen; he was trying to counteract an academic vogue that used the rhetoric of *Geistesgeschichte* with meaningless stylistic flourish; he attempted to, and did, put enthusiasm and rhetoric to productive use. His style is deliberately classical; he takes, for instance, great delight in the periodic sentence. We have tried to retain the force and flow of the German paragraphs by pushing the English periods to the outside limits; we have had to make frequent use of the semicolon and dash in order to bring all the clauses of his classically encapsulated sentences under one syntactical roof. In general, our response to the problems has been to opt for a readable English that renders accurately the intent of Zimmer's work along with a faithfulness to the content and style.

Very occasionally, an accurate and proper translation from the German would still leave the reader puzzled. At such times it became necessary to add a helpful phrase. One finds for example, near the end of the third chapter (all but one of the following examples come from there), "Kraft ist das Wesen der Welt." The categorical nature and terseness of this statement make the sentence an effective and powerful one. But to translate it baldly, as it stands, even retaining an alliteration

("Energy is the essence of the world"), might confuse the reader. For smoothness of transition and for clarity, "is held to be" was added; this binds the sentence more closely to the sense of the preceding one.

Apart from these general stylistic difficulties, three other specific groups of problems posed by the translation are worthy of mention; these are grammatical, lexical, and cultural.

1. Typical of the grammatical problems posed is Zimmer's constant use of present and past participles as adverbs and attributive adjectives. Describing a particular deity enwreathed by ancillary figures, Zimmer explains their use as "verdeutlichend zu umrahmen" (literally: "to expound him explainingly"); in English this was expanded to "forming an expository frame."

Another example: "Goethe winckelmännisch blickend" (literally: "Goethe, looking winckelmannically") must be expanded to "Goethe, viewing it as would Winckelmann," or "Goethe, . . . in his acceptance of Winckelmann's judgment. . . ."

In another chapter, Zimmer speaks of the various manifestations of the Divine as they strive for preeminence: "ihr . . . rivalisierendes Nebeneinander" (literally: "their . . . rivalizing juxtaposition"). In this instance, we decided on "contentious"; this is not an exact reproduction of "rivalisierend," for it adds a note of querulousness, but we thought it proper because, reading ahead, the word anticipates a military metaphor immediately following in the words: "Kampf," "Streit," and "Sieg."

2. German traditionally constructs compound nouns. If one renders these into English, the result is at best ponderous, often jargonesque and, not infrequently, bizarre. "Zeichensprache" occurs several times; this does not mean "sign language"; "symbol language" would be awkward and calls to mind Jungian jargon. We thought it best to use the genitive here, and decided on "language of signs."

One of the strengths of German is its ability to construct a word to articulate a complex of ideas. In the passage dealing with the gods' contest for first place, we find Zimmer's unusual word "Alleingeltung" as designating the goal of their

strife. This, literally, is "sole validity," which we felt to be inadequate, and propose "sole authority" as being closer to the sense of the passage.

Frequent pleonastic doublings occur idiomatically. In one of Zimmer's footnotes, we have translated "Hort und Stätte" as "seat and sanctuary." The phrase in German incorporates the idea of the integrity and solidity of a primal source, a refuge, a stronghold and abode. In the translation we attempted, through alliteration and the archaic use of "seat," to give the phrase the mythical nuance in the German term; "sanctuary" in this phrase, implies the connection with the religious sphere.

Zimmer's use of fill-words ("also," "dennoch," "schlechthin") is a constant problem. Obviously they cannot be rendered by their English equivalents but must be interpreted from the context. On one occasion, Śiva is described as being "Tanzender schlechthin" (literally: "the Dancing One purely and simply"). Since Zimmer often uses a Latin phrase, we felt free to compose one here to solve a distinctly awkward phrase. Our solution was *homo saltans*, which suits the academic tone of the passage.

3. Throughout the text are literary and cultural allusions that may well go unnoticed. There are set phrases from Goethe, for example, functioning in the language as Shakespearean phrases do in our own. Faust's wish, for example, "that time might stand still in its moment of beauty" "verweile doch, du bist so schön") becomes, with Zimmer, an admonition spoken by a classical work of art: "verweile doch, *ich* bin so schön" ("stay, *I* am such a thing of beauty"); parodying Goethe, the statue speaks to the beholder, tempting him to lose his soul rather than pass by and fail to succumb to the statue's attraction.

More importantly, there is a subtler question of tone and the ethos behind it. Much of Zimmer's seemingly rhapsodic language and his hermeneutic approach owe a significant debt to the period in which the book was written, not only to Nietzsche but particularly to Rilke's poetry and its diction. Rilke's widely known concern with *Sein*, Being, was seized upon by Zimmer as just the proper vehicle to explain Indian

philosophy to his audience. The Rilkean element, for those not familiar with it, might best be grasped if the reader looks ahead to the conclusion of Zimmer's "Notes on the Plates," where he quotes Rilke's most famous poem on the Buddha. This may give an important clue to the particular quality of the East-West encounter—so brilliantly exemplified by Zimmer's particular genius, empathy, and interpretive skill—to which this volume attests. The reader will then be better prepared for comprehending the spiritual message of the sacred images, the particular power of Zimmer's insights, and the poetry with which much of his style is infused.

The translation from Zimmer's Sanskrit sources has been made from his German text, with three exceptions. Quotations from Avalon and from Kramrisch's translation of the *Visnudharmottara* have been left in the original English because Zimmer based his German translation on them. In Chapter Five, he turned to Laufer's German translation of the *Citralaksana*; we have quoted from B. N. Goswamy's pioneering translation of this work into English, and recommend his introduction for further reading on the subject.[14]

Regarding the visual material, Zimmer states in his "Notes on the Plates" that he deliberately chose to illustrate smaller pieces, partly because he was working under the publishing constraints of the time, and partly because he was already planning a larger illustrated volume on Indian art. Thanks to Joseph Campbell's labors, today the reader can refer to the two volumes of *The Art of Indian Asia* while reading the present book. Although it appeared twelve years after Zimmer's death, it is an appropriate companion piece to the present book, and should be consulted frequently—there are too many cross-references for them all to be listed in the notes here. The publisher has generously allowed us to add approximately twenty illustrations, most of which demonstrate *ad oculos* Zimmer's brilliant juxtaposition of Indian visual images with the tradition of classical Western art.

[14] B. N. Goswamy and A. L. Dahmen-Dallapiccola, trs., *An Early Document of Indian Art: Citralaksana of Nagnajit* (New Delhi: Manohar, 1976).

Acknowledgments

OUR FIRST debt of thanks is to the *spiritus rector* of this project, Joseph Campbell, who is in the true sense of the word Heinrich Zimmer's first translator. His enthusiastic descriptions of the significance of his friend's work and teaching made Zimmer a real presence to us from the outset, and did much to remove any laboriousness from our labors.

Thanks go also to the agencies that contributed indispensable financial assistance at various stages: the Arts Research Board of McMaster University; The Social Sciences and Humanities Research Council of Canada, Ottawa, through their program of International Collaborative Research; and Inter Nationes, Bonn.

Of the many individuals to whom we are indebted for the kindness of their help we would like to thank:

K. Sivaraman and J. Soni of McMaster University for valuable help in checking and correcting Sanskrit references, spellings, and meanings; also of McMaster University: Katherine Dunbabin, Alvin Lee, Alexander McKay, Hayden Maginnis, William Slater, Warren Tressider, Elizabeth Toews, Chauncey Wood; our colleagues in the German Department for their aid in unraveling some of the Teutonic tangles; our secretarial assistants: Vicky Bach, Molly Pulver and Bessie Evink; Jack Whorwood, for photographic help; Emmi Morwald, McMaster's Research Officer; Gary Kitchen and the staff of the McMaster Printing Office. Also Jack Howard, Far Eastern Library of the Royal Ontario Museum, Toronto; Evelyn Nagai-Verthrong, University of Toronto; Sister Wilma Fitzgerald, Pontifical Institute of Mediaeval Studies, Toronto; Vishaka Desai, Boston Museum of Fine Arts; Dr. Volker Moeller, Museum für indische Kunst, Berlin; Prof. Dr. Bock, Gemälde Galerie, Berlin; Robert Spaethling, University of Massachusetts, Boston; Victor Lange, Princeton University; William McGuire of Princeton and the production staff of

Princeton University Press; Nina, Glen, and our children for their much-tested understanding and patience; Karen McKnight for her editorial assistance and encouragement.

This book owes its chief debt, however, to our editor, Margaret Case: for her unflagging interest and support from its incipiency. Her good humor, common sense, skill, and incredible patience have guided us through the inevitable problems with admirable finesse. Shanti, Margaret, and svāhā.

Throughout the work of translating and editing we have been aided by our collaborator Michael McKnight, who initiated this project and was an invaluable source of assistance for understanding terminology and concepts unfamiliar to two professors of German language and literature. He has contributed the bulk of the notes concerning the Indian material, and we wish to express our gratitude for his collaboration. That the team was international in composition is only fitting for an enterprise that was dedicated to bringing an outstanding document of international and intercultural understanding to the English-speaking world.

Our final words of thanks are for the gracious lady to whom the translation is dedicated. Christiane Zimmer gave liberally of her time and energy and encouraged us from the start with the warmth of her hospitality.

McMaster University Gerald Chapple
Hamilton, Ontario James B. Lawson
November 1983

NOTE: Numbered footnotes are Zimmer's; lettered ones are editorial.

ARTISTIC FORM AND YOGA IN THE
SACRED IMAGES OF INDIA

nādevo devam arcayet

"God shall be worshiped by none but God"

The Indian Sacred Image and Classical Art

Our knowledge of Indian art is steadily increasing: at widely separated sites, one by one, art works long buried in rubble are coming to light and are being welcomed by an ever-increasing host of enthusiastic devotees. All the ancient and more recent works of art now unearthed are becoming accessible to the public at large. The classification of individual works according to their content is becoming more precise, and our understanding of their stylistic details is growing more refined; we are weaving ever more closely a network of historical links that organize the mass of detail. Yet those working in the field of Indian art have begun to affect an attitude of familiarity with its style and character that may be acceptable in relation to objects belonging to our own cultural tradition, but that, when dealing with examples from a tradition other than our own, is nothing short of extraordinary. A case in point: our knowledge of the character, significance, and cultural matrix of a major category of Indian art—the sacred image—has been very meager up to now; it is certainly not sufficient to explain the singular quality of the sensation that takes us unawares when we come face to face with these objects in all their uniqueness.

We may hear and read much about Indian art, and can learn a great deal in the process. Aside from the indispensable, purely iconographic studies that explain the internal references and lay the foundation for any further work, stylistic analysis, aesthetically evaluative observation, and direct emotional involvement have also proven to be remarkably productive. But on reviewing the variety of critical comments in these areas, we search in vain for an answer to one central question: why

is so prominent a phenomenon of Indian art as the sacred image, in its most basic formal structure, constituted the way it is? Or why do the sacred image's particular shape and stance appeal to us, who live far from India's borders and its Southeast Asian cultural sphere, and awaken in us again and again both an elemental emotion and an inhibiting awe? We stand, as it were, at the image's threshold yet lack the ability to cross it. Knowledge of the name and significance of the deities that assume form in the image is obviously not sufficient to create such closeness and easy familiarity as afford us a link to the monumental works of our own artistic tradition. We can sense that the peculiar form of these sacred figures is special; but knowing about the philosophical doctrines from which they came, or about the symbolism of their gestures, emblems, and role in a legendary context, is not in itself enough to clarify this special quality. If we fully absorb these intellectual references, then of course we know more about the images' significance, and they become intellectually understandable. But their tangibility, the appearance and effect of their form—which, as well as being intellectual expressions, also allow, within certain limits, a spiritual interpretation—retain a very basic, undeciphered element that produces the tension-creating distance between us and those figures. To eliminate this tension completely would require us to slough off our modern Western habit of mind. But since we so greatly admire these testimonials of another world, it is incumbent upon us to resolve this tension at least intellectually: to elucidate what always happens to us when confronted with them and why this *must* happen. The question that the tension compels us to face does not concern the special content or style of any of these religious images, however the style of any one of them may have resulted from its place or time. A knowledge of content and style is a necessary prerequisite for further study, and for an adequate command of detail; but any possible answer stemming from such knowledge would be either too general or too specific to resolve our sense of tension. An answer so derived would apply equally well, for example, to any of the grand relief series of the Indian god- and Buddha

legends, as to the sacred image—even though the reliefs speak a different language. The very fact that we are considering *sacred* images indicates a possible direction for us to take in order to resolve that tension. They are not, after all, self-contained constructs, not pure expressions of a religious *Weltanschauung* that our knowledge can appropriate; they are purposeful links in a chain of spiritual, ritualistic procedure. The practice of such a ritual is, of course, denied us, but if we might re-present it to our mind, we may just succeed in paraphrasing the quite peculiar function of those constructs that have fascinated us as self-contained things of beauty and as spiritual symbols, and may succeed, as well, in comprehending from within why they are as they are.

The ambivalent sensation of painful tension and enchanted estrangement vis-à-vis the Indian sacred image is not as widespread in the West as it should be. Our present interest in Indian art is still at the stage where we see it as being diametrically opposed to classical art; in museums, it has often been measured, naively, against a canon of values derived from the classical style and catalogued under ethnographic material.[a] Where critics, schooled on classical concepts, have, in a kind of reverse snobbery, managed to disregard their prejudices, they do indeed arrive at a point where they can make some meaningful statement about the eternal, self-contained, and pristine significance of the *material* of Indian art. But when they set about describing its *essence*, they either indulge in a subjective, rhapsodic enthusiasm that projects their own exalted emotional state into the content of the icons, or else they become mired in questions of historical detail—dating, stylistic sources, and the background of the history of ideas. But although an inevitable feeling of estrangement and a sensation of having stepped into an altogether different

[a] The treatment of Indian art in Western museums has improved considerably since Zimmer made this observation. Curators such as Ananda K. Coomaraswamy (1877–1947) at the Boston Museum of Fine Arts have changed the ways Eastern art was catalogued and displayed. Cf. Roger Lipsey, *Coomaraswamy: His Life and Work*, Bollingen Series LXXXIX:3 (Princeton: Princeton University Press, 1977).

realm repeatedly take any Westerner by surprise whenever he finds himself after a lapse of time before a piece of Indian sculpture, Western critics, for their part, only too willingly suppress them; the sensation of estrangement has become for them simply part and parcel of their involvement with Indian art. If consciously admitted, that feeling would undermine their confidence when speaking out; and confidence is something sorely needed if one is to be bold and daring enough to venture a personal interpretive opinion in this poorly lighted waste of ruins.

Revolutions in the traditional Western way of looking at art have ultimately toppled the absolute rule of the classical ideal. Proponents of classicism were and always have been able to belittle Indian sculpture by citing Goethe, who, in his acceptance of Winckelmann's judgment, had written of "temples full of elephants' and gargoyle faces, a gloomy welter of troglodytes and a mad concoction of curlicues."[b] After these revolutions, however, even the impending revival of classicism could only really leave its mark on a quiet interlude within the Age of Reaction, the Biedermeier period. In the light of this historical development, it is difficult to understand why we should not admit openly to having that feeling of strangeness that so frequently accompanies our first impression of an Indian *objet d'art*—especially since the feeling could today hardly be linked to a disparagement of Indian material. An understanding of any art requires that we bring our first impression into unprejudiced focus, that we be honest enough not to skim over any one part of our impression. When we discover in our encounter with Indian sculpture that there is no thrilling, spontaneous immediacy of contact, when we find time and again that our initial sensation is instead a gentle

[b] "Elephanten und Fratzen-Tempeln, düsterm Troglodytengewühl und verrückter Zierat-Brauerei." Johann Joachim Winckelmann's (1717–1768) great influence on the classical period of German literature began with his *Gedanken über die Nachahmung der griechischen Werke in der Malerei und Bildhauerkunst* (1755), in which he gave wide circulation to a phrase of A. Oeser (1717–1799) that seemed to sum up the classical ideal: "Edle Einfalt, stille Grösse" ("Noble simplicity, quiet grandeur").

tremor of awed wonder, then instinctively the soul treads softly, as if entering lofty rooms most strange, half shrouded; "strange presentiments steal o'er us."[c] Since this is the case, it will ultimately prove more rewarding to identify and acknowledge this constantly recurring element of our impression rather than to banish it the instant it impinges on our consciousness, to banish it because of the twinge of self-conscious embarrassment we feel—as if this strange feeling were somehow unworthy of our passionate thirst for knowledge and irreconcilable with our evident delight in entering the vast world of Indian art. No matter how familiar we are, or at least think we are, with Indian art, we cannot for a moment discount the fact that during the course of our education we have been trained to see by looking at classical art. The classical mode of seeing was dominant right into the era of Impressionist art. And we cannot in our own day disregard the fact that our dwellings and our city plazas have been cast predominantly in the classical mold; neither may we forget that our eye at every turn has still to confront some wretched derivative of a grand style and deal with it, however much its frequently monstrous artificiality may offend and repel; nor can we dismiss the fact that our way of looking at any form of art at all has been determined and schooled predominantly in the classical mode.

Even if, as a consequence, our all-embracing love of Indian art can blot from our consciousness every memory of classical models in order to immerse itself in the beloved element as in some sacred sea—in order, as the expression has it, "to understand it on its own terms"—even if this does happen, such an approach could still hardly satisfy someone who consciously and frankly acknowledges the feeling of ever-re-

[c] Zimmer is echoing a line from the second stanza of Goethe's poem *Selige Sehnsucht* ("Blissful Longing," 1814): "In der Liebesnächte Kühlung, / Die dich zeugte, wo du zeugtest, / Überfällt dich fremde Fühlung / Wenn die stille Kerze leuchtet."

Literally: "In the cool of nights of love / Which begot you, in which you have begotten, / Strange presentiments steal o'er you / When the peaceful candle gleams."

newed wonder at the sight of a piece of Indian sculpture. In its effort to understand, that approach assumes an ability to circumvent with impunity an essential element in our impression of the sculpture, an element characteristic of our relationship to the art. It is a relationship whose nature we are not able to define; it is simply imposed upon us by our place in historical time. By bringing into sharper focus the element of wonder, we immediately gain a degree of insight into the peculiarity of Indian sculpture—and to understand these images is of course the main concern of our inquiry. Since this insight is based on the pure subjectivity of experience, it will just be provisional, and of value only as a stimulus: it leads us to inquire about the pertinent facts that explain the peculiar effect the Indian sacred image has on the aesthetically aware observer, because these facts form the basis for its appearing the way it does. Our focus will become completely clear only by juxtaposing classical art with Indian, which will enable us to detect, and to a certain extent interpret, our different attitudes toward the two types. It goes without saying that the terminology used in order to sharpen our focus implies no evaluation of the works themselves.

For this comparative study it would appear superfluous to begin by delineating the concept of classical art that originated in fifth-century Greece and, as a stylistic phenomenon, has since played an incomparable role in Europe. Its nature is well known and is not the matter in question here: we are interested in it primarily as a control for guaging our reactions to the effect Indian icons have upon us. Here we need simply refer to works whose classical character is undisputed: the Doryphoros by Polykleitos, the Apollo Belvedere, the Aphrodite of Knidos, or the related Medici Venus, and reliefs like the Parting of Orpheus and Eurydice (Plates 1–5).

In the great wealth of Indian sculpture, on the other hand, the images of the Buddhas and saints found in the northwest border province of Gāndhāra present a unique phenomenon: as a mixture of the classical style and that of the totally Indian sacred image, they reflect both their chronological and geographic position midway between the earlier, Hellenistic art

of the Mediterranean cultural matrix and the later art of India proper, along with its spheres of cultural influence farther east. These works mark the spread of Hellenistic art into India, and their form has little in common with the native Indian sacred image. Their pronounced Western flavor permits us to use some of them as foils for unadulterated Indian variations of the same motif, like the beautiful statue of the Buddha in Berlin (Plates 6, 7). But since Western training is of no help in understanding these images that do show Western influence, it would seem advisable, when studying the form of similar but purely Indian works, to discard *a priori* customary Western habits of mind, and to remove the limitations imposed by our traditional methods of considering art which, for an Indian, simply do not exist. Only the Indian sacred image itself can establish the limits to any study we may make of its form. The figurative sacred image patterned on the human body must be understood in terms of its own distinctive fashioning. If it should prove short-sighted and unjustified for us, following Western practice, to separate this genre from other constructs that, in the Indian view, are closely related to it and can even be substituted for it in cultic rites—as different as they may appear to our untrained eye and untutored mind—then we must appropriate *in toto* specifically Indian modes of comprehending and expand the scope of our study accordingly. Wherever the native soil of India does not yield enough visual material to study, then we will have to draw upon the cultural tradition of her neighboring lands, where India once sowed the seeds of her own culture.

. . .

UPON first seeing a piece of Indian sculpture, we are immediately struck by an all-pervasive stillness in the surrounding space, even if there are figures represented as being in great movement. A tranquillity radiates from these figures and, settling about the observer, forces him to slow his pace and reduces him to complete silence, stilling even his inner voice.

These art works do not inspire us with an urge to engage them in enthusiastic or deferential converse: they are not there

to be examined and pronounced beautiful. Each one leads a life of its own, and even the Buddha (Plate 8), one hand uplifted and the other opened downward, seems somehow to have found himself in our presence, instead of posing there; in his gestures, his essential quality is completely contained under the aegis of his aura, without any need to address himself to our person. In the presence of this tranquil being, we simply cease to be. He does not automatically draw our gaze to himself as does a classical figure in its space, which instantly transfixes any museum-goer's puzzled or searching gaze and will not release him until he finally wrenches himself away from his delight in following the play of the statue's form, or until he falls under the spell of the as yet unexplored charms of another statue nearby—all this can happen quite unexpectedly as he wanders from room to room or when some chance turn brings another figure into view. But a piece of Indian sculpture is apparently oblivious of our presence, and we feel inhibited in our attempt to establish even initial contact with it.

At the same time, the concrete nature of its presence brings it closer than any classical sculpture. It shares the space with us, whereas classical art lives and moves, as it were, in an ambiance all its own. To us, a classical statue seems encapsulated in crystallized air, but a Buddha's hand protrudes into the place where we stand. Only the Buddhas' tranquillity, their self-absorption, their unawareness of our approach prevent them—sharing space with us as they do—from becoming a mere object, like a sarcophagus or an inscribed stone. If this were not so, an inquisitive and profane hand might reach out and touch them.[d]

How different is the way a classical statue powerfully attracts our eye toward itself, addressing it persistently while still preserving an unencroachable distance by not deigning to share with us that space occupied by our physical presence!

[d] In this passage, Zimmer seems to be attributing states of consciousness, such as "tranquillity," "self-absorption," and so on, to the sacred images of India. It is precisely the inner state that is intangible to the "inquisitive and profane hand."

Its magic captivates us visually, and if our eye seeks to observe the work closely, it cannot reduce its distance from that object indefinitely, to a point where the object would be within reach. Our eye is not even at liberty to choose how close it may come to the object; on the contrary, it is the object itself which, by virtue of its intrinsic meaning, establishes the perimeters for our eye movements if we intend to understand its message. If our eye ignores these limits, then it is facing an inert mass rather than a work of art.

The classical work of art directs its appeal to our eye, promising us a glimpse of the infinite if our gaze does but follow its mysterious, beckoning call; we still have to ask where the appeal of Indian sculpture is directed—it is certainly not directed to our inquisitive eye. For the Indian figures refuse to take notice of us or to make eye contact with us that, once established, might then guide our eye over their richness of forms. Classical art appeals to our eye and to our eye alone. Anyone brought under its spell is physically galvanized, transformed into pure sight. With Indian sculpture, we circle about in vague disquiet; it does not look at us, and in vain do we try to capture its gaze.

Our eye is unaware of the actual material quality of what it sees. Whereas Indian sculpture seems simply to repose before us, mute, heavy, compacted in space, the classical figure exists in a realm unconfined by matter or gravity—it is without weight. And that is why it can appear to share our space as well as to be standing within its own sphere. By capturing the beholder's gaze and transforming him into pure sight, it causes his eye to bring about a transubstantiation of the statue: its concrete reality evaporates into a purely optical one. It is a weightless projection in space; Indian art, on the other hand, remains a material construct. The material substance of Polykleitos' Doryphoros (Plate 1), for example, is dissolved as such, for our eye perceives only the statue's shape. Only the mind in an act of aesthetic reflection, reexamining the component parts of the eye's impression in the attempt to reduce them to their first causes, can account for the material quality that stone and bronze possess. The Doryphoros is the very

form of a youth, whereas in Sundaramūrtisvāmin, we have the bronze figure of a beautiful youth (Plate 9; cf. the classical parallel, plate 10). Classical art transcends matter as such (in exhausting its possibilities) and transfigures it into a likeness, but the material used in Indian art remains palpably near. An Indian statue is material that the artist has wrought, but it still retains its peculiar material quality, and in looking at it one can admire only the execution of its formal fashioning. In that material, we find not an actual youth or bull but rather the stone or bronze sculpture of a youth or bull. For the material does not bind us with the kind of spell that makes us into pure sight, nor does it cast us into the role of mere observer; on the contrary, it leaves our physical nature intact. That also allows the Indian image to preserve its own physical integrity.

This is why the Buddhas on the inner walls of Borobudur (Plates 11, 12), for all their otherworldliness, are enveloped by the same atmosphere that gently brushes the pilgrim wandering along the terrace at their feet; seated in their niches, they are just as close to him physically as are the masonry walls in which they are set; they share with the surrounding stone the same tangible atmosphere that flows into the space over and around them. Their apparent ability to create a sense of remoteness does not come from an act of transubstantiation performed by our eye but stems instead from their self-contained aloofness, which creates a buffer of space around them—a characteristic something like the unapproachability possessed by a living saint walking through a throng of people who give way to him because he is oblivious of them.

· · ·

THE classical work of art directs its appeal to our eye and mesmerizes us. It has an eloquence all its own. Its intention is to express itself, and this is what it is in fact able to do. It reveals itself totally as a many-sided, interconnected set of relationships as finely articulated as an eloquent sentence in which a meaning is expressed, but which is simultaneously divided into a multitude of interlocking verbal signs ultimately forming an integrated whole. The classical work's spellbinding power over our eye derives from a similar rich-

ness in the relationships of its parts to one another. It prompts our gaze to move in circular fashion, encompassing the work on every side, from top to bottom, causing the observer himself to circle the statue again and again within an enchanted orbit. Each aspect of the classical work of art is connected to the others, for everything in it has reference to every other thing. The magical wealth of relationships within that elaborately articulated whole transports the observer's gaze and his whole person into a rapturous disquiet of movement, where our consciousness of the inexhaustibility of this magical effect creates an indispensable and delightful element of tranquillity. The classical work of art generates in us an insatiable curiosity to see. It salutes the eye with the words: "Verweile doch—ich bin so schön!"[c]

The unforeseen and quite differently constituted spell cast upon us by the image of a Buddha or some other Indian divinity emanates from the immense, self-enveloping feeling of tranquillity these images create. They do not compel our gaze by means of some essential nature they might manifest before us, for this they reveal not even to themselves; they are simply at rest within themselves. They are pure Being, undivided by self-knowledge; Being does not become an object in Its own eyes, and therefore can dismiss us from Its presence without ever having wished to become, for us, an object.

The magic found in the classical work of art resides in its perfected articulation that guides our eye movements in any number of ways. Our gaze cannot escape its spell because, once captivated, it becomes enmeshed in an irrational system of visual guides prescribing the proper direction for its movements. The classical sculpture contains a wealth of contours intended to conduct our gaze along certain paths; in waves of light, the active play of its surface undulates, their brightness drawing our eye along avenues where shadowy recesses entice and divert our gaze. Our eye is expected to scan every part

[c] "Tarry a while! I am so fair!"—a parody of Faust's famous line in two important scenes with Mephistopheles: "Verweile doch! du bist so schön!" ("Tarry a while! thou art so fair," *Faust*, 11. 1,702, 11,580). "Thou" refers to the moment in time that Faust might wish to bring to a standstill.

of the work—it is on parade before us. But Indian sculpture is in repose, sufficient unto itself.

In the classical style, a number of structural elements articulate the entire figure: the sparseness and rich detail of its ornamentation; the workmanship evident in its body surface and hair, and the arrangement of its garments. As constituent parts of a concerted whole, they play into one another's hands. If an observer attempts to analyze the cohesive effect of that combination of parts operating within and for one another, then his knowledgeable description of their material and architectural structure, which is to be understood simply as a guide for the eye's movements, will express something fundamental about the effect a classical work attempts to achieve.

Analyzing a classical work in this way is like parsing a well-constructed sentence. In parsing, a simple inventory of the word content and of the grammatical and syntactical structures yields basic information about the sense of a particular sentence. As a further stage, annotations may go beyond the sentence's elaborate syntax and beyond the resonances of the separate words' rich semantic overtones to indicate their rightful place in a broader intellectual context, and to give due weight to a personal stylistic variant of a general syntactic pattern; these annotations make it possible to breathe life into the stark grammatical outline of the sentence, once its concepts have been analyzed, and to bestow on both syntax and concepts that luster and luminous glow found in all reflections of the *élan vital*. In following these steps, analysis achieves all it can achieve in the deciphering of a sentence. When interpreting a work of classical art, we commonly attempt to bring life both to its components (which have been listed in an analytical description) and to its rich architectural design (which functions as a visual guide) in the following ways: by striking through to the wider context of the work's historical and intellectual referents; by comprehending these referents with the aid of their specific stylistic features; and finally, by assigning to them appropriate descriptive adjectives from the semantic fields expressing charm, dignity, or human spirituality.

But with respect to Indian sculpture, the same analytical procedure yields nothing that might prove productive. If a critic's rambling descriptive catalogue should direct our attention to those features of a statue that are either more or less apparent—to the figure's limbs and their placement relative to one another, to its ornamentation and garb—then we will end up with a mere list of what is obviously present. What we, as well as the critic's directive commentary, lack are piloting guides for our eye's movement, visual guides that could transform the work's architectural design into a powerful visual experience. All attempts at talking about or perceiving the image in this way will yield only a stock-taking of the materials item by item as we find them, an inventory that we can understand only as a list of particulars; but the mere act of stock-taking does not reveal the wealth of meaningful relationships binding the image's parts, nor would our inventory expand to include those significant interconnections.

In the case of Sundaramūrtisvāmin (Plate 9), garments and jewelry appear simply as additions enhancing his overall appearance; they are hardly visual guides at all, unlike the ornaments and lines of our own apparel, which are designed to order our personal appearance and emphasize the body's natural structural elements. Originally, lines and patches of color may have been introduced into our clothing to function as guides for our eye (which means the color has been structured), but, not surprisingly, this role is eliminated to a great degree by the very stuff and substance of our clothing and by the very nature of color itself. This happens because the coloring in our clothing is able to attract, isolate, and rivet our gaze by virtue of the self-contained quality colored material shares with whatever else exists as matter in our world. In exactly the same way, Sundaramūrtisvāmin's garb and ornamentation rest in the imperviousness of all material things that are wrapped up in their own existence, free of any desire to catch our attention. This explains why the analytical observer schooled in the analysis of classical art is powerless to detect anything concerning the essence of Indian religious

sculpture. The analysis of classical art has its own dynamic—searching for facts and recording them one after the other; but in Indian art, analysis will discover no network of paths that would let our gaze glide along many criss-crossing routes until the sum total of what our eye has discovered in this higher realm crystallizes into an image of the figure studied. Here, the body and its ornamentation are not really attached to each other in an articulated manner; they do not merge to form an elequent whole, either by contrasting with one another or by accentuating their similar features. To our eye they are a single, irreducible unit, a totality of Being. With this type of sculpture, there is nothing to be gained by pointing out and discussing its separate parts one after the other, for there are none. We convey little information about a person's outward appearance if we describe him as being a naked man plus clothing, for what we are looking at is a clothed person; and just as little is achieved if we try, by analyzing an Indian sacred image, to contrast its garb and ornaments with the body. In the unity of its body and garment, nothing is thrown into relief. Even its head is not articulated as such, distinct from its torso, unlike the way the head of the Apollo Belvedere (Plate 2), for instance, is set off by the gathered material running from shoulder to shoulder; or unlike the way the head of the statue of the Gāndhāra Buddha now in Berlin (Plate 13)[f]—commonly regarded as being classicizing in manner—is set off by the definite shadowed fluting of its garment. (This figure, however, does not have a collarbone casting a shadow to accentuate the base of its neck.) Indian sculpture is not really meant for an eye that is looking at a mass of external features—an eye by nature perpetually in outward-reaching, restless, but rewarding motion—because it has never been the purpose of Indian sculpture to direct anyone's gaze in any way or to reveal to analysis its own cohesiveness, which is devoid of any differentiating accents and structural contrasts. This sculpture does not seek to create an effect,

[f] See also Plate 62a in Heinrich Zimmer, *The Art of Indian Asia*, Bollingen Series XXXIX (Princeton: Princeton University Press, 1982), Vol. II. Cf. Zimmer's remarks on p. 236 below.

because it does not even acknowledge the existence of the person looking at it.

Sundaramūrtisvāmin is the dancer intoxicated with his god: his slender form vibrates in ecstatic rhythms; he is about to set his soul a-dancing in the play of his limbs, rendering homage before the image of his god in the temple; his god is hovering before his blissful inner vision even more tangibly than in the concrete image. Yet Sundaramūrtisvāmin is not simply posing there before us, or even for us—he trembles before the countenance of the god, who is seen as a vision filling his whole inner being. This artistic representation of the dancer does not capture the single, significant, impressive moment of his dance but the whole Being instead, that hovers there, self-contained, oblivious of Itself.

But how different is all this from classical art! There the figures are completely aware of themselves and of us. They seem to depend on an observer for whose fascinated gaze they render immortal an idealized moment. The Apollo Belvedere (Plate 2), poised with leg extended, arm outstretched, head in profile, bids time stand still around him, for we can imagine him in this pose only in this, the briefest of moments. Immortalized in that moment, he requires an observer who is prepared to accept his pose as a momentary one; unless there is an observer able to look upon it as being momentary, then all that his pose implies would make no sense, for it is in fact something that is permanent and lasting. The statue's design assumes that there is always an observer keen to follow the vibrant thrust of his stride, the sovereign turn of his head, and the expansive sweep of his arm. Even the pose of the Medici Venus (Plate 4) is situated in time and assumes the presence of an observer. The observer whom she permits to witness and pay homage to her unveiled beauty is just as essential a factor in the statue's artistic conception as are the momentary nature of the occasion and the frozen, yet fleeting quality of the event itself; like all classical figures, she exists in time. If we have just been viewing an Indian sacred image and return to the deities portrayed in classical art, then we have stepped out of the realm of unceasing, immutable Being

and once again encounter a work in a pose immortalizing a momentary situation; if at the same time we do not fall under the spell of the classical work, then we might look at the Apollo Belvedere, for example, and think: "How boring it must be for him to hold his arm outstretched like that all the time, even when these rooms are dark and deserted." Or when leaving the Aphrodite of Knidos (Plate 3) to herself after standing in contemplation of her, we might even be tempted to take the garment she is holding over the jug and place it gently about her shoulders to keep her naked body from shivering as she prepares for her bath, because who knows for how long she has to remain in the same position. For she exists, we must remember, in a single moment of time.

By contrast, the two hands of a Buddha image exist as gestures in a sphere beyond time—one hand extending forward, palm upward, offering protection, the other opened downward in the act of bestowal. In these hands, both the virtuous act of giving and the compassionate power of protecting all living things take on visible form: they are timeless elements of a Buddha's essence. (Plate 8; cf. also Plate 14.) In making this gesture, they *are* Buddha. They do not ask whether or not anyone is watching them in this expressive pose; the pose is inalienably theirs as the part of their essential nature that lies beyond the contexts of place and time. Even the dancing Śiva (Plates 15, 16) is not simply a dancer portrayed during a moment of his dance; he is the very embodiment of dancing—*homo saltans*. In sculpture and literature he always appears as the supreme dancer. In Sanskrit he is called by a variety of names describing him as a dancer: the "King of Dancers" (*natarājā*), the "Lord of Dancers" (*nateśvara*), and the "Friend of the Dance" (*natapriya*), among others. Though his manifestations are numerous, once we perceive him as being the Divine Dancer whose dance is the world's unfolding, play, and destruction, then he is nothing but dancer, the dancer eternal. His dance is more than just a characteristic pose, frozen and rendered immortal in the image: dancing is his elemental state. Dancing is one of the many aspects of his

divine essence, one of the allegories in which his infinitude assumes perceptible form. But each one of these allegories is absolute with regard to its content and is connected directly with the god's essence, which lies beyond all perception. These allegories do not all exist simultaneously in our consciousness when, through meditation with the aid of one of the allegories, our consciousness immerses itself in the god's essence. They exist simultaneously only in the words of an inspired believer—leaving aside the observations of a scholar of religion—a believer who compares one allegory of the god with another: that is, who compares one totality of the god's essence with another (as in the serial progression of a litany, perhaps), all of which cancels out one allegory by exchanging it for another and reveals the inadequacy of all allegories when they attempt to capture the infinite nature of the Divine.

The classical work of art assumes that there will always be an observer present whose lingering gaze is delighted by the work as it interprets it; the work is well aware of its beauty and is resolved to exploit it for full effect. Sure of its triumph, the work sings out to the viewer like Salome in her deranged wooing of the prophet: "Mortal, behold me!"[g] And if our gaze should fail to be enchanted and we move on, drawing away from the work without having succumbed to its charms, then it has every reason to echo Salome's plaintive lament to the severed head of Jokanaan: "Oh! wherefore didst thou not look at me? If thou hadst looked at me thou wouldst have loved me." Nothing, of course, would give us the right to apply to ourselves her words that precede this passage: "Thou didst put upon thine eyes the covering of him who would see his God"; yet this statement, together with the image of Jo-

[g] Zimmer is paraphrasing from the conclusion of Strauss's *Salome*, where the heroine sings the words, "Warum siehst du mich nicht an?" (in Lord Alfred Douglas' translation of Wilde's play on which the opera was based, "Wherefore dost thou not look at me?"). In Zimmer's original German text, the two quotations that follow are much closer to Hedwig Lachmann's libretto. We have used Douglas' version there as well.

kanaan's descent into the dark and solitary confinement of his cistern, where visions of his God shine round about him, might give us some intimation of that inner world where images of the Buddhas and gods and saints of India find their origin and life.

Yoga and the Figurative
Sacred Image

The Worship of the Figurative Sacred Image
(THE *pratimā*)

The spiritual world in which the Indian sacred image is firmly rooted lives in the great traditions of the Hindu sects which, from the beginning of the Christian era, we find attested in an extensive body of literary works of a more or less esoteric nature. The later corpus, the literature of the tantras, is highly informative both in regard to the role the sacred image plays in the religious life of believers of vastly different sects, and in regard to specifying the actual meaning attached to that image by the devotee himself. These valuable source materials have never been adequately treated by Western scholarship.[a] This can be attributed to the sheer volume of the visions that laid open India's spiritual heritage to an industrious but small band of scholars; another reason is the natural tendency to devote oneself first of all to more ancient documents of Indian culture because these, like records of early stages of all of human culture, seemed preeminently worthy of consideration. Measured by Indian time standards, the tantras cannot claim the authority of great antiquity; nor are they surrounded by the nimbus of a world religion, which assures Buddhism,

[a] Although dozens of books on tantra and translations of tantric texts have been published since this assessment was written, it is arguable that Western scholarship still has not done an "adequate" job with the tantric material. The sheer immensity of sources has proven to be an obstacle for scholars. Moreover, their esoteric, inscrutable qualities have kept the uninitiated away from their deeper significance. Wendell C. Beane outlined these difficulties in the introcuction to his *Myth, Cult and Symbols in Sakta Hinduism* (Leiden: E. J. Brill, 1977).

for example, of universal interest. Moreover, they are still alive, even though their popularity is declining. It is by virtue of their esoteric nature, then, that they were relatively more shielded from scholarly inquisitiveness than were documents of earlier, long-lost spiritual worlds that were able to resist the desecration of scholarly inquiry only because they were difficult to understand. Until now they have, for the West, been enveloped in their intrinsic occult quality, and whatever vague knowledge of them did circulate was not particularly calculated to attract the attention of nonmetaphysically and positivistically oriented research, whose direction every now and then betrayed a puritanical Christian influence.

The tidal flood of tantric literature reflects that last, commanding vision of the world in which the very spirit of India, welding its ancient heritage into an organic whole, once again magnificently manifested itself before the Western world which, in following its Christian, positivist bias, dismembered it and destroyed the fiber of its being. The tantras appropriated the solemn formulations of Vedantic philosophy and the marvelous psychological experience of yoga practiced for thousands of years; they provide the framework comprehending both the lofty Hindu ideas of God and the wealth of magical rites that promise mastery over everyday existence and life itself—rites that control the circumscribed, multifaceted, capricious, and unfathomable world around us, and that grant access to distant realms and spheres unknown. As a whole, the tantras form a design on the grandest scale, and seen in the detail of their closely knit historical heritage, they are incredibly intricate: a labyrinth.

Arthur Avalon has rendered great service by rescuing this inexorably darkening world from the gathering dusk and by bringing it under the lamplight of the scholarly intellect; it was he, first and foremost, who opened up this world to western inquiry, and the present limited study would not have been possible without his epoch-making, pioneering work in textual edition, translation, and the writing of introductions, for all of which he enlisted the aid of native Indian colleagues.

By undertaking an evaluation of the vast material that he un-
covered, which aids the understanding of formal character-
istics of the Indian sacred image, the present study stands as
a small token of gratitude for all the light his works shed on
past eras, especially on the last and greatest, of ancient India.

The tantric world of thought and artistic forms dominates
one whole age of the Indian spirit and, as an expression of
the orthodox Brahman *Weltanschauung*, it has influenced and
shaped the faith and modes of life of those heterodox Buddhist
and Jaina sects that flourished and declined in the midst of
orthodox Hinduism. Coexisting for centuries, both doctrines
took over from later tantrism ideas of God, sacred forms, and
symbols, and during this protracted process of amalgamation,
Buddhism in the Indian subcontinent essentially lost its own
peculiar stamp until it was, in the end, completely obliterated.
For all these reasons, what the orthodox Brahman tantric texts
have to say about the meaning and function of the sacred
image finds parallels in Buddhist literature, and may properly
serve as a guide for understanding the general formal aspects
of Buddhist sacred images. It appears legitimate to assume
that, historically, the sacred image and its worship gained
entry into the Buddhist world only after it had appropriated
tantric concepts into its ascetic doctrine of release and after it
had transformed its own worthies and saints into godlike
beings modeled on the great Hindu divinities.

In following qualified experts in tantra, Arthur Avalon
found access to the hermetically sealed world of the tantras,
and, as an excellent introduction to it, he translated a com-
prehensive work by Śiva Candra; this man, recently deceased,
was a disciple and teacher of tantra whose thorough acquaint-
ance with, and faithfulness to, the ancient tradition was un-
tainted by modern Anglo-Indian influences. The second part
of his *Tantra Tattva* (Principles of Tantra) draws entirely on
the ancient sources and interprets them, detailing the function
of the Hindu gods in the believer's everyday religious life.
Here we can discover how an Indian initiate views the mean-
ing and role of the sacred image, and we can above all com-

prehend the spiritual world in which the images of the Hindu divinities are rooted.[1]

The cosmic vision of the tantras perceives the world as the multitudinous unfolding of divine energy (*śakti*, power) into a world rich in manifestations. This energy is essential Consciousness (*cit, caitanya*) and its true state is Being, devoid of emotion, hence free from pain as such, and it is a blissful (*ānandamaya*) state of Being. Furthermore, this true state is without attributes (*nirguṇa*). Tantric doctrine acknowledges this by adopting the idea of Śankarācārya, the great teacher of Vedanta, that *śakti*, in its innermost nature, is just like *brahman*: Being, Awareness, Bliss (*sat cit ānanda*), and the one totality of Being, "Without a Second" next to it (*advaita*). In this state it is Being Not-Yet-Unfolded (*avyaktam*, a concept developed in Sāmkhya doctrine). But it is endowed with the power of *māyā*, of illusion, and because of this, the play (*līlā*) of cosmic unfolding from the not-yet-unfolded spiritual state devoid of attributes can now proceed. In this play, pure spiritual divine energy takes delight in transforming itself into a personal form of the god possessing attributes. Dividing itself

[1] *Principles of Tantra (Tantra Tattva) of Shrīyukta Shiva Chandra Vidyārnava Bhattāchārya Mahodaya,* edited with an introduction and commentary by Arthur Avalon (London: Luzac, 1916), 2 parts. The following remarks are chiefly based on this encyclopedic presentation of tantrism, and the key quotations (which form the major part of this chapter) are taken from Part II (Chapters XV-XX). Śiva Candra has himself quoted these passages from older authoritative books of instruction. Since these original sources will be quoted directly later on, it seemed inappropriate here to encumber introductory remarks on a little-known area with source references.

Arthur Avalon has published original tantric sources in the eleven-volume series, *Tantrik Texts* (London: Luzac), "with English introductions giving summary or general descriptions of contents." Cf. further his translations: *Tantra of the Great Liberation (Mahānirvāna Tantra)*, a translation from the Sanskrit with introduction and commentary by Arthur Avalon; *Hymns to the Goddess: From the Tantra and Other Shāstras and the Stotra of Shankarāchāryya*, with introduction and commentary translated by Arthur and Ellen Avalon; *Wave of Bliss* (Ānandalaharī), translation and commentary by Arthur Avalon; *Greatness of Shiva (Mahimnastava of Pushpadanta)*, a translation and commentary by Arthur Avalon, together with [the] Sanskrit Commentary of Jagannātha Chakravartti; *The Six Centres and the Serpent Force*, etc.

into many forms, the spiritual realm becomes conscious of itself as World and as the divine power permeating and governing it. Viṣṇu, Śiva, Sūrya the Sun God, Gaṇeśa the elephant-headed "Lord of Hosts"—those great gods of the Hindu faith tower over the other personified divine figures. In all of them, earth-bound human consciousness, where the spiritual is caught up in the separation between perceiver and perceived, can behold and worship eternal spiritual Being-without-Attributes (*nir-guṇam brahman*) in a visible form that does have attributes (*sa-guṇam*). In its play, the divine spiritual energy (*śakti*) leaves the purely spiritual state (*nir-guṇam caitanyam*) and enters into conscious Being—that consciousness which always requires a world made up of many things, which can only exist when it senses those things that can be differentiated (those very attributes, *guṇas*). Then *śakti*, in delight, binds itself with the bonds of its own *māyā*. Within the several, duller levels of our consciousness of the phenomenal world's many differentiations, *śakti* realizes itself above all in the consciousness of the individual human soul, in *jīva*. But since nothing can exist apart from this divine spiritual energy, the lower worlds of animals and plants—even mountains and rocks—are simply stages of the unfolding of the one single Śakti into which, in play, it divided to form the duality of consciousness. Their lack of spirituality, their insensate nature exist only as opposites to the dimly lit spirituality of human consciousness; bound to this consciousness by its own *māyā*, the spiritual, that energy, does not know itself as the Universal One.

In sheer delight, pure spiritual Being splits into vital Being laden with attributes so that It may become aware of Itself in the many shadings of ever-increasing dimness and impenetrable, unilluminated gloom; in so doing, It repeatedly strives to return to Its undifferentiated state in both human and divine consciousness, to return to that crystalline peace within Itself where, completely undifferentiated and without attributes, it has no knowledge of itself. Man wishes to experience himself as *brahman*; he wishes to weld together the split between the perceiver and the world of appearance; in experiencing pure,

total Consciousness, he wishes to obliterate his own consciousness of self as being something differentiable, fed by the constant fluctuation of all that it contains.

The path for attaining that goal is, in tantric teaching, worship before images of the gods. Whichever of the great divine figures the believer chooses as a focus for his devotions is of secondary importance. The choice will be determined by his own or his family's inherited set of beliefs, or else by the ritual taught by his spiritual adviser, his guru. The personal form of the divinities whose image and essence are made the object of contemplative ritual are, after all, only the most elevated aspects with attributes (*sa-guṇa*) of pure, undivided Consciousness without attributes (*nir-guṇa caitanya, brahman*); the divinities cannot be envisaged in their pure state (because the perceiver forms a unity with what he perceives), but they can be envisaged in their various aspects. They are merely transitional stages on the way to the ultimate goal of devotional practice: to experience pure, undivided and unenvisaged Consciousness, to feel It and oneself as being one and the same. Properly considered, any of the divinities can lead to this goal.

Alongside these—but far more prominent than they—there is the female figure of Kālī-Durgā who is, for human consciousness, the noblest form in which divine, spiritual energy (*śakti*) may be envisioned. Pure Consciousness (*caitanya*) divides, within human consciousness, into the human soul and the god which is its object; and within that division, pure Consciousness comes to consciousness of Itself—playing in the web of Its own *māyā*; pure Consciousness beholds Itself most clearly in the Dark Goddess, in Her, who is feminine in gender, like the word *śakti* (energy), as which undifferentiated spiritual Being—*brahman*, which is neuter—represents Itself; and *brahman* does this when it divides within itself as the seductress in the enticing dance of the variegated world of appearances, and when *brahman*, motherlike, sustains all the many kinds of consciousness in the world as the unfolding of its Self, and when, in the end, it swallows up all these forms of consciousness again and again, annihilating their separate-

ness.[b] Kālī-Durgā is the epitome of *śakti* in its visible aspect, by whose power the other divinities in personal form attain life. She is the most directly perceived, attribute-laden unfolding of the invisible, undifferentiated, pure divine Spirit-Being (*brahman*), which can only be felt in the experience of total unity, in the melting away of one's conscious existence— for inner visualization, she is the purest possible manifest form of the unenvisionable, which, once experienced, merges the perceiver with what he perceives.

The process of human thinking can never really overcome the duality on which human consciousness, like all consciousness, is based; for thought presupposes consciousness and is itself only a movement or transformation (*vritti*) of consciousness. In the realm of thought, consciousness can, at best, only have theoretical knowledge about how to overcome the duality of perceiver and perceived; it can address this task as its goal but can never eliminate or overcome this duality. To resolve the duality is to extinguish consciousness. Whenever pure, divine Consciousness (*brahman*) binds Itself with the magic of its *māyā* and assumes in play the form of human consciousness, then It may naively feel Itself to be part of a many-sided, variegated, articulated, and interconnected world; and so It may devoutly worship the personified divinities who inform this interconnected world, revering them in contemplation, images, and symbolic signs so that It might find Its way through the world which is unfolded before human consciousness; but when Consciousness elevates Itself to become the will to experience, as a totality and unity, Its

[b] Zimmer's description of Brahman as "motherlike" is in keeping with the tantric tradition's view of the Great Goddess as the totality of all that is, seen and unseen. As Woodroffe stated, "The Devi, as Para-Brahman, is beyond all form and guna. The forms of the Mother of the Universe are three-fold. There is first the Supreme (*Para*) form, of which, as the Viṣṇu-yāmala says, 'none know.' There is next her subtle (*Sūkṣma*) form, which consists of mantra. But as the mind cannot easily settle upon that which is formless, She appears as the subject of contemplation in Her third, or gross (*Sthūla*), or physical form, with hands and feet and the like as celebrated in the Devī-stotra of the Purānas and Tantras." *Introduction to Tantra Sastra,* 5th ed. (Madras: Ganesh and Co., 1969), p. 14.

own essence spread out in rich variety—the will to enter into Itself to find repose—then images and signs will serve as tools (*yantras*) for bringing about the union (*samādhi*) of perceiver and perceived.

. . .

THE image that the believer places before him for his daily devotions is made the focus of his concentration and consequently becomes the absolute object of his consciousness. When opposed to consciousness (the perceiver), which is the One, the image is the epitome of the Other (the perceived)— the Second in Its totality, the hieroglyph for the world. The changing flow of appearance, which like the play of the waves washes round consciousness that is in a nondevotional state and open to the world, solidifies in that image into a picture of peace, taking the form of that image; unity is crystallized out of the self-moving, oscillating multitude of things found in thought; from this inchoate mass, where external phenomena and the human soul find themselves in company, there arises a concentrated duad: the preliminary stage for the union of the perceiver and what he perceives (*samādhi*), the accomplishment of which is the goal of devotional practice, where consciousness comes at last to rest and spirituality leaves all differentiations behind, returning to pure Being without attributes.

Since here, as in acts of magic, the sacred image is used as a tool, it is a *yantra*. This word is a very broad designation for an instrument or tool, a device or mechanism a person uses for carrying out a specific task. The sacred image is a device of very efficient construction used for both magical and ritualistic, spiritual functions. In all these uses, however, the figurative image (*pratimā*) of a divine being is neither unique nor isolated among all the technical devices; it does not even assume a dominant position among those mechanisms serving exactly the same function. Besides the *pratimā* there are other handmade, meaningful constructs that more or less differ from it in form but serve precisely the same purpose and may replace it within the sacred ritual. These include *cakras* ("circle-shaped" designs), mandalas ("ring-

shaped" designs), and, related to them, exclusively geometric, linear figures that have no other name but *yantra*. Accordingly, the figurative sacred image (*pratimā*) is just one member of an entire family of representational sacred devices (*yantras*). It is markedly different from the other *yantras* because of its choice of means, of the signs it uses exclusively to reveal in the realm of appearance the essence of the deity it represents: its figurative elements in human and animal form, together with their attributes (weapons, clothing, decoration), are all taken from the sensual world of appearance. The other types—"circle" and "ring" designs and purely linear figures (*yantras* in the narrower sense)—do, to a greater or lesser degree, dispense with these figurative elements. Figurative elements are not in the least a required component of these designs. In them, the figurative element can be replaced by written symbols, but these purely geometrical shapes made of triangles, squares, circles, and quasi-geometrical lines resembling lotus petals can also be complete without any symbols that might make clear the essence of these designs even to the eye of the uninitiated (Plates 17-19). Highly stylized constructs of this type, meant for temple use, also combine a rigidly geometrical structure with richly figurative decoration (Plates 20, 21).

If we wish to reach a basic understanding of the unique formal characteristics of the Indian sacred image, then we have to come to grips with the absolute functional congruity of all these constructs, though they are apparently so different in form, and although in linguistic usage their common designation is *yantra*. When considering the figurative sacred image (*pratimā*), we cannot isolate it from other, equally important *yantras*, if we want to understand the essential quality of the *pratimā*'s form. Only insight into the real functional identity of these types employing so very different languages of forms can enable us to view the figurative sacred image (*pratimā*) with eyes anything like those for which the *pratimā* was created—and whose creation it is: the eyes of the Indian initiate. To learn how to see the figurative sacred image, we follow a path from it, via the geometric diagram decorated with fig-

ures, and ultimately reach the purely linear, geometric *yantra*, until our sight—filled with what it has contemplated, and now transformed—may then return to the *pratimā*.

Finally, to understand the choice of particular formal symbols that are used in many of these sacred images to symbolize divine essence requires a slight extension of our vision to include a completely different kind of phenomenon that may replace sacred images in the act of devotion. In their stead, human beings can appear as incarnations of the Divine, even in esoteric rites. The adept's teacher (guru), as the transmitter of tantric doctrine, is a living embodiment of that immortal archetypal teacher who first revealed its truth and is accepted by sacred tradition as having first given voice to it: Śiva, the Great God. And furthermore, it is woman—in the first instance the adept's wife, but all women and girls—who is the tangible, manifest form of cosmic, divine power (Śakti) which, in play, unfolds itself to the world of appearances; her maternal womb (*yoni*) gives birth to the world of *māyā* that holds us enthralled. Pure Being, in Its first transformation from Its undifferentiated state without attributes (*nirguṇam brahman*), reveals Itself as the divine couple: as Śiva and Śakti, as the god and his divine energy. They are two, and yet one; they are the one Divine, seen under the two aspects of repose-in-itself and of the energy-that-unfolds-itself, *māyā*. In the language of figurative forms, the symbol for both of them is the lovers' sexual union (Plates 22–25); on the plane of linear expression, it is the symbol of the triangles pointing upward and downward which signify womb and phallus (*yoni* and *linga*; Frontispiece, Plate 17). It is the aim of devotion to raise oneself from the *māyā*-bound human state to divine Being, that is, to bring the *brahman*, dark and obscured in the consciousness of *jīva*, to the crystal clarity of its essence; to achieve this, there is a transitional stage in which the initiate, whose sentient life is to be totally purified and controlled, experiences himself as Śiva by elevating in worship, a female person to Śakti. Both these striking acts in the occult ritual, in which this stage of the deification of the initiate's person is carried out, and the symbolic world of the sacred images referring

to these acts, are reflections of one and the same meaning on two different levels of vivid physical manifestation, which elucidate one another. Whatever an uninitiated person might feel to be puzzling about the practice of this ritual is explained by the traditional conceptual formulas, as well as by the visible forms of the images, and we find the images' world of symbolic forms, in turn, explicated in the esoteric rites.

The designing of the geometrical sacred images (mandalas and *yantras* in the narrower sense), which are graphic mirrors of supernatural essences, is of course strictly controlled, because they are employed as expressions of those essences, and they are free of any subjective decorative fashioning on the artist's part, since that would destroy their purely expressive and iconographic character and degrade them into scrawls without significance, even though they might be very pleasing to the eye. The same is true of the role of the figurative sacred image (*pratimā*), as attested by its name and use as a *yantra*. The word *pratimā* means literally "counter-measuring," and denotes that thing which is measured against and tailored to the original. The figurative sacred image is therefore the accurate copy of a phenomenon and stands to it in a relationship of absolute, conscious fidelity, free of any capriciousness. We can compare this relationship to the one existing between the silhouette of a living object and the object itself, where the value of the silhouette resides precisely in the faithful reproduction of the contour of that three-dimensional phenomenon. On the plane of three-dimensional, physical representation, the figurative sacred image strives to achieve the same purpose, to reproduce essence flawlessly, just as the graphic, two-dimensional *yantra* does by being a construct composed of significant lines to which written syllables may be added.

Possessing a tangible, material immediacy, both the *pratimā* and the graphic *yantra* are works of human hands, mere implements, and as such they may be discarded or even destroyed after they are made. Along with the sacred images for temples and domestic altars, which are manufactured from sturdier materials and are meant for frequent and repeated use in devotional practice, innumerable unfired clay images were

made, and are still made, morning after morning for daily rites in orthodox Hindu circles, just as *yantras* and mandalas are drawn and, after they have been used, are consigned to the rivers, where they dissolve or else are broken up, like quickly produced, unglazed clay vessels or plates made up of leaves, which are simply tossed aside after a meal. Even so recent a poet as Tagore could depict the ephemeral life of these sacred images, which are newly made every day, in a poem called "The Crescent Moon," in which a mother answers her child's questions, "Where have I come from? Where did you pick me up?":

> You were hidden in my heart as its desire, my darling.
> You were in the dolls of my childhood's games; and
> when with clay I made the image of my god every
> morning, I made and unmade you then.
> You were enshrined with our household deity; in his
> worship I worshipped you.[c]

It is not until the spiritual activity of the devotee makes a particular *yantra* (*pratimā*, mandala, or a *yantra* in the narrower sense) the focal point of all his powers of concentration, that the *yantra* takes on any significance.

This process of transformation, which human consciousness performs on the material substance of the *yantra*, occurs in the act of worship, in *pūjā*. The image is not the deity, nor could the deity's essence, through some magical evocation, enter from somewhere outside into the heart of the image for the duration of the ceremony of worship; the believer produces in his own inner being a vision of divine essence and then projects it upon the sacred image placed before him, in order to experience visually the divine essentiality in that state of duality which corresponds to his own consciousness. This inner vision of divine essence in human shape is not, of course, the result of an arbitrary whim; in the vision, a divine Being,

[c] *The Collected Poems and Plays of Rabindranath Tagore* (London: Macmillan, 1967), p. 57. The passage comes from "The Beginning," a poem in the collection entitled *The Crescent Moon* (1913) and translated by the author from the original Bengali.

invisible to the outer eye, is to enter the inner field of vision—a suprahuman, higher reality is to be mirrored in human consciousness.

How this suprasensual essentiality is presented to human sight has been set down by the tradition of its self-revelation. In the course of the ages, the Divine reveals Itself ever anew in word and in visible form; both Its word and image are part of the inherited sacred tradition of the initiates, handed down from teacher to disciple and preserved in their communities. Image and word, as self-revelations of the Divine, contain statements concerning the essential nature of the divine cosmic order, and they incorporate the higher Truth. They are Truth in the purest form that a consciousness, bound in duality, is capable of envisaging. In the image and the believer's consciousness, the pure, not-yet-unfolded Consciousness (*nirguṇam caitanyam, brahman*), which is totality, splits apart into two forms of appearance laden with different attributes (*guṇas*), because of the spell of its *māyā*, and Consciousness can see Itself—that is, It becomes aware of Itself in Its differentiation. This process of worshiping the image is one part of the rapturous unfolding of purely spiritual energy (*śakti*) before itself, from which energy plunges back into the state of enfolded Being (*avyaktam*)[d] when the image and the beholding consciousness unite (*samādhi*). At this point the goal of sacred ritual is reached: the believer experiences himself as divine.

The sacred image is able to absorb the inner vision projected upon it and let itself be suffused with it because its own material components (wood, stone, clay, bronze, sandalwood paste, or pigments) are only specific unfolded forms of the

[d] The term *avyaktam* is often translated as "unmanifested," as in Hume's translation of the following verse in the Katha Upanishad: "Higher than the Great is the Unmanifest (*avyakta*)." *A Source Book in Indian Philosophy*, edited by Radhakrishnan and Moore (Princeton: Princeton University Press, 1957), p. 47. In the present context, Zimmer uses the term "enfolded being" in order to clarify the distinction between the outer-directed unfolding being and the inner-directed enfolded being. This inner being is *ipso facto* unmanifested for the outward observer.

One Śakti, stages of the One Spiritual that have been concretized for human comprehension. Found with the image, and considered equally important expressions of the essence of the suprasensual, are sound, syllable, and word, which are more compact, more concentrated unfolded forms of *brahman* intended for the ear. Their significance for the believer initiated in the tradition lies in the extent to which they are charged with meaning above and beyond their function in everyday language. Since they are exponents of divine essence in the realm of sound, the believer can, by uttering them aloud, whispering them, or repeating them silently to himself, conjure up inwardly the essence-related vision of divine Being, and he can in worship concern himself with that aspect of the Divine which is unfolding itself to his inner field of view and totally occupying it. In the mantra—the significant formula which, for the uninitiated, may be an incomprehensible sequence of syllables or a sentence of no obvious relevance—we find the highest, spiritual, attribute-laden energy (*śakti*), which is totality concentrated in any number of forms as *mantraśakti*.

Owing to the symbolic value of each of the mantras' phonetic signs, the mantras are composite concentrated expressions of essence; their substance—*śakti*—is not discernible through discursive reasoning, but instead through the power of the believer's mind when it is successfully focused on them in meditation, thereby expanding their meaning to fill totally his mind, to permeate his consciousness. Similarly, the sacred image's mystery is revealed only to the fixed gaze of contemplation, which keeps to the path of traditional techniques and knowledge concerning the importance of the pictorial, spatial complex of forms (just as the *yantra* has graphic symbols and the mantra acoustic ones). "To the eyes of the uninitiated, it is merely an image that is being worshiped; but the true devotee sees in the nonspiritual implement, in his suprasensory vision, the bodily manifestation of the divine energy which is spirit." The person who judges, from the outside, the act of worshiping the image (*pūjā*) without any personal experience of the spiritual processes entailed, can be compared to

a man who talks about the display in a candy-store window, but who has never tasted a piece of candy.[e] From this comparison, we can understand why—apart from the possible historical stylistic problems as yet unsolved, and apart from consideration of the *geistesgeschichtliche* and sociological relations accruing to the work of art—our desire to probe the inmost nature of Indian sacred images is bound to remain on the periphery.[f]

· · ·

THE sacred image is a *yantra* and nothing but a *yantra*. It is superfluous for a person who is able, without it, to place himself into the state of *samādhi*, where the perceiver and the perceived become one and where dualistic consciousness comes to an end. The sacred image is not the most essential element for the act of devotion; it simply introduces some variety into the process. It is not, after all, a source of primary energy.

A passage in the *Bhāgavata Purāna*, quoted here from Śiva Candra, teaches how an initiate, after learning how to bring pure divine Being (*brahman*) before his inner vision in the attribute-laden, personified manifestation of Viṣṇu, is to reach *samādhi* successfully without a sacred image. The God Viṣṇu himself says how he wishes to be envisioned:

A Yogī will call to mind within the circle of fire in the lotus of his heart this form of mine, beneficial in meditation—namely, a form full-limbed, calm, of beautiful features, with four long and beautiful arms; graceful neck and a fair forehead; with divine and gracious smile;

[e] Zimmer is paraphrasing a passage quoted in *Principles of Tantra* (II, 277): "One who does pūjā and one who merely observes it are not, surely, the same thing. One who looks at a sweet-shop can tell us the shape, colour, and quantity of the sweets there, as also whether they are hot or cold to the touch; but can he tell us whether their taste is sweet or bitter, sour or pungent?"

[f] This passage expresses the distinctive nature of Zimmer's approach to the study of Indian art. He felt that one must go beyond the peripheral tasks of cataloguing and rationally analyzing works of art if one seeks real comprehension. Personal experience, or what Zimmer called the Archimedic point of support outside the material, becomes a key to the inner significance of this form of religious art.

decked with brilliant ear-ornaments in his two well-shaped ears; dressed in yellow or deep blue; brilliant with the beauty of the Śrīvatsa mark; bearing a conch shell, a discus, a club, and a lotus in his four hands, and a garland of wild flowers on the breast; with lotus-feet shining with the lustre of bejewelled anklets; illumined with the light of the Kaustubha gem; ornamented with shining crown, bracelets, waist-chain, and armlets; beauteous in all limbs, pleasant; his countenance sweet with grace, with tender eyes and form fair to look upon. He will meditate on this pleasing Brahmā-form by fixing his mind on all its limbs. Drawing his senses, such as sound, touch, sight, taste, and smell from their objects by means of his mind, and with the aid of Buddhi, the charioteer [of the soul, that is, the intellect], the Sādhaka will bathe his mind completely in the waters of love for Me. After that he will draw that mental vision [cittavṛitti] hitherto spread over all my limbs to one place and hold it there. It will not then be necessary for the Sādhaka to think of anything else [such as a part of the god's appearance, a separate member, ornament, or attribute]. He will only meditate upon My countenance, on which plays a soft and sweet smile. When the mind can uninterruptedly and without distraction contemplate that countenance, he will withdraw his single-pointed mind and fix it in the ether. Then, after perceiving My (aforesaid) subtle manifestations [vibhūti, the countenance itself envisaged by the single-pointed mind] in ether, in the mansions, or in the whole of the infinite ether, he will draw his mental faculty, which has had the entire ether as its object, and again rest it in Me as the Paramātmā. Then it will not be necessary to meditate on anything. The Yogī, thus in Samādhi, will see me as the Paramātmā of all Jīvas as his own Ātmā; as one light mingled with another, and not different from it. In a Yogī, who has thus by intense meditation attained Samādhi, the three forms of error—

namely, object, knowing and action—will soon be subdued.[g]

Samādhi, the union of the divided Divine (linguistically related to the Greek word *synthesis*), is the ultimate goal of *pūjā*: the completion of a purely spiritual act, that is, the changing of consciousness from the state of *jīva* into the unconscious Consciousness of *brahman*. *Brahman* is found in *jīva*, for of course nothing exists outside it; how to resolve into unity the duality of soul and world, of perceiver and perceived, the illusion of which makes up *jīva*'s consciousness of self, is simply a matter of maturity and technique.

The technique Viṣṇu's words recommend requires the worshiper first to shut out all sensual impressions coming from the outside world. If he surrenders himself to their profusion, then he will always be powerless in the face of their numbers, their tenacity, their intensity and changeability, and he will be unable to take even the first step toward that complete *samādhi* of perceiver and perceived, to attain the union of the world's diversity. This can take place only in the sphere of inner vision, where the phenomenal world crystallizes in the image of a personified deity that is, to the phenomenal world, the all in all—its material source as well as the cause of its unfolding, its matter as well as the principle over which it holds sovereign sway and power of dissolution. The first goal of the ritual practice of meditation is to create in its field of view a state of tranquillity filled with figures, to fill that field totally with the detailed and elaborately shaped image of the deity. It involves, of course, considerable effort for the adept to bring before his inner vision, bit by bit, this many-sided composite without having his mind wander or become fatigued, and to see at every moment only what pertains to the god's image and still to envisage that image clearly and distinctly, to hold it fast until in the end he unites it into an integrated whole—until, with the uniting of the parts, no one

[g] Avalon's translation, *Principles*, II, 275–76. Throughout this chapter, we have kept Avalon's original quotations when we have been able to trace them.

of them outshines or obliterates the other; until the parts no longer vie with one another to distract the meditator's attention or to direct his restless inner gaze from point to point, that is, to cause his power of imagination to summon up with particular intensity one part of the image at a time while, for the moment, he disregards all the other parts.

In this first stage, the aim is to hold simultaneously before the inner eye all parts of the desired image in a tranquil state in which each part is attractive to exactly the same degree. The sort of distractions that may disturb concentration and frustrate the devotional act—the kind of obstacles that may interfere with the desired sequence of inner images—is illustrated in a tale Śiva Candra recounts to demonstrate the magnitude of the risk involved in performing inner worship by itself, without the aid of a *yantra*. Mahārāja Rāma Kṛṣṇa, while worshiping his goddess Kālī-Durgā, was using a technique that is related to the one recommended by the God Viṣṇu's words, since it is purely mental: the goddess' image that our meditation creates is to be adorned and worshiped just like an actual sacred image—the whole should be an inner process of worshiping the deity, without images. Śiva Candra tells his tale:

> At a particular time during the first stage of Sādhana, after initiating, when the Mahārāja, in disregard of his public duties, and with prohibition of public access, used to remain constantly immersed in Pūjā, Dhyāna, and so forth, a pair of gold bracelets were ordered for his wife, Rāṇī Kātyāyanī. A few days after the order had been given, the Rāja, seeing the wrists of the Rāṇī unadorned, asked her the reason for it, and was told in reply that the bracelets had not yet been prepared. Next day, when he was engaged in Pūjā, a Sannyāsī with matted hair appeared at the gate of his palace, and asked the gatekeeper: "Where is your Mahārāja? Tell him that a Sannyāsī [a Brahman mendicant ascetic] has come to see him." They replied with great humility: "Lord! the Mahārāja is now in the house of worship. No one may go there; and even

if we speak to him now, there is no chance of getting a reply." The Sannyāsī laughed and said: "I tell you, go." The gate-keepers were afraid of disobeying him, and did as they were told to do, but to no effect. Rājā Rāma Kṛṣṇa was at that time immersed in mental worship of his Iṣ-ṭadevatā, and so made no reply, notwithstanding the arrival of the Sannyāsī. The gate-keepers came back and told the Sannyāsī what had happened. This Sannyāsī raised his eyes a little, smiled, and said in a deep voice: "When the Mahārājā comes out after finishing his worship, tell him that to think of the Rāṇī's bracelets is not to perform mental worship of Iṣṭadevatā." Saying this, the Sannyāsī went away hurriedly. The gate-keepers did not understand the meaning of his words, and did not dare oppose the Sannyāsī from going away, for as an ascetic he was free to come and go.

Afterwards, on coming out of the house of worship, Rājā Rāma Kṛṣṇa asked the gate-keepers: "Where is the Sannyāsī?" In fear they told him the Sannyāsī's words, and of his departure. "To think of the Rāṇī's bracelets is not to perform mental worship of Iṣṭadevatā." With the quickness of lightning these words entered through the Rājā's ears into his mind. He shook with fear at the of-fence which he had committed, and repeated the words, "Where is the Sannyāsī?" in a voice choked with sorrow and trembling with fear. The Rājā then himself ran into the public road to find him, but as he was then in a spir-itually unfit state to meet the Sannyāsī, he was unable to discover him.

Nevertheless, what the Sannyāsī had done and said made the Rājā seclude himself from everybody after this incident. No one could say as to where he was or what he was doing at any time. He became inattentive, his gaze was fixed, and his self ever immersed in a stream of con-tinuous Samādhi. Three years passed in this way.

Then one day, when, according to his usual practice, the Rājā was engaged in worship in his house of worship, the same Sannyāsī again appeared. On seeing him, the

gate-keepers made obeisance at his feet, and respectfully
conducted him to the door of the Rājā's house of worship.
On that day also the Rājā was busy performing mental
worship, but he found himself in a great difficulty. In
order to worship the Devī who is mind itself with mental
articles of worship, the Rājā had that day adorned the
brow of the Devī with dishevelled hair [that is, Kālī-
Durgā] with a high-crested mental jewelled crown. He
then proceeded to adorn the shell-shaped neck of the
Devī, who bears great love for Her devotees, with a men-
tal garland of crimson Jabā flowers. But as often as he
raised his hands to put the garland on the Mother's neck,
so often his effort was baffled by the high crest of the
crown. Having repeatedly failed, he became sorrowful
and anxious, and thought to himself: "Perhaps to-day I
shall not be able to put a garland on the Mother's neck."
In unbounded sorrow his large eyes filled with tears, and
weeping he cried: "O Mother! what shall I do?" A voice
from outside replied: "Rāma Kṛṣṇa! why do you weep?
It is by putting a crown on the Mother's head that you
have to-day brought about all this trouble. Take it off,
and then garland Her." Rāmā Kṛṣṇa started, left the
Mother and Her worship, and opened both the outer and
inner doors of the house of worship.

He then saw before him a Mahāpuruṣa ["great man,"
a general term for the perfected human being], a Sannyāsī
smeared with ashes and full of Tejas. He recognized him
as Pūrṇānanda Giri the perfect Sādhaka [one who has
walked in the path to *brahman*], who had been his com-
panion in Sādhana [an ascetic practice that leads to per-
fection in *brahman*] done by them in cremation-grounds
in the previous birth. He bowed at his feet, and said
"Brother! this is my condition to-day! The Mother and
you know how I have passed these three years since you
went away, after having done me the favour of putting
me to shame." Pūrṇānanda laughed, and said: "Have no
fear, brother. It is because I then left that I am able to
approach you to-day after these three years. Being what

you were then, the time had not yet come for me to see you. Think what a difference there is between your former thought of the Rāṇī's bracelets and your present difficulty about the garland. It is because the Mother has blessed you that I am here again to keep my promise given in the previous birth."

After this incident Mahārājā Rāma Kṛṣṇa became a Bhairava [a mendicant monk, a follower of Kālī-Durgā] and Mahārāṇi Kātyāyanī a Bhairavī, and companions of Pūrṇānanda Giri in Mahāsmaśāna-sādhanā [the path of the perfection at the great cremation-grounds], on the banks of the Ātreyī at Buxar.[h]

There are not many who are both inclined to take this path of *sādhana* and possess the talent for achieving some measure of success in pursuing it. Mahārāja Rāma Kṛṣṇa sacrifices the panoply and pleasure of his royal power to his will to perfect spiritual *pūjā* long before he sets out to become a wandering ascetic who frequents cremation grounds. He withdraws from everything with which his birth had endowed him and, still a king, he is reduced to a completely nameless existence—a thing impossible for a worldly man. But even the intense zeal of three years' total dedication to worship brings him no nearer his goal. Upon Pūrṇānanda Giri's return, he is still struggling with a difficulty that may seem somewhat elementary in the eyes of one who has reached perfection: an obstacle having nothing to do with the last phase of the many stages of the *pūjā* procedure, but rather with the process of construction, whereby the attribute-laden manifestation of the deity is brought part by part before the inner vision; this is one of the introductory acts, which is to be followed by more critical and doubtless more difficult ones. King Rāma Kṛṣṇa took a logical step in the course of his development when to move forward he cut the last ties binding him to the world and, when under Pūrṇānanda Giri's guidance, his outer self vanished within a nameless existence in order for him to lose

[h] *Principles*, II, 409–12.

himself inwardly in the unity of the *brahman* that has no at-
tributes.

His path of purely spiritual worship is a path for the few
alone. For the many, who are not yet able to leave their
worldly mode of existence and seek out cremation grounds,
river banks, lonely sand bars, and the places of peace and
quiet, where the homeless yogi prefers to dwell—for the
many, the path of easiest access is worship with the aid of a
yantra.

. . .

FOR the *yantra*'s use in devotion, the mental and external pre-
liminary acts are less significant than the subsequent, critical
procedure that may then be carried out on the *yantra* itself:
the "insertion of breath" (*prāṇapratiṣṭhā*); but these acts set the
stage for the performance of *pūjā*. The ritual of the solitary
worshiper who is his own priest is of necessity complicated
since for the worshiper—and here the authoritative sources
are unanimous—the goal of worshiping the Divine is to be-
come himself divine. Pure divine Consciousness binds itself
with the fetters of its own *māyā*: *brahman* thinks of itself as
jīva; God is in us; we are the Divine; but many preparatory
procedures are needed before we are able to lift ourselves up
into the state of duality, where the ritual act of *pūjā* takes place,
and, moving beyond this stage, before we can feel ourselves
to be divine. This experience is quite clearly and repeatedly
considered to be the goal of worship. Two examples from
the *Vāsiṣṭha Rāmāyaṇa* regarding the worship of Viṣṇu: "If a
man worships Viṣṇu without himself becoming Viṣṇu, he will
not reap the fruits of that worship"; and again: "Man should
not take the name of Viṣṇu without himself becoming Viṣṇu,
nor worship Viṣṇu without becoming Viṣṇu, nor remember
Viṣṇu without becoming Viṣṇu."[i] Only the man who be-
comes God can ever experience Him.

The pathway to this experience leads through acts of magic
and mental concentration utilizing the effects of divine power,
which is represented by significant syllables and words as *man-*

[i] *Principles*, II, 441.

trasakti. The path begins with the act of entering the house (or area) of worship. It is a matter of no small consequence how the believer deports himself, or even which foot takes the first step; and when he enters, he is to turn his thoughts toward the lotus feet of the deity enthroned in his heart. Upon entering, the worshiper casts aside any possible disruptive influences from the heavenly sphere by staring straight ahead, unblinking, so that his gaze is like that of the gods, who know no sleep; opposing elements from the middle region between heaven and earth he turns away by uttering *phat*, the magical "missile"-word (*astramantra*), which ensures that he is impervious to them; finally, any distractions lurking in the earthly sphere he drives away by striking the ground three times with his heel.

The devotional ritual leaves nothing to chance, to human whim; its great significance means that no one of its details is trivial, even though the many parallel strands within traditional practice may contradict one another in those details. Fixed rules govern the height of the devotee's seat, the material of which it is made, the compass points according to which it is to be oriented; govern the time of worship and its environs, as well as the course of the devotional exercise itself. Anyone with a vocation to worship must first purify himself. Like the requisite initial purifications of the area of devotion and of the ritual devices, this is a process both natural and magical in quality. The magical acts that follow upon external ritual purification consist of uttering significant syllables, of meaningful gestures and breathing exercises,[j] whose special efficacy is well established. The point is to transform one's natural body into a body of a higher nature, and, by the act of purification, to arouse the divine nature belonging to it. Then follows an act of concentrated meditation (*ekāgradhyāna*) that, guided in the inner vision by a series of spoken formulas and syllables (*dhyānamantras*), constructs the image of the god's essential nature from the feet to the head and back again. This act of inner worship is to precede every external one. It

[j] These arts are mantra, *mudrā*, and *prāṇayāma*.

is something essentially different from simply reciting aloud
the accompanying formulas that further the act of worship,
or from reciting them as a silent, inner whispering, or merely
calling them to mind. If this act is reduced in practice to a
merely mechanical sequence, then its essential part remains
incomplete, for the creation of the mental image of the deity
is a prerequisite for productive external *pūjā*, or, as the cat-
egorical formulation would have it, "Only as long as *dhyāna*
lasts, does *pūjā* last." Without *dhyāna*, wholly outward wor-
ship has no value; purely inner worship in *dhyāna* is far su-
perior to outer worship, but who could be so bold as to try
to reach the goal by using that alone?

Here the *yantra's* function comes into play, whether it be
shaped in the form of human or animal figures (*pratimās*) or
in the form of purely linear constructs (mandalas and *yantras*
in the narrower sense). In the *Swelling Stream of Bliss of the
Believer in Śakti* (*Sāktānandataranginī*) it is written:

> Those who seek the Devatā without, forsaking the De-
> vatā residing in the heart, are like a man who wanders
> about in search for glass after throwing away a Kaustūbha
> gem which he held in his hand. [Viṣṇu gained possession
> of the jewel *Kaustūbha* while the gods and demons were
> stirring up the milky sea of heaven and he wears it as an
> ornament on his breast.] After seeing the Iṣṭadevatā [cho-
> sen deity] in one's heart, one should establish Her in the
> image, picture, vessel [for example, a pot can serve as
> the *pīṭha* of the deity], or Yantra [in the narrower sense],
> and then worship her.[k]

Describing the worship of Kālī-Durgā, the *Gandharva Tan-
tra* teaches us about this act of installation in which the deity,
clearly seen in one's own self with the aid of *mantraśakti* during
the state of *dhyāna*, is often installed breathlike (*prāṇapratiṣṭhā*),
as the divinely vivifying element, into the material *yantra*:

> Next, after performing Prāṇāyāma [the preparatory
> breathing exercises], the Sādhaka [devotee] should take

[k] *Principles*, II, 497.

handfuls of flowers. The Devī should never be invoked without handfuls of flowers. The Sādhaka who controlled his Prāṇa will meditate on the Parameśvarī [that is, the Highest Ruler] as above described, in his heart, and seeing by Her grace that image, the substance of which is consciousness in his heart, let him think of the identity between the image manifested within and the image without. Next, the energy [*tejas*] of consciousness within should be taken without by means of the Vāyu-Bīja [the mantra "*yam*"] with the breath along the nostrils, and infused into the handful of flowers. Thus, issuing with the breath, the Devatā enters into the flowers [he is holding to his nostrils]. The Sādhaka should then establish the Devatā in the image or Yantra by touching it with those flowers.[1]

Devotion to the *yantra* can only take on meaning after divine essence has entered any one of the *yantra*'s forms as its seat (*pīṭha*) for the duration of the outward ceremony of worship—and only after this has happened through an act of concentrated imagination like the one just described: physically manifested corporeality, so to speak, in the impressive act of transferring the inner image in a breath that permeates the flowers. Otherwise, all this would be unproductive, sterile play acting. Replacing the deity's image in the inner vision, the deity's tangibly visible presence relieves the worshiper of his capacity to meditate as long as he keeps firmly in mind, during external worship, that his heart's deity—*brahman* with attributes, whose *māyā* allows him to be present in the believer's consciousness—is present physically (in whatever palpable form) before his very eyes, and that the deity is contemplating himself there in the state of duality.

With this visible form of divine essence, the earthbound devotee performs the religious ritual that King Rama Kṛṣṇa meant to carry out with the purely mental image of his deity. This ceremonial rite is a sacred form developed from the traditional customs welcoming and honoring an important

[1] *Principles*, II, 501–502. [Avalon has "Yang"—ed.]

guest: the deity is placed on the seat of honor; he is greeted (*svāgata*); like a newly arrived guest, he is offered water for his feet (*pādya*) and then the customary gifts of welcome (*arghya*): flowers, sandalwood paste, refreshments, and so on. A bath is proferred, then fresh garments and all kinds of ornaments and food, followed by water for rinsing the mouth and washing hands; the deity is celebrated by swinging lamps back and forth (*nirājana*), by offering flowers (*puśpānjali*), by songs with instrumental accompaniment, dance, and hymns of praise. The devotee bows before the godhead and walks around the image, keeping his right side to it as a mark of reverence. The components of this highly structured act vary in the different traditional sources, but they all have the same underlying purpose. The ritual culminates in the act whereby the believer surrenders his Self to the deity (*ātmasamarpaṇa*): after he has paid the deity due reverence in this impressively elaborate way, he gives himself over to him completely. Here, the devotional exercises come to an end, and all that remains for the believer to do is to reverse the whole procedure by moving away from the deity and taking himself back into himself (*upasamhāramudrā*), and thereby he receives back into his own heart the divine Consciousness which he had breathed into the *yantra* through *prāṇapratiṣṭhā*.

The tantric literature repeatedly emphasizes that this form of worshiping and experiencing the Divine is not the highest one, but it never conceals the fact that it is futile, even dangerous, to dispense with it before the spirit has winged its way upward to the pure form of inner devotion without using images. The *Gautamīya Tantra* says: "This inner worship [*antaryāga*] brings release to Sādhakas even during their lifetime, but Munis [ascetics] alone who are desirous of liberation have the competence to perform it."[m] According to the *Tantra Samhīta* there are two forms of worship: "the inner is designed for the *Sannyāsis* [who have given up house and family, like Rājā Rāma Kṛṣṇa when he followed Pūrṇānanda Giri's example]; both inner and outer worship are befitting for other

[m] *Principles*, II, 404.

men." The *Tantra of the Great Liberation* (*Mahānirvāna Tantra*) ranks the different forms of worship:

> The highest state is that in which the presence of Brahman is perceived in all things. The middle state is that of meditation. The lowest state is that of hymn and Japa, and the state lower than the lowest is that of external worship. Yoga is realization or the accomplishment of Unity between Jīva and Paramātmā. Worship is based on the twofold knowledge that He is Īśvara [the Supreme Being], and I am His servant but for him who has known that everything is Brahman there is neither Yoga nor worship.[n]

The correct devotional exercise using a *yantra* represents a lower stage in the evolution of limited human consciousness into a form that is less confining: for him who has experienced himself as *brahman*, once the realm of multiplicity is transcended, every religious act using words and offerings has become hollow; whoever at every moment knows himself to be divine and, at the same time, to be one with all, has no further need of these acts. The urge to overcome forever the state of duality of soul and world has borne him, on wings of an equanimity that desires nothing more (*vairāgya*), away from the shackles of this world, from house and home, and has taken him to a nameless, undefined realm that knows neither home nor possessions; the potency of the inner desire to return home to the original state of crystalline unity leaves no room for the life goals set by the community of men.[o] But whoever, like most people, is actively engaged in and with the world, and is still totally caught up in duality, that person needs the combination of religious sign and devout soul in

[n] *Principles*, II, 341.
[o] The concept of a "return home to the original state of crystalline unity" is a pervasive theme in all of Zimmer's works. Indeed, in his memorial to Zimmer in the *Review of Religion*, Herbert Steiner wrote, "He spoke of life as 'a homeward journey to one's self.' All too suddenly he has reached his goal." Steiner, "Henry R. Zimmer (1890–1943)," *Review of Religion*, VIII (November 1943), 19.

order to become once again, every day, conscious of his own divinity by being confronted with the divine, when the *yantra* receives life through the consignment of breath, and the deity from his own heart steps before him and becomes visible. The external religious act, repeated daily, matures the mind so that it is able to experience the deity in pure meditation, to experience itself as deity. The tantras refer to themselves as the way to experience unity through the experience of duality. They explain that it would seem contradictory to avoid this two-pronged primal experience when attempting to ascend to the experience of unity that constitutes the transcendence of the duality of world and self. The indispensable form of transmitting Truth—the teacher-disciple relationship—perpetuates in itself the state of duality; how can this relationship have as its subject the teaching of unity?

But even for the pious man, who has experienced unity, to dwell in the realm of duality and to worship his beloved deity with an image can both be expressions of his love's elemental force:

> What is gained by liberation?
> Water mingles with water,
> I love to eat sugar,
> But it is not good to become it.[P]

In the ultimate *samādhi* that merges the worshiper and God into one, the binding links of love that embrace the divine mother and her child who is lost in rapturous contemplation are, along with everything else, totally extinguished.

Rāmaprasāda, the great singer of the Dark Mother to whose worship he dedicated his life, once sang:

> Veda says that Kaivalya is attained by worshipping
> the
> formless Deity.

[P] *Principles*, II, 355. This quotation, like the following two, is from "Rāmprasāda Sen, the celebrated Bengali poet (born, 1718; died, 1775)"; Avalon's note 2, *Principles*, II, 285.

To me, this notion seems wrong, and the effect of
 lightness of intellect.
[Rāma-] Prasāda says the mind ever seeks the Black
 Beauty.
Do as Thou dost wish. Who wants Nirvāṇa?[q]

"Mother," the pious prayer to the Dark Goddess, to Śakti
who is *brahman* (*brahmamayī*), is the expression of unity in the
state of duality—or "the call of duality in the ocean of unity."
Everything in life is the unfolding of Śakti, but only in the
separation into duality can the inexhaustible bliss of contem-
plating Her be fully enjoyed. That is why it is reported that
Rāmaprasāda was seldom heard to speak of worshiping the
Divine who has no form:

O! hundreds of true Vedas say that my Tārā is
 "without form."
Śrī Rāmaprasāda says, "The Mother dwells in all
 bodies.
O blinded eye! see, the Mother is in darkness the
 dispeller of darkness."[r]

. . .

IT MAKES no difference whether the devotee's consciousness
vis-à-vis the sacred image remains, as Rāmaprasāda's mind
did, in the state of duality constituting his essence, or whether
his consciousness pushes on to the extinction of his Self in
complete *samādhi*, or even whether, for the sake of a definite
practical goal, he worships with magical practices the deity
in the image—the devotee always finds himself, during the
act of worship, facing a man-made image of the deity, a *yantra*,
into which the essence of an inner vision has entered. In order
for the essence of the inner vision to enter into the sacred
image, the image has to conform to it in every respect.

It is clear that this relationship to meditation (*dhyāna*) has
to be of importance for the fundamental aspects of the sacred
image's crafting. It is probable that the particular formal qual-

[q] *Principles*, II, 354.
[r] *Principles*, II, 346.

ity of methodical meditation (*dhyāna*)—as opposed to the properties of outward vision and the imaging in the eye of the objects it sees—is most useful for shedding light on the special quality that is characteristic of all Indian sacred images, irrespective of time and school, and no matter where they are found—a quality that, to our eyes, is so alienating. The inner image the believer envisages in the course of his devotions is for its part a reproduction of an original inner vision of one aspect, fixed by sacred tradition, of divine essentiality. And, accordingly, the sacred image is a magic vessel for the god's individually differentiated manifestation, in which the Not-Yet-Unfolded, the Unenvisionable, presents Itself to the inner eye of the pious, depending on the sect to which the believer belongs and the particular rite into which he has been initiated. To function properly, the sacred image has to correspond in its form to the image of the "deity in the heart" as well as to the god's manifestation laid down in sacred tradition. Both of these—the deity contemplated in the heart and the manifestational form of the tradition—are, after all, one and the same; it is not granted to any believer to shape by himself, according to his own ideas, the deity's image he wishes to construct in himself, for only the Divine itself can bear witness to what is Divine. The particular manifestation in which God is to appear is His to decide, and to deviate even in the slightest from the traditional way He is perceived and represented— which lies at the heart of sacred tradition—is a patent absurdity, for this tradition, as its literary form attests, is nothing less than the orally preserved self-revelation of God. The Divine gives verbal expression to Itself in the literary tradition, and elucidates the aspects by means of which man grasps Its essence; a God Himself is speaking and says what He is for man and for the human understanding of His manifestation, and of what above and beyond this His nature is composed. In the sacred texts it is the gods themselves who speak of themselves and those who are like them, and it is just that which gives the texts their authority, in the face of which, any willful attempt to conceive of or contemplate the godhead in another form is clearly wrong-headed. In sacred tradition,

God's self-revelation through His own word is confirmed, elucidated, so to speak, by accompanying suprasensory contemplation that the Divine graciously grants to him who has first discovered in the texts this aspect of divine essence.

In the *Bhagavadgītā*, the Divine reveals itself anew to men through Viṣṇu's words at the dawning of a new age of the world. It expresses Its own essence and assigns to humankind its place and pathways in the divine order. In the *Bhagavadgītā*, Prince Arjuna wishes to drive his chariot in the great decisive battle for empire and world domination; after he listens to Viṣṇu, who has revealed himself as Kṛṣṇa, his brother-in-law and a prince of this world, he asks Viṣṇu (Canto XI, 1–4) whether he might possibly behold Viṣṇu's immortal divine form. The god grants him his wish:

Yet never will you be able to see Me with this your [physical] eye. I will give you a divine (*divya*) eye. Behold My lordly Yoga. (XI, 8)[5]

After these words of revelation, the Divine grants Arjuna the godlike suprasensory sight to percive Him; and the ecstatic words of the beholder, granted a vision of the creative play of Divine omnipotence, pours out this rich vision in the god's presence, records for posterity the images his inner eye has seen, and can vouch for their truthfulness because they are his very own words, just as they flowed from his lips at the moment of his vision.

The omniscient Buddha (Śākyamuni) proclaims to his harkening throng of disciples the teaching of Buddha Amitābha and his blessed realm in the West:[2] how he, wandering the earth as a monk aeons ago, through his vow of all-embracing love for the creatures of all the worlds established his glory,

[5] Translated by Georg Feuerstein, *The Bhagavah Gita: Yoga of Contemplation and Action* (New Delhi: Arnold-Heinemann, 1980), p. 117.

[2] In the Buddhist text, *Mahāyānasūtra Sukhāvativyūha* (longer version). An English translation is found in Volume XLIX of *Sacred Books of the East*. [*The Larger Sukhāvatī-Vyūha*. Part II. Translated by F. Max Müller (London: Oxford University Press, 1876). Zimmer paraphrases the story related on pp. 59–63.]

which he, through the practice of all perfections, has turned into reality. He expounds the miracle of his power that effortlessly draws into his realm all men who desire release and are on the path of faithful devotion to him, and makes them blissful with his Enlightenment; he portrays the wonder of this realm: a flowerlike vision of Nirvāṇa. Then he bids his disciple Ānanda, to whom he is addressing his words, stand and bow down toward the West and, with a hand full of flowers, worship the Buddha Amitābha. Thereupon Ānanda requests permission to behold Amitābha himself, encircled by his bodhisattvas, the Great Beings who serve and help him in his unending work of love. At that same moment and in his infinitely distant world, Buddha Amitābha releases a beam of light from the palm of his hand that causes the wondrous nature of that world to rise resplendent before the worshiping host around the Earthly Buddha. Through myriads of worlds that, like one egg set next to the other, lie between his world and the earth, he places the vision right before their eyes with his light which illuminates and shines through the world's mountains, forests and all the creations of divine and human hands—and whatever else lies between them—as if all these were glass. Then the Buddha of this world, Śākyamuni, questions a bodhisattva from the surrounding throng about many of the phenomena he sees in his magical vision; and the master's questions and answers that revolve around the rich vision, describing and interpreting it, corroborate in the end the truthfulness of Śākyamuni's words of revelation. The truth from the Perfected One's lips is confirmed by the words of the instructed disciple, who proclaims that he truly sees in suprasensory light what his aural sense has already perceived.

The human mind may well perceive an image of the suprahuman yet everything about the image will remain an enigma to it; but the Divine discloses to pious devotion and the power of yoga that element of Itself which is visible to the sense beyond the senses, just as the Divine also speaks to man through human speech. This is the reason for the incomparable value of sacred tradition and for the incalculable importance of preserving it faithfully. The appearance of the

Divine that the believer conjures up in himself is, as the texts show, firmly fixed, down to the smallest formal detail of its limbs, its particular physical characteristics, and the dimensions of its size—fixed in its colorations, expressions and poses, ornaments and attributes, all of which are beyond the whim of human fancy. The Divine's apparitional form is a true copy of an original suprasensory inner vision, one totally in accord with the precepts of an authenticated tradition. This not only explains the great power of the tradition in determining the use of formal elements in the sacred image—elements that are constant as to types but appear in variants that demonstrate gradual change, depending upon the era or geographic area where they are found; this relationship to the inner vision, whose vessel, whose three-dimensional projection the sacred image is, also explains the fundamentals of the sacred image's style.

The sacred image grows out of the inner vision, which it serves as a vehicle in the form of a *yantra*, or else as a focal point when the vision's content is externalized; in its style, however, the sacred image is completely alien in nature to the physical sense of sight. It has nothing to do with the eye that looks outward. The sacred image does not go in pursuit of that eye and can supply it with no information whatsoever; just as the image is not simply to be beheld, but, instead, to *be* held steadily in the eye's gaze. Even though its forms are constructed completely of images of things taken from the world the outward eye perceives, the sacred image is itself a reflection of the purely inner vision from which it originates as a formal type. And in the fundamental aspects of its style, the sacred image is subject to the laws of the inner vision.

OUTWARD SIGHT AND INNER VISION

Outward sight and inner vision (meditation, *dyhāna*) are radically different in essence. It follows that sacred images, which are remarkable copies and appropriate vessels for inner visions, have to be qualitatively different from other *objets d'art*

in their fundamental form. The other works of art are born of the delight in capturing the world's illusory beauty, and exist in order to transfigure it. Their appeal is to our insatiable, restlessly roving, observing outer eye. But Indian sacred images do not exist simply to be looked at; once life has been imparted to them by the heart's devotion, the intent is that the inner eye fixate upon them.

Even though we, who rejoice in our capacity to observe, lack *a priori* the ability to bring the images to life by worshiping them, we can nonetheless gain a modicum of understanding for the peculiar form of the constructs that the process of worship has evolved for its own purposes, once the opposing natures of outward sight and meditative vision have become evident.

As our eye looks out upon the world, it finds itself confronted with a multiplicity of disparate phenomena that it cannot possibly comprehend or take in with equal sharpness of focus at any one single sweep. If it directs its absorbtive power to one single item in the multitude of things arrayed before it, then it is of course aware of other objects found in its field of vision; but these remain relatively blurred and out of focus, and are not grasped, penetrated, and interpreted by our total consciousness so as to allow us to retain a clear picture of them. They are still within our field of vision, but at least a portion of them cannot, if we were to take a subsequent inventory of what we saw, be part of that inventory, though they might have perhaps been sensed but not actually registered in the viewer's mind. For the viewer has not fixated his gaze on them. If our eye actually expects to deal with the multitude of things in its field of vision, it has to roam about, to rove back and forth, to fixate upon one bit of the field after the other, in order to focus upon it and have it recorded in the mind. The extraordinary difference in the range of, on the one hand, the partial field encompassed in one glance and fixated in sharp focus and, on the other, the remaining extent of the field, of whose content our eye is but vaguely aware, unable to note it with the same exactness, leads to an ongoing sense of dis-ease, a constantly agitated looking about, if our

eye tries to do equal justice to the whole panorama its field of vision encompasses at any given moment.

Our outwardly directed vision is similar to a large lens with a small focal point: if we wish to see in sharper focus something vaguely perceived, then that focal point must be shifted constantly. With each shift of the focal point back and forth within the field of vision, the eye retains a degree of freedom of movement. Bright hues and striking outlines successfully draw, capture, and direct our eye's attention; whatever is grandiose, pleasing, or bizarre attracts our eye, inviting it to linger. But if, instead of merely submitting ourselves passively to the diversity of things in our field of vision, our will to assimilate it *in toto* is aroused, then our will moves the focal point of our intense vision as freely as a searchlight beam over things already seen or not yet discovered. But our will must constantly choose and free the beam of intense vision from one particular spot that then will disappear into the dark again when another spot is to be fixated upon and brought into focus in its turn. Our eye's play, ever exploring within our field of vision, is like the dance of the sun's rays and clouds' shadows across a landscape. All in all, it is a delightful game, a repeated abandoning of that which has but just been grasped, then a grasping of something different, which will in turn be released in favor of some more distant goal that happens to catch the eye. Our eye exults in its power to take control at will of whatever object it chooses from those spread before it; it senses its sovereignty in the giving or denying of attention, and is like the type of woman who, knowing naught of fidelity, flirts with many men, following only her whims and what charms her.

How different is our inward vision! Here there is no richly colored surface, crowded with shapes, that patiently waits for an eye's roving center of focus to correct the disturbing lack of focus and clarity of the objects in its view. It is like a deep dark well, over whose edge flickering figures lean, reflected in its watery depths. But outward vision always turns its attention away from what it does not want to see in its field of vision; in effect, those things no longer exist for it; others

immediately take their place, filling up the entire area of its focus. Without regret it lets delightful things escape because it knows it is free to return to them at will. But over the dark well's edge unwished-for shapes may loom, and in vain does the mirror surface tremble below, unwilling to accept their image; but the image stays on and on. Delightful visions suddenly incline themselves over the edge, but their image shies away, almost before the mirror has had an opportunity to capture it, and in vain does the mirror entreat these just-fled shapes to stay. Unless a powerful will trained in yoga is in control, it is hardly possible to keep the mirror free of undesired images or transient, empty trivialities, and it is difficult to refill it with constantly varied grand visions that will either remain or plunge into its surface at will, into total emptiness.

Our untrained inward sight is generally successful in recalling images that have appeared, only to vanish immediately; but it seems that, without technical aid from other areas of the Self, we are denied the ability to summon up for ourselves any image we choose. Our inward sight can indeed satisfy its wish to fill its obscure and beclouded view with some clear image or other, but it is not within its power to determine which particular images come whenever it feels the need to call them forth. Only occasionally, and then circuitously, will our untrained inward sight be able, after the fact, to account for the reason why one particular image and not some other appeared from a whole series of images, any one of which we might have expected to respond to its call. And if that vision has the temerity to greet the image's appearance with the words "Thou art the one desired; my call was meant for thee," then it has fallen prey to self-delusion. For the image addressed was already on the way to the surface; its coming was already somehow perceptible; it must have been sighted, however dimly, in order to be addressed. And it could taunt the command, "Come! Show thyself!" with the following doubts: "Did you not call me because I was already coming? And is it not true that you were able to call me because I had already shown I was coming? Are you not like someone who

really wants and expects a person to come in but doesn't know who it will be; and then, when someone, not exactly un-wished-for, puts in an appearance, he wants to create for him-self and the newly arrived one the impression that *that* person and no other was just the one desired; isn't this done by speak-ing to the one approaching? If, instead of me, some really unwished-for person had come, it would have been evident that you cannot invite whom you will—but perhaps you *are* capable of chasing off the new arrival by exclaiming: 'Let any other, more acceptable person come, just not this one!'"

When there is no salient object that catches our physical, outer eye, forcing it to return repeatedly to the object, then the eye casts about, playfully but still in command, among the many forms in its field of vision and selects one from among these, determining for itself how long it will look at it. But our inner eye is exposed to overwhelming, uninvited apparitions that impose themselves upon it; that cannot be expelled from its gaze without struggle or repeated command; that must frequently be entreated to stay; that are grasped at as they flee and are begged to return—an act of recalling that always costs great effort.

Our physical eye is able to select, take in, and transfix any one of all the delights within its view on which it focuses and to do this with equal accuracy, for its great strength lies in that very power to focus. But the sharp focus of the images before our *inner* eye that has not yet been trained by concen-tration is not solely dependent upon the eye's ability to bring the images into sharp focus. The varied degree of clarity and intensity of these images seems to a great extent to be an individual peculiarity of each and every one of them, and the desire to view them more sharply soon reaches a barrier that in no two cases is ever the same. For the outward eye, any-thing not seen clearly is still somehow there, because it lies within the field of vision no matter how concentrated the eye's focus is. But the alternation between being in or out of focus, as may happen in any field of vision, is completely absent from the way the inner eye sees. Whatever the inner eye sees simultaneously is also seen in all its diversity, with equal

sharpness or fuzziness of focus, because the focus of its attention is not like a lens with a small focal point and a wide, indistinct area surrounding that point. It would be more accurate to compare its field of view to an opaque screen that, in progressive stages of focus, shows first a gray shadow without an outline, then a blurred outline with indefinite areas of color—all in varying degrees of focus—culminating in a very clear, definitely outlined, sharply focused image. But either clarity or vagueness will always predominate in the illuminated field of view; no one part of it will stand out more clearly than another.

This characteristic of inward sight—that it at no time permits any essential variation in intensity within the vision as a whole, and accordingly allows the eye no dis-ease—is in fact the key to understanding the most fundamental stylistic trait of Indian sacred images, which are, after all, material and physical manifestations from within the inward sight and must display the peculiar qualities of inner sight if they are to be proper *yantras*, if they are really to absorb the likeness of the chosen deity as conjured up and constructed in inward sight by successful concentration, and if they are to carry out their role in the act of devotion.

The believer certainly experiences great difficulty in gathering before his inner eye the image of the deity in its many forms; the components of a particular form will always appear when he tries to envision them in sequence. The initiate's sacred tradition contains instructions as to how to call them up, and he of course knows the instructions by heart; he needs only to recall the words of the text to cause corresponding apparitions to appear before his inner eye. It is the power of the syllable (*mantraśakti*), whether whispered or simply inwardly articulated, that can, in the realm of inner vision, produce whatever corresponds to the sound. Especially effective for this activity of calling forth inner images is the *mantraśakti* of numinous syllables, for example, *om*, where the essence of suprasensual realities is represented in the realm of sound. If the mind concentrates on them by articulating them audibly or inaudibly, they compel the visual manifestation of the es-

sence, which in them has become sound, to enter into the inward eye's field of view.

What is extraordinarily difficult, however, is to retain the image's components once summoned up, and to have them remain even after new ones have crowded into the same space. Once they are assembled, an agitated scurrying commences, not so much like the moving of a light beam over some twilight area as it is like a grappling with, and grasping at, figures that are in danger of disappearing; there are repeated cries: "Stay put!" "Come back!" and commands like "You, there, get over here too!" Long training is required before it is possible to gather for any meaningful length of time a number of components of the images significant enough for one larger single composition, and then to devote equal attention to each of them. For as soon as one element feels itself neglected, it pales and vanishes, disappearing again into that dark abyss out of which it had been summoned by the proper technique: either by uttering the relevant sound or by relating the element to some nearby object already present within the inner eye's field of view. The components are guests who have been invited into that field of view and agreeably followed the invitation to appear; but if the host who called them to begin with ignores them, or pays them no or too little attention, then they glide soundlessly off through the shadowy, curtainlike walls into the amorphous dark they came from, and the summoning process must begin all over again.

But finally, success! The motley crew jostles its way into the narrow, close, bright confines and each manifestation takes its appointed seat; late arrivals enter, positioning themselves without displacing their predecessors. Then the confusion of welcomed arrivals and unexpected departures comes to an end; the disorderly milling about of those already present has subsided, order is established and quiet descends: the inner image has been composed and there it stands. This does not happen until the inner eye is focused on each one present so that not one of them is in danger of fading and disappearing, because no single one of them receives a particle more of the vital energy that seizes and retains whatever has appeared. For

any increase of the attentiveness directed at one or the other of them, thereby raising the intensity of its presence, diminishes something of the radiance in the others that brings them to life before our inner eye. With equal intensity and without showing favor, our inner eye must illuminate everything gathered before it, just as the sun in an unclouded sky shines upon everything lying beneath it. "In contemplating this bliss-bestowing Brahman figure, he is to address his mind to all of its features,"[t] as Viṣṇu reveals in the Śrīmad Bhāgavata.

The multifaceted divine manifestation is now suspended before the inward sight trained to see it: no one of its facets ranks above or below an other one; each sparkles with the same intensity; though united into one structured composition, each part is an equally self-contained unit. No part of the manifestation is in motion; nothing distracts the inward gaze elsewhere to anything of significance because our inward sight has no focal point that can be directed back and forth over several things; the entire space before our inward eye is equally in focus, so that everything present shines forth with equal clarity. Each part is at rest within itself; every facet is aware only of itself. These are characteristic of manifestations before the trained inner eye; they will of necessity disappear totally from untrained inner sight the moment one part is fixated upon. The marvel of training and the perfection of concentration explain why, in spite of their labile quality, not one of those manifestations disappears. Instead, they linger on in the pristine grandeur of their One-beside-the-Otherness, with no outward interrelatedness that might entail some mysterious unending motion, and that might be understood only by an equivalent restless movement of the physical eye that is completely foreign to our inner eye. In spite of its vast complexity, the multifaceted form that stands motionless before our inward eye may even seem to be the focal point of a narrow single focus of concentration, because each part is so indiscriminately, but intensely, fixated upon; in this, the proper state of mind, the inner vision's entire surface can be

[t] *Principles*, II, 275.

focused on equally and at every point. Yet the mind's ability to focus on a single point of the inner image never obliterates the clearly seen image's multifaceted quality and all its self-contained parts. On the contrary, the totality of diverse parts is transcended (*aufgehoben*) and each is retained down to its smallest detail that, seen alone, would be unimportant and unable to command the focus of the concentrating mind. The mind's focus is directed at the whole as the sum of its parts, to the structure, not to the individual structured members, to the "pose" the image strikes, not to the material of which that overall "appearance" is made.

This peculiar type of visualization that fills up the entire field of view and that is in every detail equally clear and self-contained, is as an entirety more than a mere collection of individual parts: it is a specific product of inward sight. Our physical eye, constantly in motion, can never see anything remotely similar. This quite particular kind of visualization, which combines two opposites—the image's broad surface together with a clear focus on a single point on it—and is totally motionless, is the mental yet visible content that is projected upon the sacred image during the act of devotion. Because of the basic law governing its form, the visualization determines the sacred image's fundamental style if the image is to serve as a *yantra*—in the same way that the visualization is the primary source of the image's three-dimensional manifestation. Given the nature of that visualization, the peculiar quality of the figurative sacred image can now be understood: the quality that causes the Westerner, again and again, to turn from it with awed feelings of estrangement, unless his senses have become dulled to it by long familiarity with the material and individual examples of it. These figures—gods, Buddhas, and saints—with their wealth of forms, are completely self-contained entities, but they lack the quality that gives the classical work of art its solidity, polish, and the unending, carefully structured interrelationship of its parts—elements that present our captive gaze with a small universe of paths to pursue.

This may well suit our physical eye. When contemplating art from the classical school, the eye surrenders its inherent freedom to focus its attention at will; it accepts in exchange the order imposed by the object it sees. Our eye is delighted to pursue the meaningfulness of the object's structure along paths that follow their own nonrational logic, without ever tiring of them. But when our eye, which is accustomed to such pleasurable sacrifice of its freedom, first encounters—unprepared—an Indian sacred image, fully expecting to lose its freedom in it; and when our eye expects to exchange that freedom for the remembered experience of blissful probing within a mysterious interplay of forms (the eye's experience of whirling in rapture amid astounding marvels, amid familiar things that repeatedly reveal new facets, amid details that differently combine anew with something different—the eye's experience of abandoning its normal, undisciplined speed of focusing for the particular rhythm imposed by the structure of a classical work of art), then our inadequately prepared eye, now faced with an Indian sacred image, will find not a single one of those expectations fulfilled.

In contemplating the Indian sacred image, our physical eye can dwell forever on each of its detailed facets without once being conducted further or carried on toward another part, or feeling compelled to survey its entire surface, bit by bit, in restless, roaming movement. Here, all is calm, signifies nothing but itself, and stands apart as something final, with no attempt at indicating some structural, functional connection. The necklaces, breast adornments and hip belt, arm bands and foot rings of the dancing Kṛṣṇa (Plate 26b) derive the compelling self-contained quality of their existence from the clarity of the inner vision; they are there of themselves because they could no more be absent from the manifestation than could the mace and conch, the discus and lotus from Viṣṇu's four hands (Plate 27). They are not members in some structural design; they are the assembled ingredients of values characterizing his essence for the act of contemplation. The dancing pose of the Kṛṣṇa, for all its energy, also has a reserved, suspended quality about it; he is at rest, as it were,

even in the moment he is moving, and is subject to no law
of gravity. This is because the inner eye that brings forth the
divine child in his victory dance sees him as though he were
dancing, but not as if he were dancing now in one position
and now in that. For all his sprightly energy, Kṛṣṇa remains
for the inner eye an image that is steady; for inward sight,
the law of gravity has been revoked; similarly, the pillarlike
feet of the standing Viṣṇu are not there to support his mag-
nificent torso; nor do his hands require any expenditure of
effort in holding the mace and discus (Plates 28, 29). In its
parts and with its attributes, this figure is a juxtapositioning
of essential signs, palpably visible to the physical eye, that
must appear together in order to express in traditional fashion
his essence in the visible realm as this particular juxtaposi-
tioning; and at the same time, each piece—be it crown or
breast ornament—sits beside the others with an air of im-
placable complacency; it expresses itself and itself alone. This
compelling quality appears to our profane eyes to be some-
thing magnificently sealed in tranquillity, something impe-
netrably solemn and objective that makes no attempt to please
anyone. At the same time, the infinite charm enveloping the
bodies and poses of these figures—Viṣṇu, Rāma, Lakṣmī, the
Buddhas, and all the others—is not a calculated effect intended
by the artist; it is a reflection of a necessary ingredient of the
inwardly perceived image from which they came and which
they attempt to embody (Plates 30–33). Once the internal
spectacle is assembled before the devotee, he is to "bathe his
consciousness, submerging it in waves of love" for the chosen
deity that he contemplates. Beauty is as much a part of these
divine manifestations as is the terrifying shape in which the
Divine may reveal itself. The inner image of the deity and the
visible *yantra* that is to copy it radiate graciousness, swim as
in ethereal sweetness, because the eye that created it and held
it in contemplation has been bathed in the flood of its love
for God.

There does indeed exist a profound relationship among all
the formal elements that combine in the sacred image as its
inventory of visible forms; it is, however, neither structural

nor dynamic in nature; it is a relationship based on an idea. Not one of the formal elements may be omitted, or else the *yantra* would be an imperfect instrument, an incomplete reproduction of a supernatural essence, and would serve no purpose; no element may occupy a different location within the general framework or alter its pose without substantially changing the meanihg of the whole or rendering the entire image meaningless, which is a more frequent occurrence. Expressing the essence of a web of supernatural powers, the sacred image has no structural dynamics, because of its fundamental connection with inner vision; but it does possess an inexorably fixed order to its wealth of forms, an ordering much more rigid than would ever be possible for the classical work of art.[u]

[u] The concept of the sacred image as an expression of "the essence of a web of supernatural powers" is very close to the traditional view of the *yantra* as a spider's web with the central point, the *bindu*, as its radiating source of energy. Cf. M. Khanna, *Yantra—the Tantric Symbol of Cosmic Unity* (London: Thames and Hudson, 1979), p. 9.

Yoga and the Linear Sacred Image
(the *yantra* and the Mandala)

GENERAL OBSERVATIONS

The Linear Composition in Magic and in Cults

In the tantric texts that are known so far, there is much more information about the linear, quasi-geometrical *yantra* (Frontispiece, Plates 17–19) than about the figurative sacred image. These regularly shaped, two-dimensional compositions enjoy such great popularity probably in part because they are so simple to prepare, in part because, in spite of their frequent and widespread use for magical and other esoteric purposes, they nevertheless reveal so little to the uninitiated. Another major reason for their popularity surely lies in their power to convey in uncomplicated symbols a greater richness of meaning than can the figurative sacred image through its complex means of expression.

In the various textual sources there is unanimous agreement about the high value of the linear *yantras*. Functionally, they are on a level with the figurative images related, if not superior to them. The *Kulārnava Tantra* says this about them:[1]

> It is taught of the *yantra* that it consists of mantras [meaningful sacred syllables and words]. For the deity's form is mantras [*devatā mantrarūpinī*]. If the deity is worshiped in the *yantra*, then it is immediately filled with grace.
>
> The *yantra* is called a *yantra* because it brings under control [*ni-yantrana*] all the evils stemming from desire,

[1] *Kulārnava Tantra*, edited by Tārānātha Vidyāratna, Tantrik Texts, V (London, 1917), VI, 85–90.

anger, and other errors. A god worshiped in the *yantra* is full of divine grace.

What the body is for the spark of life [*jīva*], what oil is for the lamp's light, that is what the *yantra* represents for all the gods.

Therefore one is to draw an auspicious *yantra* with its surrounding frame or unfold it before one's inner eye [*dhyā*] after one has learned everything one needs to know about it from a teacher's lips, and then one is to worship it according to the ordinances.

If one worships the deity on a seat [*pīṭha*] separately, without a *yantra*, then one tears apart something which belongs together[2] like the limbs of a body, and brings upon oneself the deity's curse.

Each deity on his own seat, and each one with his own special *yantra* appropriate to it: in this manner one is to worship the deities with their encircling retinue according to the ordinances.

So great is the esteem in which the linear *yantra* is held that the *Kulārnava Tantra*, for one, calls into question the *pratimā*'s capacity to act as the vehicle for receiving the deity unless the *pratimā* is used in conjunction with its corresponding linear *yantra*.

The *Kulārnava Tantra*'s etymology of the word *yantra* is of but limited value. That it cannot pass the scrutiny of scholarly criticism because it ascribes more special significance to the word than there is, is a poor reason for rejecting it. The issue for us hinges on knowing what meaning the Indian devotee happens to connect with the word *yantra*. The possibility of interpreting the words and syllables boldly and variously is understandable from the extraordinary role tantric doctrine accorded them as bearers of esoteric meaning. The boldness with which the etymological interpretation can perceive an occult as well as the usual meaning in each and every linguistic element is almost enough to validate that interpretation, which often happens with the esoteric theological etymologies

[2] *Angāngitvam parityajya*, ibid., VI, 89.

found in the ancient Vedas. In the religious thought of India, as in that of other countries, we often discover a sovereign naiveté that distinguishes theological etymologies from those in the secular sphere.

In the *Kālīvilāsa Tantra*, the etymology of *yantra* is interpreted differently:[3] "Because the correct knowledge concerning the different corners into which the seed-syllables [*bījas*] must be placed is carefully [*yatnatas*] preserved [*trāyate*] by the *yantra*, it is called a *yantra*." This explanation derives from the fact that in the linear *yantra* an important role is assigned to the corners of the evenly shaped figures (triangles, squares, and so on) of which it is composed, and these corners distribute in their proper places the significant syllables and words (mantras) from which partial aspects of the deity emerge, once those syllables are fixated upon in meditation. That is why they are called seed-syllables (*bījamantras*) or simply seeds (*bījas*). By keeping the number and sequence of these seeds firmly in place in the corners and angles, the *yantra*'s network conceals within itself, secretly, the instructions for developing images in meditation in a manner faithful to the tradition. Although grammatically unacceptable, this interpretation of the *yantra* is as remarkable as the earlier one with regard to its factual content.

The dominant role of the linear *yantra* in the tantras' world of forms is attested not only by the countless instructions given for its use but also by the paradoxical fact that, in the *Kālīvilāsa Tantra* just referred to, there is a passage which prohibits the present age from making use of the linear *yantra*. This only underscores the high regard in which it is held. For the *Kālīvilāsa Tantra* is distinguished from similar texts by the severity of instructions that prohibit mankind, in its present state of decline, from using precisely that group of the most important esoteric sacred forms which are to be reserved for a more worthy age. These are taught and recommended elsewhere, but in this work they are forbidden. For the *Kā*-

[3] *Kālīvilāsa Tantra*, edited by Pārvatī Charana Tarkatīrtha, Tantrik Texts, VI (London, 1917), xxx, 1.

līvilāsa Tantra has set as its special task the approval of only those things from the sacred heritage of ancient times which, as a consequence of this tantra's pessimistic view of the inadequate ethical and spiritual maturity and capabilities of the present age, are commensurate with those capabilities. The devotional techniques using a linear *yantra* no longer fall into the category of sacred acts that a man of our Dark Age (Kali Yuga)[a] is permitted to practice with any prospect of success: "No worship shall be practiced with a *yantra* in the Kali Yuga. Worship [*pūjā*] which involves drawing a *yantra* will certainly bear no fruit"—and demonic-divine creatures will deprive of his emanating power (*tejas*) any devotee who dares to practice this form of worship.[4]

The linear *yantra* serves as a "tool" for many purposes. Its lowest function is a magical one. The thirty-second chapter

[a] For further information on the Kali Yuga, see: Zimmer, *Myths and Symbols in Indian Art and Civilization*, edited by J. Campbell, Bollingen Series VI (Princeton: Princeton University Press, 1972), p. 15.

[4] *Kālīvilāsa Tantra*, VII, 9. This tantra gives evidence at every turn of the particular rigor that makes it unique in tantric literature: "the devotee will have no success with the litany of the thousand names of the Ruler of the World [*bhuvaneśvarī*, an aspect of Kālī-Durgā]. For the Kali Yuga, there is no name for the Goddess beyond the litany of a hundred names" (ibid., X, 2). Another passage condemns as being no longer appropriate for the Kali Yuga the enjoyment of alcohol, fish, meat, and other stimulants that have a special place in tantric ritual, although they are forbidden in everyday life. Only those belonging to the earliest age, the Age of Truth (*Satyayuga*) were mature enough to use them with impunity (ibid., VI, 24–25; X, 22). Cf. further ibid., XXVII, 19–21; XXXV, 31.

As in most of the tantras, the *Kālīvilāsa Tantra* is in the form of a dialogue between Śiva Maheśvara, the "Great Lord," and Kālī-Durgā, his divine consort. For instructional purposes the Divine-One divides Itself in play into these two supreme forms of the male-female polarity—the God and his Śakti—in order to reveal the forms for worshiping It by means of questions and answers. Here the Goddess asks the questions and the God instructs Her with his responses. The words the Goddess repeatedly uses to introduce her questions show that, in transmitting the tradition, it was especially important for the *Kālīvilāsa Tantra* to contain within the sacred forms and concepts handed down only those things it judged to be of permanent worth and therefore suited to the Kali Yuga (*kalikālasya sammatam*). Cf., for example, ibid., IV, 1; V, 1; XIV, 1 and 14; XV, 1, and Avalon's references in his introduction to the text.

of the *Prapancasāra Tantra*, which contains instructions for preparing numerous *yantras*, begins with the words:[5] "Now I will teach various formulas [mantras] which are accompanied by many traditional practices, together with the preparation of their *yantras*, which will be of service to the pious, expert in mantras, in attaining both earthly goals and higher ones." Descriptions follow of *yantras* that are to assure long life and health, to free one from headaches or to make one invulnerable, to protect against thieves, to compel women to love, to bestow the favor of princes and grant power over other men; the list goes on. We also find related texts that yield similar information. The believer wears these magical signs as amulets, paints them on walls, buries them in the ground, or sleeps on them, and so on, as befits the symbolism of the magical procedure for which they are a mere tool.

The linear *yantras* used in magic are apparently also referred to in a verse in the penultimate chapter of the same work, which discusses the "consignment of breath" (*prāṇapratiṣ-ṭhānā*) into the *yantras*:[6] "Without the consignment of breath, the customs hitherto described are without substance and as dead."[7]

The consignment of breath, required here for all *yantras* to make them usable, must appear in a different form when its magical application occurs in such cases as a figurative *yantra*. The consignment of breath is the insertion (the in-spiration) of divine power, the same power that animates the devotee, into the composition he has before him. He takes the power from within himself, where the granting has been direct. Whoever worships a figurative sacred image brings before his inward eye the *śakti* animating him in precisely that manifestation through which he is accustomed to see the Divine, by virtue of his initiation into his family's tradition or the particular guidance of his teacher; this manifestation also corresponds in form to that of the sacred image. On the other

[5] *Prapancasāra Tantra*, edited by Tārānātha Vidyāratna, Tantrik Texts, III (London, 1914), xxxii, 1.

[6] Ibid., xxxv, 1.

[7] "*Vyartha*" and "*gatajīvakalpa*."

hand, anyone employing a linear *yantra* for magical purposes, and not as a graphic, symbolic representation of a diety's aspect, breathes divine life into it, which is exactly what the *yantra* needs in order to be effective; this he does by bringing before his inner sight divine energy (*śakti*) in the elemental form of the breath of life, instead of visualizing a particular aspect of the divine person. Wherever the divine power of the breath of life (*prāṇa-śakti*) appears before the inner eye, it is one of the innumerable variant manifestations of the supreme Śakti: a formal transformation of Kālī-Durgā's image, who is the Śakti of the "Great God" Śiva. In the inner vision of the initiate who wishes to perform by means of that vision the consignment of breath into a *yantra*, she is seen in the following form: "She shines like the rising sun. She has three eyes and full breasts. She sits on an opened, reddish lotus in a boat in the middle of a sea of blood. Her hands hold a noose, the sugar-cane bow, a goad, five arrows, and a skull-cup filled with blood"[8]—these are the martial emblems of Kālī-Durgā, the conqueror of demons.

Apart from ordinances for employing the linear *yantra* in magic, the tantras contain a wealth of directions for its use in cults. The sum and substance of these ordinances—which are the primary concern of the *Prapancasāra Tantra*, among others—give instructions regarding the connections that exist in these ritual acts between the inner visualization of the deity— the idea it contains—and its graphic form in the linear *yantra*. These ordinances usually describe the complex of words and syllables (mantra) constituting the deity's aspect in the linguistic sphere. For the deity's form can also be made up of a mantra (*devatā mantrarūpiṇī*). Through its mantra, the deity is worshiped both in the contemplation of silent recitation and in the sphere of audible sound; furthermore, by means of this mantra, the deity's inner visualization related to it is called up in meditation (*dhyāna*). This is nothing less than a manifestation of that same Divine Being, but it is now on the plane of contemplation.

[8] Ibid., XXXV, 7.

Next to the mantra, an indispensable component of these ordinances for ritual worship is a more or less detailed description of the deity's palpable, figurative manifestation that is to be summoned up before the inner eye in the process of *dhyāna*. The deity's aspect is fully depicted: its friendly, composed expression (or its threatening one), its emblems, clothing, and pose are all characterized in the ordinances. The deity's surroundings for that particular occasion are also indicated. These include, above all, other attendant deities and divine beings of lesser rank that make up its retinue. The ordinances describe the figurative images of meditation that are congruent with the objective figurative sacred images, which present to us, the uninitiated, a visible concretization of what the ordinances contain. Their long descriptive lists neatly lay out the figurative details one after the other, just as we ourselves would have to do if we were to undertake a basic inventory of the formal elements in the Indian figurative sacred images familiar to us.

The ordinances concerning *dhyāna* are usually followed by instructions dealing with the forms of offerings, of recitations, and whatever else belongs to the outer worship of the deity in the *yantra*. Varying from case to case, these instructions are determined by the particular aspect in which the Divine is worshiped and by the particular goals of the cult.

In the final section of the whole exposition instructions are normally given regarding the linear *yantra* with which the deity's ritual is to be performed. The description of how it should be drawn is usually brief, and it would have to be supplemented by visual material in order to be made intelligible to the uninitiated.

Mantra, *dhyāna*, and linear *yantra* are three quantities that are congruent in their underlying idea. They are materially different expressions of one and the same aspect of the Divine: in sound, and in contemplation of something either figurative or linear; three statements, that is, in three different languages, about the same essential thing. Because their differing forms give expression to the same basic idea, they can be called

congruent in form, and they are in fact constantly treated as such in actual practice.

The verbal expression of divine essence (mantra) can be completely superimposed upon the linear expression by inscribing it syllable by syllable onto the linear *yantra*'s configuration of lines. In every instance, this is done according to a specific unalterable rule composing a part of the occult doctrine. If, in this way, the mantra and *yantra* forms of expression regarding divine essence are fused into one, then linear compositions are created whose interior areas are decorated with evenly spaced letters (Plate 19). The hidden, essential connection between the linear *yantra* and the mantra—the identity of the ideas they embody—becomes apparent through the fact that all the syllables of the mantra evenly fill up the regularly shaped forms of the linear construct, whenever the mantras are distributed over the *yantra* in accordance with the appropriate instruction.

In ritual practice, the figurative visualization and the linear *yantra* are congruent on innumerable occasions: each time that the consignment of breath (*prāṇapratiṣṭhā*) is performed with a linear *yantra* in order to worship a deity. For the ordinance regarding *dhyāna* sketches out a figurative vision which the believer is then to project out onto the linear *yantra* by means of *prāṇapratiṣṭhā*. In the requirement that the figurative vision be transposed onto the linear *yantra*, it is already assumed— as if there were any other way of doing it—that a total identity of idea exists between the linear composition and the figurative inner vision. Otherwise, the elaborately shaped inner vision could not possibly be so completely absorbed into the geometric apparatus (*yantra*).

Within the repertoire of Indian art, there exists still another counterpart to the "lettered" linear *yantra*, which verifies the complete identification and fusing of the mantra and the *yantra*; this counterpart will provide evidence for the same relationship between figurative *dhyāna* and the linear *yantra*. Here we must move from the Indian subcontinent to Tibet to find different images—mandalas, "ring" drawings— whose linear framework is filled with figurative elements

(Plates 20, 21). They belong, in fact, to a part of Buddhist tantrism, not to the orthodox Hindu branch, but their pictorial symbols, borrowed for the most part from Śaivism, are proof of their origin in Indian tantrism. The *yantra* was unknown in ancient Buddhism; along with many other elements it crept into Buddhist practice from Hinduism during the great process of assimilation that Buddhism ultimately underwent in India. In the artistic practice of Lamaist silk painting, Buddhism seems to have preserved something that was simply a given in orthodox tantrism, even though at the time of writing there is no visual evidence for this.

Finally, it is superfluous to mention again that the mantra and the *dhyāna* of a deity, as two expressions of the same basic idea, are also identical. Their identity of content is the source of the mantra's power (*mantraśakti*) to conjure up inner visions like them in essence, whenever they are recited or concentrated upon in meditation.

But it is worth noting that mantras, as one possible shape the god takes, are placed, syllable by syllable, alongside the proper individual parts of the figurative visualization. In the ninth chapter of the *Śaktānandataraṅgiṇī* ("The Swelling Stream of Bliss of the Believer in Śakti"), a twenty-one-syllable formula (mantra), the "Queen of Knowledge," which expresses the essence of Dakṣiṇā Kālikā, one of Kālī-Durgā's manifestations (Plate 34), is equated, syllable by syllable, with the parts of her visible representation. Its first two highly significant syllables, "*krīm*," "*krīm*," are her head and brow. Then the sound elements of her manifestation in the mantra are located in descending order next to the parts of her figurative *dhyāna* manifestation until, finally, the formula's concluding expression of respect, "*svāhā*," is divided up, with its first syllable next to her feet, its second at her toenails.[9] We note that speculations of this sort are not peculiar to the tantras alone; they were already present in Vedic theology.

[9] Cf. *Karpūrādistotram*, introduction and commentary by Vimalānanda Svāmī, translated by Arthur Avalon, Tantrik Texts, IX, n. 1 on p. 10 of the Sanskrit text of the commentary to verse 5, and Avalon's reference to it, "Preface," p. 2.

The Unfolding and Enfolding of Inner Visions

In normal ritual practice, meditation culminates in the transferral of the visualization onto the *yantra*. Then the outer worship of this enlivened *yantra* can begin; it concludes with the reabsorption of the "chosen divinity" into the believer's heart. (Cf. *supra*, p. 40). There is a psychological wisdom in the fundamental axiom taught by the tantras regarding the worship of the sacred image: "Only as long as *dyhāna* lasts, does *pūjā* last." By means of consignment of breath (*prāṇapratiṣṭhā*), in which this principle is incorporated, the ultimate truth of the tantras is made manifest to the believer during every ritual act he performs: the truth that he is himself the Divine (*brahman*), the "One-without-a-Second" (*ekam advitīyam*). The ultimate aim, to know oneself as divine (*brahman*) and to dispense with the ritual altogether, is anticipated here by the act of devotion and is recognized implicitly in it. The performance expected of the believer presupposes and gives expression to an awareness of this ultimate purpose; only someone already enlightened could ever have discovered it and introduced it as a sacred ritual act, the practice of which could lift those as yet unenlightened to his own state of enlightenment. The believer makes the core of his own being, the "god of his heart," into the core of the figurative *yantra*, which is simply nothing without the life he lends it. But the figurative *yantra*, brought to life by the breath of the "god of his heart" through *prāṇapratiṣṭhā*, becomes a hieroglyph of the phenomenal world because of the significance of the divine manifestation that is visible in the attributes existing in it. Through its shape and in concentrated symbolic form, it characterizes the realm of *māyā* in an aspect of the Divine that appears to the unenlightened consciousness as the counterpart of his own self.

In the sacred image, when it is correctly worshiped—that is, with *dhyāna* and *prāṇapratiṣṭhā*—there is contained an unavoidable paradox: the nucleus of the image is simply the inmost core of the devotee himself—both are one and the same; but as long as the devotee maintains his reverent attitude

before it, it exists as an Other, apart from the One. The wisdom of the rite lies in confronting the believer with this paradox, in every one of the ritual acts, until the saying, "That, thou art" (*tat tvam asi*), which is contained in the paradox and implicitly imposed upon the devotee as an act in the consignment of breath, permeates him explicitly as an overwhelming experience, as Ultimate Knowledge. When that happens, all ritual as such comes to an end, and the sacred image becomes meaningless and superfluous, like any tool (*yantra*) that can be dispensed with once it has served its purpose.

Not a single part of the sacred image's worship was conceived or organized by *māyā*-bound human consciousness; if it had been, then how could its worship ever claim to be able to nullify (*aufheben*) that consciousness? Belonging to the very heart of divine revelation, it expresses the secret of divine *brahman*-like existence in the language of the ritual acts. It bids the soul (*jīva*), which is caught up in the illusion of opposition of Self and world, to take action from its *brahman*-like position so that the paradox between that position and the activity carried out within it will gradually be revealed. At that point, the spell of Ignorance (*avidyā*) is broken and the *brahman* returns to its own true Being from its *māyā*-darkened state as an individual soul (*jīva*) ensnared in this world.

The psychological principle behind this technique of devotion, which controls the mind, is to place the believer, as an active agent, onto the higher plane he is to attain as one who perceives and knows. Being grows out of Doing; the repeated act of Doing gives shape to the believer's Being; perseverance in that kind of Doing crystallizes into a Knowing in which the new Being and believer are conscious of Self. This principle originates in the same view that has assigned the idea of *karma* its proper status within the framework of the Indian teaching of incarnation; according to this view, the thoughts and actions of earlier lives are the seed that grows into the fruit either of spiritual maturity or delusion, of spiritual enlightenment or darkness. The Buddha-in-the-making (bodhisattva) must of necessity progress by means of a pre-

paratory course, measured in aeons—a course in which he experiences everything with an ever-purer heart, and has suffered everything it is possible to experience, and has comprehended the purpose of it all—to the maturity of highest attainable Enlightenment, which signifies omniscience. In his final life, as the enlightened Buddha, he plucks the fruit of knowledge from the tree of perfection of his Being, whose "roots of the good" he planted during all his other, earlier existences.

The enlightened person, the perfected yogi who has arrived at the end of his course, knows himself to be in the state of pure, undifferentiated divinity: for him the contradiction between I and Not-I (world) is now transcended (*aufgehoben*) illusion; the *brahman* within him has returned unto itself. The doctrine that the Divine without attributes chains itself with Its own *māyā*, and in so doing unfolds Itself in delightful play (*līlā*) as the variegated phenomenal world, is not, for him, Ultimate Truth. He sees in the world the grand illusion that is truth for the *māyā*-bound consciousness. The doctrine that divine energy unfolds into many manifestations and beholds itself in them is for him a lower order of truth that is transcended as soon as he realizes that this play of *śakti* is illusion (*māyā*). The technique of worshiping the sacred image represents the bridge leading us from the near shore of illusory truth to the farther shore of Ultimate Truth, the bridge that therefore rests on both shores by virtue of its inherent and unavoidable paradoxical nature.[b]

At a lower stage of worship, the believer is content to appreciate his Self and the world as unfolded forms of one and the same divine power (*śakti*) without fusing its different man-

[b] In another context, Zimmer describes the technique of worship as immersion in the unconscious: "Tantric Yoga teaches its adepts to respect and live at peace with the world of the unconscious; by evoking the unconscious, they preserve their balance; total and repeated immersion in it is indeed the very core of Tantric Yoga." Zimmer, "The Significance of the Tantric Yoga," *Spiritual Disciplines*, Bollingen Series XXX:4, (New York: Pantheon Books, 1960), p. 39. So, part of the paradox of the "suspension bridge leading us from the near shore of illusory truth to the farther shore of Ultimate Truth" is that the bridge leads to immersion in the waters after all.

ifestations—himself and the sacred image—into one, by means of a ritual act. He knows Self and world to be one and the same in their divine essence, without pressing forward, through further yoga exercises, to overcome the illusory contrast between world and Self, which constitutes consciousness; he does not yet attempt to experience in overwhelming immediacy the identity of divine existence above and beyond the differentiated manifestations which that contrast conceals. If he does intend to forge on to overcome the contrast, then he is confronted with the task of fusing into one entity the two poles—the Self and the world—of the unfolding of the divine essence into illusion. That is, he has to absorb into his act of seeing the inner vision of his chosen deity, the hieroglyph of the Divine as the visual unfolding of the world: the perceiver and the perceived must melt into one. The *Bhāgavata Purāna* teaches us how this process of reabsorbing the inner vision may be accomplished, during which the yogi needs to envision nothing further and, in complete identity (*samādhi*) with his vision, actually lives as his chosen deity, as the essential essence of all that lives, as his own essence: "As light is submerged into light, and cannot be separated from it."

The ultimate return of *brahman*, which is bound to human consciousness by *māyā*, to its pristine state occurs, therefore, in two stages: there is the initial unfolding and fixating of its cosmic, divine manifestation before the inward sight with or without the aid of a *yantra* conforming to the inner visualization; this is followed by the enfolding of this construct of the personalized Divine into the agent who has constructed it, into his inner eye. The contrast between the One and the Other is transcended (*hebt sich auf*) and with it there disappears also any possibility of expression, since without the principle of opposition there are no limits, and these are, after all, the very substance of an act of expression.

This yoga process of enfolding the unfolded vision either has to free itself from the figurative sacred image or it has to dissolve it. In any case, from the image's actual physical presence the yogi cannot receive any indication as to how it can be enfolded; instead, he will meet with the resistance that any

form, by its very existence, offers to any attempt at dissolving it.

With the linear *yantra* it is completely different. This form includes different types of various natures. With one of these types, ordinary ritual practice may be observed, which is content to worship the Divine in one of its sensually perceptible aspects; another type of linear *yantra* will be of greater significance in leading mind and soul onward. With its planes and concentric rings it reproduces the typical forms of the essence of the pure Divine's unfolding into the realm of appearance, which we may call varied forms of consciousness or images of the world. World and consciousness of Self are actually two names for the same thing. A *yantra* of this type, with its concentric structure, is from the center point to its outermost edge an image of the Divine unfolding itself in play, and it sets the adept of its esoteric teaching the task of enfolding its variegated forms right back into its center point. This center is the Divine in its pure, not-yet-unfolded state, and the believer is to know himself as that center. He is himself, after all, the *brahman* that, in the play of its own *māyā*, has consigned itself to the bonds of human consciousness.

In the static form of this higher variety of linear *yantra* there is a remarkable, built-in dynamic that is absent from the figurative sacred image (Frontispiece). By its very form the figurative sacred image, like its corresponding visualization, resists any deconstruction, whereas the linear *yantra* in fact invites it. For the devotee to experience himself in its unfolding and enfolding as *brahman*, instructed by his initiation, he anticipates mentally, as he also does in the case of the figurative composition, the fact of his own divinity, so that he may then in the course of contemplation totally experience his divinity overwhelmingly. He identifies himself with the center of all centers in this linear complex, with the dot in the middle, from whose tranquillity all the lines of movement radiate forth, expanding in waves—he identifies himself with *brahman* as the source of all manifestations. Before his inner eye, in the "process of unfolding" (*sṛṣṭikrama*), he develops out of this dot in linear symbols (which can be filled with

figurative elements) the play of *māyā*, in both its most delicate and materially coarser manifestations, right up to the *yantra*'s outermost edge. In this unfolded composition he contemplates the world in its varied aspects; he views his own self with its diverse spheres of sensual and spiritual life, and he views the Divine in Its manifold personal manifestations.

Hard upon this first, graduated stage of stepwise construction there follows a similarly graduated deconstruction of that which has been unfolded, the "process of enfolding" (*laya-krama*). This reduces the differentiated elements of the linear figure into Oneness: into that point in the middle (*bindu*) from which they unfolded. Ultimately, even that disappears. Here, with different means that perceptually satisfy the need for contemplation, the same goal is sought which the *Bhāgavata Purāna*'s instruction for *dhyāna* sets for the yogi when it tells him to direct his gaze outward from the god's image, the single point of his concentration, into Emptiness, in order, by dissolving his vision, to relinquish the distinction between the perceiver and his perceived vision.

A linear construct of this kind, which harbors within itself the dynamics of unfolding and enfolding its forms, is a guiding pattern for developing a corresponding series of inner images, and is therefore a mere instrument for the yogi, a *yantra*. The advanced yogi may dispense with it altogether. One Buddhist tantric text[10] recommends for the most advanced devotee a meditational exercise for unfolding and enfolding images that avoids using a linear composition as its basis, taking instead the adept's navel as its starting point. From the navel, his vision is to develop a four-petaled lotus as a symbol of the phenomenal world. Each of its petals signifies one of the four elements constituting that world: earth, water, fire, and air, and a blue dot in the middle of them represents the fifth and most refined element, ether. All five symbols of the elements are to bear the lettered symbols (man-

[10] *Śrīcakrasambhāra Tantra: A Buddhist Tantra*, edited by Kazi Dawa-Samdup, Tantrik Texts, VII (London, 1919), 56–58. [For more on the discussion of elements that follows, see Zimmer, *The Art of Indian Asia*, I, 216.]

tras) expressing the essence of these five elements in the aural sphere.

After the unfolding of this visualization comes its enfolding (*laya-krama*). The inner order of this process is arranged according to a basic idea of Indian cosmogony. Since Vedic times, there has existed a teaching concerning the unfolding of the undifferentiated Divine into the phenomenal world: the five elements are graduated transformations of constantly increasing material density into which the not-yet-unfolded Divine Being without attributes has changed Itself. From the most refined state of transformation, the ethereal one, the more compact air is separated out; from this, fire develops; from fire, water, and from water, ultimately, earth, as the physically most substantial transformational form of the Unenvisionable Divine. On the plane of his own inner sight the yogi now reverses this process of the unfolding of the world. He causes the differentiated world, which he has unfolded from his navel, to sink back again into the undifferentiated state. In doing so, he experiences his Self directly as the pure Divine (*brahman*), which in truth he is. He anticipates his divine status when he causes the world, simplified into symbols, to emerge from his navel through the process of meditation. This is an exalted, godlike action. And it is confirmed by the immediate experiencing of the fact that this godlike status is indeed his birthright, that it is this that constitutes the very core of his nature, and not his *māyā*-bound human state, which he strives to overcome. *Brahman*-like he causes the unfolded phenomenal world to melt together: petal by petal, the unfolded lotus shrinks back into itself until, in the sequential progress of the world's unfolding, the fourth and last leaf, the symbol of the air, along with its appropriate mantra, falls back into the ether, the blue dot at the center. Then the yogi fixates upon this blue dot; at the same time he yields himself up, as he had already done in the preceding acts of enfolding, to the rhythm of controlled breathing until the vision of a pure, cloudlessly transparent, completely untrammelled celestial vista is spread out before him. This vision, free of all shapes or forms, is the truest image of the undif-

ferentiated Divine with attributes. It is to this that the yogi returns in the progression of his inner contemplative visions. He experiences his own essence as the essence of this pure crystalline Emptiness, into whose formless state the lotuslike phenomenal world as which he had unfolded himself, has melted away and dissolved.

LINEAR *yantras* CONTAINING FIGURES
(LAMAIST MANDALAS)

The most complete directions for developing before the inner eye a linear *yantra* with figurative decoration that is alive with the dynamics of enfolding and unfolding can be found, among the presently known sources, in the *Śrīcakrasambhāra Tantra*,[11] a Tibetan (Lamaist) text. This work is a product of an era in Buddhism's development in which the main stream of the Buddha doctrine in its course through time acquired so great an influx from the tributaries of Hinduism that its content became virtually indistinguishable from Hinduism. It is only its tone that betrays the fact that this work diverges from the main channel of orthodox tradition. In this work, we find thought common to India in general couched in conceptual language specifically Buddhist. Among the figurative and linear symbols that represent the visible expression of the Buddhist tantric conceptual world, ideas appear, which are generated by Buddhism, together with borrowings from Hindu mythology. Śiva and Kālī-Durgā, who are the foremost symbols of the Divine in the realm of orthodox tantrism, assume here too—masked and interpreted in Buddhist terms—a definite preeminence. Reason enough why selected examples from Lamaism may be applicable in those situations where sources and images from the Indian subcontinent are at present inadequate.

The instructions given in the *Śrīcakrasambhāra Tantra*, and the beautifully colored silk paintings that are their equivalent

[11] Ibid. Foreword by Arthur Avalon: "the first Buddhist Tantra to be published and the first to be translated into any European tongue" (p. iii).

expressions in art, cannot be understood from the viewpoint of ancient Buddhism's basic doctine on the problem of release. The richly figured silk mandalas are shaped by an approach to the questions of actual and apparent reality quite different from the one taught by Buddha to his disciples; the mandalas' colorful contents (Plates 20, 21) display in the upper sections the transcendent calm of Perfected Ones, but they include, in the lower ones, contained within a rigid code of symbolic gestures, the demonically noisy riot of fierce protective deities; their innermost nucleus, which signifies order at rest within itself, is surrounded by walls of impenetrable lines.

It was the epoch-making nature of the Buddha's mission that his "Path" refused to enter the fields of metaphysical speculation. He rejected any attempt to explicate *a posteriori* and metaphysically the experiences of Buddhist yoga, which were intended to make all speculation superfluous. The dying Buddha did not regard his testament for the world as a philosophical interpretation of the eternal enigmas but rather as a practical guide for transcending illusion and ignorance about the nature of the world and the Self.[c] According to the Ceylonese tradition, his ultimate message is a call, not to the *via contemplativa* of conceptual and systematic thought, but to the *via activa* of yoga. The Buddha left unanswered the great question as to how one was to conceive the mundane existence of the Released One who had successfully escaped the bonds of error and ignorance (*avidyā*) and crossed over the flood of *saṃsāra* onto the shore of Nirvāṇa. Language, which is a mental reflection of the phenomenal world and of experience of

[c] The passage Zimmer is referring to is found in the *Mahāparinibbana Sutta*, which is said to contain the Buddha's final teachings. "So, Ananda, you must be your own lamps, be your own refuges. Take refuge in nothing outside yourselves. Hold firm to the truth as a lamp and a refuge, and do not look for a refuge to anything besides yourselves. A monk becomes his own lamp and refuge by continually looking on his body, feelings, perceptions, moods, and ideas in such a manner that he conquers the cravings and depressions of ordinary men and is always strenuous, self-possessed, and collected in mind. Whoever among my monks does this, either now or when I am dead, if he is anxious to learn, will reach the summit." *The Buddhist Tradition*, edited by W. T. de Bary (New York: Vintage Books, 1972), p. 29.

Self, is completely at a loss when it has to characterize a condition in which world and Self have ceased to be. It would be foolish, then, to imagine that the application of language to formulate speculative ideas would help the pilgrim along on his path to Nirvāṇa. The Buddha saw the cure of release as lying solely in the personal activity of spiritual purification and the purposeful practice of yoga, which set as its goal not the cognitive preoccupation with Nirvāṇa, but the direct experience of it; yoga was to elevate the proficient yogi into that very state of Nirvāṇa.[12]

On his path to the state of inner collectedness (samādhi), the Buddhist yogi experiences step by step the extinction of all sensual thought processes, all emotional tensions. The release from these serves to teach him the conditional quality of all phenomena that constitute his objective reality. It is for the yogi to determine whether the phenomena are to exist or not. His path of transcendence (Aufhebung) emerges into a state where consciousness ceases: into total extinction (Nirvāṇa) or into pure Emptiness (śūnyam). This state cannot be transcended by means of any further yoga practice; it is the ultimate and highest abode. Inexpressible in terminology from the real world, it cannot possibly be subsumed under such terms as "Being" and "Nothingness." To call Emptiness or Nirvāṇa nothing is a trap into which an everyday, uninitiated mortal may well fall.

For the Perfected One, who is permeated with the Truth of Nirvāṇa, there is no problem as to how Nirvāṇa may relate intellectually to the phenomenal world. He is of course (when not at a given moment engrossed in yoga) surrounded by this

[12] Ancient Buddhism's rejection of metaphysical speculation has frequently been emphasized. See the often-quoted first dialogue (of two) between the Buddha and Mālunkyaputta in the Majjhimanikāya (No. 63), translated by Karl Eugen Neumann, in Die Reden Gotamo Buddho's aus der Mittleren Sammlung (Munich: Piper, 1922), II, 184. Another source would be the Dīghanikāya, translated by R. O. Franke (Göttingen, 1913), IX, 154 ff. [For an English translation of the latter passage see Dialogues of the Buddha: Part I, translated by T. W. Rhys Davids. Sacred Books of the Buddhists, Vol. II (London: Luzac, 1956), 256–64. See also Zimmer, Art of Indian Asia, I, 196–97.]

world even after achieving Enlightenment. But that phenomenal world has become empty for him, without heart or substance, once he has experienced Nirvāṇa, Emptiness, as the sole nontranscendable state (*das Unaufhebbare*). He is aware of the world's appearance as simply that; and thanks to the perfected yoga techniques that have led him to Nirvāṇa, he is able to experience repeatedly the insubstantial nature of all appearance. He extinguishes the reflection of that world in his sentient life and in his mental activity; he brings to a complete standstill both the sensual and the spiritual within him: the world then ceases to exist. When the yogi, together with his Self—an entity as unsubstantial as the world—is effaced, the last shadow of the world is dissolved along with him.

In its attempt to maintain this magnificent stance of triumphant perfection which, in the immediacy of its absolute possession of inescapable Truth, was able to renounce all speculative efforts, Buddhism has been less than successful. It succumbed to the example of Hindu speculation surrounding it and annexed the speculative metaphysical structure of Hinduism to the pure experimental psychology of its yoga practice, which was based on experience rather than thought, which was content with ultimate experience itself without any attempt at interpreting it. Buddhism began to see a problem contained in the question that Buddha as the great Physician of the Soul never afforded the dignity of consideration: the question as to the origin of the disease of Ignorance—the question as to why Enlightenment (*bodhi*) and Nirvāṇa, why Truth and pure nameless and formless Emptiness have to be experienced through the painstaking path of yoga, instead of simply existing as givens—why all of creation surrounding the seldom-encountered Enlightened Ones has fallen victim to, and is so painfully caught up in, the spell of the phenomenal world which reveals itself in name and form—why name and form, by nature unsubstantial and empty at the core, have been able to shape consciousness, only to have to be elevated (*aufgehoben*) into that Emptiness that *is* their essence, by means of the yogi's instructions and the most solitary of his inner experiences.

The trap inherent in this question was recognized by that great spiritual guide whose enlightenment in the form of Buddhism has shone down through the ages. Since the question forces us back into the sphere of the intellect, the Buddha points us away from it in a different direction; he directs us along the Path of Yoga to the pure experiencing of Nirvāṇa, the full possession of which obviates the meaning of the question itself. The envisioned ideal disciple would renounce further the intellectual comprehension even of his own errant strivings, once they had been transcended, and he would be satisfied by their nullification (*Aufhebung*), blissful beyond all expectation, relieved of joy and sorrow. For in the desire to understand the strivings of the insubstantial, transcendable Self, the Perfected One could recognize a still present trace of interest in this Self and its world. In it he could discern a most subtle form of the "thirst" that binds one to the world of name and form—the desire to master it intellectually, to organize it conceptually in the mind. He perceived it as the most subtle form of the human will to power.

Succeeding generations gave much thought to the wonder that was Nirvāṇa—not, to be sure, solely because they saw it as a wonder. They acknowledged its Emptiness as the ultimate essence, but a perplexing problem arose for them in trying to determine why the realm of form and name, the world and Self, is placed as an overpoweringly dazzling illusion over against the Void. Name and form are empty for the yogi, who is able to see beyond their contours; emptiness is their one element of reality, and yet with even their minimal presence they are capable of overwhelming anyone bound up in Ignorance. Between one's everyday perception of the world and the yoga experience of an ultimate goal, there yawns an abyss that the narrow span of the practice of yoga bridges. Whoever crosses to the distant shore realizes the essential emptiness of those things on the opposite bank, the world and Self he has just left behind. Whoever stays on the nearer shore, remains bound up in name and form. But Brahman speculative thought managed to reconcile the contrasting nature of these two different perceptions. It objectified in myth

the two conflicting states of mind represented, respectively, by the uninitiated and the yogi. It spanned the gap between these two polarities with its concept of *līlā*, an activity that acted as intermediary. The perfected yogi finds his experience objectified in the concept of *brahman*. His state of being is *brahman*. But the unenlightened man finds his experience to be the reality of the phenomenal world. His state of being is the division between world and Self, objectified in the idea of *māyā*. Both states of being are interpreted as the primal condition and the changeable form of the Divine. *Līlā*, the concept of the play of divine energy (Śakti), is the factor mediating between the two. In the timelessness of myth, different levels of psychological experience have been objectified as cosmic reality.

Buddhism pursued much the same Brahman course: alongside the yogi, for whom the overwhelming nature of pure experience was quite enough, Buddhism allowed for the role of a meditative person who, in his speculations, was to carry out the task of bridging conceptually the tension created by the polar contrast between the common experience of the everyday world and the yogi's experience of having achieved the goal. Nirvāṇa, originally the state of the Enlightened One, the experience of pure Emptiness beyond name and form, became objectified into Being-in-Itself. Emptiness becomes That-Which-Is-Empty. That-Which-Is-Empty (*śūnyam*) is, as indestructible ultimate Being, That-Which-Is-Essential, the primal basis of all things. To illustrate *śūnyam*, we might choose an image used in the orthodox Vedantic doctrine of *brahman*: there, it is compared with water, an element that remains itself no matter what guise it may assume. By nature formless and shapeless, it can appear in the differentiation of separate waves and, in the rhythm of their dance, transform itself into foam and bubbles. The one element may then take shape at one and the same time as water, wave, and foam. But when its constant agitation ceases, it sinks back within itself; the foam is absorbed in the successive play of the waves until finally their shifting contours subside or melt into the placid surface of the motionless deep; we are left with the

knowledge that it was after all only water and water alone that had swelled up and swirled in such tumultuous forms.[13]

In the doctrine of *brahman*, foam and wave are symbols of the way the One-and-Undifferentiated unfolds into both divinely individualized consciousness (*īsvara*) and human consciousness (*jīva*). When the unfolded *brahman* sinks back into its own primal state, then human consciousness is absorbed by yoga, where it knows itself to be in essence an individual state of the Divine, back into a state of namelessness and formlessness, just as foam is lost within the waves and they, in turn, in the motionlessness of the deep. But when *brahman*, caught up in its own *māyā*, experiences itself as a human being (*jīva*), then it is living in the consciousness of the everyday world. On the other hand, where it feels itself one with the essence of the deity in human form, then it exists at the level of meditation (*dhyāna*), in the spheres of yoga. Where it reverts to its true state, it is the One-without-a-Second; here it can have no knowledge of itself, for it is pure Being.

Buddhism too is aware of this tripartite division into the illusion of everyday consciousness, the illusion of the higher levels of inner vision, and essential Being itself, Emptiness without attributes. It speaks of them as the "three bodies." Along with the "Body of the Essence" (*dharmakāya*) or the "Body of Diamond" (*vajrakāya*), there exist the "Body of Bliss" (*sambhogakāya*), as the object of suprasensory yoga meditation, and the "created" or "physical Body" (*nirmāṇakāya*), the object of sensual contemplation. All these are phenomenal variants of the Enlightened One, the Buddha. For Emptiness, the ultimate Essence of all things, can only be the Buddha. Whoever experiences enlightenment (*bodhi*) is in Nirvāṇa, that is, he sees himself and all phenomena as equally empty of name and form. All difference between the I and the Not-I disappears, since names and forms are essentially empty because emptiness is their essence. For the Buddha, all is Buddha. This is why the concept and image of Buddha are

[13] Cf. *Vākyasudhā*, 46–47, quoted in the commentary *Subodhinī* to Aphorism 7 of the *Vedāntasāra*.

the symbol and hieroglyph for Emptiness. He denotes pure Emptiness and its manifestation in the metaphysical and physical spheres of names and forms, whose Essence is, after all, Emptiness.

All is Buddha, that is, all is Nirvāṇa, Emptiness—just as foam and waves are but water. Enlightenment means to recognize, in knowing one's own true state, the state of all beings. For one who knows, who is aware of the undifferentiated Emptiness of all phenomena, there never has been a Buddha upon the earth. What wandered in the world of illusion as Buddha is but one ray of illusion that breaks forth from the Emptiness of Nirvāṇa into the variegated mosaic of the play of the world of illusion. That world itself, and all its multitude of beings with name and form, are but illusion; their essence is Emptiness. The figure of Buddha, so well established by chronicles and legends, is but a "created, assumed Body" (nirmāṇakāya) of That-Which-Is-Emptiness, wandering through a world of illusion, teaching and redeeming it in appearance only. The physical body of Buddha, who lives as man among men (nirmāṇakāya), is the concealer of the "Body of the Essence" (dharmakāya) of all creatures within one improvised form that is suitable for the sentient, everyday experience of the world of forms. As the counterpart of the Body of Essence, the "Body of Bliss" (sambhogakāya) lives in the realm of metaphysical contemplation, in the higher spheres which the experience of yoga opens up. The Buddhist adept has a goal beyond both these bodies. It is his task to become Buddha, that is, to experience Emptiness as his own essence and as the adamantine, undifferentiated Essence of all Essences—just as the believer in brahman seeks to experience himself as brahman, the undifferentiated Essence of all Essences.

The diamond (vajra) is the symbol for what is eternally Unchangeable, which is, in the impenetrability of its nature, indestructible and unassailable. From time immemorial in India, the vajra, as the name of a weapon shaped like a thunderbolt, was the symbol of supreme divine power. The earliest "Father of the Heavens" (Dyaus pitar, Zeus pater, Diespiter)

bequeathed it to his sons, the heirs of his supremacy over all the other gods: Mithras in Persia, and in India, Varuna. In India, he evolved into Indra when, in later times, Indra became the king of the gods, overshadowing the earlier king of all the gods, Varuna. In Buddhism, the diamond is the symbol for the sphere of absolute Being. This is the reason why the *vajra*, the thunderbolt-like implement, is a favorite among artistic symbols used to represent the realm of pure Emptiness. Buddha figures wear it in their crenelated crown (Plate 35); figures borrowed from the Śaivite world of tantra, and which were reinterpreted by Buddhism, wear it in their crowns (Plates 24, 25) and wield it in their right hand. It is a symbol always associated with the Lama, who has as his goal the experiencing of his own essence as adamantine Emptiness. In the Lamaist mandalas which, as linear *yantras* filled with figures, make manifest pure Being—Emptiness, with its re-flections on the planes of physical and metaphysical illusion—the location of the adamantine sphere is in the center of the concentric structure. As a page from a pictorial atlas of the spirit, their diagram discloses in its outer reaches the sphere of *māyā*, the phenomenal world, accepted as reality by minds clouded in unawareness, and then—nearer to the center—it shows those realms of the yogi's inner experience which lead to that very heart whose essence lies beyond name and form.

Various aspects of cosmic reality, which are at the same time stages of consciousness, are contained within these mandalas, which represent spheres of *māyā* or ignorance (*avidyā*), meditation (*dhyāna*), and, ultimately, the highest wisdom that is Enlightenment, Nirvāṇa. In them, from within the inner experience, the Path to Perfection is presented, didactically and visually, in the form of images, and is set down as a statement expressive of the Essence of all Essences. But they do not exist to be contemplated in a state of calm immobility. Faced with them, the Buddha contained within the initiate is to awaken to his own Buddha-like nature by following this figured map of his way stations, from the outermost fringes of unilluminated Existence right to the centermost point.

Caught up in ignorance (*avidyā*), he is himself, after all, the very essence of that adamantine center. In these images, the mind of the worshiper contemplates his own pure essence in the differentiated stages of his estrangement from self and his return to its truth; returning home to that center point, he experiences an awakening (*bodhi*), which is a "passing away" (Nirvāṇa) into dreamlessly profound rest, because the distinction between I and Not-I, an inalienable part of waking and dreaming, is experienced as being empty of essence.

The *Śrīcakrasambhāra Tantra* (written in Tibetan), which deals with the development of the *Śrīcakra*, the "Circle of Bliss," as an inner image, places the divine figure of Mahāsukha ("Highest Blessedness," in Tibetan, "*bDe-mchog*") in the center of the figurative *yantra*. He is the symbol of Emptiness, a form of the *vajrakāya*, the "Adamantine Body" (Plates 22, 23). His erect, many-armed, flame-encircled figure supports with two of his hands a loving creature with whom he is in sexual union, as she embraces him with her arms and legs.

Mahāsukha and his beloved are a borrowing from the Śaivite world of symbols. Śiva and Kālī-Durgā in an embrace represent the Divine and His Śakti. Pure Divine Being and its unfolding, within illusion, into motion, are one and the same and yet they are two different things. The phenomenal world is the illusion of the Divine, not its essence, but yet, on analysis, this illusion is fundamentally and in essence nothing but the Divine. *Samsāra* and Nirvāṇa are two different things, and yet they too are one and the same; Divine Being and its energy, which expresses itself by unfolding, cannot be separated. The most eloquent symbol for this paradox in logic, which comprises the whole truth of *brahman* and its unfolding as *māyā*, is the sexual union of lovers: the mystery in which two are insolubly one. Their image in art is the hieroglyph for the divine oneness of the world; it is the one comprehensive statement of Being that shows god and man, actuality and illusion, in undifferentiated relationship to each other.

Since the female figure represents Śakti, which, grammatically, is feminine, it is assigned in orthodox Brahman belief an active role as the proper expression of her nature. Śiva, the Divine in the still not-yet-unfolded, immobile state, is usually depicted resting. The belief holds that he lies motionless, as in death, while the goddess, bending over his chest, tenderly merges with him.[14]

In the Buddhist conception, the poles of the symbol are reversed. To Buddhist belief, the male element is not the symbol of pure Divine Being, nor is the female figure the expression of Its power to unfold into the world of illusion; the belief is that the female figure represents the wisdom from Nirvāṇa's distant shore (*prajñā*) or Emptiness, whereas the divine lover embracing her is the image by means of which the mind can grasp the highest Truth. He is at once the Buddhist doctrine's Path to Truth, where the repertoire of names and forms is transcended (*upāya*), and, at the same time, he is the ethic whereby Truth bears witness to itself in the world of illusion. This ethic is Total Compassion (*karuṇā*): the obligatory activity of the wisdom that knows the emptiness of all names and forms, discovers the undifferentiated nature of all phenomena, and is aware of the universal Buddha-like nature of all things. The deity embraces the female figure of ultimate wisdom and unites with her sexually as she embraces him; in this way, the deity makes visible the oneness of wisdom and the passion for knowledge, the insoluble union of Truth and the path leading to it, which is simply the unfolding of its nature into the realm of forms and the formulated, the realm of names and the expressible; a path that, when it has finally led to ultimate Truth, exposes the emptiness of all those names and formulations.

[14] Cf. *Karpūrādistotra*, Tantrik Texts, IX, 18. If in our minds we separate the god from his divine power, then we rob him of life; all that is left is a corpse (*śava*). Śiva without *śakti* is only a *śava* (corpse). The Indian finds confirmation of this viewpoint in the fact that the vowel *i* is the mantra for *śakti* and that, when one removes the *i* from the letters spelling "Śiva," there remains in the Sanskrit spelling, "śava." Cf., for example, *Brahmāvaivarta Purāna*, III.2.8 ff.

The Buddhist view evidently had to reverse the male and female poles as symbols of the Divine and its unfolding, because otherwise they would not have coincided with the grammatical gender of the Buddhist concepts they are to incorporate. The expression for the unfolding of truth, the Buddhist doctrine's Path (*upāya*), is masculine in gender; ultimate Truth, Nirvāṇa, Emptiness, *Prajñā*, is feminine. The positioning of the two figures, as Buddhism found them in Śaivite art, made this reversal of meaning possible; in the Hindu prototype of the Mahāsukha pair, Śiva's pose is not one of deathlike quiescence but an ecstatic dance of triumph. The original Śaivite interpretation of the Mahāsukha pair is unmistakeable, since Lamaism altered it so little when it was adopted: Mahāsukha, in the fierceness of his ornamentation, bristling with weapons, is one of the terrifying (*bhairava*) manifestations of Śiva, which celebrate Him as the victor over inimical demons. He has slain the elephant-shaped demon and, embraced ecstatically by the goddess, he celebrates his triumph in the dance. His trophy, the bloody hide of the enemy, he brandishes in the midst of his weaponry.

Buddhism did not alter the basic substance of this epic and mythical theme, but it did revise totally its details and devices. An epic event has now become an expression of timeless essence; everything that characterized the individual quality of its identity, not pretending to express anything other than itself, has become spiritualized into a symbol. The Buddhist adept who conjures up before his inner eye this originally purely Śaivite image of the Divine, which in substance has remained the same, in order to put himself in its place, undertakes a grand interpretive play in which the sensual symbol assumes the transparency of allegory.

Mahāsukha and his beloved, as the central figure of the *śrīcakra*, signify essential Being, the "Adamantine Body" (*vajrakāya*), which the initiate sets out to experience as his own essence and Essence of all Essences by developing before his inner eye the dynamics of the "Circle of Bliss" (*Śrīcakra*). As

an adept he has been taught that if his worship is to be suc-
cessful he must anticipate in his mind the goal of his exercise.
He has to begin the exercise in the knowledge that he knows
himself as the center of all centers of his *yantra*, that is, as
Mahāsukha, and he must hold fast to this consciousness dur-
ing the process of unfolding and enfolding the inner image.
To prepare the adept effectively for this, the *Srīcakrasambhāra*
recommends an evening exercise that is to enable him the
following morning to begin the elaborate procedure of med-
itation in the proper frame of mind. Before falling asleep, the
believer is to know himself as "Buddha whose pure nature is
diamond" (Buddha Vajrasattva) and, in this knowledge, he
glides gradually into the composed state of Emptiness. On
awakening, as though in a divine body, he is to feel himself
in his surroundings as the central point of a mandala, is to
know himself as Divine Being in Its pure state, by envisioning
himself as the divine couple locked in an embrace. Aiding him
in his endeavor is a mantra with which he accomplishes ver-
bally this identification of self and image.

Then the adept develops internally the feeling proper to his
awareness of the undifferentiated sameness of all phenomena
in the Emptiness that constitutes their essence. It is a feeling
proper only to his godlike condition: he develops the feeling
of that Total Compassion which spreads without distinction
benignly forth in all directions. To perform this act, he makes
use here as everywhere else of meditation. From the four heads
of Mahāsukha, who, in the adept's inner vision, he has himself
become, he sends out rays in every direction, colored ac-
cording to the cardinal compass points—blue, green, red, and
yellow. Their colors are a surety that his feeling of Total
Compassion (*karunā*) permeates the entire cosmos.

Further preparatory exercises for developing meditational
images follow, to mature him to the point where he can de-
velop before his inner eye the actual mandala with its extraor-
dinary wealth of figures. In these figures the believer sees
himself in his human, adept state, and honors the long succes-

sion of teachers through whom the secret of the mandala has been passed on to him. He envisions himself increasing into a countless band of reverent disciples honoring their teachers. At the head of all these teachers stands Mahāsukha himself, for divine revelation must in the final instance be the self-revelation of the Divine. Mahāsukha is the original teacher of his mandala, just as Śiva is the first teacher of the orthodox tantras. The adept honors the succession of teachers by performing, in purely spiritual form before their inwardly perceived presence, those ritual acts which a believer would normally practice before the visible sacred image, or before his own inner vision of it (cf. *supra* pp. 45–46). With prayer and profession of faith he dedicates himself in his meditation to those teachers and to the teaching of the mandala in which, for the spiritual well-being of the initiate, the Divine has cloaked Its essence in names and forms. The adept recites formulas that destroy any obstacles in the way of his commencing worship, and that will ensure its success; he accompanies them with images of their internal effectiveness; he sees countless luminous figures setting out on the Path to Truth, the path of Buddhas-in-the-making (bodhisattvas), and he sees other, obscure figures, their heads pierced by a dagger.

To conclude these preparatory exercises, which are to saturate him with the certainty that he is mature enough to experience in himself Truth's self-revelation in the activity of unfolding and enfolding visions, the adept chants the grand formulas that embrace the whole sense of the mandala, the wisdom from the Far Shore: "*Om*, I am pure [*śuddha*] in essence, as all things are in their essence pure [that is, empty]," and, "My essence is the adamantine knowledge of Emptiness." In the recitation of the mantras, he anticipates mentally what he intends to experience within himself in meditation.

From the Emptiness that is his own essence, he develops— in analogy with the illusory unfolding of the pure Divine into illusion—an image of the entire world. Emptiness is nothing but himself, in the different realms of sensual and spiritual existence; for that very reason, it must have, just as does his

own essence, at its inmost core the figure of the closely en-
twined couple, Mahāsukha and his beloved.[15]

In accordance with ancient Brahman doctrine on cosmic
development, the adept causes that which has no name or
form (Emptiness, which he knows to be his essence) to be
transformed, step by step, into the four elements, which
emerge one from the other: from Emptiness, air; from air,
fire; from fire, water; and from water, finally the earth. He
brings about this developmental process by conjuring up be-
fore his inner eye the symbolic images of the elements: a white
semicircle with flying pennants; a red triangle with a fiery
jewel; a white circle with an urn, and a yellow square with
triple-angled thunderbolts in the corners. They issue forth
from Emptiness and emerge successively one from the other
as they are conjured up by the *mantraśakti* of mystic syllables,
which are their manifestation in the realm of sound: the syl-
lable *yam* is air, and magically evokes its symbolic image; *ram*
is fire; *vam*, water, and *lam*, earth. They emerge from within
the inner image of syllables, just as, from the syllable *sum*,
the radiant manifestation of the gods' Mount Sumeru
emerges—the axis of the Cosmic Egg, whose four-faceted
crystal-, gold-, ruby-, and emerald-jeweled torso sparkles in
the colors of the four points of the compass. A devout Hindu
would perceive on its peak the palatial court of Indra, the king
of the gods, and his Celestial Ones—Amarāvatī, the "Home
of the Immortals." In lieu of this palace, the adept of the
Buddhist mandala develops a temple cloister (*vihāra*) as the
only fitting surroundings for the Buddha (Plates 20, 21): a
rectangular building made of jewels with portals on each of
the four sides, enclosed by magical walls of diamond (*vajra*).
Its roof is a peaked dome similar to those earthly stupas which,

[15] Unfortunately, I cannot find any representative work to illustrate the
following directions for developing the inner image. Nevertheless, the man-
dala pictured in Plates 20 and 21 (which had no accompanying descriptive
text) presents the typical characteristics of that kind of development. Some
of its details—for example, the rectangular temple in the center and its or-
namentation—shows a close correspondence to the directions in the *Śrīcak-
rasambhāra Tantra*.

as mausoleums, testify to the completed Nirvāṇa of the En-
lightened Ones. At its central point inside, there is a circle
containing an unfolded lotus, its eight petals pointed in the
different directions of the compass (the four cardinal points
and the four intermediate ones). The worshiper envisages
himself standing in the flower's center as the figure of Ma-
hāsukha embracing the female figure. As the "Supreme Bliss
of the Circles" (cakramahāsukha), he sees himself as being four-
headed and eight-armed, and is, in his contemplation, con-
scious of his essence. His four heads signify the four ele-
ments—earth, water, fire, air—in their immaterial, supra-
sensory state; they simultaneously designate the four eternal
feelings (apramāna) which, as they become part of the adept's
substance through constant practice, constitute his ever-in-
creasing maturation toward Nirvāṇa: Total Compassion (ka-
ruṇā), Infinite Love (maitrī), Infinite Serenity (muditā), and In-
finite Forbearance (upekṣā). Furthermore, they designate four
forms of knowledge: that of the emptiness both of Being and
of Not-Being (bhāva- and abhāvaśūnyatā); that of the Empti-
ness of Essence (paramārthaśūnyatā), and that of the absolute
Equality of all Things, due to their common essential emp-
tiness (Plates 22, 23). Mahāsukha's front visage is blue; the
rear one, red; the countenances to the left and right are green
and yellow, respectively; with these colors the faces dominate
the cosmos in each direction. Each has three eyes, keeping in
sight the past, present, and future, and simultaneously the
three worlds of sensuality (kāmaloka), of suprasensual vision
of the succession of form-filled worlds (rūpaloka), and of the
form-emptied worlds known to the ultimate stage of yoga
practice (arūpaloka).

Mahāsukha has twelve hands. They signify knowledge of
the twelve-part formula of the evolution and dissolution of
the phenomenal world and consciousness, which is in essence
both ignorant and limited: the fundamental concept of Buddh-
ist doctrine (pratītyasamutpāda). The state of highest perfec-
tion, the State of Emptiness that is expressed in undifferen-
tiated Total Compassion free of the Self, is symbolized by the
emblems in the two uppermost hands, which are crossed in

embrace: the thunderbolt (*vajra*), as the sign of *śūnyam*, and as the symbol of Compassion, the bell, resounding in every direction. The uppermost of his outstretched arms tear in two the elephant hide of Ignorance covering his upper torso; a third right hand holds an hour-glass-shaped hand drum, like the one Śiva carries during his ecstatic dance as he triumphantly brandishes in the forest of his arms the bloody hide of the elephant-shaped demon—this is the symbol of the joy that radiates from doctrine. The fourth right hand holds a battle-axe, which separates birth and death and destroys *samsāra* at its root; the next wields a dagger, which removes all the obstacles from the yogi's path (pride, unbelief, insufficient earnestness, and so on), while the last right hand wields a long trident that slays rage, greed, and delusion. One of Mahā-sukha's left hands bears the ascetic's staff with rattles such as that carried by mendicant monks who, in order to maintain their own silence and inner calm, use it to indicate their approach to persons who they hope will fill their bowls with food. The staff is crowned with a *vajra*. This indicates that dwelling there, in the adamantine state of Emptiness, is Mahāsukha, with whom the worshiper identifies himself in inner contemplation, in order to become the same as he. In three outstretched left hands are, in sequence, a blood-filled skull-cup, a noose, and, held by the hair, the severed, four-faced head of Brahmā—for the state symbolized by the figure of Mahāsukha puts an end to Being and Not-Being, catches up all creation with a diamond noose, and obliterates the world of *samsāra*. In Buddhist thought, Brahmā is at *samsāra*'s spiritual peak, its supreme regent. Brahmā now has lost his preeminence, lost the purpose of his existence as understood in orthodox Hindu thought.[d] There, Brahmā was Truth and Essence beyond all phenomena, the cosmic basis and sources of all revelation. Now the Buddha, on his path to Enlightenment, has displaced him from his absolute position and even eclipsed him. For Buddha's followers, Brahmā is merely the

[d] The relationship between Brahmā and Buddha is explained by Zimmer in *Philosophies of India*, edited by J. Campbell, Bollingen Series XXXVI (Princeton: Princeton University Press, 1969), pp. 464–67.

Weltgeist ("world spirit") in the highest of all spheres that are revealed to suprasensory vision; he is merely the sublimest creature in the world of illusion—still too caught up within it to be able to produce by his own strength the true and highest Enlightenment, as did the Buddha. His sublime spirituality lacks the One necessary Element: the Enlightenment that removes, in Nirvāṇa, the illusion in which he lives, of which he himself is a part. Brahmā's spirituality is just sublime enough to allow him to recognize the Buddha as Buddha when he himself has achieved Nirvāṇa through Enlightenment, and to do reverence to the Destroyer of the world of illusion as He sits in solitude beneath a tree, pondering the meaning of Enlightenment. It is his duty, as the supreme sovereign of the phenomenal world, to beseech the Enlightened One to illumine the world with his wisdom and to lead it to Nirvāṇa, whenever the Buddha seems about to withdraw his knowledge into himself as something incomprehensible to the mind of the many. From Brahmā's divine lips pours forth praise in celebration of both the start of the Enlightened One's course and its finish—when the Buddha, as he enters into complete extinction (*Parinirvāṇa*), removes from human sight the illusion that is his embodiment, removes himself as the *nirmāṇakāya* of adamantine Emptiness.[16]

[16] Cf. *Mahāvagga*, I.5 (in Oldenberg's translation, *Reden des Buddha* [Munich, 1922], pp. 38 ff.) Brahmā's strophe concerning Buddha's *parinirvāṇa*: *Mahāparinibbānasuttanta*, VI.10 (*Dīghanikāya* XVI) (found on page 185 [actually on page 245—ed.] of R. O. Franke's translation of the *Dīghanikāya*). [An English translation of the strophe is in *Dialogues of the Buddhists: Part II*, translated by T. W. and C. A. F. Rhys Davids. 5th edition. Sacred Books of the Buddhists, Vol. III (London: Luzac, 1966), 175. The following story from *Dīghanikāya* XI is translated by Rhys Davids in Sacred Books of the Buddhists, I, 281–82; see *supra*, n. 12.] The *Kevaddhasutta*, verses 81–83 (*Dīghanikāya* XI; in Franke's translation, p. 165), deals with Brahmā's inability to dissipate the illusion ensnaring him, even though he is the supreme Being in the world of illusion. It tells of a monk who elevates himself through *samādhi* to increasingly luminous celestial spheres and who begs the Divine Beings for the resolution of the great question: what might bring about the total dissolution of the material nature of the world (its basic elements of earth, water, fire, and air)? He is referred even higher from the lower heavens of Indra and the Vedic gods upward until he arrives at the supreme spiritual

With his right foot, Mahāsukha subdues the reddish, shriveled body of Time, holding a dagger and skull-cup; Time signifies the delusion that Nirvāṇa is Annihilation. His left foot crushes a black demon holding in its two right hands a hand drum and dagger and in his left hands a staff and skull-cup. The demon is the symbol of an opposite belief that samsāra lasts forever.

Like these grand poses and emblems, every detail in the pose and attributes of the figure of Mahāsukha is full of meaning and is to be understood by the adept in its peculiar, Buddhist sense and in its spiritual significance, so that he may be completely permeated by Mahāsukha's essential quality, with which he equates himself in meditation.

As a sign that he has stored up in himself the fruit of all preparatory good works purifying his nature, a wish-fulfilling jewel (cintāmani) that grants every gift adorns Mahāsukha's hair, which is bound up in a forelock. A crescent moon adorns the left side of his forelock; it signifies the inevitable growth and self-perfecting of wisdom in the disciple. A four-edged diamond, bearing the colors of the four points of the compass, crowns his head and testifies to the fact that the Buddha's

authority of the higher and even highest supersensory phenomenal spheres, to the Great Brahmā himself. But even he, for all his grand words and his claim to omniscience, has to admit that he has no answer to the puzzle and refers the monk to the Buddha. For knowledge of the dissolution of the phenomenal spheres is the wisdom of Nirvāṇa: its dawning is Enlightenment. For a Buddhist, Brahmā is enmeshed in avidyā, otherwise he would not be the spiritual governor of the world; he would be undiscoverable, ineffable— he would himself be Nirvāṇa. He is not the original cause of the world who is transformed into the world's illusion, nor does he produce that illusion; he is, instead, among all the creatures of which the phenomenal world consists, the primus who, after the periodic dissolution of the world and at the beginning of each new era, emerges from the state of the Undeveloped-without-Attributes.

His sublime spirituality, caught within illusion's spell, enables him further to recognize which being is perhaps at all adapted, by reason of its age-long maturation, to lead itself and others up to the highest Enlightenment of all; Brahmā is able to inspire that creature with the desire for the goal of Enlightenment (bodhicitta-utpāda). But for Brahmā himself, his godlike state reveals no direct path to Enlightenment.

doctrine, which enters into wisdom, as Mahāsukha does his beloved, addresses itself to beings everywhere in the world. The five-skulled crowns that he wears on each of his heads, together with the wreath of fifty severed heads that dangles to his knees, symbolize spiritual victories on the Path to Perfection. His visages are menacing, baring their teeth as a sign that Māra, the Tempter, as well as all heresy have been overcome. For the shimmering appearance of the Tempter, who again and again crossed the Buddha's path in both his developing and his perfected states, symbolizes all the obstacles that might possibly confront the mandala adept, the Buddha-in-the-making. Encircled by his lovely daughters, the Tempter, the Beauteous One, a vina in his hand, seduces the adept to a delight in life, seduces with the illusion that whatever is in fact totally empty should be seen as having essence and substance. But in his other, terrifying form he threatens with a host of raging demons any who resist, fostering in them that fear of death which binds them to life and conceals from them the knowledge that both death and life are equally empty of essence.

Ear ornaments, necklace, arm bands, belt, and the wreath of bones on Mahāsukha's head signify fearlessness, love, chastity, strength, and inner vision: the powerful qualities with which the path to knowledge of the Truth is fringed.

It is remarkable how completely the Buddhist mind has been able to reinterpret for its own purposes a Śaivite figure so emblazoned, without changing the figure's external form. Anyone familiar with Indian symbolism could hardly find anything forced about these spiritualizing interpretations. Nor is this transformation of myth-laden emblems into allegorical devices an achievement limited to Buddhism alone; it can be found in Hindu thought as well.

The tantric component in late Buddhism brought the Śiva figure to the zenith of its own realm of symbols; but it is just that figure which afforded so many openings to an ascetically slanted, spiritualizing interpretation. Śiva combines in his nature the polarity of the sensual and the ascetic. The *Kāmasūtra* is revealed by his servant, the divine bull Nandin: from the

loveplay on the wedding night of the "Great God" and his consort Pārvatī (Kālī-Durgā) there emerged for mankind the knowledge of the art of sensual happiness. But Śiva is also the great yogi among the gods: the ray of light from his eye, aglow with the fire of asceticism, reduced the God of Love to ashes as he dared aim an arrow at him. Śiva even bears the symbols of asceticism when depicted in the victory dance with the elephant hide, or while embraced by his ecstatic spouse. Like all the other symbols, they are retained in the Mahāsukha figure: the tiger's skin, paws, and tail dangling at his hips; the ashes from the funeral sites smeared on the body, and the long beggar's staff of the wandering ascetic.

It is from Śiva, the lord of Śakti, who is inseparable from him, that Mahāsukha has inherited the expressions we find differentiated by his four faces: peaceful calm, menacing anger, the ruler's dramatic expression, and the enigmatic visage of the *māyā* with which Śiva, the cosmic yogi, unfolds the world's play of phenomena.

Even the female figure, who holds the powerful deity in passionate embrace, has remained the same and yet, to the knowing eye of the Buddhist adept, been completely transformed. No longer Pārvatī (Kālī-Durgā), Śiva's consort, whom opening prayers (found in royal inscriptions) celebrate figuratively as the erotic arouser of his strength, she is now the symbol of Truth. In uninhibited play her limbs wind themselves round the body of the Sublime One but not because she is the divine, idealized symbol of the loving consort whose mythical immolation helped ignite so many sati funeral pyres here on earth. Raised into the crystalline light of pure spirituality, the infinite loveliness of her pose, the completeness of her submission, give expression to the belief that Emptiness, Wisdom, Perfect Peace, and the Greatest Bliss are inseparable from the Thirst for Knowledge, the Path of Wisdom, and Total Compassion. She brings bliss with her embrace—as does Nirvāṇa when it embraces the Enlightened One, the Victor. She has but one countenance, for in Emptiness, which is the essence of all phenomena, all those phenomena have one and the same face, without distinction. She

has two eyes, for she encompasses both kinds of Truth: the Truth of Illusion as well as the higher one of Essence.[c] Her left hand holds a skull-cup; her right, a dagger with a hilt of diamond, the symbol of Wisdom. This instrument cuts off all reflective thought that stands in the way of Highest Knowledge, encumbered as it is with names and intellectualized form. Her hair hangs loose, because for her the knot that binds all things is untied. She stands naked: no veil of passion, which has its origin in Ignorance, is there to conceal her. The fire of Highest Knowledge consumes all that confronts it, and this is the reason why the worshiper is to envision the wisdom contained in the Path to Knowledge as standing within a circle of flames.

Surrounding the rectangular temple cloister in which Mahāsukha and his beloved, as the image of the Emptiness, of pure Being and bliss without name, are locked in embrace, lie the form- and name-filled spheres of consciousness; into these, formless Being unfolds itself; into these spheres of illusion, the yogi falls back from his experience of Nirvāṇa as long as his illusory personality—the fruit of long periods of ignorance in earlier lives—has not yet been dissolved in the final extinction (*Parinirvāṇa*) of death. At each of the four points of the compass, cloister portals are open into the state of Truth, enclosed by the walls of the temple itself; recumbent deer, flanking the Wheel of Doctrine, adorn the lintel: an emblematic device recalling the miraculous act of healing in the Deer Park at Benares, where the Buddha first set in motion the Wheel of his Doctrine's spiritual conquest of the world. Even today these heraldic devices adorn the entrance to Buddhist monasteries, and similarly, other ornaments with festive symbols customary in actual holy places have to be reproduced in the image before the inner eye: banners and ropes of bells, along with white parasols and yak-tail whisks as symbols of the world's universal monarch adorn the tem-

[c] The concept of the two levels of truth in Indian philosophy is well explained by M. Hirayana in his *Outlines of Indian Philosophy* (London: George Allen and Unwin, 1965), pp. 69–80.

ple's outer walls; stupas, as symbols of Nirvāṇa, crown the entrances and the temple roof, as well.

Just as this cloister upon the peak of the World Mountain is to be constructed before the adept's inner eye as a shell containing the nucleus of the two divine figures with all significant details—an accurate reproduction of actual holy places and a hieroglyph of the ineffable state of perfection—so too, there will be other areas, encircling the central cloister and filled with figures, whose cosmographic and individuated components of the Divine represent still other facets of Divine Essence.

First, a blue circle is to surround the temple, to symbolize the first unfolding of Emptiness into illusion that has name and form; it is to signify the spiritual (*cittam*) in richly delineated form. Within the circle are the Indian world's eight great places of pilgrimage, together with their appropriate gods.[f] The subcontinent of India itself—extending southward from the middle of the world like the point of a lotus petal, with the sacred Mount Sumeru thrusting up at the center of the flower like a gigantic pistil wreathed by the Himalayas' high, distant reaches of snow—is similar to a realization of the unfolding of Emptiness into illusion: it is just like, on another plane, the form-filled world of the mind that is nourished by its sensory perceptions. The internal and the external, the world and the consciousness postulating it, are one and the same: two halves of an apparent polarity; two illusory halves of one essence which, collapsing into one with each other, enter into their real essence, which is Emptiness.

Emptiness further unfolds into the realm of language, which the adept is to see as a red circular area enclosing the blue circle. Even this area, too, is filled with earthly holy places and their appropriate divinities. But at the same time that the inward contemplation of the mandala widens ring by ring, emerging from the spirit, surfacing from within the inner man by way of language, the accompanying image's

[f] For a list of India's major pilgrimage sites, see S. Pavitrananda, "Pilgrimage and Fairs: Their Bearing on Indian Life," *The Cultural Heritage of India*, IV (Calcutta: Ramakrishna-Vivekanada Press, 1956), 500.

cosmic significance (which started in the heavens above the peak of the World Mountain) becomes even more profound. The blue circle of the spiritual is a symbol for those celestial spheres with whose spirits the yogi, on his path to Emptiness, to Nirvāṇa, communes without need of the spoken word; the red circular band is the symbol of the earth's surface. To the spirit, language lends wings, which become expendable once it emerges from the dense atmosphere of the sensual, three-dimensional world. As the bridge between the spiritual and the spatial, the outer limit of the language's red symbolic realm will border on the white ring of the corporeal, to which, as an unfolding within the world's design, the spheres beneath the earth's surface correspond.

Three sets of eight divine couples, in the *yab-yum* position of Mahāsukha and his beloved, fill up the three rings that represent the essence of man and the three-sphered universe as unfoldings of Emptiness (*śūnyam*). When with them the yogi extends his inner vision into circles, constantly widening like ripples created by a stone cast into a pool, and when he has fixed them clearly in his vision, then he is not to take them merely as symbolically significant creations of his inward eye. In all of these Divine Beings who have pilgrimage shrines on India's soil, Pure Being has differentiated Itself into person-ifications of the Divine; they are the *nirmāṇakāya* of *śūnyam*.

But every figure in the rings of these mandalas within the mandala is at one and the same time a single expression in an individual manifestation of Truth, since, in the realm of the mind and the spirit, the unfolding of the Truth without name or form, of Emptiness (*śūnyam*), is in reality Buddha's pro-claimed Path of Knowledge in all its stages, within which the Truth's (*dharma*) store of concepts and formulas is articulated. (In the same way, the Divine unfolds Itself from its pure state [*dharmakāya*] either into sensually tangible illusion [*nirmāṇa-kāya*], or else into its suprasensory, inner visualization [*sam-bhogakāya*].) Those figures are all concepts basic to the Bud-dha's teaching. On the Path to Knowledge they are the milestones and markers that the adept must reach in the full knowledge of what they are, only so that he may pass them

by on his pilgrimage to the ultimate goal indicated by the mandala's inmost center.

The final task for the adept is to direct his inward eye anew to that inmost point after he has contemplated the circles he unfolded from it in ring after ring; he lets the unfolded, figure-filled spheres melt back into one. Step by step, before the inner vision, the conglomerate of manifold forms falls back into its central point and crystallizes into one great multicolored diamond wedge that the adept recognizes as his own corporeality, his own essence; for the centermost center in this mandala is the very visionary himself, whose inmost, integral essence is adamantine Emptiness—just as he knew himself, at the outset of his devotion, to be Mahāsukha and his beloved. His own person is the adamantine World Mountain and the cloister at its summit; it is his body where dwell all the gods he had seen one after the other in the variously colored rings.

In this manner, he enfolds into himself that world which he had first unfolded from within himself, and, his aim achieved, he proclaims to himself the knowledge of the Path he has traversed externally and internally, a knowledge expressed at the start of his devotion in two mantras: "*Om*: my essence is diamond," and, "I am the pure diamond of all adamantine pure Essence."

These two mantras complete a full circle, linking the programatic formulation of Truth with a summarizing expression of Truth. Truth, transmitted by instruction and perceived only intellectually, has now become unmediated experience, and the knowledge of it has been exalted to Being.

As a faithful reconstitution of the development of the inner image, a mandala will have meaning and purpose only when the circular path of the world's and Self's evolution and dissolution has revealed the total clarity of all the symbolic inner visions and is reabsorbed into its point of origin; only when this path is charged with complete insight into the nature of the figures crowding it and is seen as a display of unfolded Truth, not simply as a play of mental images; and only when, finally, the path is bolstered by the consciousness of the inner

vision's absolute sovereignity over everything that it may behold—only then does the inner vision summon up and develop whatever it will, and then extinguish it again, as may suit the purpose of the highest Wisdom, unfolded in the design of the mandala. Admiring the mandala's beauty, or analyzing its meaning, may uproot it from its very life soil—only the initiate is capable of bringing it to life.

For the uninitiated, the mandala has no more meaning than would a map for a child who is unfamiliar with its mysterious conventionalized symbols—a random collection of color-filled, eye-catching contours whose meaning is unknown. Even for the scholar familiar with the ancient commentaries, the mandala takes on only an illusory life: he sits there like a geographer before the map of a country to which he has no physical access; to understand it, he must avail himself of travel diaries and descriptions of others. Between the informed Western observer of the mandala and its initiate, there yawns the same enormous chasm by which a person attempting to understand a distant land by means of books, maps, and pictures in the privacy of his study is separated from the natives of that land, who have grown up among its hills and under its trees, who have quenched their thirst in its waters, who have drawn life and nourishment from its earth to which they will ultimately return. To the foreigner, a country's mountains may well appear beautiful in pictures as they are lit by his study lamp. From pictures of them he gleans some information about their inhabitants. But for the people actually living on those mountains, there are forces at work much more powerful than seductive beauty alone: the mountains are the life soil that conceived them, that sustains them, that upon their death at last will cover them. The very earth, air, and water in these places have welded them together in a special way, forged them into something more than the simply natural; only someone who treads that soil and shares their fate can hope to experience how completely the inhabitants are wedded to its particular elements. A country's people can never be comprehended through mere study.

The mandalas, regardless of all their structural beauty and interesting detail, are, as images, the crystallization of the inner life's activity based upon visions. Themselves transformations, they transform in turn the adept. Anyone moved by their beauty to analyze them in order to arrive at the center of their essence is like someone who tries to familiarize himself with some exotic fruit by painting it, instead of biting into it—let alone digesting it.

Mandalas are like road maps in their origin and purpose. In them there can be no free play of an active imaginative fantasy; they are designed like maps. First comes the gridlike overlay that gives them their structure and subdivides the surface area into a number of smaller units. This is the way the cartographer divides the map's surface initially into longitude and latitude, or coordinates. These smaller areas are then no longer equally significant. Their position relative to the compass points that are built into the map's grid plan, is a determining factor of their existence. Whatever is to be engraved on the map, its geographic location is already fixed in the grid's symbolism and assigned a particular value. Similarly, the entire figurative detail of the mandala image, superimposed upon a linear schema, carries a specific meaning, determined either according to its position in relation to the center, or, occasionally, according to its position in the upper or lower portion of the mandala as a whole. The relative distance from the center point gives to a particular detail its rank in a hierarchy of values on the scale of Unfolding that extends from illusion to Essence; the rank is determined solely by the point on which it happens to be entered.

The figurative detail incorporated into the linear schema of the mandala is, furthermore, as an evident symbol just as clearly outlined and stylized in form as are the syllabic symbols in a linear *yantra* inscribed with mantra syllables and words. Not one single facet of the detail may be altered or shaped by the imagination of the artist who is embellishing a mandala with decorative figures. In its traditional combinations, the mandala's language of figurative forms is just as stylized as is our own alphabet, although much richer; it is

as highly conventionalized as is the wealth of symbols used for topographical maps. The mandala painter manipulates them like a cartographer who enters on his grid the symbols for mountains, rivers, and towns. Were the engraver to vary them at whim by even the tiniest bit on the map—in their size, color, or outline—then the mountains, rivers, and towns would be not at all those that were supposed to be represented symbolically; his map would be the projection of an imaginary landscape. It would be of no help to anyone who consulted it in the hope of orienting himself. Similarly, there can be no freedom allowed in constructing the mandala's figurative details; for it, like a map, is after all a tool, a *yantra*, and it is supposed to enable the perception of Truth, so that its adept can find his way between illusion and Essence. It is the road map of Truth. It is for this reason that its figurative detail is not to be designed afresh in each instance; quite the contrary, for the established symbols are first traced and then later filled in with the traditional colors appropriate to them. From the rich store of forms of figurative symbols, the adept will select and combine in the mandala only those symbolic forms that must correspond visibly to its ideational content; in doing so, no aesthetic considerations—for example, a concern with the total effect of the richly figured and colorful construction—may in any way compromise the particular predesigned contour of the figurative symbol or its colors. That would result in stripping the figurative elements of their symbolic character; the mandala's purpose, the expression of essence, would be destroyed, and it would no longer be a *yantra*: it would serve no purpose. Like the mandala painter, the cartographer prefers to work by rote when entering his symbols on a new grid pattern, and he traces his designs because for him, too, it is of great importance that the work of duplicating be accurate and exact. In both cases, a linear design is overlaid with symbols whose hieroglyphic forms express an underlying essence; their vital symbolic function forbids any artistic license with their form.

The mandalas decorated with figures enclose within their design a complex of symbols that derives its coherence from

the connecting links between the individual ideas behind its components—from their links to one another and to the overriding idea behind the mandala. But there is no formal, architectural bond unifying the figures either in outline or in color; the figurative symbols are simply in juxtaposition, as much adjoined as divided by the design. Each figure is unattached, autonomous in its place, self-contained; but its right to be as it is—individual in its form and color—is independent of its place in some overall, aesthetic plan. Each of them leads a life of its own, and not one tiny detail of their appearance is covered or determined by some overriding rule of an absolute aesthetic economy, or is built in as some piece subordinated to some general architectural plan. The reason for the integral quality of an individual figure's appearance lies in its function as a symbol, not in its relationship to an aesthetic whole in which the figures are subsumed as members of a single aesthetic grouping. It lies in something outside the aesthetic sphere. The mandala is not, as paintings usually are, an aesthetic organism; it is a mosaic of symbols. The rigidity with which the placement of every detail is governed, its function as a symbol in the mandala, is matched by the severity of the prohibition against any individualizing element in the detail, any alteration in its form which would seek to adapt it to some underlying aesthetic effect, to change it and weld it into one organic whole.

What fascinates the aesthetically trained observer of the mandala's world of forms is the careful craftsmanship of every detail, the beauty evident in each single part, and, taking the forms as a unit, the design commanding the whole. But this design is the result of an ideational system of symbols and is not a consequence of any architectural plan. Given the wealth of figurative symbols populating the linear schema, the observing eye can dally as long as it will on any one of them that might catch its attention, without being deflected from it in some other direction. We are not aware of the whole as such in the details; the independence of the individual part is not extinguished. In its conception, the whole may well be something different from and more than the sum of its parts;

but to the eye it is just that sum of the parts, in definite, ordered arrangement. It is not a living organism with several members, each of which by virtue of its simple designation as member is a constant indication that there is an organism from which, as a part of that whole organism, it derives its purpose and meaning.

A Tibetan mandala encircles a central Buddha figure, enthroned in the heart of a lotus, with a ring of eight Buddhas (Plates 20, 21) distributed evenly over the opened petals of the flower. The petals they occupy, between which can be seen the points of eight more petals, indicate the four cardinal and the four intermediate points of the compass (Plate 36).[17] Here the Buddha is the symbol of pure Emptiness. He whose Enlightenment is Nirvāṇa was for the Buddhists the primary and natural hieroglyph for adamantine, absolute Being, before the symbols of Śaivite tantrism pushed his figure, by and large, into the background. It is obvious that the center of all centers as a throne (pīṭha) is not intended for an historical and legendary, earthly Buddha like Śākyamuni, the "Wise One from the race of Śākya," who appeared on India's soil within recorded time; but that center is the proper seat for Buddha who is eternal Nirvāṇa, beyond space and time, beyond name and form. He signifies the one sole Essence: Emptiness. Śākyamuni, Buddhas of earlier eons and eons yet to be, Buddhas of countless other universes, are, in the realm of sensual illusion (as nirmāṇakāya), reflections of that Emptiness. Amitābha, and other Buddhas whom this world has not seen, appear as reflections of Emptiness (as dhyānibuddhas) at the level of suprasensory inner vision (dhyāna). Sensually visible Buddhas (nirmāṇakāya) and Buddhas of suprasensual sight (sambhogakāya) are grouped around the Primal Buddha (Ādi-Buddha), who is eternal Nirvāṇa; they are gathered in circles or layers as symbols both of those levels of consciousness and

[17] Unfortunately I have at hand no original textual material describing the development of the mental counterpart for this visible image. My interpretation is intended merely to indicate, without prejudice, the path followed during the formal contemplation of the image, and must remain elementary and hypothetical.

of the phenomenal realms, into which pure Being, bound by varying degrees of ignorance (*avidyā*), has divided Itself.

The lotus, bearing the eternal Buddha in the circle of his most exalted unfolded forms, blooms in the inner reaches of a square-shaped temple cloister whose four portals open to the four cardinal points of the compass. The entrances are adorned with a pair of recumbent deer, and the eight treasures of universal dominion, characterizing the terrestrial Buddha as spiritual soverign of this world, encircle the temple, set at the outside corners of the outer temple walls (on the left, for example, the horse and elephant).

The wreath of eight buddhas surrounding the Primal Buddha of eternal Nirvāṇa serves perhaps as a symbol of the highest levels of consciousness to which, one after the other, the Buddhist yogi raises himself before he is absorbed into Nirvāṇa. Empty of forms, they extend to the very edge of Emptiness. They are four in number: the consciousness of empty, spatial infinity; the feeling of empty, infinite consciousness without the element of space; and—beyond these two—the feeling of detachment from all things, and, finally, the boundary and transitional state between conscious and unconscious. That these four levels are symbolized by eight figures can be explained by the fact that their circle represents further pure Being's first unfolding stage, which contains within Itself Infinite-space (*ākāśa*). Its symbol is the four directions of the compass together with the four intermediate points between them.[18]

The spacious square enclosing the temple precincts seems to be divided, as if in layers, into three cosmic regions that,

[18] Similarly, the *Garbhadhātu* mandala (Plate 36), often found in China and Japan, contains a group of four buddhas around the central Buddha Mahā-Vairocana (a variant of the Ādi-Buddha), and sets them at the cardinal compass points: Ārya Ratnaketu Tathāgata (east); Ārya Samkusumita Rāja Tathāgata (south); Ārya Amitāyus Tathāgata (west), and Ārya Akṣobhya Tathāgata (north). Three *dhyāniboddisattvas* and Maitreya occupy the four intermediate compass points: Samantabhadra Bodhisattva (southeast); Manjuśrī Bodhisattva (southwest); Avalokiteśvara Bodhisattva (northwest), and, in the northeast, Maitreya Tathāgata, the future Buddha of our earth, who is already half-way between the bodhisattva and Buddha states.

in the psychic realm, are represented as lower spheres of consciousness; on the cosmic plane they are situated lower than the summit temple's cloistered silence on top of the World Mountain they surround. Far above, on clouds, floats the realm of form-filled vision, the celestial sphere. Its figures are reflections of pure Emptiness on the levels of yoga consciousness; those levels are still below the four highest ones, which are completely empty of forms. They represent the realm of the "Bodies of Bliss" (*sambhogakāya*), who are perceptible to the inner vision. Three buddhas, imperceptible to the naked eye but perceptible through meditation (*dhyānibuddhas*), are flanked by *dhyānibodhisattvas*, and they, enthroned between sun and moon, symbolize that celestial sphere.

Further down, in the mandala's middle part, the mountains of the earth thrust up to the bank of clouds, above which extends the celestial sphere of crystal vision. They are the symbol of the earth's surface and of the physical world of sense. In their shade sit the terrestrial, corporeal bearers of the Truth, Buddhist saints sheltered by spirits hovering over their heads. They are *nirmāṇakāya*: a reflection of the pure Emptiness represented at the level of sensual consciousness, just as the *dhyānibuddhas* above the clouds are *sambhogakāya* of pure Emptiness—a reflection of Emptiness at the level of suprasensory vision.

At the very bottom of the mandala, there is the demonic, subterranean kingdom, scorched by flames, whose creatures make threatening gestures at heresy, as they protect pure doctrine from its attack. This is the realm of the body and of physical force, the unfolding of pure Emptiness into dull materiality, which serves as a protective shield for the spiritual forms of unfolding Emptiness as It returns from the sensual world home to Its true state.

These three spheres in the mandala's outermost right-angled area are as little related structurally with one another as they are with the center. What unites them is the abstract idea of their common service to one and the same context of meaning—the same element that also relates them to the center, which is so sharply set off from them in the mandala.

Even taken individually, not one of these three spheres is itself closely knit in structure; instead, they are an arrangement—that is, they are simply symmetrically ordered. The three *dhyānibuddhas*, along with the *dhyānibodhisattvas* above the clouds, hover beside one another, something like decorative medallions that may be grouped together on a wall, though each could just as well appear by itself. Similarly arranged are the flame-lit figures of the underworld and the saints in front of the rock cliffs. What keeps them together and assigns each its own place is their symbolic element. They are to be unfolded and brought together in the mind's eye; or, alternatively, the physical eye is to look them over and derive some connecting sense from the way they are combined. They are put together the way verbal symbols are, when the symbols are to form an incantation (mantra). The mantra's words also are able to stand by themselves, and each makes sense by itself. But combined in a mantra, they produce a more comprehensive meaning: the essential message of the spoken formula. A painted mandala, which fixes the development of inner images for the external eye according to the directions of the *Srīcakrasambhāra Tantra*, is nothing less than the figurative hieroglyphic writing of the mantra: "I am the pure diamond of all adamantine pure Essence."

In the final analysis, not even the symmetry of the figures' arrangement stems from any artistic interest in decoration. It is the idea of the whole that demands this symmetry. The symmetry is already there in the idea of a nucleus unfolding into various spheres of illusion. This unfolding is in itself infinite and balanced. The finite number of symbols representing the infinite quality of the process has to make evident the preordained regularity and suprapersonal element in it by means of the symmetry and balance of the figures' distribution. The figures in the three spheres, so lifelike in their symbolic poses, are for these reasons as alone in their solitude and yet linked by that same calm stemming from symmetry as are the eight inanimate symbols of happiness situated like medallions, in a semicircle at the top, around the central ring.

BOROBUDUR: AN ARCHITECTURAL MANDALA OF THE PILGRIM'S PATH

The centerpiece of a Tibetan mandala of the kind just examined—where Buddhas are grouped in a circle around one central Buddha—recalls, in a miniature form, the stepped terraces of Borobudur in Java (Plate 37). To which genre this impressive structure belongs is a question still unsettled.[g] But however one may ultimately explain the figurative detail of this monumental edifice, one thing is clear: Borobudur must be regarded as the most impressive mandala the art of Buddhism has ever created in the visible world as a symbol of its truth.

The cryptic message of the wealth of forms confined within its symmetrical plan will never be deciphered if its grand design is understood merely as a self-contained construction—and that is how it does appear to an untutored eye.[19] Borobudur is a place of pilgrimage. Both its elaborately figurative ornamentation and the architecture of its galleries and passageways that ascend one over the other must be understood in the light of their functional purpose; the intent is that the pilgrim make his way through the structure in spiraling ascent until he surmounts its topmost height. The purpose of Borobudur is to release a spiritual process in the pilgrim during his ascent through sculpture-embellished terraces to the unadorned summit, to bring about a complete transformation of his sense of being, a transformation by nature related to the activity of meditation as practiced by the adept of the

[g] For a recent review of this question see L. Gomez and H. Woodward, *Barabodur: History and Significance of a Buddhist Monument* (Berkeley: Asian Humanities Press, 1981), chap. 2.

[19] The voluminous literature on Borobudur obviates a more complete description. Cf. Karl With, *Java* (Berlin, 1920); J. Scheltema, *Monumental Java* (London, 1925); J. P. Vogel, in *The Influences of Indian Art* (London: India Society, 1925), which contains a bibliography of the most recent literature. Cf. further, A. Salmony, "Der Boro Budur in der Landschaft," *Ararat*, No. 12 (December, 1921), special issue on Asia (published by the Goltz Verlag, Munich).

Tibetan mandala described above. The austere geometric plan of its construction, in which peripheral rectangles serve as both the underpinning and enclosure for inner circles, seems designed to provide space for the parallel development, in some purposeful sequence, of an inner spiritual process and of the impressive concept of Being experienced during that process. In the same way, the figurative ornamentation seems designed in its entirety to set off in its own fashion the rigorous geometry of the architectural complex, which is experienced inwardly and outwardly by the pilgrim as he is drawn into the series of terraces in his spiraling ascent. Between the structure's basic horizontal and vertical plan and its wealth of figural ornamentation, there exists the same absolute ideational relationship that obtains between the painted mandala's linear design and its world of figurative symbols.

The architectural design of Borobudur invites the pilgrim at his approach to undertake the physical effort of a circling climb that has a spiritual purpose. This function links Borobudur with older, related structures such as the Thūpārāma and Ambaśthala *dagobas* in Ceylon and the most ancient representatives of this type on the Indian mainland in Sānchi and Bharhut.[20] But the physical activity they require and the spiritual activity they seek to engender are less complex than the activities initiated by the structure of Borobudur. Consequently, their architectural form and ornamentation are simpler. It is not surprising that the form and purpose of these ancient relic mounds undergo, in this late masterpiece of their historical development, a transformation into a mandala of

[20] Cf. the illustrations of the Thūpārāma and Ambaśthala *dagobas* in F. M. Trautz, *Ceylon* (Munich, 1926), plates 62–63; further, A. Nell, in *The Influences of Indian Art*, and Otto Hover, *Indische Kunst*, in Jedermanns Bücherei (Breslau: F. Hirt, 1923). Cf. further A. Cunningham, *The Stupa of Barhut: A Buddhist Monument Illustrative of Buddhist Legend and History in the Third Century* (London, 1879), and from the more recent literature, the plates in William Cohn, *Indische Plastik*, Kunst des Ostens, Vol. 2 (Berlin, 1922), and Stella Kramrisch, *Grundzüge der indischen Kunst* (Dresden-Hellerau, 1924).

monumental proportions.[h] Here it is simply a matter of finding reflected in architecture what we discovered earlier in the technique of *samādhi*. In ancient Buddhist times, the use of the mandala as a means to Nirvāṇa was alien even to that technique. Within the Buddhist store of forms it appears as one more part of the inexorable absorbtion of Hindu ideas and symbols into Buddhism, an influx marking one of the major developments in the history of that religion. The magnificent structure of Borobudur, so often described, deserves special mention within the context of this present study because the initiate's visual and physical experience during the ascent constitutes a transposition of the Buddhist path of yoga, which utilizes the mandala technique described earlier, into three-dimensional tangibility—a concrete representation of the Buddhist path to Nirvāṇa.

Even the simple, unterraced plan of the domed structure in Bharhut is designed, with its relief-embellished enclosure, to engender a spiritual experience in the pilgrim treading his pious path in a clockwise direction; while his eyes are scanning the extensive series of reliefs with their scenes of the Buddha Śākyamuni's millennia-long journey to the Enlightenment which is Nirvāṇa, the pilgrim, even though far from his ultimate goal, as he traces the path of the "Shower of the Way," anticipates that path inwardly in contemplative meditation all the way to Nirvāṇa, here made tangible by the central domed structure. A pilgrimage to Bharhut presented the believer with the opportunity to experience palpably that legendary Buddhist tale recounted in the story of the Master's evolution, which from the remotest of ancient times has served the faithful as an exemplary model. Entering the sacred precincts of the stone enclosure, he would undertake to pace off, in the fullness of his knowledge, an exhaustive symbolic *imitatio* of the Buddha and, in following the Master through successive

[h] The plan of this monumental mandala in stone is clearly based on the conception of the Śri Yantra, which is discussed in detail at the close of this chapter. Cf. M. Khanna, *Yantra—the Tantric Symbol of Cosmic Unity* (London: Thames and Hudson, 1979), p. 148.

reincarnations from *samsāra* to Enlightenment, he would be supremely aware of the similarity to his own path and goal.

But at Borobudur the pilgrim's feet and spirit complete symbolically a different journey as they follow the spiral path to the very top, over terraces adorned with images and cupolas; from the phenomenal world of the senses, replete with forms, from the soul-flattening division of consciousness into the Self and the Other (that is, World), the pilgrim makes his way homeward to the Pure Void.

Four rectangular terraces with shivered outline,[i] set one over the other, encompass a circular center section where three stepped circles descend, so to speak, toward them from the surmounting cupola at the peak. Their rectangular passageways are a world full of forms. From one end to the other embellished with pictorial friezes that are divided by pilasters in bas-relief and interrupted by four sets of stairs, they tell, on the lower two levels, the tale of the infinite number of Śākyamuni's lives: his path of preparation, his maturation to Buddhahood, his Enlightenment and proclamation of Truth. Their story corresponds to the motifs in the relief on the stone parapets of Bharhut. In them, the Pure Void presents itself as *nirmāṇakāya*. Happy though the content of the scenes along the passageway may be, its elevated sides create for the pilgrim a sense of confinement. For the outer balustrades of the lower galleries rise up like walls (Plate 38), and are adorned with images, as are the inner walls forming the base of the next terrace above. In pursuing his course, the observer finds himself inescapably hemmed in on every side by shapes and figures laden with meaning. Only high overhead does he perceive the blue presence of pure Emptiness.

Not until the pilgrim has reached the last of the multicornered terraces does the flood of imagery subside. The outer wall gives way here to a lower, cupola-crowned parapet without images (Plates 12, 39), allowing the form-free vault of the heavens to emerge on the pilgrim's left. Beginning with the upper rectangular galleries, the pilgrim leaves the form-filled

[i] See note 30 below.

Figure 1. Borobudur, Ground Plan

world of the senses behind, and enters the plane of form-filled inner vision: their decorative reliefs are devoted to the *dhyānibodhisattva* Samantabhadra, and to the coming of the Buddha Maitreya, whose glory has never been beheld by mortal eye, but only inwardly envisioned.

Samantabhadra, the "Kindly in Every Respect," is a favorite luminary in the Buddhist pantheon. As a *dhyānibodhisattva*, he belongs to the spheres of unfolding, which may be attained only through meditation (*dhyāna*). His name identifies him as the symbolic embodiment of Total Compassion, which is the only possible quality fit for him who possesses the Highest Knowledge of the undifferentiated Emptiness of all names and forms. The *Śrīcakrasambhāra Tantra* tells of him in an ordinance for a devotional exercise dedicated to the "Bearer of the Diamond Weapon," Vajradhara. In Buddhist tantrism he is one of the most exalted symbols representing the state of perfection, pure Emptiness. He is pictured as being two-armed and in ecstatic union with his Śakti (Plates 24, 25).

Like Mahāsukha, he is a variant of a type of Śaivite image, a symbol of the not-yet-unfolded divine essence which, with its *śakti*, is both two and one.[21] The *Śrīcakrasambhāra Tantra* gives instructions concerning the path that lifts the Buddhist practitioner into Vajradhara's state: practice in the twofold pattern of meditation—in the paths of unfolding and subsequent enfolding of the unfolded—leads to two stages of *samādhi*; this is where the distinction between the seer and his vision vanishes, along with the division between the Self and the Other, the division of consciousness. In essence, these two levels of *samādhi* are the same, but they manifest themselves in different ways. The lower level is brought about by the will, using yoga techniques; the higher level breaks upon the adept spontaneously, but only after long training. In the latter case, Nirvāṇa has become the adept's second nature. Continuous cultivation of this highest of all states favors him with the ultimate wisdom (*prajñā*) that lies beyond all worldly knowledge. But part of this regimen is the perfect imitation of the exemplary path of the *dhyāni-bodhisattva* Samantabhadra, the "Kindly in Every Respect." If the goal is to achieve Nirvāṇa, then it is a matter of first adopting the bodhisattva's essential quality—the practicing of that love which extinguishes the unreal difference between the I and the Not-I—and then making that quality one's own second nature through practicing it. After this, the way leads along the bodhisattva's twelve-step path to perfection—to Buddhahood. Total Compassion, the great virtue of Those who Know, confers miraculous powers. These are the signs that signal one's entry into the diamond state of Vajradhara, whose hands bear the Diamond Thunderbolt of Truth and the Bell of Compassion. As the very embodiment of Total Compassion, Sa-

[21] During the successful invasion of Hindu symbols into the Buddhist world of forms, Vajradhara assimilated the five highest *dhyānibuddhas*. His being embraces the more ancient Buddhas belonging to the four corners of the earth—Vajrasattva, Ratnasambhava, Amitābha, and Amoghasiddhi—who can combine themselves into a mandala around Vairocana, the "Sun"-Buddha, who forms the fifth one in the center, as do the nine Buddhas in Plates 20 and 21.

mantabhadra is the adept's noblest escort on the path to the
Enlightenment that is Nirvāṇa. As the model of every "Bud-
dha-in-the-making" (bodhisattva) who strives for Enlight-
enment, he is himself a bodhisattva and, as the ideal of em-
bodiment of the highest virtue of a bodhisattva, he exists in
the world of pure meditation (dhyāna) as a dhyānibodhisattva.
In this form he represents the transition from the form-filled
world of the senses to the form-free world of inner vision
that is the stage preceding Nirvāṇa.

Continuing upward past this elaborately figurative, relief-
studded part of Borobudur, the pilgrim arrives at the upper
circular terraces (Plate 40). Here, seventy-two smaller cupolas
made of fretted stone are clustered around one large, raised,
centrally located cupola whose surface is completely unper-
forated. In this area, the extravagant number of sculptural and
ornamental forms has vanished: all those images which drew
their subjects—humans, animals, and flowers—from both the
external, sensual world and its reflection in inner vision. Here
a whole range of Nirvāṇa symbols juts up, row upon row,
into the pure void of the celestial dome that arches above in
a vivid, uniform blue, extending from the zenith down to the
surrounding horizon of mountains and jungle. But the rows
of latticed cupolas, ranged above one another on the three
ascending circular terraces, were still not symbols of the Su-
preme State; since each one contains a Buddha figure that the
stone fretwork does not quite hide from view. The cupolas
are emblems of the higher worlds of form-free contemplation
that constitute the stage just prior to Nirvāṇa. Above them
all towers the crown of the whole edifice, a massive central
dome. This architectural feature also contains a Buddha, but
the figure is completely concealed from view behind an all-
enclosing, unperforated, arched exterior. The form of the sur-
rounding latticed cupolas represents an intermediate stage be-
tween the massive central dome and the cupolas of the lower
balustrades (Plates 12, 39) that are cut in half, as it were, to
form niches exposing their dhyanibuddhas fully to view. The
latticed cupolas form a connecting link between those lower
symbolic forms, perceived in inner vision, and the symbol of

blissful Being situated at the very top. Placed halfway between these two types of symbols, the cupolas guide the pilgrim, by means of architectural forms and the ideas underlying them, from the precincts of form-filled inner vision right up to eternal Nirvāṇa, to that one single cupola in the center of all the others; they are images of the form-free, transitional stage between the spheres of inner visions, which do have names and forms, and that nameless and formless state which conceals itself from itself.

In the devotional ascent demanded of the pilgrim by Borobudur's upward-spiraling passageways, he is presented with more than the opportunity simply to imitate Śākyamuni in body and mind. Here, Pure Emptiness, which human consciousness divides into the Self and the world of forms, returns to Its true state; It ascends symbolically through the figure-filled world of visions and the senses, then passes through the realm of form-free contemplation up to Its Nirvāṇa that has no beginning; Emptiness casts aside, one after the other, the fetters of Ignorance that conceal the true nature of Emptiness from Itself; the fetters are left lying behind, as are the lower terraces during the ascent; Emptiness becomes the extinguished Buddha, without name or form; It becomes the Emptiness that is the essence of all phenomena. The whole of Borobudur acts as a *yantra* for the external, tangible surroundings, in which the pilgrim finds his homeward path leading from the mandala's outer reaches—which are various forms of consciousness, the world, and the Self—toward its heart: to the pilgrim's own true, ineffable essence.

The meaning of Borobudur is basically found in the way the symbol of the Buddha image is presented: it is placed in a sequence of stages progressing upward from the structure's lowest levels to its summit. In the reliefs on the narrative and descriptive friezes, the symbol of the Buddha is shown interacting with human beings and the world of nature. On the next higher level, in the cupolas opened to form niches, the Buddha symbol, in disengaged solitude, is visible to the pilgrim who gazes up to it in contemplation. It is totally visible. In the latticed cupolas on the topmost, circular terraces, the

Buddha is at the point of disappearing from view, just as a Buddhist yogi's mind, in form-free contemplation, is at the thin line dividing conscious from unconscious. The domed structure at the peak conceals the symbol entirely. On each of these four levels, the initiate comprehends the identical nature of the Buddha symbol. And he understands that it signifies nothing less than his own essential, innermost being, which is Nirvāṇa and Enlightenment, even though these are still shrouded in Ignorance. He develops the lower sphere of sensual perception by walking through Borobudur's galleries and allowing its world of symbolic images to unfold before his eyes. He then lifts himself up above that realm of *nirmāṇakāya*, transcending and melting it away by progressing to the intermediate level and entering the levels of the symbols of inner vision. But this realm of *sambhogakāya* is also left behind and transcended when he arrives, by way of the circular terraces of form-free vision, at the topmost symbol of Nirvāṇa. Confronted with this ultimate symbol, he experiences his very self as *vajrakāya*, and knows: "*Om*: my essence is diamond. I am the pure diamond of all pure adamantine Essence."

THE PURELY LINEAR *YANTRA*

The Figurative Sacred Image and the Linear yantra

Along with the figurative sacred image (*pratimā*), whose wealth of forms is derived from the sensual world, we find the purely linear *yantra* (Frontispiece, Plates 17–19). The two differ radically in form, but both are *yantras* and serve one purpose. They are vessels designed as receptacles for the visualization of a god whom the believer has summoned up before his inner eye.

The totally compelling nature of these purely linear *yantras* as expressions of divine essence is unique, whether they are kept purely linear or are decorated with letters and words. The fact that they are found side by side with those *yantras*

resembling human form (*pratimās*), and that they are indeed used interchangeably with them in sacred practice and in language, should make it clear that any attempt to grasp the nature of the *pratimā* type of *yantra* from its aesthetic impression on the uninitiated will fail to produce the key to its inner meaning, or to find the right words to express and establish its character.

In their visible form, the purely linear *yantras* are related to arabesques used ornamentally to fill in empty planes, but they differ radically from the basic purpose of decorative art. Structurally their character is determined by the fact that they are the graphic expression of a conceptualized relationship; they are saturated with meaning; they are perfectly self-contained as the symbols of the knowledge that permeates a mental vision, and they project a sense of inflexible order. Unlike decorative ornamentation, these *yantras* do not express the dynamics of a will to form, which has been immortalized in lines and surfaces; in ornamentation, a will to form courses meteorlike through the material, giving it shape and pattern even as it penetrates it.

In their ability to express how something fundamental coheres, the purely linear *yantras* are superior to architecture, where the will to shape matter struggles with the physical weight of the material, with its mass; and what the will to construct actually does create in the mastering of gravity and mass can come about only if the will recognizes the laws to which they are subject; in adapting to their dictates, where these are followed in the building of an edifice, it can at best produce an illusion of freedom from exigency. If we look for something comparable to the *yantra*'s labyrinth of lines, we can find it only in the marvelous maze of orbits that the celestial bodies trace across the darkened sky before the eyes of those who understand them.[j]

[j] This insightful observation is in accord with the Hindu tradition's understanding of *yantras* as cosmic symbols. The central point of the construct, the *bindu*, is the still point of the universe (Śiva, the Self, and so on) around which swirls the multiplicity of stars and galaxies in an ordered array. In the *Bhagavadgītā*, the Lord informs Arjuna about the true nature of the

The fact that the figurative and the purely linear *yantras* are different in form yet identical in function creates a certain sense of tension in the uninitiated observer. There is a challenge, implicit in the tension, to illuminate by the comparative method the particular nature of the appearance of each type. Only an observer thoroughly familiar with the linear *yantra*'s form and knowledgeable about its sense can correctly interpret the intent behind the figurative sacred image's form. Unrelated to one another as they may seem, they are in fact inseparable.

Both types evidently fulfill their task of being a *yantra*, a vessel for the inner vision, in different ways and with fundamentally different means. The figurative image is, as the word *pratimā* denotes, a "replica"-*yantra* symbolizing the inner vision; it reproduces the vision's vast store of forms in the physical realm, in three dimensions. The purely linear *yantra* speaks a language different from the one familiar to the eye. Their kinship lies in their common relationship to sacred yoga, to the inner vision, but their difference lies in the divergent ways they serve as a *yantra* for it.

Literary tradition dealing with the Hindu pantheon also teaches us how the inwardly envisioned shapes are to be depicted and worshiped in the *yantra*; and by referring to the process of contemplation, the texts resolve the formal conflict between the two types of *yantra* even in the eyes of the uninitiated. To this end, it is simply a matter of comprehending both the figurative sacred image and the linear *yantra* not as autonomous constructs of the creative imagination but, instead, as functionally determined utensils for a spiritual, sacramental rite.

Great is the number of distinctly different ways for the Divine to manifest itself when it abandons its nameless and formless state in the play of its *māyā*. And greater yet is the host of varied aspects in which these personified manifestations present themselves. Their number must be infinite, since

cosmos: "All that is here is strung on me as rows of gems on a string" (VII, 7). A *yantra*-like image of the universe emerges as one thinks of the stars strung together on enormously long strings.

the whole of the phenomenal world and the essence of man are but the Divine in ever new varieties of its unfolding. This explains why the tantras contain an almost unlimited number of specific instructions for meditating upon the figurative inner image (*dhyāna*), and why the puranic tradition, which is on the whole somewhat older than the tantric one, has transmitted a huge number of directions as to how the figurative sacred image depicting the personified manifestation of the Divine is to be executed in detail, depending on the special aspect to which the believer is addressing himself, and in accordance with his sect or the particular purpose of his rite.

The *Agnipurāna*, for example, gives among other things detailed instructions as to how Viṣṇu's various manifestations are to be represented in the sacred image. The various possible ways taught here of depicting the god are differentiated in a very basic fashion—the text does not deal with the finer distinctions—by the varying arrangement of the emblems held in the god's hands. Through their specific location in each case, the particular aspect of the god is made clear. To the uninitiated, it may appear insignificant that the same emblems—conch, mace, lotus, discus, or bow—appear, now in the one, now in the other right or left hand of this four-armed deity. For those initiated in the cult, however, the ordering of the emblems—and in many cases it is only their placing in the arrangement—reveals which of the god's manifestations he is to see in the image before him, and which aspect of Its essence the Divine, in Viṣṇu's person, is presenting Itself to him at that moment, and which form of worship is, as a result, the only appropriate one at that time. The worship to be performed can be efficacious only if the god's appearance in the sacred image is the same as in the adept's inner vision, and corresponds to the mantra belonging to that particular manifestation. Otherwise, the spoken or silent recitation of the mantra (*japa*), which is an essential component of ritual practice along with all the other details of the cult (*pūjā*) that are individually suited to each of the divinity's aspects, is at best

a pointless and at worst a dangerous game played with superhuman powers.

The manifestations that, for example, Viṣṇu's divine personage exhibits in the entire mythic tradition are numerous, but their quantity does not single Viṣṇu out from other great gods of Hinduism—Kālī-Durgā, for instance. His well-known embodiments (avatāras) do not exhaust the store of his guises. These avatāras—the animal figures, fish (matsya), tortoise (kūrma), and boar (varāha); the hybrid form of Man-Lion (Nṛsiṃha), the Dwarf (Vāmana) who, growing to giant size, traverses the universe in three strides; Rāma, the ideal royal hero of the Rāmāyaṇa, and his Brahman namesake with the axe (Paraśu-Rāma); the demon-slayer Kṛṣṇa, who proclaims the Bhagavadgītā, and his half-brother Balarāma, who wields the plow as his weapon; Buddha, the teacher of Nirvāṇa, and Kalki, the redeeming hero who will purge India's soil of infidel rule—all these avatāras are but an important selection from the manifestations in which the god presents himself for human comprehension. Many of these manifestations dazzle us with their numerous aspects: Vāmana, "the Dwarf," and Trivikrama, "Who Takes Three Strides," are differentiations of one and the same avatāra; they embody the initial and ultimate stages of the same myth. Similarly, Viṣṇu's three manifestations as Kṛṣṇa, Govinda, and Dāmodara refer to one and the same incarnation of the god and are associated with different aspects of that incarnation. Others could be added to this list. Mankind is familiar with as many manifestations of a god's essence as the god has names; each separate name for a given object expresses a different aspect of the god's essence. For each aspect, there is a separate form to be envisaged in meditation, and the sacred image has to correspond to these forms with the same number of differentiated characterizations of the god.

In the form of a short catalogue, the forty-eighth chapter of the Agnipurāna lists the basic variations characterizing Viṣṇu's sacred image in each particular embodiment of the god the image is to portray. It is a list of their names and tells, in stereotyped order, how to distribute the emblems appropriate

to the image so that it may prove a valid representation of Viṣṇu. The observer counts them off, moving upward to the right (*pradakṣiṇam*), that is, starting at the lower of the two right arms, moving to the upper right one, and then passing over and down from the upper left arm to the lower left one. The secret as to how the different manifestations of the god's essence can be indicated with the same four attributes, which are an inalienable part of him, lies in varying their arrangement as they reappear so monotonously, according to the simplest law of permutation. Observance of this law makes the sacred image that exhibits the attributes into a recognizable portrayal of Viṣṇu, and yet makes it a simple matter to distinguish them as different images of the ways his divine personage may be viewed. The simplicity and the regular application of this law for constructing Viṣṇu's sacred image make possible a schematic representation of the information contained in the *Agnipurāna* (see table).[22]

Together with these ordinances for representing Viṣṇu's different aspects, the *Agnipurāna* offers directions that are less rigid. For some of his manifestations, two-armed images are possible instead of four-armed ones, and tradition occasionally allows some freedom in the placement of the emblems. As long as the form adopted complies with the two prerequisites of being both unambiguous and characteristic of that manifestation, there are no hard and fast rules to follow; instead, there are a number of guidelines signaling a narrowly defined freedom of choice from among the various, traditionally used, characterizing types. In the next chapter, the forty-ninth, the *Agnipurāna* deals among other things with the representation in sacred images of the ten *avatāras* of Viṣṇu:

[22] For the scholar who is not an initiate, the value of the information contained in sacred tradition must be obvious. With the aid of such material it is possible, for example, to distinguish exactly the two Viṣṇu types on Plates 27–29. In the first instance he is presented in the aspect of Janārdana; in the second two, as Trivikrama. The way the god's image is to be constructed and viewed is set down in each case in exact canonical detail. In the production of the image the only matter left to the individual artist is the imponderable quality of artistic execution that we, the viewers, experience as charm, banality, or crudeness in a given predetermined form.

OUTLINE FOR THE STRUCTURE OF VIṢṆU'S SACRED IMAGE

Aspect of Viṣṇu	Emblem in the:			
	Lower Right Hand	Upper Right Hand	Upper Left Hand	Lower Left Hand
1. Nārāyaṇa	conch	mace	lotus	discus
2. Mādhava	mace	discus	conch	lotus
3. Govinda	discus	mace	lotus	conch
4. Viṣṇu Mokṣada ("Releaser")	mace	lotus	conch	discus
5. Madhusūdana	conch	discus	lotus	mace
6. Trivikrama	lotus	mace	discus	conch
7. Vāmana	conch	discus	mace	lotus
8. Śrīdhara	lotus	discus	mace	conch
9. Hṛiṣīkeśa	mace	discus	lotus	conch
10. Padmanābha Varada ("Gift-giving Lotus-naveled One")	conch	lotus	discus	mace
11. Dāmodara	lotus	conch	mace	discus
12. Vāsudeva	mace	conch	discus	lotus
13. Saṃkarṣaṇa	mace	conch	lotus	discus
14. Pradyumna	mace	discus	conch	lotus
15. Aniruddha	discus	mace	conch	lotus
16. Puruṣottama	discus	lotus	conch	mace
17. Adhokṣaja	lotus	mace	conch	discus
18. Nṛisiṃha	discus	lotus	mace	conch
19. Acyuta	mace	lotus	discus	conch
20. Upendra bālarūpin (as a child)	conch	mace	discus	lotus
21. Janārdana	lotus	discus	conch	lotus
22. Hari	conch	lotus	discus	mace
23. Kṛṣṇa★	conch	mace	lotus	discus

★ Kṛṣṇa and Nārāyaṇa, Mādhava and Pradyumna, Padmanābha Varada, and Hari have the same emblems in the same sequence.

Viṣṇu's incarnation as the Fish and the Tortoise are to be represented in the shape of actual animals "or with human limbs [*narāngin*]" and in his depiction as the Boar, who lifts the earth above the floods of the world-ocean (*bhūvarāha*), he is to "hold the mace in his right hand, but in his left, the conch or the lotus, or even [his consort] Lakṣmī. The Goddess Śrī [= Lakṣmī] is to be depicted on his left elbow or thigh [*kūrpara*]; the earth and the serpent Ananta [the embodiment of the world-ocean] are to nestle at his feet" (vv. 1–3).

In his "Man-Lion" incarnation, he is to be represented "with jaws agape." His victim, "the demon struck down by his outstretched paw" is stretched over his left thigh. He is mauling the victim's chest. Around his neck hangs a wreath of flowers, and in his two lower hands [the others are disemboweling the victim], he wields the discus and mace" (v. 4).

"As Dwarf, he is to bear parasol and staff," for in his incarnation as the Dwarf [*Vāmana*], who expands into the World Giant, he appears in human form as a mendicant Brahman, and has consequently only two arms for holding the attributes appropriate to the guise assumed. Nevertheless, "he may be depicted as four-armed" (v. 5). The text does not reveal which emblems he holds in his two other hands. Probably they are the ones that are usually found in his four-armed images and that are the instruments found in Viṣṇu's anthropomorphic aspects: conch, discus, lotus, or mace.

Of the three different Rāma figures among Viṣṇu's *avatāras*, the Brahman Rāma always appears four-armed; to distinguish him from the other two he is labeled by the epithet "Rāma with the Axe." "Rāma is to hold the bow and arrow, to carry sword and axe as well" (v. 5). Of another Rāma, the prince, the hero of the *Rāmāyaṇa*, the text says: "Rāma bears bow, arrow, sword, and conch, or else he is depicted as two-armed" (vv. 5–6). The text does not indicate which emblems the two-armed prince selects from the four emblems placed in a circle starting at the right, or whether he has completely different ones. The twofold possibility of portrayal, with two or with four arms, apparently depends here as in other cases upon the different lights in which these incarnations can be seen: he

appears two-armed if the emphasis is on the god's assumption of human form, but four-armed if the accent lies on the divine quality of that earthly manifestation.

The third Rāma incarnation of Viṣṇu can also be depicted in the sacred image with two or four arms. Here Viṣṇu appears as the half-brother of Kṛṣṇa (himself an *avatāra* of Viṣṇu), Balarāma, who is named for the plow with which he guided along behind him the waters of the Yamunā, drawing the river from its bed when it refused to heed the Intoxicated One's wish that it flow to him so that he, the Hero, could bathe in its waters. The text describes his appearance for the sacred image: "Rāma bears mace and plow, or else he is four-armed. In his raised left hand, he is to hold the plow; below, in the other left hand, the shimmering conch; in the raised right, a pestle [the kind used in removing rice hulls], and [in the lower right,] a shimmering discus" (vv. 6–7). Another instruction describes him as "two-armed, holding the conch in one hand, with the other performing the gesture of giving [hand opened, fingers inclined downwards], or even as four-armed; [in that case,] he holds in his four hands plow, mortar, mace, and lotus," apparently in a circle to the right (vv. 11–12).

When the orthodox Hindu accepts the Buddha, that great heretical teacher of Nirvāṇa, into his pantheon as one of Viṣṇu's incarnations, he adopts those iconographic characteristics which Buddhism developed for representing Buddha in the form of images. The *Agnipurāna* describes Viṣṇu's *Buddha-avatāra* as follows: "Calm in nature, with long, pendulous earlobes, bright yellow skin coloring. Clothed in a long garment [*ambara*], holding a lotus in one uplifted hand, or with both hands in either the giving [*varada*] or protecting gesture [*abhayadāyaka*]."

Last of all, the image of Kalki, the liberator of India's soil, the final *avatāra*, who is to appear in the future, is to be shown "with bow and quiver, riding on a horse, wielding in his [four] hands sword, conch, discus, and arrow."

More complex than these sacred images of the four-armed Viṣṇu are the multiarmed manifestations of Kālī-Durgā. The fiftieth chapter of the *Agnipurāna* is devoted to them. It bears

the title, "[A] Compilation of the Characteristics of the Devī's Sacred Images [*pratimās*]" (Devī, the word "goddess," is in itself a common designation for Kālī-Durgā). Its opening instructions apply to the goddess' portrayal in her aspect as Candī, the "Furious One," who overcomes in battle a demon in the shape of a bull, the enemy of all the gods, and through that victory regains for the Divine Its lost dominion over the world (Plate 41). The description of the goddess begins as follows: "Candī is to be depicted with twenty arms. In her right hands she holds a trident [*śūla*], a sword, a javelin, a discus, a noose, a shield, an arrow, a hand drum, and a short spear." With the eighth of her right hands she performs the protective gesture: "Fear not!" (*abhaya*). Since the description begins with the lower right hands, it apparently continues, as do all the others unless noted otherwise, "upwards to the right": it begins with the bottommost right hand, advances toward the head, and continues down on the other side, enumerating the emblems in the left hands. "In the left hands she holds [in descending order] a [magical] lasso of serpents, a shield, an axe, a goad, a bow, a bell, a banner, a mace, a hammer, and a hand-mirror."

The characteristic quality of the grouping of attributes is a product of the myth in which she figures as heroine. The gods, in their despair over the power of the demon Mahiṣa, who drove them from heaven, unite to create, from the emanating rays of their anger that are concentrated into one, the mighty figure of Candī, the "Furious One."[23] She alone is capable of destroying the demon to whom all the gods have succumbed in their impotence. For in her, the radiations of the manifold powers of all the gods have been concentrated into one. Her essence is the sum of all divine powers. She is the Śakti that lives, differentiated, as divine energy in each of them. Since

[23] H. von Glasenapp offers a pictorial representation of this scene: *Der Hinduismus* (Munich, 1922), Pl. 16. For a further study of the Candī myth see the translations of the second and third cantos of the *Devīmahātmya* in Ludwig Poley, *Devīmahātmyam: Mārkandeyi Purāni sectio* (Berlin, 1831), a translation into Latin, and F. E. Pargiter, *The Mārkandeya Purāna* (Calcutta: Bibliotheca Indica, 1888–1905), a translation into English.

Śakti was present in fragmented form in each of them, and since the Caṇḍī image reassembles them in order to assert the dominance of the Divine over the demonic, it is only fitting that all the remaining divine personages, who have divested themselves of their power and invested the goddess with it, bestow upon her also those weapons and emblems of their power that their individual divine energy would normally wield. And so it happens that Caṇḍī gathers in her hands the weapons of all manner of gods, in the same way that her body, with its twenty arms, unifies within itself the energy of so many two- and four-armed gods. Her image would hardly represent the concentrated power of all the divine personages if it did not wield Śiva's trident, Viṣṇu's discus, the Fire God's javelin, and the magical lasso of serpents belonging to Varuṇa, who has dominion over the waters where the serpents dwell. The God of the Winds gave her the bow and arrow; Indra, the bell of his elephant; Kāla, the God of Death, his sword and shield; Viśvakarman, the artful celestial builder, his carpenter's tool, the axe.

However, the instructions as to how Caṇḍī is to be portrayed are by no means exhausted with a simple recounting of the attributes that, in proper sequence, belong to her sacred image. The text goes on: "Beneath her is, with severed head, the demon Mahiṣa in the shape of a steer. The head lies apart from the torso. From the neck, a male figure with furious visage rises, sword in uplifted hand. This figure holds a spear in the [other] hand; he is spitting forth blood, and his eyes, his hair, and his wreath are red. But the lion [that the goddess is riding] has already seized him in its jaws, and the noose is strangling him. With her right foot, the goddess is standing on the lion; with her left, she treads underfoot the deposed demon. This Caṇḍī is three-eyed . . . " (vv. 1–6).

As well as this twenty-armed image of Kālī-Durgā in her aspect as Caṇḍī, we find less elaborate ones depicting the same myth. The Agnipurāna concludes its twenty-fifth chapter, "Characteristics of the Goddess' Sacred Images [pratimās]," with the description of a ten-armed representation: "Candikā is to have ten arms. On the right, she brandishes sword, tri-

dent, discus, and spear; on the left, the 'serpent'-lasso, a shield, a goad, a miniature axe, and a bow. She rides upon a lion, and Mahiṣa's head is being pierced with a trident."

Since only four of the right hands are characterized by emblems, and since the left hands wield weapons other than the trident piercing the demon, it must be the free right hand that deals him the fatal blow; and the spear that wounds the demon must be some other than the one listed among the four emblems in the other right hands. Probably it is the uppermost (going counterclockwise, the last) right hand that deals the blow against the demon. For, generally speaking, of the several arms it is those uppermost, "natural" ones growing from the shoulder that play an active role, whereas the others, whose jointing with the torso is less marked, must be content with the more modest role of passively bearing emblems.[24] To recall Mahāsukha for a moment: his two uppermost arms carry out the act of embrace, and so express the symbolic purpose of the Mahāsukha pair, while the remaining arms carry, simply and not in any particular pose, emblems that elaborate the essential nature of Mahāsukha himself.

These descriptions of the sacred images of Kālī Durgā's Caṇḍī aspect are more extensive than the briefly sketched remarks on the defining role played by the different placing of Viṣṇu's emblems, to which the *Agnipurāna* limits itself in its instructions for the sacred images of his various aspects. Yet even they are quite incomplete and concerned only with basics. For example, the instructions say nothing about her facial expression, nor of her garments, nor of the ornamentation for her head and the other parts of her body. And yet all of these—like every other detail in the sacred image—are important and meaningful and, within certain variable limits, are prescribed as exactly as are the attributes enumerated in

[24] There are well-known renditions of this scene that demonstrate an even simpler structure. The beautiful Durgā Mahiṣāsurā in Leyden has only six arms, and Her mount, the lion, is missing—not to mention other simplifications in the detail. Cf. the illustrations in Karl With, *Java* (Hagen, 1920), Plates 130–32, and A. K. Coomaraswamy, *Vishvakarman: Examples of Indian Architecture* . . . (London, 1912 ff.), Pl. 37.

the texts. Because the *Agnipurāna* can assume the initiate's familiarity with secondary details, it is at liberty to omit from its compendious ordinances all material that conveys information of less essential significance than the emblems and gestures it does enumerate. In the fashioning of sacred images, there are three factors that prevent any arbitrary treatment or alteration of its repertoire of symbolic signs: first, the literary tradition of myths, in which a particular aspect of the divinity takes on an active role, preserves descriptions of its appearance; second, the tradition of artistic craftsmanship, which, like every occupation in this caste-bound land, normally passes from father to son; and last but not least, there are the models that previous generations have handed down as standardized and obligatory representations of the deity.

How much important detail the *Agnipurāna* fails to mention, and how rich is the traditionally required formal repertoire of the sacred images, which the text lists in its repetitious instructions, become evident when we compare the literary characterization of Viṣṇu Trivikrama with examples of this manifestation that have survived in Indian art (Plates 28, 29). Inseparable from the image of Candī is the figure of the vanquished demon, who in his agony deserts the water buffalo's body in which he thought himself to be invincible, and leaps forth from the decapitated figure only to succumb, in his human shape, to the goddess. In his aspect as Trivikrama, Viṣṇu does not necessarily appear in the act of taking his three cosmic strides; he can also appear in statuesque calm. But just as the Candī image cannot do without her opponent, whose figure and pose make clear the goddess' really essential quality and give her aspect its precise definition, Viṣṇu's divinity as it appears wreathed in emblems also requires for its portrayal a setting and entourage that clarify the essence of his manifestation. In the generally accepted view, the god's exalted form is surrounded by figures forming a kind of court that is to be reproduced more or less completely in his image. Its composition and pose were established within narrow limits once and forever by the pronouncements of divine self-revelation as they are laid down in the literary tradition. Viṣṇu

Trivikrama is traditionally accompanied by his two con-
sorts.[25] Lakṣmī, the Goddess of Good Fortune and of Beauty,
stands at his right, with Sarasvatī, the "swiftly flowing" God-
dess of Speech at his left, playing the lute. Two retainers (*āyu-
dhapuruṣa*) flank the group. The position of their hands—the
right one in the protective gesture (*abhayamudrā*), the left
propped against the hip—is as firmly prescribed as is the
charming pose of the goddesses with the "triple curve" of
their bodies (*tribhanga*). Tradition establishes just as strictly
the composition of the horde of lesser celestial creatures that
must encompass the deity whenever he appears, in dignified
calm, in his aspect as Trivikrama: celestial musicians (*gan-
dharvas*) hover above clouds and bear their spouses on their
thighs; female spirits, whose torsos end in ruffs of feathers
(*kinnarīs*), rise above sea monsters with elephantine trunks
(*makaras*), and lionlike griffins that trample underfoot ele-
phants along with their riders. The *Agnipurāna* does not even
mention any of these in its concise list, although in the above-
listed sequence they are peculiar to the Trivikrama aspect, and
then only in one of his possible representations. Whenever
Viṣṇu is represented in his aspect as Trivikrama taking the
three cosmic strides (which are the origin of his name, Tri-
vikrama), then tradition holds a different schema in store
which, due to the vigorous nature of its subject, offers the
possibility of still more variations.[26]

The *Agnipurāna* mentions neither the great throng of ce-
lestial beings (*āvarana-devatās*) accompanying Viṣṇu Trivi-
krama nor the traditional ornamentation of his figure: the sa-
cred Brahman thread, slung from the left shoulder to the right
hip; the pectoral brooch with the jewel Kaustubha; the wreath
of flowers about the god's knees; his elongated earlobes

[25] Compare the beautiful statue in the Varendra Research Society Museum,
Rajshahi, Bengal, which Stella Kramrisch reproduces and describes in *Grund-
züge der indischen Kunst* (Hellerau-Dresden, 1924), Pl. 7, and pp. 95–97. It is
closely related to the two Berlin pieces (Plates 28, 29).

[26] Cf. the Ellora relief in Kramrisch, *Grundzüge*, Pl. 9, and the Māmalla-
puram relief at the Wuladalundha Cave, in W. Cohn, *Indische Plastik* (Berlin,
1922), Pl. 90.

weighted down with rings; the ornamental bracelets on his upper and lower arms and his ankles; and on his brow and palm the symbols of perfection betokening good fortune.

Nor does the text give any indication that, when Viṣṇu, in his aspect as Janārdana, is portrayed seated, Garuḍa, the divine King of the Birds, is part of his sacred image as Viṣṇu's mount. The text can assume what it knows will be self-evident to the initiate: that a seated deity will always be depicted on the seat appropriate to its personage, normally its accustomed mount (vāhana):[k] Śiva on the bull Nandin; Durgā on the lion; the God of War, Skanda, on the peacock; the reclining Viṣṇu on the great serpent; and Brahmā on the lotus throne.[27] Other texts must be consulted if we wish to form some idea of the characteristic detail appropriate to any particular, isolated aspect of the divine beings: some idea of the divine figures who surround them (āvaraṇa-devatās), of their mounts, and of their pose and ornamentation.

It is in the tantras that detailed descriptions of this sort are to be found. There they form a necessary component of the instructions dealing with the ceremonial worship of divine personages and their aspects—in particular, of the instructions concerning the development of the inner image of the deity whose ritual worship is being described. For example, the sixteenth chapter of the Prapancasāra Tantra supplies the instructions for meditation (dhyāna) used in worshiping the moon. It prescribes the following visualization of the deity: "He stands upon an immaculate [white] lotus and his moonlike countenance radiates serene calm. His right hand performs the gesture of granting a wish [varada]; his left holds a lotus. He is adorned with a slender strand of pearls and other ornamentation. He glitters like crystal and silver" [v. 4]. Around the male manifestation stand nine female figures as

[k] The character of the vāhanas is integrally related to the distinctive personality of the divinity who is carried upon it. As Zimmer has noted in another context, "These vehicles or mounts (vāhanas) are manifestations on the animal plane of the divine individuals themselves." Zimmer, Myths and Symbols, p. 48.

[27] Cf. Viṣṇu with Lakṣmī upon Garuḍa, Plate 32 and Skanda, Plate 33.

symbolic personifications of his divine energy (Śakti) in varied forms: "His nine *śaktis* are: Rākā [the night of the full moon, personified]; Kumudvatī [the mistress of the white lotus blossoms that open by night]; Nandā [Joy—the name of the three days of the lunar month that bring good fortune]; Sudhā [that is, the gods' draught of immortality, whose vessel is the moon]; Sanjīvanī [the Life-Giver]; Kṣamā [the Benevolent One]; Āpyāyinī [the Granter of Plenty]; Candrikā [that is, Moonlight]; and Āhlādinī [the Quickener]" [vv. 8–12]. In these nine personalized aspects of his divine energy, the moon's mild, beatific character is unfolded before the worshiper's inner eye, and represents an accurate reflection of the Indian perception of the moon as the "Coolly Radiant One," who extinguishes the baking heat of the Indian day, the symbol of all that refreshes and comforts.

> In the stamens of the lotus [into whose symmetrical shape we project the divine manifestation and its retinue], the person of the god is worshiped; the *śaktis* are to be worshiped outside [the pericarp, the center of the flower]. On the pointed petals of the eight-petaled lotus, one is to worship the eight planets, and immediately alongside them [that is, between the points of the petals], the guardians of the [eight] points of the compass. . . . The *śaktis* gleam as brightly as the blooming jasmine; they wear pearl strands of stars. They are adorned with snow-white fragrant flowers and carry silver bowls. Their garlands and their garments are white; they apply white cosmetics and place their hollow palms together worshipfully. This is the way they are to be envisaged.[28]

A subsequent chapter of the *Prapancasāra Tantra* sketches a similar, but more richly figured image for the inner eye used in the worship of the god Gaṇeśa, the elephant-headed "Lord

[28] Cf. Tantrik Texts, Vol. III, Chap. XVI, vv. 4, 8–12. Verses 9–10 mention, along with the *śaktis*, still other goddesses in the retinue, who in part are taken from the series of constellations (houses of the moon) [sic], through which the moon progresses, and are considered to be his consorts.

of Hosts."[29] This son of Śiva and Kālī-Durgā, who "elim-
inates all obstacles," is in his function as our helper in all
earthly tribulations one of the most beloved popular divinities
of India, worshiped in every village far and wide. He is to be
seen mentally as follows:

In a quadrant with shivered outline,[30] made of jewels, its
inner areas filled with sun- and moonlight, swept by a
fragrant breeze carrying with it a fine spray from the
waves of a honeyed sea and softer than the wing beats
of the bees amongst the jasmine and boughs of God's
own trees, there sits Gaṇeśa under a celestial tree [from
which one can pluck the fulfilment of all desires], whose
fruits are jewels, whose blossoms diamonds, and whose
boughs are coral. . . .A painted lotus [is his throne] and
its feet are decorated with lions' faces [in effect, a com-
bination of the Lion Throne (siṃhāsana, cf. Plate 13) and
the Lotus Seat (padmāsana, cf. Plates 42, 43)]. [This lotus]
radiates forth from three [inscribed] 'six-points' [that is,
from three interpenetrating pairs of triangles].[31]

[29] Cf. the reproductions in Coomaraswamy, *Vishvakarman*, Plates 34–35,
in William Cohn, *Indische Plastik*, Plates 168–69, and elsewhere.

[30] "With shivered outline," in Sanskrit, "*śiśirita*," that is, actually, "shiv-
ered," not "straight," but moving back and forth, all aquiver, atremble.
Described here is an area with a contour jutting alternately in and out, like
those found in many purely linear *yantras* as a basis for diagrams of triangles,
wreaths of lotus petals, and circular rings. The "shivered" line customarily
forms the outermost outline of diagrams made up of concentric lines. Cf.
Frontispiece and Plates 17 and 18.

[31] Cf. Pl. 17. The linear *yantra* of the "Durgā of the Forests" (Vana Durgā
Yantra) contains an eight-petaled lotus in a rectangular area surrounded by
a "shivered" outline (like the diagram of the moon described above), and
like the diagram of Gaṇeśa, it "radiates" interpenetrating triangles or three-
points that are found in an "inner circle," inscribed three times inside the
eight-petaled lotus. In the Gaṇeśa Yantra, three pairs of triangles interpen-
etrate, that is, they are superimposed in such a manner that the apexes of the
one point upward, those of the others downward; the *yantra* of the Durgā
of the Forests contains only three interpenetrating triangles.

I prefer the use of "three-point" to "triangle," since the analogous term,
"hexagon," instead of "six-point," would create a false picture. The words
"hexagon," "octagon," and the like, call to mind geometric figures that are

Gaṇeśa "has a fat belly [he is the God of Prosperity] . . . he has only one tusk; he has ten arms and an elephant's face and his coloring is reddish." Of his "lotuslike hands," the lowest right one is "filled with grain," the next two hold (in ascending order) a mace and a bamboo bow; the fourth right hand bears a ewe; the topmost, a discus. In his left hands (in descending order) he holds a conch, a noose, a lotus, his second tusk (on the tip of which hangs a grain of rice), and a bowl filled with jewels. "He is to be imagined embraced by the lotuslike hands of his consort, glittering with jewelry—he who brings about the unfolding, destruction, and preservation of the universe, the Shatterer, the magnanimous Provider of Good Fortune." With the shower of jewels, pearls, and corals raining down from the bowl he is holding, he pours an endless flood in all directions, amply rewarding with good fortune his pious worshipers (sādhakas). A circling swarm of bees, enticed by the sweet moisture of his brow, is driven off repeatedly by blows of his flapping ears. Gods and demons in couples wait upon him: "Directly before him is a bilva tree, next to it stand Ramā [the Goddess of Good Fortune and Beauty, Lakṣmī] and Rameśa [that is, 'Ramā's consort', Viṣṇu]; at his right, under a fig tree, is the Daughter of the Mountain [Pārvatī, that is, Kālī-Durgā] and the god whose symbol is the ox [Śiva]; behind him, under a pippal tree, the Goddess of Love's Delight [Ratī] and the God with the Five Arrows [that is, the God of Love]; on his left, next to a priyangu tree, is the Earth Goddess and the Divine Boar [that is, Viṣṇu in his avatāra as the Boar]."

The worshiper who venerates Gaṇeśa as the deity of his heart subordinates to him, as the Most High, all the other familiar personal aspects of the Divine as his supporting retinue, among them the greatly revered Śiva, Durgā, Viṣṇu, and Lakṣmī, as well as lesser divine manifestations. The instruction for meditation also lists the emblems that characterize the individuality of the deities in the retinue (āvaraṇa-

obtuse-angled and without intersecting lines, whereas the constructs dealt with here are all star-shaped, with acute and obtuse angles and with intersecting lines.

devatās). The emblematic devices of these gods are typical ones but they are modest in number, since those who bear them appear with only two arms, as befits their station, which is subordinate to the ten-armed, central figure of Gaṇeśa: "The first-named pair [Viṣṇu and Lakṣmī] is to be imagined with two lotus flowers and a discus in their hands; the second pair [Śiva and Kālī-Durgā] with noose, goad, axe, and trident; the third pair [the Goddess of Love's Delight and the God of Love] with two lotus flowers and a bamboo bow and arrows, and the final couple [the Earth Goddess and Viṣṇu as Boar] with a parrot and a grain of rice, mace and discus."

But this by no means exhausts the number of *āvaraṇa-devatās* who would properly accompany this particular manifestation of the god. The text continues: "[Other] 'Lords of Hosts' are to be envisaged all around at the six corners of the angles of the triangle diagram." These other "Lords of Hosts" are conceived as doubles of the central figure: they are emanations of Gaṇeśa's essence, manifesting him in duplications. Their forms are simpler than the central figure's, but four-armed as they are, they appear as more powerful than the four worshipful divine couples under the trees. "In [two of] their hands they bear the noose and goad, and [with the other two] perform the hand gestures 'Fear not!' [*abhaya*] and 'granting what is wished for' [*iṣṭa*]. They are joined sexually with their youthful lovers. Their body coloring is red [to indicate their delight in love and their zest for life]. They succumb completely to the power of love's unfettered passion"—all of which indicates that they are to be envisaged in the same pose as Mahāsukha and his beloved (Plates 22, 23). If we were to envisage them in Vajradhara's pose (Plates 24, 25), the text would of course indicate that they are to be viewed as seated.

In addition to the above, other partial aspects of Gaṇeśa's divine essence are arranged in a circle about the central figure:

At the corner [of the diagram] which the central figure faces, "Good Humor" [*āmoda*] is to be imagined; in either corner, left and right, "Jubilation" [*pramoda*], and his "Smiling One" [*sumukha*] are to be envisaged, and at his

back, the one designated by the epithet "The Scowler" [*durmukha*], and beside the latter are the "Obstacle Maker" and the "Obstacle Remover."

At his left and right, one is to imagine containers filled with seashells and lotus petals, agleam with pearls and rubies, and constantly raining down streams of treasures. [Eight] youthful goddesses in couples take up their position beside Gaṇeśa's treasure chests: "Success" together with "Abundance," "Charm" with "Repletion," "Dissolution in Desire" with "Abandoned to Desire," "The Bearer of Treasures," and "Rich in Treasures."[32]

These couples complete the joyous image of the deity.

Seated beneath their appropriate sacred trees, the grand divine couples in the richly figured diagram give, as they worship Gaṇeśa from all four points of the compass, testimony that he is the most exalted of all the personalized divine manifestations. If even they worship him, it must be that he is the most powerful god, and worshiping him will most surely bear the richest fruits. The remaining figures of his retinue are meant to represent tangibly the various facets of his essence, performing thereby a task similar to the one served by the emblems in his ten arms. This explains why these figures may be omitted from sculptured depictions that represent the god's image in simpler terms. Two opposing sides merge in them: darkly threatening characteristics peculiar both to Gaṇeśa as the son of Śiva (historians of religion might say: Gaṇeśa is a splitting of Śiva's essence) and of the Dark Goddess; and on the other hand, the lovable and benevolent traits characterizing Gaṇeśa in his capacity as the people's Helper in Distress. A god of life and of the every-day, as Protector of Agricultural Prosperity and the Farmers' Toil, he holds kernels of grain and a ewe in his hands, along with his parents' weapons of destruction; from the majesty of his central figure, the affirmation of life and the delight in love radiate outward as different personified emanations. Viewed from the front, the god in his greatness is all happiness, benevolence, and generosity;

[32] Cf. *Prapancasāra Tantra*, Tantrik Texts, III, xvii, 5–17.

from the rear, his dark aspects are revealed: "The Scowler," "The Hinderer." Interpreted, this means that if the god, who is capable of setting aside obstacles to happiness and prosperity, turns his back on some mortal, that person will find impediments at every step of his path. In consequence, even sculptural depictions of the god, which cannot possibly reproduce every aspect of his essence, display his menacing countenance on the reverse side, while his frontal, elephant visage usually wears an expression of sovereign good humor and benevolent or sly cleverness.[33]

Similar detailed descriptions of the divine manifestations are to be found wherever tantric literature deals with its main subject, the ritual worship of the gods. The development of a complete and accurate visualized diagram of the deity in the worshiper's heart is, after all, the *sine qua non* for any worship, with or without a *yantra*. In almost all of the *Prapancasāra Tantra's* Chapters 9 to 23 (the penultimate one), for example, instructions are contained for developing images of divine manifestations for meditation (*dhyāna*). One after another, meditative images (*dhyānas*) of the familiar Hindu deities are described within the framework of the special rites appropriate to each. The twelfth chapter shows, for example, the *dhyāna* of Lakṣmī encircled by her nine *śaktis* embodying the various aspects of her essence; and, continuing, her *dhyāna* as Rāmā, an aspect in which she is encircled by thirty-two *śaktis*. Reflecting the great number of aspects attesting to the greatness of Viṣṇu, Śiva, and Kālī-Durgā, instructions for their *dhyānas* are found throughout the various chapters.[34] Even for

[33] Cf., for example, the Javanese Gaṇeśa image in William Cohn, *Indische Plastik* (Berlin, 1922), plates 168–69. [See also Zimmer, *Art of Indian Asia*, I, plate B12a.]

[34] The following are chapter references for *dhyāna* instructions relating to Viṣṇu: as Kṛṣṇa, XVIII, 43, 47; as Mukunda ("Savior from *samsāra*"), XVIII, 48; XX, 4; XXIII, 4; as Vāsudeva, XVIII, 49; as the sacred syllable *Om*, XIX, 4, 8–12; as the Boar, XXIII, 18; as "Man-Lion," XXIV, 8; as Trailokyamohana ("spell-binding Enchanter of all Three Worlds"), XXXVI, 35–47 (this depiction is translated by Avalon in his "Introduction," Tantrik Texts, Vol. III, 61 ff.); cf. also XXV, 21.

Chapter references for *dhyāna* instructions relating to Śiva: for the following

the worship of sacred verses in which the Divine assumes form, there are personified images to be used during meditation.[35]

These instructions for the development of meditative images are remarkably copious and detailed in their description of divine aspects. Practically speaking, however, they are of use only to an initiate familiar with the technique of superimposing figurative combinations upon a linear background of triangle diagrams, lotus-petal wreaths, and the like. The uninitiated would be bewildered not only as to how to represent correctly the images of many of the figures mentioned above—for example, in the Gaṇeśa diagram, "Good Humor" and "Rejoicing," or "The Scowler," and "the One Who is Rich in Treasures"; he would find it just as puzzling to know the exact arrangement of all the divine figures at the several corners of the overlapping pairs of triangles. Due to the esoteric nature of the tantric and puranic texts, the uninitiated will never find their instructions adequate for developing inner images or for the crafting of sacred images; these are, after all, actually one and the same thing, since the sacred image must be the three-dimensional realization, the crystallization of a visualization, in order to function as a *yantra*, or

six aspects, XXVI: Sadyojāta (the "Just Born," that is, the Primordial One); Vāma (the "Friendly One"); Aghora (the "Not-Terrible"); Tatpuruṣa (the Highest Being in personified male form); Īśāna (the "Lord"); Maheśa (the "Great Almighty Lord"). For a further four aspects, XXVII: Dakṣiṇāmūrti ("He of Friendly Guise"); Aghora; Mrityunjaya ("Conqueror of Death"), and Ardhanārīśvara ("Half Man, Half Woman"), the merging of the poles whose interplay represents the unfolding of the world. Ardhanārīśvara is conceptually rather than physically hermaphroditic: composed of male and female halves (the right and left, respectively), he stands as a symbol for suprapolar unity in its latent condition of polar differentiation.

Chapter references for *dhyāna* instructions relating to Kālī-Durgā: for her Durgā aspect, XIV, 4 ff.: Bhuvaneśvarī ("Queen of the World"), XV, 3; Tripurā, IX, 8; Mūlaprakṛiti (or Ambikā, the "Primal Material in the Unfolding of the Universe"), XXXII, 38; Bhadrākālī (Kālī, the Bringer of Good Fortune), XXXIV, 8.

Chapter references for *dhyāna* instructions relating to Bhāratī, the Goddess of Speech and Knowledge: VII, 3; and for the God of Love, XVIII, 4.

[35] Cf. *Prapancasāra Tantra*, XXX-XXXI.

even to be a sacred image. The instructions are present in the stream of the oral tradition, passing from teacher to disciple, to serve only as mnemonics for the essential and the characteristic; not mentioned are many other details that are simply carried along as matters too familiar to note. The amount a given textual instruction fails to mention depends in each instance on what the text can justifiably omit without doing violence to the accuracy and integrity of the tradition, in its confidence that the knowledge is already part of the oral tradition. The text transmits occult knowledge that cannot be used effectively by any uninitiate into whose hands it might accidentally fall. The more it omits as it instructs, the more secure its occult doctrines are from profanation. What distinguishes the initiates is that they understand one another anywhere by means of simple suggestion, and that they require no more than fragmentary, allusive axioms as mnemonic devices found in a particular tradition. The entire tradition of orthodox Brahman philosophy, as it occurs in its classical aphoristic texts, rests upon this same allusive, enigmatic principle of literary formulation; the texts themselves would be nothing but obscure and enigmatic books were it not for the teacher's commentary, itself added in writing at a later date.[1] But in this philosophy, the principle of omission is applied with a skill so consummate that the esoterically stylized language of the puranas and tantras pales in comparison.

The Purely Linear yantra: Its Language of Forms

The accounts of inner visions of divine manifestations that the *Prapancasāra Tantra* and other representative tantric texts present as being obligatory conceptualizations of the Divine are but rarely suitable subjects for sculptural art. This is why the sections of the *Agnipurāna* that contain directions for accurately drawing figurative sacred images severely delimit the symbolic apparatus necessary for symbolizing the Divine—a

[1] A good example of an aphoristic text is the *Yoga Sūtra* of Patanjali (2nd century B.C.). The pithy sutras demand a commentary in order to be intelligible to the reader.

drastic reduction when compared to the tantras. But even to paint and to draw the Divine according to tantric descriptions place great demands on natural ability and technical training. Both of these were readily available in temples and monasteries, due to the vitality of the craftsmanship within an exclusive, caste-bound family and educational tradition, and because of the monastic practice passed on from generation to generation. The Tibetan mandala depicted in Plates 20 and 21 is evidence of this artistic tradition in the monasteries. Tantric teachings, however, deal chiefly with domestic rites passed on from father to son and practised as a family tradition under the watchful eye and tutelage of the family's spiritual instructor. Just as by custom the teachings and initiation are ever renewed in the family with each new generation, so too, the office of teacher and family spiritual adviser (guru) is hereditary within that teacher's family. The religiosity of the tantras is tied to the household and flourishes in the bosom of the family. In most cases the initiate is his own priest and therefore is, on the whole, dependent on himself for the devices required for the act of worship. The many needs of the domestic cult, however, vary with the requirements of the day and with the individual's desired goals. The tantras supply ritual practices for life's exigencies and desires, as well as for transcending all human inadequacies; in a given instance the practices may be applicable to an entirely different manifestation of the Divine; and to worship it may require various devices for ritual worship, but above all, a different *yantra*. Reason enough, then, for drawing the *yantras* as simply as possible, while maintaining the scrupulous accuracy that is the secret of their efficacy; it means that even someone untrained in the technique can prepare them and put them to use as needed, varied as they may be. Moreover, the devotee has to be independent of outside help from those trained in the craft, since in many cases he needs *yantras* for personal reasons or for magical rites whose purpose he must keep secret.

So it is that we find figurative sacred images (*pratimās*) and artistically figurative *yantras* side by side with purely linear *yantras*. Because of the artistry of their execution, the first two

are destined for long years of use in temples, monasteries, and on domestic altars; the last type is formally a much humbler genre whose preparation requires not so much the special training of skill in the craft as it does the knowledge one gains through initiation. This type can be created without effort as need and occasion may require.

With regard to form, the exclusively linear *yantras* are closely related to the richly figurative ones, like the Tibetan mandala paintings. Common to both is the symmetrical, concentric division of the surface plane with its linear elements, for instance, circular lines and rings of lotus petals (Frontispiece, Plates 17–19). In many exclusively linear *yantras* there is a symmetrical perimeter line whose square shape is broken (*śiśirita*, "shivered") by the line's repeatedly folding back on itself at right angles, which may appear surprising and strange to the inexperienced eye. Only an eye that has already assimilated the formal wealth of richly figured *yantras* will effortlessly decipher the meaning of the purely linear ones (Frontispiece, Plates 18, 19). It will recognize that the square, with its four protruding T-shaped pieces extending symmetrically from the sides, is in fact the inside of a square sanctuary together with its broad-stepped entranceways that lead into it from all four points of the compass. The solid walls, which in the *figurative* representation of this symbol (Plate 20) bracket the temple's interior at its four corners, seem to have been sacrificed to the simplifying stylization of the purely linear compositions. The heavily outlined ground plan of the sanctuary is reduced to a linear schema whose significance becomes comprehensible only because of the colorfully more sensuous mode of its presentation—a reduction revealing that the exclusively linear compositions are indeed simplifications of their more striking counterparts. From the treasury of figured images that function as *yantras* and decorative elements in the monasteries and temples, only those features suited to a plain stylization were incorporated into the abstract, simple images that were constantly required by the universal practical need for daily domestic devotions and for magical rites.

Our delight in this abstract simplicity preserves a remnant of that original "primitive" imagination that does not insist on the formal, "realistic" resemblance of the symbol to its subject for it to be considered as a valid symbol.[m] It was, after all, in the tantras that the lower classes, who until then were almost untouched by Brahman erudition, came into contact with the exalted realm of Brahman ideas and symbols; at the same time their culture appeared in literature through the work of the Brahmans, who thereby copiously enriched their own tradition—their acknowledged repository of truth—with materials previously disregarded or rejected, but now appropriated from the secret societies of the lower classes. Emerging from the lower classes, the erotic component, with, *inter alia*, its elaborate symbolism, ultimately forced its way to the summit of the realm of mythological deities. This triumph, on the plane of ideas, seems to parallel the intrusion of these primitive symbolic forms into the canonical, formal language of Brahmanism, where they developed into expressive formulas for a symbolic geometry of ideas.

The remarkable simplification of the two-dimensional sacred image from a richly figurative construct of lines to a purely linear one follows two principles: the reduction to exclusively linear symbols and to writing, and the omission from the *yantra* of some elements of the inner vision. Right-angled lines, circular lines, and wreaths of lotus petals that give the richly figurative, painted *yantras* their symmetrical structure—it is not difficult to reduce all these regularly-shaped figurative elements to purely linear symbols. Forfeiting color, pared to pure outline, they become dematerialized. As a substitute for the linear schema's elaborate figurative content, which demands special technical devices (various symbolic colors, for example) and a particular training, the exclusively

[m] The adjective "primitive" is used here in regard to man's evolution of consciousness. Tantras are effective symbols because they have the ability to "speak" to us at a "primitive" or prerational level of thought. Zimmer would agree with the following remark of Edward Edinger: "Modern man urgently needs to re-establish meaningful contact with the primitive layer of the psyche"; *Ego and Archetype* (Baltimore: Penguin Books, 1973), p. 100.

linear *yantra* develops a special symbolic language: it fills the framework of lines with linear graphic symbols, which may possibly be accompanied by letters of the alphabet.

Of all the linear graphic symbols, it is the triangle (or, more accurately, "three-point") that plays the dominant role. It is often also called *yoni* (womb), rather than *trikona* or *tryaśra*, the geometric terms for "three-point." *Yoni* as womb is used generally as a term for the *fons et origo*, but in its graphic, pictorial form as a triangle, it is a symbol of the Feminine as well.[36] In the symbolic language of the tantras, the feminine element represents the energy (*śakti*) of the Divine through which the Divine in play unfolds and manifests its essence. Yoni is *śakti*. Now because any individuation[n] of the Divine into personal aspects is one play of the *śakti* of the pure Divine without attributes, the triangle as *śakti* symbol has an added function: to serve as a natural schema for the gradually developing representation of those diverse aspects into which all divine essence, when manifested as a person, subdivides in order for the believer to contemplate the Divine and to comprehend It in all Its component parts. This explains why, in the *yantra* of Gaṇeśa, for instance, the god's lotus throne is composed of three interpenetrating pairs of triangles. Forming a kind of ground plan of his divine essence, they provide an organizing pattern in which the divinities are grouped symmetrically around the central figure as emanations of its es-

[36] As a sign for the *yoni* and a hieroglyph for the Feminine, the triangle is often encountered beyond India's borders. W. Schulze has listed in a brief article several examples from Greece (Aristophanes) and Phoenicia, as well as from the streetwalkers' language of our own day and from other linguistic areas. See his "Delta, aidoion gynaikeion," *Zeitschrift für vergleichende Sprachforschung*, XXXIX, 611.

[n] The term "individuation" is not used here as it is in Jungian psychology but rather in reference to tantric metaphysics. It is one of the fundamental tenets of tantra that unity is reality and that multiplicity is ultimately illusion. Yet, from the individual's perspective, primordial energy (*śakti*) takes on countless different forms; this is "the god's individuation." For a comparison of the Jungian process of individuation and tantric *sādhana*, see A. Mookerjee and M. Khanna, *The Tantric Way* (Boston: New York Graphic Society, 1977) pp. 161–63.

sence. These divinities express various essential characteristics and powers of the divine personage that is being contemplated, and symbolize his *śaktis*; and in the same way that the divinities combine into one meaning rich in nuance, so too all the points and angles of the relevant diagram, each with its own divinity, combine into a single, if complicated, configuration of lines. In order to characterize the individual nature of one particular personal aspect of the Divine, the devotee needs only the skeletal diagram: its superimposed triangles and other linear elements, its encircling significant rings, lines of lotus petals, and other related signs. To the degree that his initiation enables him to find such a linear construct meaningful at all, he will know all that he needs about the diagram's content in order for him to bring its mute structure to life; that is, he will understand precisely which figurative elements of meditation must go with which point, which ring, which lotus petal, and with the empty spaces in between. For the actual practice of worship, he is instructed first to conjure up before his inward eye the deity's image together with its surrounding figures, its *śaktis* (he is aided in this by the repeated, litanylike recital of verses that describe the god's manifestation), and then he is to project the completed visualization into the sketched linear *yantra* lying before him. It is at this point that the enigmatic ground plan of the divine essence—composed of a complex of lines dictated by the tradition—comes alive.

Exactly the same conformity exists between the elaborate, figurative visualization of a divine personification and the purely linear pattern serving as its vehicle, or *yantra*, as exists between the visualization and the figurative sacred image (*pratimā*). The figurative sacred image, by using its own resources to portray the vision's content, accommodates as far as is humanly possible the devotee's need to make the inner vision concrete. The linear *yantra*, for its part, can provide that inner vision only with an organizing schema, and calls upon the inward eye to flesh out this framework with an envisioned galaxy of figures. To the degree that the devotee can, by dint of long practice, spontaneously embellish this unadorned

schema with the densely populated image of his particular deity's essence, the purely linear *yantra* is for him an unmediated replica of divine essence. It is exactly in this way that the linear *yantra*, in lieu of figurative forms, serves also to adorn temples, for anyone who stands in contemplation before it brings it to life by the visualization proper to it. For the trained believer, it is never a mere linear composition, but an expression of one aspect of the Divine's essence. On each of its planes, in each angle of its inner core, it bears some piece of information about the god—information neither expressly articulated nor patently obvious, but intended to be recognized as such by the initiate and then made clear through one particular figurative element of his inner sight.

The linear *yantra*, by forgoing totally the entire figurative element that is properly the content of the inner vision, fulfills its function as a vessel for the inner visualization. It limits itself to its structural framework, to serving as the organizing pattern for the inner vision's wealth of figures. Now the *figurative yantra* obviously cannot do without figures; but its capacity for mirroring inner visions is equally limited, although in a different way. When sculpted, especially as a bronze, it cannot always faithfully replicate the specific color tones as they are positioned on the figure; these are inseparable from the content of any inner vision, and are essential to it, since colors have symbolic significance. Moreover, it does not render those extremely complicated, densely populated inner visions that the linear *yantra* can effortlessly render through the abstract symbolism of its ground plan (as in the diagram of Gaṇeśa described above). The figurative *yantra* is suitable only as a vessel for comparatively simple and less elaborately figurative visualizations of divine essences.

It is true that extensive reliefs often do present divine characters inside a rather large circle of supporting figures who are either companions, subjects, or worshipers of the central figures. But their number is usually limited to characters who, in compliance with the traditional description of the scene in epic literature, are necessary for illustrating the event recorded in those narrative reliefs. Conceptual analysis of divine essence

into its components (as in Gaṇeśa's case into "Laughing Mouth" or "The Scowler," and so on) never occurs, nor is the god's energy radiated into a ring of doubles of its manifestation. The relief's area will not accommodate an unlimited number of figures. After all, it exists to express the Divine's essence, and the accuracy of expression depends primarily on whether or not all its components are clearly visible. These details are not to overlap or block the viewer's line of sight but, in full awareness of their significance, they are to be placed either next to or above one another. For this reason, the figurative relief, which is naturally seen from the front and which can only place the groups of figures over one another, is hardly suited for rendering the inner visualization of a divinity when that visualization is subdivided into a symmetrical, star-shaped pattern containing a myriad of symbolic figures on all sides. Obviously still less suited for replicating such inner visualizations is the independent decorated column, whether free-standing or engaged. But it is just this form of the figurative sacred image that is most frequently encountered. The column's very form militates against the replication of those densely populated, symmetrical visualizations of a divine essence; their complex structures are to be comprehended only from a bird's-eye view, because a side view is impossible. In rendering these complex visions, the purely linear *yantra* is ideal for presenting a bird's-eye view and preserves the simple ground plan, as would a map.

The purely figurative *yantra* (sacred image, *pratimā*) is distinguishable from the linear *yantra* not only by the way it represents visions but also by the number of figures it depicts. This quantitative difference cannot be expressed in statistical terms; it is, however, inherent in the differing structures of the two types and is dictated by the varying angles from which they are viewed—either from in front or from above. If the linear *yantra* is filled in with figures, as are the Tibetan mandalas, for example, the increase in the number of figures when compared with the average *pratimā* is evident even to the uninitiated; but if it is presented to our sight as a purely linear composition, then one may deduce from the literary tradition

any additional meaning to the figures; the texts indicate which of the figures contained in the inner vision are to be aligned with the linear composition and, further, which of them the initiate is actually to incorporate into the linear composition by taking the step of coalescing the *yantra* and the image envisioned.

Since the two types can be interchanged when they are employed as *yantras*, they are evidently connected to visualizations that differ from one another in structure and in the number of their figures, even though these visualizations may depict the same divine essence. Different types of visualizations are rendered by the two types of *yantras*. These may include comparatively simple visualizations limited to the figure of the god in the center, together with his throne, his steed, a few ancillary divinities (consorts, servants, and so on), and perhaps even the subjugated enemy—all of which form an expository frame around the central figure. Besides these, there are amply figured visualizations that symbolize the god's essence, trait by trait, in the distinctive, surrounding figures. These latter visualizations exhibit through groups of special figures the various essential characteristics whose articulation, in the case of the simpler images, is provided by a profusion of faces and an array of arms bearing various emblems. The forest of arms, which serves in the comparatively simple images to represent the divinity's numerous essential characteristics, is transformed in the more complex images into a forest of shapes that clarify in detail the central figure's essence by encircling him with a symmetrical display of all that he is.

Since the linear *yantra* is reduced to an organizing schema, it is better suited for representing such a densely populated visualization of the deity than is a figurative sacred image, and we may assume that it is precisely in connection with the symbolism of the purely linear *yantras*, and with the idea fundamental to their symbolic language, that those densely populated visualizations have attained their high degree of elaboration. In literature, the densely populated visualizations are predominant in the tantras, whereas the simpler ones are

taught mainly in the puranas. The central concept of tantric ideology is Śakti. Energy is held to be the essence of the world. Each personification of the Divine is seen as only one of the forms energy elects in order to make itself manifest. Eternal, divine Śakti divides itself into countless individual personifications of the Divine. But each divine personification, itself a manifestation of Śakti, develops Śakti further into a series of aspects that we may call its own *śaktis*. The idea of Śakti therefore frees the grand figures of the Hindu pantheon both from their autonomy as individuals and from their contentious rivalry with one another as a group, reducing them to the elemental concept they always had in common: to their very self, to divine energy. Śakti is the substance of the Divine; the diverse shapes it assumes are but apparitions—aspects of Śakti. The emergence of the idea of Śakti puts an end to a prolonged, ancient struggle for preeminence and sole authority among the separate ways we conceive of the Divine; no one of them emerges victorious from the conflict of sects and cults. Even though these ways vary in representing the richness of divine power and glory, they are of equal rank because each and every one, as a mere manifestation of the Divine, is subordinate to that idea ultimately constituting its divine nature: to Śakti, to divine energy.

The symbol of Śakti is the triangle—*the* graphic emblem of the Divine Feminine. Because Śakti manifests itself in a variety of aspects as divinity and person in one, the triangle in its various combinations is therefore the appropriate sign for expressing the diverse forms of the god's individuation. Since the triangle as a whole was meaningful, each of its parts had to be imbued with special meaning as well. By reason of its simple structure, the triangle could be charged, segment by segment, with those conceptual values into which the ideal essence—symbolized by the whole triangle—could be subdivided. Understood in this way, the graphic symbol opened the gates to an elaborate development of an occult language of linear images, the segments of which, one by one, symbolize the separate components of a divine essence.

As a symbol, however, the triangle signifies not only Śakti, *das Ewig-Weibliche*° of the Divine Cosmos, but also its antipode into which the Divine Cosmos develops as well, when it separates into diametrically opposite poles and qualities. We can deduce this *a priori* from the concept of the Divine as undifferentiated and‚without attributes if we study a figure like the Śri Yantra,[P] and from the relevant explanatory texts simply infer that the *yantra* is supposed to mirror the Supreme Divine as it proceeds to develop into divine manifestations that are endowed with attributes (Frontispiece). If the triangle were only a symbol of the Feminine, only *yoni*, the Supreme Divine would be purely and simply the Feminine, since triangles take up the middle area of the figure and comprise its significant nucleus; the Supreme Divine would then not be an undifferentiated state devoid of attributes, but would instead be fixed to one pole and a single set of attributes. Moreover, we could not explain how this lone Feminine-Divine could all by itself develop a profusion of figures. In the case of the Śri Yantra, we are apparently to interpret the dynamism of the pairs of triangles, which interpenetrate with their apexes facing one another, as symbolizing the life-engendering union of male and female poles—the triangles are symbols into which the Divine without attributes separates during the joyous play of its unfolding when the procreating force of *māyā* begins.

This conjecture is corroborated by a commentary to verses describing the Śri Yantra.[37] At the beginning of the instructions for outlining and drawing the Śri Yantra figure, the commentary establishes some general rules and definitions (*paribhāṣas*) applicable to the subsequent elaborations. The instructions distinguish between two types of triangle, the *śakti*

° Goethe's "The Eternal-Feminine." See the last lines of *Faust*, Part II.

[P] See also below, pp. 000–000 for a detailed description of how to draw this *yantra* and Zimmer's exploration of its symbolism. A more general discussion of the *yantra*'s role is found in *Myths and Symbols*, pp. 140–49. See also the last lecture Zimmer gave before his death: "Śrī-Yantra and Śiva-Trimūrti," *Review of Religion*, 8:1 (1943), 5–13.

[37] Bhāskararāya in his commentary *Setubandha* (bridge) to the *Nityāṣoda-śikārnava* ("*Sea of the Sixteen Eternal Figures of the Divinity*"), edited by H. N. Apte, Ānandāśrama Sanskrit Series, LVI (Poona, 1908).

and the *vahni*, depending on their orientation toward the adept drawing the figure. The *śakti* triangle has its base farthest from the adept and the apex turned toward him (the *śakti* triangles are those "on top" with their apexes down); the *vahni* triangle points away from the adept, with its base located nearest to him. Of a triangle pointing toward the adept, the commentary says: "its name is *śakti* and the names of [female] divinities, Pārvatī, for example [as the daughter of Himālaya and the consort of Śiva she is the benign aspect of the goddess Kālī-Durgā], are synonyms for *śakti*." It is, therefore, a symbol of all female manifestations of the Divine. The commentary gives a corresponding description of a triangle pointing out and away from the person of the adept—whether drawing or meditating—and into the *śakti* triangle: "its name is *vahni*, and names of [male] divinities, Śiva, for example, are synonyms for it."[38] The word *vahni* is masculine in gender—*śakti* is feminine—and has the primary meaning of "fire," but is also a general designation for male divinities.[39] In the Śri Yantra, four male triangles interpenetrate five female ones, and we are to visualize, in dead center, a dot (which may be missing in the graphic rendition of the *yantra*); added to the innermost *śakti* triangle, this dot completes the ultimate pair of triangles. The symbol as a whole has the force of an image of vibrant creative ecstasy—the ecstasy of the eternally engendering divine powers whose essence is found in the fusion of their opposing poles.

[38] Ibid., p. 27.

[39] Along with the masculine word *vahni*, a neuter one occurs with a similar range of meaning: *tejas*, fiery energy. Like *śakti* it stands for energy and power. On the one hand, *tejas* characterizes the external form and essence of the (masculine) sun which, according to ancient tradition, is the very seat and sanctuary of everlasting eternal life, just as it symbolizes the king's essential nature—the dazzling display of power; on the other hand, *tejas* distinguishes the yogi above all men, who has transformed all his energy, beginning with his generative power, into a miraculous, magical force, and keeps it stored up within himself, ready for discharging; finally, it has the straightforward meaning of sexual potency and male sperm as the most elemental manifestation of the vital, divine energy found in man. [See further J. Gonda, *Ancient Indian Kingship from the Religious Point of View* (Leiden: Brill, 1966), p 35.]

It may be that an erotic and cosmic connotation is implicit in the symbol of the lotus as well, whose two wreaths of petals enclose the symbolic interlocking triangles in the pericarp at its center.[40] But considered structurally, the wreaths function as an inner frame for the whole symmetrical composition; in so doing, they correspond to the sixteen-petaled lotus with its eight Buddha figures at the center of the Tibetan mandala (Plates 20, 21), but indicate a less complicated pattern of thought. Ringed by lotus petals pointing outward, the circular area at the heart of the image can clearly only be the lotus

[40] The expository section of the *Anangaranga* ("*The Love-God's Stage*"), an erotic and eugenic manual for use in the family written by Kalyānamalla in the sixteenth century, begins by classifying women into four types, of which the *padmini* type figures as the highest. *Padmini* can be translated as "lotus-*yoni*" (*padma*, lotus), for this type and the three others take their names from special characteristics of the *yoni*: the *yoni* of the *padmini* type emits a fragrance "sweet as the lotus in full bloom." The lotus with its beauty serves everywhere as an object of comparison for characterizing a thing as the best and fairest of its kind; in the same text this typology of the *yoni* appears: "many *yonis* are inwardly as delicate as the filaments of the lotus flower; others are sown with little pearl-like nodules; still others are covered with a number of minute folds, while others are coarse to the touch as the tongue of a cow. Connoisseurs know that in this series the *yonis* are arranged in decreasing order of refinement" (IV, 30–31).

As one might expect of a sixteenth-century Hindu author, Kalyānamalla follows the tantras closely. His small but substantial book concludes with the *gāyatrī* to Kāma, the god of love; this is a late variant of the most sacred verse of the Vedic hymns: "*om manobhavāya vidmahe pancabāṇāya dhīmahi / tan nah kāmah pracodayāt.*" ("*Om*, let us comprehend Him Who arises from within our hearts; let us behold the God with the Five Arrows with our inner eye. / May Kāma arouse us to this.") This is obviously not an impertinent parody of the sacred Vedic formula, "*tat savitur vareṇyam bhargo devasya dhīmahi dhiyo yo nah pracodayāt*" ("Let us behold with our inner eye the light of the God Savitar [the "All-Quickening God"] which is our most fervent desire. May He waken these visions in us") (*Rigveda*, III, 62, 10), any more than *The Love-God's Stage* is an immoral text; it is instead a variant of the *gāyatrī* verse which, in the tantric ritual of the god of love, expresses the god's essence. In the eighteenth chapter of the *Prapancasāra Tantra*, dealing with the worship of the god of love, we find the verse in the following form: "*Kāmadevāya vidmahi Puṣpabāṇāya dhīmahi tan no 'nangah pracodayāt*" ("Let us comprehend the God Kāma; let us behold the God of the Flower-Arrows with our inner eye. May the Bodiless One [that is, the god of love] arouse us to this").

throne where Brahmā, "the Lotus-Born, the Self-Engendered One" (*padmaja, padmayoni*), has been seated since time immemorial. It can only be the lotus bud that once sheltered the primordial essence floating upon the waters of primordial time, and that has blossomed out to serve as his throne. As Brahmā's seat, the lotus is a symbol of the Absolute, the Self-Engendered, the Autarchical; as a seat or a resting place for the feet, it appears with other figures that we recognize as the earliest and most exalted deities, like Viṣṇu (Plates 27, 28), Śiva (Plates 15, 16), and Lakṣmī (Plate 31). Consequently, the lotus has become the common attribute of whichever personification of the Divine enjoys preeminence in the devotee's worship as his chosen deity (Plate 32). When the Buddha is portrayed in art, his throne is not invariably the lotus. Whenever he is seen as the human being who, by virtue of his perfection (because he is a perfect human, a *mahāpuruṣa*), is chosen to be the spirutual ruler of the world, he is depicted seated upon the lion throne (Plate 13)—a symbol of dominion; but, on the higher level of cosmic being, whenever he is the symbol of the Absolute—of drifting, changing Nirvāṇa—and the symbol of the Emptiness that is the essence of all things, he appears seated upon the lotus throne—the emblem of the Absolute (Plates 11, 42–46). Like him, the Jina, the saint of Jainism who through his own efforts attained Truth and abides within It, is also enthroned upon the lotus (Plate 47), as are Buddhas-in-the-Making (bodhisattvas) and the saints of Hinduism who, during their lifetime, have ascended from human imperfection to a godlike position (Plate 9). For all these reasons the lotus is the only appropriate site and seat for those divine couples embodying the Absolute, Pure Emptiness (Plates 22–25), and it is of necessity the frame in the center of the figurative mandalas, signifying there the very heart and nucleus of Pure Being. For this role, the lotus has been selected from the great store of striking natural forms and added to the repertoire of visual emblems belonging to the symbolic language of lines, where it can be imbued in detail with special meaning. For example, in the moon *yantra*, where stamens are to be drawn on the petals (as in the Annapūrṇā-bhairavī

yantra [Plate 18]), the deity is worshiped in the stamens of the lotus flower, evidently because they symbolize the moon's rays. On the other hand, in the instructions for preparing the Śri Yantra, Bhāskararāya quotes a verse from the *Bhūtab-hairava Tantra* prohibiting the use of decorative stamens on the lotus petals in the wreaths, since the initiate, if he did this, would be exposed to the danger of being harmed by lesser genies (*bhairavas*) and their female companions (*yoginīs*).[41]

The Śri Yantra

Among devotees of Indian art, the purely linear *yantra* has until now failed to arouse the interest it deserves as an illu-minating companion piece to the figurative sacred image. This is because, prior to Arthur Avalon's publishing the texts and his analytical introductions to them, our comprehension of the ideas behind these interesting formal structures remained rudimentary. Nor have later published texts and casual ref-erences to them been able to awaken any serious interest in this obscure and intricate material. In order to make clear a number of ties between the linear *yantra* and its related func-tional form in the spiritual realm, the figurative image (*pra-timā*), it might help to outline the characteristics of one of these formal structures. For this purpose, the Śri Yantra (Frontispiece), which we may call the foremost of all linear *yantras*, is better suited than others, since whole volumes have been dedicated to explicating it, whereas others have been treated only in brief sections, for example in the *Prapancasāra Tantra*.[42]

[41] Bhāskararāya, *Setubandha*, I, 42 (p. 36).

[42] Apart from the *Nityāśodaśikārnava*, see *Tantrarāja Tantra*, Part I, edited by Mahāmahopadhyāya Lakṣmaṇa Śāstrī, Tantrik Texts, VIII (London, 1908), I–XVIII. It is in keeping with the esoteric nature of the purely linear *yantras* that the uninitiated person needs a precise descriptive and interpretive text to understand them, even more than he does for the highly structured figurative compositions adorned with attributes. He will find most of the textual references concerning linear *yantras* inadequate: they are concise verses to aid the memory, and their key words catalogue the *yantra*'s forms (triangle, and so on), but they assume that the reader has the practical knowledge to

Figure 2 Figure 3 Figure 4

To the eye of the uninitiated, the nucleus of the Śrī Yantra may appear to be simply four upward-pointing triangles (*vahni*) superimposed upon five downward-pointing ones (*śakti*); but for the initiate, the configuration of lines is seen further to be a number of figures set concentrically around one another: in the very center there is a three-pointed figure (Fig. 2), a triangle, enclosed by an eight-pointed one (Fig. 3). Further from the center, two ten-pointed figures, one smaller (Fig. 4) and one larger, (Fig. 5), extend into the surrounding space, and a fourteen-pointed figure (Fig. 6) makes up the

combine them correctly. Like knowledge contained in the Vedas, the knowledge of the tantras is passed on orally by teachers, not in book form. If even the majority of textual references are insufficient to allow someone uninitiated to draw an impeccably correct *yantra*, then it seems foolhardy to try to interpret such complex compositions—that are expressions of a multifaceted, individual nexus of ideas transmitted by a symbolic code—aided only by a vague familiarity with their repertoire of forms and their thoughts without the advantage of precise evidence from the literary tradition. The *yantras* in Plates 17–19 are reproduced merely to show various types of the linear *yantra* along with examples of figurative ones; there is no material to help us interpret them in the texts discovered until now. The thirty-second chapter of the *Prapancasāra Tantra* discusses Annapūrnā, but not her *yantra* (Plate 18); the twelfth and sixteenth chapters of the *Kālīvilāsa Tantra* deal with Bagalāmukhī (Plate 19), but again no *yantra* is mentioned. Both chapters include litanies of her names: the first of these describes her as being "without a Second," as far as her form is concerned; she was present at the world's birth [XII, 2], is Viṣṇu's Śakti, Śiva's Śakti, the Śakti of All [6], is Kṛṣṇa's Śakti [8]," and so on. A promise is appended to the second litany that is also found with other litanies: "whoever recites these one hundred and eight highest names regularly will become lord of all magical powers [*siddhi*], yea, he will become a son of the Goddess. Whoever recites them regularly in the morning, at noon, and in the evening will attain perfection [*siddhi*]. He can reach his goal by no other way, even in tens of thousands of the world's ages." (XVI, 27 f.).

Figure 5 Figure 6

outermost contour line. Bhāskararāya begins his instructions for drawing the Śrī Yantra with a quotation from the *Yāmala Tantra* enumerating its formal elements:

> The highest divinity proclaimed that the Śrī Cakrarāja was to consist of:
> a point [*bindu*, which may be omitted in the drawing itself]
> a three-point [*trikona*]
> an eight-point [*vasukona*]
> two ten-points [*daśāra-yugma*]
> a fourteen-point [*manv-aśra*]
> an eight petal [*nāga-dala*]
> a sixteen petal [*śodaśāra*; actually, sixteen-point]
> three circles [*vrittatraya*]
> three earth-houses [*dharanī-sādana-traya*; the square is called an "earth-house" (for example, *bhūgṛha*) because the element earth is represented in the Tantras as a yellow square[43]]

[43] Cf. the verse from the *Yāmala Tantra* quoted by Bhāskararāya on the *Nityāśodaśikārnava*, I, 31 (p. 27).

The individual *śakti* and *vahni* triangles facing one another are to be considered only as structural members of the *yantra* but not as elements with their own individual symbolic meaning. What is significant are the concentric figures spreading out from the point in the center and from the inmost triangle to the framing square. For meditation, they provide a graduated, nine-step path along which the processes of unfolding and enfolding of forms takes place, as happens with the richly figured Mahāsukha mandala. The *Nityāṣoḍaśikārnava* is instructive regarding the technique for producing inner visions.[44, q]

> The unfolding [*sṛṣṭi*] begins at the "nine-three-point diagram" [*navayoni*[45]] and ends at the "earth" [that is, the outer rectangle]; the enfolding [*samhṛiti*], for its part, starts at the "earth" and ends at the "nine-three-point diagram": that is the substance of the instruction. . . . This concentric structure is ninefold: the first part [looking at it from the outside] is composed of the three rectangular frames [*bhūtraya*]; the second is the sixteen-petal, the eight-petal is the third; following that is the fourteen-point [*manukona*); the fifth is the ten-point [*daśakona*] the sixth a ten-point, too; the seventh an eight-point (*vasu-kona*), and the eighth is the three-point of the center (*madhyatryasra*). The ninth is the center point of the three-point (*tryasramadhya*).

The procedure for drawing the Śrī Yantra moves along this nine-part path in the opposite direction, not from the outside

[44] *Nityāṣoḍaśikārnava*, VII, 78–82.

[q] Figure 6 was printed inverted in both editions, on pp. 133 and 187, respectively. The frontispiece to the second edition reproduces the Frontispiece of this edition (the Śri Yantra), but it is also inverted. We have corrected some errors in Zimmer's instructions for drawing the *yantra*. This was also noted by P. H. Pott, *Yoga and Yantra: Their Interrelation and Their Significance for Indian Archaeology*, translated by Rodney Needham (The Hague: Nijhoff, 1966), p. 42.

[45] The eight-point is called a "nine-three-point figure" because nine three-points can be found in it: the eight outer ones that determine its form as an eight-point, and the three-point located in the center of the figure.

Figure 7

inward as the enfolding process (*samhriti* or *layakrama*), but from the inside outward as an unfolding process (*sriṣṭikrama*). It begins with the nine-point figure that automatically produces a central triangle.[46] Bhāskararāya describes this procedure:[47]

> Draw first a *śakti* triangle and bisect it half way down with a horizontal line: From either end of the horizontal line, extend lines to meet at a point beyond the point of the first *śakti* triangle, to form a second *śakti* triangle [Fig. 7]. Following this draw a *vahni* triangle: starting at a spot above the base of the first *śakti* triangle, draw a point [or angle, *koṇa*], extending its sides so that intersections of two straight lines [*saṃdhi*] and three straight lines [*marman*] occur with the sides of the two existing *śakti* triangles, and then draw its base so that it touches the apex of the first triangle drawn. This will result in eight triangles which point in the eight directions of the compass and in one triangle lying in the center: all told, there are nine. There will be six intersections of two straight lines and two intersections of three straight lines and two "hand drums" will be formed [*damaru*, cinchings, which characterize the hour-glass shape of hand drums].[48]

[46] That is why the earlier description of the characteristics of *sriṣṭi* and *samhriti* only goes back and forth between the "earth" and the "nine-three-point figure."

[47] On *Nityāṣodaśikārṇava*, I, 32 (p. 28).

[48] Cf. Curt Sachs, *Die Musikinstrumente Indiens und Indonesiens* (Berlin, 1915), Illus. 54.

At the center of the middle triangle, a point (or drop, *bindu*) is to be set. "In this way, three concentric figures (*cakras*) are brought about." They are: the point, the triangle (Fig. 2), and the eight-point (Fig. 3).

The nucleus is further developed by extending the base of the first (upper) *śakti* triangle at both ends, and then by drawing, from the new terminal points, two straight lines which meet beyond and below the apex of the second *śakti* triangle. "This new *śakti* triangle encloses all of the nine-triangle design except the one triangle [that is, the apex of the *vahni* triangle] pointing away from the person drawing the *yantra*." The legs of this new, larger *śakti* triangle are drawn so as to pass through the vertexes on the base of the *vahni* triangle.

Similarly, the base of the *vahni* triangle is extended and lines are drawn from its new terminal points, meeting beyond the apex of the existing *vahni* triangle. The two sides of the emerging *vahni* triangle are placed to run through the terminal points of the original base of the first *śakti* triangle. This sideward and upward development is followed by a related expansion of the area beyond the base of each of the first *śakti* and the *vahni* triangles. (The second *śakti* triangle once again remains untouched.) The sides of both triangles are extended beyond their bases and two new bases are formed parallel to the old ones. In this way, the first ten-point figure is created, having intersections of three straight lines (*marman*) at the terminal points of the original bases of the first *śakti* and *vahni* triangles, and "consisting of three *śakti* and two *vahni* triangles" (Fig. 8).

By following the same steps, we can develop the larger ten-point figure from the smaller, and from this the fourteen-point figure is created. We arrive at the larger ten-point figure (Fig. 5) by expanding the uppermost *śakti* triangle and the lower *vahni* triangle, first, by moving their bases upward (or downward, as the case may be) and lengthening them in both directions, then by extending the two remaining sides of each triangle, and finally by running the new sides, which start from the ends of the extended bases, through the terminal points of the bases of the uppermost *śakti* triangle and the

Figure 8 Figure 9

lower *vahni* triangle. We advance from the ten-point figure to the fourteen-point one by developing the two uppermost *śakti* triangles and the two lower *vahni* triangles in the same way: sideways, upward, and downward (Fig. 9).

Around this unfolded nucleus, the outer reaches of the *yantra* are arranged concentrically and bounded by a threefold square (*bhūpura/bhūbimba*) "embellished with four gates" (Fig. 10).[49] In this way, nine areas are created that are given the following auspicious names (starting from the outer edge):

> Enchanting all three worlds (*trailokyamohana*)
> = the square;
> Fulfilling all desires (*sarvāśāparipūraka*)
> = the sixteen-petaled ring;
> Shattering All Things (*sarvakṣobhakara*)
> = the eight-petaled ring;
> Granting every happiness (*sarvasaubhāgyadāyaka*)

[49] Cf. the elaborate instructions for drawing the Śrī Yantra in Bhāskararāya's commentary on *Nityāṣodaśikārṇava*, I, 31–42 (pp. 27–40).

Figure 10. Śri Yantra

 = the fourteen-point;
Creating all prosperity (*sarvārthasādhaka*)
 = the larger ten-point;
Granting every protection (*sarvarakṣākara*)
 = the smaller ten-point;
Removing all sickness (*sarvarogahara*)
 = the eight-point;
The accomplishment of all miraculous powers
 (*sarvasiddhimaya*)
 = the triangle;
Consisting entirely of Bliss (*sarvānandamaya*)
 = the point in the middle.[50]

The all-one, universal, divine energy, perceived by the contemplating initiate as his own being and awakened in himself through the religious rites, is here represented in a ninefold aspect, any number of which the believer can approach, de-

[50] *Nityāṣodaśikārnava*, VII, 82–85, and, in reverse order, I, 44–47.

pending upon his particular intentions. Based upon the unity
of the Self with Śakti, the outer reaches represent various
forms of power over the phenomenal world, which is the
manifestation of Śakti; but toward the middle, the multifa-
ceted, unfolded divine energy returns to its pure form: via the
sum of the perfections and miraculous powers (*siddhi*) that
release the initiate (*sādhaka*), or the perfected yogi, from the
cycle of the phenomenal world, the path leads into the unity
of undifferentiated divine being that the doctrine of Vedanta,
drawing from the Upanishads, calls "bliss" because it is the
"One without a Second" and "spiritual": the immaterial to-
tality of pure Being.

These nine spheres (*cakras*) are the playful unfolding of pure
Being, represented by the point in the center (*bindu*) as un-
differentiated Being without form. By dividing itself into the
duality of Self and world, it becomes conscious of its essence
as energy (*śakti*)—to the extent that the bias of wish and il-
lusion or the degree of Enlightenment allow—in different
forms symbolized by the variously shaped outer parts, that
is, from the inner triangle to the framing square. These forms
are caught up in a continual current that joins them together;
they do not exist in and of themselves, but are mere aspects
of the One, which develop—due to the snare of Ignorance
(*avidyā*)—into an increasingly more solid, concrete idea of
what *śakti* might be and into increasingly concrete purposes;
these aspects may, just as easily, coalesce and cancel one an-
other out (*aufheben*) as we approach Truth, step by step, mov-
ing from the outside toward Its center. World and Self are
mirror images of each other, but the knowledge as to what
is actually being reflected in each of them cancels out the two
images: their elaborate richness collapses into an undifferen-
tiated void—whose symbol is the invisible point in the mid-
dle, which is not drawn—just as the many-petaled and many-
pointed constructs dissolve into the empty, formless center
as the devotee's contemplation progresses from the outside
inward. The nine spheres of the *yantra* are interrelated, like
the three cosmic states, which themselves are simply attitudes
of consciousness: evolution, preservation, and dissolution. In

essence, the *yantra*'s three outer spheres are development; the middle three, preservation; and the inner three, dissolution. The play of the three states is repeated in the triad of these three groups: the outer square is the evolution of evolution; the sixteen-petaled figure is the preservation of evolution; and the eight-petaled figure is the dissolution of evolution. Similarly, in the innermost group, the eight-pointed figure is the evolution of dissolution; the triangle is the preservation of dissolution; and the invisible point is the dissolution of dissolution.[51] The evolution of universal divine energy is by its very form as much in flux as is the devotee's (*sādhaka*) form of consciousness, which returns, in yoga, from appearance to undifferentiated Being, in which the seer and the vision merge. For this consciousness that strives to go beyond its own limitations as something differentiated, and therefore conscious, is nothing less than divine *śakti*. The inner dynamics of the nine spheres establish the rhythm to the steps the Divine (the *śakti*) undergoes in returning from human consciousness to its pure essence.

This simple organizing schema becomes a sacred image by being enlivened, part by part, through a wealth of figurative elements from the realm of inner vision, which are inserted into its configuration of lines by means of *prāṇapratiṣṭhā*.[52] For purposes of the worship necessitated by the duality of god and man, the highest Śakti has to be imagined as having attributes. An inner visualization of Her[53] could serve as a model for a painting or a sculpture:

> The goddess is as beautiful as the lotus and reddened like the first rays of the morning sun, the color of a [red] *japā* blossom, like the blossom of the pomegranate, shimmering like a ruby, colored like saffron water,

[51] Cf. *Nityāṣoḍaśikārṇava*, I, 47, and Bhāskararāya's commentary on it, p. 40.

[52] *Prāṇapratiṣṭhā* is also called "*āvāhana*," "to bring near." According to Bhāskararāya, the image of the inner deity is transferred by an act of the mind into a hand bearing many flowers which, in this case, are placed on the middle of the *yantra*, where the *bindu* is found (p. 81).

[53] "*Dhyāna*," *Nityāṣoḍaśikārṇava*, I, 138 ff.

framed by a veil of bell-like rubies of her shimmering diadem, made enchanting by curls that look like a swarm of dark blue bees;

the whole of her lotuslike face is the color of the rising sun; the even plane of her brow is slightly curved like the crescent moon; the fine tendril of her eyebrow has the sweep of Śiva's bow;

her eyes glisten in the scintillating play of bliss and joy; her golden earrings sparkle with the fullness of a shower of rays; the curve of her beautiful cheeks is more perfect than the nectarine circle of her mouth; her nose is as straight as the line used by Viśvakarman [the craftsman among the gods] when he created his [model] creatures in the beginning;

she has lips sweet as nectar, coral red as the finest of the bimba fruit;

with the sweetness of her smile, she conquers the ocean whose taste is sweet, illumined by the luster of her teeth that glow like diamonds, and the seeds of the pomegranate;

her tongue illuminates the earth like a jewel's heart; her voice is gentle, her chin of incomparable grace, her throat shell-like in shape; her arms gleam like the threads of the lotus root;

the lotus blossoms of her dainty hands look like the petals of the red lotus; the luster of the nails on her lotuslike fingers transforms the heavens into a canopy;

her prominent breasts are graced by a tendril-like string of pearls; three folds across her belly, adorned by a navel like an eddy in a flood of charm;[54] a girdle of pearls beyond price adorns her hips;

a fine line of hair runs like an elephant goad between her rounded, elephantlike hips; her thighs are as slender

[54] "Charm," *lāvaṇya*, which originally signified "saltiness," from *lāvaṇa*, salt, salt sea.

as the shafts of the pisang [banana]; her knees are like diadems of rubies;

her two legs are as graceful as the shafts of the pisang; her ankle-bones are unobtrusive; her toes excel the turtle [in delicacy]; the moonlike luster of her toenails radiates in all directions;

her smile radiates like a wave of charm, like a hundred shimmering moons;

her blush is more crimson than red lead, japa flowers and pomegranate blossoms; she wears crimson garments, holds the noose and goad in her raised hands; she stands on a crimson flower and is adorned with crimson ornaments;

she has four arms and three eyes; she bears five arrows and a bow;[55] in her lips she holds a betel leaf wrapped around a piece of camphor;[56] the god Indra, basket in hand, offers her a betel leaf;[57]

her body is red with saffron and exudes the fragrance of musk; each of her garments is pleasing to the senses; she is bedizened with every kind of adornment;

Brahma and Viṣṇu touch her lotuslike feet with the jeweled ornaments of their brows;

she sets the world into a transport of delight; she floods the world with joy; she is made up of all the sacred sounds

[55] Bhāskararāya (p. 80) cites in support a verse mentioning the distribution of the weapons: the arrows in the lower right hand; the goad in the raised right hand; in the upper left hand the noose; in the lower left hand the bow.

[56] The popular chewing article that is passed from mouth to mouth as a token of love or friendship.

[57] Indra, the king of the gods in the pantheon of Vedic theology, appears here as he did in the conceptual world of more ancient Buddhism, in the attitude of a servant paying homage. The same applies to Brahmā and Viṣṇu, two members of the Brahmā-Viṣṇu-Śiva triad who pushed Indra into the background of the Hindu pantheon. Śiva cannot share the fate of the other two, for in the tantras he has become the most exalted male manifestation of the pure Divine wherever it represents itself with attributes: the goddess to whom Brahmā and Viṣṇu do reverence is no one other than his Śakti.

and sayings [mantras]; she radiates with all happiness; she is made of all the goddesses of good fortune [Lakṣmī];

the Eternal One [nityā] is ecstatic with the highest bliss.[58]

The vision of the supreme female deity is depicted here, as so often in the tantras, in similes and images that have for centuries been cultivated and polished in the courtly poetry of India as the traditional verbal characterization of idealized feminine beauty. By Indian stylistic standards, the description is without literary pretension; it presents an objective standpoint that is determined by the subject's inherent dignity. The fact that, in places, this flood of praise may for the uninitiated be reminiscent of a panagyric can be understood by recalling the function of those *dhyāna* ordinances recited from memory, whether aloud or silently, in order to produce a required inner visualization. The successful utilization of these instructions requires an inner and deeply felt emotion that can be generated by the sympathetic vibrations of hymnic overtones during a simple recitation of this rich store of forms.

The first and foremost Śakti in which the Pure Divine assumes form bears the name Tripurasundarī.[59] Just as pure sunlight reveals a spectrum when refracted, in rainbow upon rainbow, this all-encompassing, central figure develops, in its encircling spheres, the facets of its being in one wreath of individual *śaktis* after the other: universal energy divides up into a number of particularized forces. Three of Her aspects

[58] *"Paramānandananditā."*

[59] "The Most Beautiful" (woman) of the "three worlds," that is, of the universe. The *Prapancasāra Tantra*, Chapter IX, deals specifically with Her worship and, at the beginning (v. 2), interprets Her name as meaning that She, as the source of the divine triad (*trimūrti*)—Brahmā, Viṣṇu, and Śiva— is superior to them in age: She existed prior (*purā*) to these three (*tri*); furthermore, it is interpreted as meaning that She completes (*pūraṇa*) the evolved "tri-world" (*trilokī*) during its dissolution. The Three is proper to Her name since, as a revelation of the absolute on different levels of appearance, She is represented in three different aggregate conditions, for example—at the level of consciousness—as waking, dream sleep, and deep sleep, a trinity that confronts the Brahmanlike fourth (*turīya*) state (cf. also Avalon's note 3 in the "Introduction" to Chapter IX of the *Prapancasāra Tantra*).

take up the centermost triangle: Kāmeśvarī, "the Queen of Love" (in the apex pointing downward); Vajreśvarī, "the Diamond Queen" (right-hand corner); Bhagamālā, "the One Adorned with the Crown of Glories" (left-hand corner).[60] In the eight-pointed diagram, She divides up into eight figures:[61]

> Vaśinī, "she who bends others' wills"
> Kāmeśī, "the mistress of love"
> Modinī, "she who arouses desire"
> Vimalā, "she who is immaculate"
> Aruṇā, "the reddish one"
> Jayinī, "the Triumphant One"
> Sarveśī, "the Cosmic Queen"
> Kaulinī, "the *śakti* of Kula"[62]

[60] *Bhaga*, glory, is a protean word that can designate fortune, prosperity, fame, beauty, love's desire, morality, harnessed energy, transcendence of the material world, joy of release, miraculous strength, and omnipotence. It is a cognate of the Slavic word *bog*, God.

[61] They are distributed over the eight corners in such a way that Vaśinī occupies the lowest one, Kāmeśī is situated to the right, and the rest follow on, to the right.

[62] *Kula*, family, is the symbolic designation for tantric customs and doctrines in which the union of man and God (the Two-in-One) is seen in the form of sexual union and takes place either figuratively or literally. According to older and the most ancient ideas, the family is the perfect symbol of the unity of the diverse—the symbol of genuine Totality. Manu's *Book of Laws*, (IX, 45) describes it as follows: "He only is a perfect man who consists [of three persons united], his wife, himself, and his offspring; thus [says the Veda], and [learned] Brāhmanas propound this maxim [likewise,] 'The husband is declared to be one with the wife.'" [Translated by G. Bühler in *The Laws of Manu*, Sacred Books of the East, Vol. 25 (Oxford: Clarendon Press, 1886), p. 335.] Man and wife are one. And if they are really man and wife, then offspring will be present also, and the man in the patriarchal family order is then "whole." Concerning this verse, the commentator Kulluka quotes a passage from ancient Vedic sources: "The man [alone] is only the half of his self. As long as he has no wife, he will not reproduce himself and for that time he is for that reason not whole. But when he takes a wife, then he can reproduce and then he becomes whole." And wise men knowledgeable in Vedic lore also say: "whatever the man is, of such quality is the woman as well." [The last sentence follows Friedrich Wilhelm's edition (p. 270), since Zimmer's original punctuation is faulty.]

Between this eight-figured wreath and the trio in the angles of the central triangle, the initiate is to envisage the divinity's weapons in the area belonging to each of the four triangles that mark the four points of the compass: the arrows of the God of Love (lower point), the bow (left-center point), the noose (upper point), the goad (right-center point).[63]

The corners of the inner ten-pointed figure are taken up by the "Great Goddesses who grant all fulfillment" who are partial aspects of the central figure:[64]

> The Omniscient One (*sarvajñā*)
> The Omnipotent One (*sarvaśakti*)
> The One who grants dominion over Everything
> (*sarvaiśvaryapradā*)
> She who is full of all knowledge (*sarvajñānamayī*)
> She who destroys all diseases (*sarvavyādhivināśinī*)
> She whose nature is to support all things
> (*sarvādhārasvarūpā*)
> She who dispels all evil (*sarvapāpaharā*)
> She who is full of all Bliss (*sarvānandamayī*)

[63] The initiate transfers these weapons from his inner vision to the appropriate places in the *yantra* while at the same time uttering four words taken from the repertoire of magic love-spells: "open" ("*jambha*"), "enchant" ("*moha*"), "subjugate" ("*vaśa*"), "stiffen" ("*stambha*"). (Cf. *Nityāṣoḍaśikārnava*, I, 196.)

Śakti, whose unfolding consists of World and Self, is revealed at the most elemental level in its erotic aspect. Kāma, the God of Love, numbers "Mohanī" ("the Enchantress") and "Stambhanī" ("the Stiffener") among his nine śaktis (cf. *Prapancasāra Tantra*, XVIII, 6). In his commentary to *Nityāṣoḍaśikārnava*, I, 196, Bhāskararāya quotes a Kalpasūtra prescribing the installation and worship of the four weapons, not through these four commands, but through the usual practice of articulating seed syllables (*bījas*) along with prayer formulas (mantras); the *bījas* express their essence in the realm of sound, while the mantras are appropriate to the divine nature of the weapons. The *bīja* syllables for the (five) arrows are: *yām, rām, lām, vām, sām*; they are followed by the mantra, "all honor to the all-opening arrows—*dhām*: the all-captivating bow—*hrīm*: the all-subjugating sling—*krīm*: the all-stiffening goad!" (These are the *bīja* arrow-syllables according to Subhagānandanātha's commentary, *Manoramā*, to the *Tantrarāja Tantra*, IV, 26.)

[64] *Nityāṣoḍaśikārnava*, I, 187–91; *Tantrarāja Tantra*, IV, 84–86.

She whose nature is to protect all creatures
(*sarvarakṣāsvarūpiṇī*)
She who grants fulfillment of all wishes
(*sarvepsitaphalapradā*).[65]

In the wreath of the outer ten-pointed figure, ten other goddesses as a "retinue" (*āvarana*) mirror in other images the essence of the central figure:

She who grants all perfection (*sarvasiddhipradā*)
She who grants all fullness of happiness
(*sarvasampatpradā*)
She who spreads joy everywhere (*sarvapriyankarī*)
She who is auspicious everywhere (*sarvamangalakārinī*)
She who grants all wishes (*sarvakāmapradā*)
She who grants all happiness (*sarvasaubhāgyadāyinī*)
She who everywhere subdues death
(*sarvamrityuprasamana*)
She who keeps away all obstacles (*sarvavighnanivārinī*)
She who is beautiful in all limbs (*sarvāngasundarī*)
She who releases from all suffering
(*sarvaduhkhavimocinī*).[66]

The *saktis* in which the Divine reveals itself within the next circle, in the corners of the fourteen-pointed figure, are for the most part forces from the realm of the erotic. Directly facing the central figure, Her manifestation as "the *sakti* that excites all Beings" (*sarvasamkṣobhinī sakti*) is situated in the lowest angle; then follow, in the usual order,

[65] They are distributed here and in the following instances just as they are in the eight-pointed figures: the first is placed "in the west," that is, in the lowest angle, the one nearest the worshiper, since the direction he faces while worshiping is considered to be "the east" (in disregard of the actual compass points). The rest are arranged in ascending order to the right, finally returning on the left back to the starting point ("*apradakṣinyena*," Bhāskararāya on *Nityāsodasikārnava*, I, 179–83 [p. 91]).

[66] *Nityāsodasikārnava*, I, 184–87; *Tantrarāja Tantra* IV, 81–83. In the listing in the *Tantrarāja Tantra*, number six, *sarvasaubhāgyadāyinī*, and number ten (called there "*duhkhāt paratas ca vimocani*") are in reverse order.

She who causes everything to melt in Bliss
(*sarvavidrāvinī*)
She who attracts all things (*sarvākarṣinī*)
She who sets all things rejoicing (*sarvāhlādanikā*)
She who bedazzles all things (*sarvasammohinī*)
She who can turn all things to stone
(*sarvastambhanakārinī*)
She who opens all things (*sarvajambhinī*)
She who conforms all things to her will
(*sarvavaśankarī*)
She who delights all (*sarvaranjanī*)
She who intoxicates all things (*sarvonmādinī*)

The remaining four *śaktis* represent various aspects of divine energy:

She who advances all goals (*sarvārthasādhanī*)
She who fills up all things to abundance
(*sarvasampattipūrinī*)
She who consists of all sacred mantras
(*sarvamantramayī*)
She who dissipates all polarities [between the Self and
the Other, and between all polarities arising from
this first self-contemplative one]
(*sarvadvandvakṣayankarī*).[67]

[67] Cf. *Nityāṣodaśikārnava*, I, 179–83; *Tantrarāja Tantra*, IV, 77–79. Of the first ten *śaktis*, six are to be found among the nine *śaktis* of the God of Love (Manmatha). Cf. *Prapancasāra Tantra*, XVIII, 6: besides Mohanī and Stambhanī there are Kṣobhanī, Ākarṣinī, Drāvinī, and Āhlādinī.

In the various aspects of the Supreme Goddess (Kālī-Durgā), the charms and seduction of love play a major role. The tenth chapter of the *Prapancasāra Tantra* deals with Her worship as Tripurā (= Tripurasundarī): whoever properly worships Her *yantra* (a simplified form of the Śrī Yantra, having an eight-pointed figure in a ring of lotus petals and a square), "constantly has beautiful women at his service who are helpless in the pangs of love. Sitting in a relaxed position and keeping silence, let the initiate murmur one hundred thousand times the seed syllables which are made from the Lord of Love's desire; then he will be attended and worshiped in the world by gods and men. Offering themselves to his gaze are the young women of the gods, the anti-gods, the Perfected Ones and the spirits of the treasure, the spirits filled with magical knowledge and the *gandharvas*, the serpents and the celestial chorus. In the

Even the deities of the eight-petaled lotus ring derive their names from the God of Love: "Flower of the God of Love" (upper petal), "Sash of the God of Love" (right-hand petal), "Ecstasy of the God of Love" (lower petal), "Intoxicated by Love's Delight" (left-hand petal), "Rope of the Love God"

onrush of love's ecstasy they remove their jewelry and let fall their garments and hair nets. Their limbs tremble with inner fire, scorched by the unbearable torments of the Love God. Their thighs, their nipples, and their armpits are bedecked with round, pearl-like, flowing drops of perspiration. Their lianalike limbs are covered with fine, erect hairs; their bodies are bent beneath the firm, upward-pointing peaks of their swelling, rounded breasts. Exhausted by the violent trembling caused by the burden of their longing, they draw near, stumbling, trembling, upon lotuslike feet. Pierced by the Love God's arrow, which has struck them, their whole body is immersed in a sea of passion; their lips are curled like waves beneath the violence of their breath, and their eyes are flickering restlessly beneath the burden of the swelling flood of tears. Their two arms raised over their head with hands clasped, they offer themselves as a gift, and their eyes are gentle as the eyes of young gazelles. Ready to perform whatever may be desired of them, they bow down before the initiate." (*Prapancasāra Tantra*, IX, 21-27, abbreviated at the beginning of the passage.) The initiate must resist the temptation to slide back onto the sensual level if he intends to gain control over the worlds.

In the thirteenth chapter of the same tantra, there is a closely related section dealing with the worship of the goddess Triputā (another form of the Supreme Goddess): "Women, men and kings ceaselessly bow down before such a[n initiated] man; the women of the spirits filled with magical knowledge, the women of the spirits of the treasure together with the women of the gods and the anti-gods, of the Perfected Ones and of the celestial choruses and exquisite heavenly ladies [the *apsaras*, the women among the *gandharvas*] are overwhelmed by their heart which is given over to the initiate. Their bodies are wounded by the Love God's arrows; their lianalike limbs, covered with fine, erect hairs, are atremble. The beauty of their round breasts sparkles with great pearl-like drops of perspiration. They display their hips and thighs and their armpits; they stumble as they advance. The lotus flowers of their eyes are closed like buds; their gums are exposed like a blossoming flower, and the rows of their teeth quiver. Garment and hair are unbound; powerless from love's intoxication, they speak softly, stammering. They lift in supplication their joined hands, palms upward, to their oh so lovely heads and plead for affection: 'Behold us! Grant us a word! Our highest bliss is to lie in your arms! Come: in the groves of the gods shall we love one another, painlessly, fearlessly, according to our heart's desire.' If the initiate does not lose himself to the enticing women and words such as these, then the Goddess grants him everything he desires" (XIII, 38-44).

(upper right),[68] "Force of the God of Love" (lower right), "Sting of the God of Love" (lower left), and "the Love God's Garland" (upper left).[69]

In the deities of the sixteen-petaled lotus ring, divine energy is represented in a sixteenfold refraction as man's sensual and psychic energy, that is, as *śakti* "who attracts desires," "who attracts the will," "who attracts the feeling of self," "who attracts sound," "who attracts the sense of touch," "who attracts the sense of color," "who attracts the sense of taste," "who attracts the sense of smell," "who attracts thought," "who attracts inner fortitude," "who attracts memory," "who attracts all that is named," "who attracts seed atoms," "who attracts the Self" (this is denoted as "the highest" one), "who attracts what is immortal," and "who attracts the body."[70]

[68] The "love god's rope" (*anangarekhā*) is a line of fine hairs that is a component of ideal feminine beauty. It runs down from the navel and is regarded by the poets as the ladder used by Manmatha, the god of love "who sets hearts aflutter," as he moves back and forth between the heart and the *yoni*, which is the "love god's dwelling" (cf., for example, *Anangaranga*, I, 13).

[69] The names are: Anangakusumā, Anangamekhalā, Anangamadanā, Madanāturā, Anangarekhā, Anangaveginī, Anangānkuśā, Anangamālinī. As a model for the mantras with which they are to be transferred from inner vision into the *yantra*, Bhāskararāya quotes (p. 90): "*hrīm śrīm*, I worship the sandals of Anangakusumā." The *Tantrarāja Tantra* retains the same names but arranges them differently: Anangakusumā occupies the lowest petal, and the rest follow, just as in the above-mentioned spheres, in a circular pattern rising to the right and returning on the left to the starting point (IV, 94–95).

[70] Cf. *Nityāṣodaśikārnava*, I, 172–76 and *Tantrarāja Tantra*, IV, 72–73. In their commentaries, Bhāskararāya and Subhagānandanātha unfortunately fail to make any mention of these figures, although in some instances they would be welcome. The names are: Kāmākarṣiṇī, Buddyākarṣiṇī, Ahamkārākarṣiṇī, Śabdakarṣiṇī, Sparśākarṣiṇī, Rūpākarṣiṇī, Rasākarṣiṇī, Gandhākarṣiṇī, Cittākarṣiṇī, Dhairyākarṣiṇī, Smrityākarṣiṇī, Nāmākarṣiṇī, Bījakarṣiṇī, Ātmākarṣiṇī, Amritākarṣiṇī, Śarīrākarṣiṇī. *Ākarṣ* (to attract), which is contained in all these names, has the same nuance of meaning as our term "to make an opening move" with a piece in a chess game. The mantras with which they are installed in the *yantra* follow the same pattern: "*hrīm śrīm am*, I worship the sandals of Kāmākarṣiṇī Nityakalā (*nitya*, eternal; *kalā*, one-sixteenth: the sixteen figures are elements of a total aspect of divine *śakti*).

The framing square contains within itself three spheres.[r] In the innermost one are the eight divine protectors of the world: they serve as temple guards of the square sanctuary, and each stands at the point of the compass named for him: Indra in the east, that is, at the upper gate; Yama at the south, at the right-hand one; Varuna at the lower, and Soma at the left-hand gate; Agni and Rakṣas,[71] the one above and the other below at the right-hand gate; and Vāyu and Śiva below and above in the respective left-hand corners.[72] The square's middle sphere is occupied by the eight "mothers": the eight consorts of the chief gods of Hinduism or their *śaktis*. For a god's *śakti*—the separate part of universal divine energy who makes a single god into a particular revelation of the Divine—is presented in tantrism as the consort with whom he is inseparably united, just as, for that matter, *śakti* is a general term for spouse.[73] In this sphere, universal Śakti evolves into the great goddesses: Brahmāṇi (the *śakti* of Brahmā) at the lower gate; Māheśī (the *śakti* of Śiva/Maheśa) at the left-hand gate; Kaumārī (the *śakti* of Kumāra or Skanda, the God of War) at the upper gate; and Vaiṣṇavī (the *śakti* of Viṣṇu) at the right-hand gate. In the corners are found: to the lower left, Vārāhī (the *śakti* of Viṣṇu in his aspect as boar); at the upper left, Indrāṇī

[r] For a discussion of the three rings encircling the sixteen-petaled lotus ring, which Zimmer omits, and the placement of the colors (see Frontispiece), see A. Mookerjee and M. Khanna, *The Tantric Way* (Boston, 1977), pp. 57–62.

[71] *Rakṣas*, injury, destruction, is the male manifestation of the annihilation principle (*nirriti*) from which the southwest usually takes its name (*nairriti*).

[72] Cf. the function of the four "Grand Royal Gods" or "World Protectors" or "Kings of Heaven" as guardians in Buddhist temples. Illustrations in With, *Buddhistische Plastik in Japan*, 2nd ed. (Vienna, 1920), Plates 45–53; Curt Glaser, *Ostasiatische Plastik* (Berlin, 1925), Plates 40, 99, 100, 102–108, 148–49, 164; E. Fuhrmann, *China* (Berlin: Folkwang-Verlag, 1921), pp. 58 and 60; and compare there also (p. 33) the protective god on the outer wall of the eight-cornered base of the Marble Pagoda.

[73] Cf., for example, the ordinance concerning the ranking of the initiates in the *Kulārnava Tantra*, XIV, 99: "When, among the wife and children of the teacher [*guruśaktisutānām*], one can be found who has been initiated earlier, then the initiate is to show that person reverence as to the teacher himself and may in no way treat him disrespectfully."

(the *śakti* of Indra); Cāmundā (a terrible aspect of Śiva's spouse), at the upper right; and Mahā-Lakṣmī, Viṣṇu's consort, at the lower right. They "fulfill all desires."[74]

"Granting success in all things" are the ten aspects of the divine *śaktis*, too, that guard the gates and corners of the outermost sphere, and who are to be inserted above and below the Śri Yantra. They are aspects of divine omnipotence: its power to be infinitely small (at the lower gate); its power to be infinitely weightless (at the left-hand gate); its power to be infinitely large (upper gate); and its power of lordship over all (right-hand gate). In the four corners controlling the intermediate points of the compass, as the gates themselves do the four cardinal points, there are to be worshiped: lower left, the magical power of imposing one's own will upon others; upper left, the power to exist independently at one's own will (and to assume any shape one wishes as well); at the upper right, the magical power of delights and pleasures, and, at the lower right, the omnipotence of desires. Below the lower gate (the place corresponding to the nadir) is located the power of achieving all things, and above the upper gate (at the zenith), the power of accomplishing all desires.[75] Here we find, expanded into a list of ten, Śiva's familiar eight miraculous powers (*siddhi*) that constitute his omnipotence and characterize the perfected, godlike and Śiva-like yogi. This is done not to enrich the content of the series by significant nuances but in order to allow the divine Śakti to radiate in all ten directions of the cosmos.

Because these nine spheres, from the point in the center right up to the outer square, represent organizing schemata for varied evolutions or aspects of the divine Śakti, the divine

[74] *Nityāṣodaśikārṇava*, .I, 169–71; *Tantrarāja Tantra*, IV, 68–70.

[75] Ibid., I, 166–69, and IV, 66–67. Their names are: Aṇimā, Laghimā, Mahimā, Īśitva, Vaśitva, Prākāmyā, Bhuktisiddhi, Icchāsiddhi, Prāptisiddhi, Sarvakāma. The following are considered to be Śiva's eight *siddhis*: Aṇimā, Laghimā, Prāpti, Prākāmyā, Mahimā, Īśitva, Vaśitva, and Kāmāvasāyitā (that is, the power to extinguish all desire and all wishes, and therefore the power that transports the yogi beyond all obstacles to godlike perfection. In the above sequence this *siddhi* is missing).

Śakti is worshiped under various names in each of these spheres, and, in the center of these spheres, She is surrounded by the different rings of *śaktis* that are components of Her aspects. These names differ from one another in their linguistic form but mean the same thing, just as the aspects of divine Śakti differ from one another but are nevertheless aspects of the same essence: Tripurā, Tripureśī, Tripurasundarī, Tripuravāsinī, Tripuraśrī, Tripuramālinī, Tripurasiddhā, Tripurāmbā, Mahātripurasundarī.[76]

The fundamental connection of the Śrī Yantra and others like it to the *pratimā* and to the mandala lies in their identical function. The unfolding of this densely populated organizing schema before the inner eye, as well as the life-giving insertion of the schema's inner wealth of figures into a tangibly evident design, knows no higher goal than that of enabling the initiate to experience his own divinity. "He is to imagine his own self as the self of the Tripurā . . . whose manifestation is light."[77]

For as the initiate is described in the *Nityāṣoḍaśikārnava*:

The goddess Tripurā is his own knowledge of himself [*samvid*; Bhāskararāya renders this as *ātman* itself]; her crimson color[ed body] signifies his Comprehension; her noose and goad are considered by their nature to consist of love [*rāga*] and hate; her [five] arrows are the senses such as sound, touch [and so on]; her bow is thought.[78]

She wields the noose whose appearance is the love for the whole phenomenal world; she brandishes the goad, which looks like anger; her bow of sugar cane denotes the mind; her arrows are the five 'subtle elements' [*tanmātra*, that is, sound, touch, smell, and so on].[79]

For these reasons, the Śrī Yantra, as the image of the Divine, constitutes a picture of the human being, as well: "In the

[76] Cf. *Tantrarāja Tantra*, v, 14–15.

[77] Ibid., v, 17; cf. the same reference for various observances of her cult, IV, 99; v, 5 and 54.

[78] *Nityāṣoḍaśikārnava*, v, 41–42.

[79] A quotation of Bhāskararāya's (p. 174) from the *Rahasyanāmasāhasra*.

center of the spheres [*cakras*] made up of [human] limbs and sensory organs, stands the goddess; her shape is Self-Knowledge [*samvid*]; for the sake of universal perfection, let him worship her with all the flowers of his consciousness of self."[80]

Elsewhere, the *śaktis* belonging to the separate spheres are equated element by element with components of human nature: see Avalon's introduction to the *Tantrarāja Tantra*, Part One, Chapter IV, *passim*. There one finds, as well, other valuable references to noteworthy lines of reasoning in the texts that cannot be properly taken up here. For example, the equating of the points of the innermost triangle of the Śri Yantra with familiar holy places (Kāmarūpa, Pūrṇagiri, Jālandhara) parallels the places of pilgrimage that the *Śrīcakrasambhāra Tantra* locates outside the middle temple. These are three *pīṭhas*, the "seats" of the divinity for its aspects as Kāmeśvarī, Vajreśvarī, and Bhagamālinī.[81]

[80] *Nityāṣoḍaśikārṇava*, v, 44.

[81] IV, 91, and accompanying commentary.

Proportions and the Language of Signs in the Canon of Indian Art

A DIGRESSION into the canon of Indian artistic practice allows us to see from another angle the relationship between yoga and the form of the sacred image dealt with in the last chapter, to view the implements used in meditation and worship from the external perspective of artistic technique. For two reasons I should like at this point to review some characteristic items from the essential material on the subject: first, because the ideas underlying Indian art imagery have not—at least not in a number that accurately reflects the pervasiveness of their presence in the literature—appeared in the corpus of edited texts; second, because whatever material has in fact been pub-lished has not, as it might well have, been utilized by con-noisseurs of Indian art and *Geistesgeschichte* to illuminate their subject. In this chapter, I shall restrict myself mainly to a theoretical work on art, the *Citralakṣaṇa*,[a] and to those sections from the *Viṣṇudharmottara*[b] related to it. Besides the com-mentaries supplied by the translators of these two texts, the concise and penetrating comments of W. S. Hadaway offer

[a] Translations in the text, where identified by page numbers, are from *An Early Document of Indian Art: Citralakṣaṇa of Nagnajit*, translated by B. N. Goswamy and A. L. Dahmen-Dallapiccola (New Delhi: Manohar, 1976). See also the helpful introduction.

[b] Translations in the text, where identified by page numbers, are from the second revised edition of the *Vishnudharmottara: Part III: A Treatise on Indian Painting and Image-making*, translated and introduction by Stella Kramrisch (Calcutta: Calcutta University Press, 1928).

some fundamental insights into the proportional schemata of Indian religious statuary.[1]

Indian aesthetic theory preserves the technical secret underlying the formal relationship between (and therefore underlying the functional representational quality of) the figurative construct and its geometric organizing schema. Throughout, the theory basically stresses the stringent restrictions determining the form of the figurative works of art and the role artistic freedom plays within these limitations—a freedom that makes the art art, and not some mechanical formulaic reproduction.

Not until we had made a preliminary study of the purely linear *yantra*'s various organizing schemata was the way clear enough for us to see the related figurative *yantra*'s fundamental characteristic of its form that is based upon its use as a visible expression of divine essence. The unwavering consistency with which they adhere to this function makes the *yantras* instruments of religious life. They are mirror images of the triune nature of God, Man, and World, at different levels of perception. Given this central function, they are, in their uncompromising severity of expression, more closely analogous to modern scientific formulae (which are, of course, abstractions) than to the artistic creations of individual genius or to products of the pious inspiration typical of individual artists in the West. Just as the formulae of physics and chemistry, for example, open up to pure research a partial aspect of the world's complex of inter-relationships—an aspect valid for the scientific frame of mind—so too, a *yantra*, prepared according to instructions and properly meditated upon, opens up one part of the divine cosmic mystery, one particular area of that complex relationship uniting the wor-

[1] *Citralakṣaṇa* [in Tibetan and German], edited by Berthold Laufer (Leipzig, 1913), is a treatise on Indian art that has been accepted into the Tibetan Buddhist canon. *Vishnudharmottara: Part III: Treatise on Painting*, translated by Stella Kramrisch (Calcutta: Calcutta University Press, 1924). [See Zimmer's review of this book in *Artibus Asiae*, 2 (1927), 236–38.] W. S. Hadaway, "Some Hindu Shilpa Shastras in Their Relation to South Indian Sculpture," *Ostasiatische Zeitschrift*, 3 (1914–1915), 34–50.

shiper and the world in that one element common to them both: the Divine. Where, on the other hand, one of our scientific formulae gives our human drive for mastery and self-preservation some hold on a particular complex of natural forces—even some sway over them within certain limits—the *yantra*, for its part, as a tool of magical power, promises to do the same, and in so doing serves a practical purpose as well as it serves contemplation itself. *Yantras* and scientific formulae are alike in utilizing esoteric symbols; a formula in physics or chemistry, made up of ciphers and letters, is meaningless to anyone who cannot project into its representative symbols what he knows of the essential characteristics of nature represented symbolically in it. Without this vital infusion of a specialized body of knowledge, the formula will not yield to any amount of contemplation one iota of the essential and inner structure of the world, nor allow the will the slightest power or free play. For us, the *yantra* is similarly a jumble of enigmatic signs when its essential, symbolically encapsulated meaning is not at least to a degree illumined by the addition of some knowledge (not to mention the mental image or the consignment of breath). As long as we attempt to take the measure of the Indian sacred image with classically schooled habits of seeing, its essential nature will prove as inaccessible as a physics formula would be if we attempted to decipher its meaning with the help of multiplication tables or the alphabet.

The figurative *yantra*'s store of forms is as rigidly set in its stylization, and as far removed from personal variation, as are the geometric components and alphabetical symbols of its related linear constructs; it is conventionalized with the same precision as the symbolic language of scientific formulae. There is probably no great art anywhere so inflexibly stylized as the religious statuary of India.[c] By comparison, East Asian painting and drawings appear completely unconstrained, even though they are art forms where formal conventionality is

[c] The only comparable tradition of religious art is that practiced in Eastern Orthodox Christianity.

both an ingredient of the sovereign quality of their execution and the secret of their refinement and plainness of style. It is just this conventional quality of the numerous forms used that determines the characteristic subject matter of the theory behind the craftsmanship of Indian art. "Citralakṣaṇa" means the "symbolic language of the representational arts";[2] the sections of the *Viṣṇudharmottara* that deal with art are concerned essentially with a canon of conventional means of expression—if one disregards such elementary topics as the preparation of the individual pigments or of the surface to be painted.

These writings explain how the unqualified validity of this conventionalized language of representational art derives from its origin in the sphere of the Absolute, from the realm of the gods. In the *Citralakṣaṇa* we hear of a pious king who, by

[2] Laufer, who had no related sources available to him at the time, thought that the treatise's contents referred only to paintings: *citra*, colorful. But another text, *The Jewel of Manual Craftsmanship* (*Śilparatna*), edited by Ganapati Sāstrī, Trivandrum Sanskrit Series, Vol. 75, Pt. I (1922), Chapter 46, vv. 3–5, instructs us, as Kramrisch had noted earlier, that there are three kinds of *citra*: painting, reliefs, and statuary. The *Citralakṣaṇa*, then, deals not only with the symbols and characteristics with which objects and figures are to be represented in paintings; it is, rather, a general canon of the symbolic language for the representational arts. The fact that *citra*—colorful, colored— embraces, as a general concept, both relief and free-standing sculpture, is evidenced in the technique of polychromatic statuary found everywhere. The *Viṣṇudharmottara* states (p. 62): "The same rules that are valid for painting are also applied to clay-modelling. It is said to be of two kinds: *ghana* and *sushira*, massive and hollow. Iron, stone, wood and clay may be worked massively; skin [leather], brass and iron may be worked hollow. (In the latter case) a thick superimposition of clay has to be given to the skin and the painting has to be executed on it as on a canvas." It is given a stucco coating allowing for molding on the finest scale and for treatment with pigments. Excavations in Chinese Turkestan have brought to light any number of examples of this rather fragile artistic genre that, with regard to technique, is akin to objects created in the East Asian Kanshitsu manner, where a nucleus or hollow framework is covered with lacquer-soaked layers of material serving as the painter's surface. (Cf. A. v. Le Coq, *Die buddhistische Spätantike in Mittelasien*, Vol. I.) Examples of color-treated sculptures in the plate section of this book are Plates 6 and 7 (wood, gilded and painted red), Plate 44 (red clay paste with gilt tinting), Plates 24 and 25 (gilt silver with inlaid red and green stones in the crowns, and arm and foot ornaments).

using yoga meditation, was the first man to draw successfully a perfectly faithful replica: the image of a dead Brahman youth that was so like the deceased that the God Brahmā could bring it to life and comfort his father. This king goes at Brahmā's behest to the artist among the gods to learn to perfection the rules governing representational art. Viśvakarman, the "God Skilled in All Crafts," "who at the world's dawning belabored the gnarled body of the sun with his axe, giving it its round and even shape,"[3] reveals to him the canon of forms for art, just as he himself had first received the canon from Brahmā, the creator of the world and all its ordinances. The king begs him, "Expound to me, I pray, the characteristic attributes in the works of painting and tell me in which manner are these measurements and forms together with their methods to be put to use [p. 74]." The language of signs and the theory of proportions are regarded here as the two essential components of the true and valid artistic tradition. Viśvakarman introduces the instructions by explaining their origin, which justifies their use as components of the essential expressions of the Divine: "Brahma has painted all the forms of all the bodies to signify the welfare of the believers in the world and has imparted (their knowledge) first of all to me. With what kinds of measurements one should work, which objects and means are beautiful—all this I have received from Brahma: for the most excellent of paintings I am indebted to the grace of the holy master; it is thanks to him that I have made all works of art [pp. 74–75]." Subsequently, Viśvakarman refers to individual protraits of the gods as the source for his rules of art, found in the *Citralakṣaṇa* (the Divine must reveal itself, if it intends to be recognized):

. . . with the Creation of life through Brahma's endeavours castes and ranks made their appearance, and law

[3] *Śilparatna* I, 2. Part II of this text was not available to me. Its "Table of Contents" indicates (Chapter I, vv. 20–25) that it adds more detailed information on the technique of Indian painting, the description of which begins in the final chapter of Part I, which is also called "*Citralakṣaṇa*." [See also Zimmer, *Art of Indian Asia*, I, 213–14 and 383–84.]

and custom came to be established. After Brahma had finished this task, he directed his mind to the thoughts of the salvation of the Creation. As he was immersed in these thoughts his spiritual state produced such an effect that all beings, Kings and Gods, now possessed of the knowledge of the name, offered him humble worship constantly and without cessation. Through these thoughts of Brahma, Mahādeva, Vishṇu, Indra and all the Gods received great blessings. Through their own power, they became handsome in proportions and merits, and became like those that are endowed with good characteristic attributes [sulakṣaṇa]. They grew into beautiful forms, their principal limbs and minor parts became complete and from all sides they blossomed forth in their fully unfolded forms.

Their forms assumed numerous aspects, beautified with jewellery and garments. The different weapons which they held in their hands contributed to the multiplication of their attributes in pictures and so their figures were painted by them, themselves. As the Gods beheld these, their eyes were filled and their hearts experienced great joy. Brahma said: "Excellent!" and devoutly did he begin to sing their glories. Then they blessed their own forms and filled them with great powers. Thereupon spoke Brahma happily to the Seven Gods in the following way: "From now onwards, in all the Three-Worlds [that is, everywhere], no one can entertain doubt about the faith in the holiness of your godly forms and you shall always receive worship." . . . "So shall it be!" The Gods blessed with these words and highly pleased with their own majestic forms returned to their place [pp. 76–77].

This teaching of Viśvakarman is, then, nothing less than the knowledge of the gods' true manifestation, converted into norms and axioms.

Viśvakarman lists the components of traditional artistic theory in his statement to the king: "When you gain from me the knowledge of the nature of the measurements and the

characteristic attributes, the proportions and the forms, the ornamentation and the beauties, then will you be fully versed in all the skills, and will become a universally known and masterly expert in the art of painting [read: sculpture]" [p. 75]. Shapes and ornamentation make up the store of forms; "beauty" is one special ingredient of particular formal elements; measurements and proportional characteristics determine the rules according to which any group of formal elements is composed into a representational unit, be it in painting, a relief, or sculpture.

The *Citralakṣaṇa* does not restrict itself, as the introductory tale of Viśvakarman and the king might lead us to suppose, to the theory governing the depiction of divine manifestations in the sacred image. It deals as well with the depiction of human and demonic creatures. In the *Viṣṇudharmottara* also, two realms of artistic endeavor are discussed: the sensual (*driṣ-tam*, visible), and suprasensual (*adriṣtam*, invisible). The spheres of outward sight and inner vision frequently undergo the same treatment in art, in spite of their basic difference. In their content, both are ruled by principles of conventionalized symbolic language as a means of stereotyped characterization; in their form, by the law of strict proportion.

Representational art and the poetic works of India are alike in their standardization of the manifestations of the visible and the unseen worlds; Indian poetic works seek to depict the typical, and their aesthetic appeal lies in wondrous, ever-novel forms of expression they find for things absolutely and rigidly standardized. The instructions concerning this point, stated so matter-of-factly in the *Viṣṇudharmottara*, could in many cases be illustrated by the poetic style of countless verses, identical in content, from the great poets who precede and follow Kālidāsa:[4]

[4] Using this as a point of departure it would be a rewarding task to compare the perspective from which Indian poetry views the phenomenal world with the fashioning of works in Indian representational art. Many stylistic peculiarities of Indian statuary would then be explicable from a basis common to all artistic depiction of the external world, that is, precisely from that visual standpoint; these peculiarities would begin to tell us something of the distinctive Indian sensory approach to the world.

A king (ruler of the earth) is to be depicted just like a god. . . . Sages should be represented with long tresses of hair clustered on top of their head, with a black antelope-skin as upper garment, emaciated, yet full of splendour. . . . *Daityas* and *dānavas* [two types of demon] should have frightening mouths, frowning faces, round eyes and (one) should represent them with gaudy garments though without crown. . . . By one who knows painting, the commander of an army should be represented as strong, proud, tall, with fleshy shoulders, hand and neck, with big head, powerful chest, prominent nose and broad chin, with eyes raised up towards the sky, and with firm hips. (Oh) great king, soldiers should generally be painted with frowns on their faces. Foot-soldiers should be represented with short and showy uniforms; they should have arrogant looks and carry weapons. . . . Elephant-riders should have a swarthy complexion, their hair should be tied in a knot. . . . The most respectable people of country and town should be painted with almost grey hair, adorned with ornaments suitable to their rank, wearing white garments, stooping forwards, ready to help and with a mien calm by nature [pp. 53, 55–56].

The representation of personified natural phenomena is equally conventional in its stylization: "Rivers should be represented in human form, with their conveyances (*vāhanas*) [that characterize them]. Their knees should be bent and their hands should hold full pitchers. (Oh) best of men, in representing mountains an artist should show the peak on the head (of the personification). . . . [S]eas should be drawn [in human form] with hands carrying jewel-vessels, and (the artist) should depict water in the place of the halo" [p. 56].

Landscapes, the times of day, or the seasons are to be made recognizable by means of the same typifying attributes to which their character is insolubly bonded in the mind of any connoisseur of Indian poetry, since they form the stereotyped content of the countless descriptions spoken by the poets:

A learned (artist) should show a forest by various sorts of trees, birds and beasts. (He should show) water by innumerable fishes and tortoises, by lotuses and other aquatic animals and plants. A learned (artist) should show a city by beautiful temples, palaces, shops, houses and lovely royal roads. . . . [D]rinking places should be represented full of men engaged in drinking, and those engaged in gambling [there] should be drawn devoid of upper garments,—the winners merry and the losers full of grief. . . . (A painter) should represent a road, with caravans consisting of camels and other (animals) carrying burdens. . . . In the first part of the night women are to be shown going out to meet their lovers The (breaking of the) dawn is to be shown by the rising sun, the lamps (looking) dim and crowing cocks, or a man should be drawn as if ready for work. The evening is to be shown by its red glow and by Brahmins engaged in controlling their senses. . . . That the moon is shining should be shown by the *kumuda* flower [that is, a night lotus] in full bloom, while the many petals of the [day] lotus flower should be closed. When depicting a shower of rain, (that it is) raining should be shown by a man well covered. That the sun is shining should be shown by (drawing) creatures suffering from heat. (An artist) should represent spring with merry men and women, by "laughing" vernal trees, with bees swarming about and cuckoos.

The summer has to be shown with dried pools, with languid men, with deer seeking the shade of trees, and buffaloes burying themselves in mud. An artist should show the rainy season by flashes of lightening, beautified by rainbows, accompanied by heavily laden clouds, birds perched on trees, and lions and tigers sheltered in caves [pp. 57–58].

Feelings and moods, too, are subject to the same rigidly conventionalized portrayal. How they are to be expressed was canonized early on in Indian visual art in a tradition coming

from the dance pantomime, adopted from Indian theater. The classic primer for the stage arts is even named for the dance pantomime, "*Nātya*"-*śāstra*; and the word for "miming something" means, in Sanskrit, "to dance something" (*nātayati*). It is easy to see that the canon of gesticulation was borrowed by the representational artist from the stage, both for the expression of feeling and for the depiction of all essential movements. It was the world of the theater that was to provide a universally understandable symbolic language of affects and poses so comprehensive and rich in nuance that its conventionalized typology satisfied the purposes of pictorial representation completely and, at the same time, prevented any other system from developing that might have obscured the sense rather than enhanced the attractiveness of the representation. This is the reason why, in the *Viṣṇudharmottara*, the sage Mārkandeya, who there and in the *Mārkandeya Purāna* named for him serves as the voice of divine revelation, begins his explications of art and the question of its rules with the following words: "Without a knowledge of the art of dancing, the rules of painting are very difficult to be understood,"[5] and continues farther on in the same vein: "In dancing as well as in *chitra* [representational art] the imitation of the three worlds [that is, of all things] is enjoined by tradition. The eyes and their expressions, the limbs and their parts all over and the hands have to be treated, (oh) best of kings, as aforesaid in dance. They should be the same in *chitra*. Dancing and *chitra* are considered as (equally) excellent" [pp. 31, 35]. This is a way of saying that dance pantomime is a model for figurative art, not only in point of the expressive movements and mimed representation of actions, but also by its wealth of typical figures, distinguished by their size, clothing, and cosmetics as being definite characters, representatives of different classes and professions, and creatures of the exalted and lower

[5] However, since, according to Mārkandeya's teaching, the art of the dance is based on music and can be understood and mastered only through song, "he who knows the art of singing is the best of men and knows everything [*Viṣṇudharmottara*, p. 32]." [For more on the unity of the arts, see Zimmer, *Art of Indian Asia*, I, 213–14.]

worlds. The detail of their appearance, the various objects that a particular hand may carry in order to characterize unambiguously each type of figure, appear to have come from the world of the stage:

An eye should be of the form of a bow or (like) the abdomen of a fish, or like a petal of the blue lotus (utpala), or of the white lotus (padma), a fifth, (oh) great king, is said to be of the form of a grindstone. An eye of the form of a bow should belong to women (in general). . . .

The eye assumes the shape of a bow when looking at the ground in meditation. (An eye) of the form of a fish-abdomen should be painted (in the case) of women and lovers. An eye of the shape of the blue-lotus-petal is said to be of the ever-calm. An eye of the lotus-petal shape befits the frightened and crying. An eye of grindstone shape is in its place with the angry and grief-stricken[6] [pp. 39–40].

[6] This division into five types of eye is explained in the *Citralakṣaṇa*, vv. 619 ff., where their various sizes are discussed: "As to the width of the eyes which resemble a bow made of bamboo, the measure of three barley grains [see the following footnote] (⅜ digits) is laid down. The eyes resembling an utpala petal should have the measure of six barley grains (¾ digit). It is laid down that eyes resembling the belly of a fish should have for their measure eight barley grains (1 digit). Eyes resembling the petal of a padma lotus have a measure of 9 barley grains (1⅛ digit). Eyes that are similar to a cowrie shell amount to 10 barley grains (1¼ digits). . . . In the case of Yogis, their eyes, bespeaking of equanimity, should be made to resemble a bow made of bamboo. In the case of women and lovers should be made eyes that resemble the belly of a fish. In the case of ordinary persons, eyes that resemble an utpala should be adopted. It is laid down that to express fright and crying, eyes resembling the petal of a padma lotus should be used. . ." [pp. 83–84].

The smallest eyes are proper to the yogi, who looks "down, lost in thought," or keeps his eyes half-shut, lost in meditation. Eyes of the blue lotus (*utpala*) type are the normal size of human eyes, neither dilated in emotion nor narrowed in concentration. To indicate joyous excitement, especially in lovers, Indian poets are fond of the expression that their eyes "blossom forth," "open up like the calyx of a flower (*utphulla*)"; this corresponds to the use of the fish belly as the measure for women and lovers, which is two barleycorns larger than the blue-lotus eyes. Similarly, because of its size, the white-lotus eye (*padma*-eye) is used for eyes staring with terror or in tears.

Conventionalized, too, are the relative sizes of the various figures found in one collective image. For human figures, there are five different possible lengths of 108, 106, 104, 100, and 90 *angulas* [finger widths;[7] Kramrisch and Goswamy translate "digits"], to which special names apply, such as "swan," "hare," "man from Mālwā" (*Mālavya*; Mālwā is a region in Central India). Of these, the ideal length is the first: 108 digits (9 × 12); that size is common to both the gods and perfect men (*mahāpuruṣas*), and is suitable also for depicting kings. It is the unit of measurement called the "swan" (*haṃsa*), and is so called probably because it corresponds to the body proportions of the deified saint of Brahmanism, of the *yogi* who has become *brahman*. In the symbolic language of the *Upaniṣads*, he is called "swan," just as the swan-mount is Brahmā's emblem amongst the gods. Apart from this ideal human type in Brahmanism, the Perfected Great Ones of Buddhism and Jainism share this unit of measurement: it is a part of Buddha's manifestation, who is, after all, recognizable from birth as a godlike, perfect being (*mahāpuruṣa*) because of his thirty-two body markings and the eighty accompanying secondary signs.[d] The four lesser measurements are reduced variants of the ideal number 108, and are therefore suited only to representing human figures, distributed in proportion to the relative grandeur of the persons represented. The *Citralakṣaṇa* lists the following proportions for humans: "in their length, considering that there is one additional digit in the case of Kings, they should be reduced correspondingly by some digits in measurement [p. 107]." In the *Viṣṇudharmottara*, there are more exact instructions: sages, demons, ministers, ordinary Brahmans, and the king's royal priest (*purohita*) are

[7] The usual measurements are: *anu* (hair end); *likṣā* (nit: louse egg) = eight *anu*; *yūka* (louse) = eight *likṣā*; *yava* (barleycorn) = eight *yūka*; *angula* (finger's breadth or digit) = eight *yava*; *vitasti* or *thalam* [*sic; tāla* is correct—ed.] (span) = twelve *angula* [cf. *Citralakṣaṇa*, p. 80].

[d] For a complete listing of the thirty-two major signs and eighty subsidiary signs, see A. Foucher, *The Life of the Buddha* (Middletown: Wesleyan University Press, 1963), pp. 258–59.

to be depicted by a measure of 106 digits, whereas the king is 108; half-humans (*kinnaras*) and serpent creatures (*nāgas*) should be *mālavya*-size (104), as are women of rank. For purposes of pictorial representation, hetaerae and members of the third caste are of a measurement of the fourth degree (100), and those in the lowest of the four-level caste system, the Śūdras, are, by virtue of their measurements, considered to be "hares," 90 *angulas* in length.[8]

If these measurements, as set numerical sizes, apply to actual humans who are categorized as one of these particular types, then they assume, in the artistic representation of the human figure, the significance of an index number from which can be derived by exact rules a detailed scheme of that figure's minutest proportions. For the proportional theory of art, one *angula* is not so much an arithmetical quantity as an algebraic one, whose value is represented from case to case as the finger's width of the figure depicted. Within the framework of this theory, all proportions pertaining to the human figure are calculated as fractions of its length, or as multiples (also possibly fractions) of the width of a finger. The most disparate sources[9] give them for the ideal measurement of 108 *angulas*,

[8] Kramrisch makes reference to a passage of the *Brihat Samhitā* which indicates that these five types are also known in astrology. For these types, it is not simply a matter of height and the resultant body proportions; they are set also exactly as to skin coloring, weight, hair, and so on. Since, for the Indian, one's outward appearance represents a true mirroring of the spiritual substructure, there lies in these typings an attempt at character typology. The *Brihat Samhitā* not only indicates the spiritual inner life of these physical types, but it also sets down the relevant astrological predictions, which of course follow the horoscope of the individual member of each type. The outer and inner life, as well as the fate of man, are effects on different levels of one and the same size-number: effects of that *karma* which the individual has brought upon himself by his behavior in earlier lives.

The nomenclature in this typology is synonymous, in the case of "hare," with the masculine types found in the theory underlying Indian eroticism, which divides the Eternal-Masculine into three types: stallion, bull, and hare. [Zimmer coins the term "das Ewig-Männliche" as a counterpart to Goethe's "Eternal-Feminine."—ed.]

[9] Kramrisch gives a comparative table in *Viṣṇudharmottara*, p. 19.

and the artist calculates their shorter variations from the ideal schema. The overall size of the figures, which must be adapted to the size of the framework planned, must also be equated by the artist with the index number of one of the five types, according to their contextual relevance, in order to determine each detail according to the ideal proportional schema based on 108 *angulas*. The greater part of the *Citralakṣaṇa* is taken up with an exact analysis of that ideal schema. The face, for example, is divided up as follows:

> The face should be divided into three parts, forehead nose and chin, each of which should measure four digits. The width of the face is given as the total of 14 digits; the upper and lower parts of the face amount to 12 digits in width; on the ground of this measurement, the length of the face is taken to be 12 digits. . . . The width of the ears amounts to the two digits and their length to four digits. The opening of the ear is given as ½ a digit (in width), and 1 digit (in length). The same height applies to the tips of the ear and ends of the eye-brows; the eye sockets have the same height as the openings of the ears. . . . The space from the middle of the brows to the hair line amounts in width to 2 ½ digits. From the starting point of the brows to the expanse of the forehead a measure totalling four digits should be made. The eye sockets are 2 digits long; likewise is the space between the eyes. It is laid down that the eyes amount to 2 digits in length and one digit in width. The pupils of the eyes amount to ⅓ of the eyes; so is it laid down. . . .
>
> The nose is 4 digits (long), the tip amounts to 2 digits in height. At the point where the nostrils are shown in a slanting fashion, the width measures up to 2 digits. The width of the nostrils is six barley grains (¾ digits). Their height is laid down as two barley grains (¼ of a digit). The space between the nostrils measures two barley grains (¼ digit) and six barley grains in length [pp. 82–85].

And so all the body's proportions, down to the smallest detail, are standardized.[10]

Along with this normative schema for divine and godlike figures, there are others appropriate to the gods alone. In contrast to the reduced proportional schemas for the human body, which are constructed by subtracting a few digits from the ideal lengths and are, in their reduced state, not divisible by twelve, the images of the gods are not derivations from the normal schema, but have instead their own order of magnitude, whose measure of length is in every case a multiple of twelve. Twelve digits make a *thalam* ("span"), and according to the multiples of twelve that make up their lengths, these schemas are called "ten-*thalam*" (*daśa-thalam*), "eight-*thalam*" (*aśta-thalam*), "seven-*thalam*" (*sapta-thalam*), and "five-*thalam*" (*panca-thalam*) schemas, just as the schema with a length of 108 digits is called the "nine-*thalam*" (*nava-thalam*) schema. All of these are algebraic schemata.[11] Their application is not a matter of artistic preference; they are strictly appropriate to the various types of the gods' manifestations. Just as the "nine-*thalam*" schema seems to have been developed from the ideal human figure—the godlike saint (*mahāpuruṣa*, Buddha), whose exalted nature expressed itself in the perfect beauty of his physical body and was passed on as the norm for divine figures—so too, the other *thalam*-schemata seem to have crys-

[10] Further examples: "The nipples of the breast measure one full barley grain (⅛ of a digit) in height and the aureole, 2 digits in circumference. In the case of those who wear a lower garment and have a girdle tied around it, the part of the belly below the navel should be made to the measure of 4 digits. The penis is 2 digits broad, the scrotum is six digits long; the testicles should not hang too much and both should be shown evenly round. In the state of erection, they should measure 7 digits in thickness and 4 digits in length. One should know that the thickness of the penis should be 6 digits. The space between the penis and the edge of the belly should be 6 digits in measurement" [pp. 87–88]. These proportions are indispensible for the correct construction of the ubiquitous type of tantric statuary depicted in Plate 21.

[11] Cf. the sketches of these schemata in Hadaway, *Ostasiatische Zeitschrift*, 3, (1914–1915), 35–42. An elongated variant of the *nava-thalam* is also mentioned there reaching 124 *angulas*. An overall length of 111 *angulas*, instead of 108, is sometimes used.

tallized out of the characteristic physical qualities belonging to individual divine figures and have become the canonical proportions for them. The appearance of some female deities cannot be adapted to the schema of the ideal male figure without destroying the image's nature as an expression of its essence; furthermore, figures whose head and body sizes are in a proportion different from those of a well-formed adult human require a special canon. Consequently, Ganeśa in his corpulence, supporting on his squatty torso a massive elephant head, is shaped according to the *panca-thalam* schema, with his head (measuring one *thalam*) assuming one-fifth of his overall height. The same is true in the representation of Kṛṣṇa as a boy, where, befitting his childlike stature, his head (Plate 26, the *panca-thalam*) has to be larger, in proportion to his body, than it is in the case of the dancing Śiva (Plate 15, the *nava-thalam*), the ideal adult figure.

The basic element of the optical effect that this style owes to the structuring of its figures in exact accordance with canonical proportional systems is dealt with in W. S. Hadaway's article as follows: "A word of explanation in regard to the diagrams may be useful. One must grasp that they are all drawn in 'elevation' exactly as an architect or a cabinet maker would make a working drawing of the façade of a building, or front of a cabinet. It is, of course, quite impossible to ever see a figure exactly in that way, for it is a draughtsman's convention, assuming that the eye is on a level with each part of the figure at one and the same time" (p. 42).

What Hadaway presents here to explain his graphic representations of the proportional schemas is valid not only for them but also for the artistic creations themselves that are constructed according to those proportions; its validity holds in each and every respect for each and every Indian sacred image. And this optical discovery, which the Western observer can confirm by even the most superficial perusal of Indian images—as Hadaway noted in his sketches showing the proportions on which they are based—corresponds exactly to all that was learned "from inside ourselves" by contemplating the sacred image used as an implement during the

devotional act of meditation. The absolute quality of the image's crafting, which is intended to force the inner eye to dwell simultaneously on all parts of the figure at whatever level is appropriate for each part, is a result of the process of meditation, perceptible even to the uninitiated: the task of making itself adequately understood, which the sacred image imposes through its visible presence, cannot be accomplished by our physical eye, which keeps moving its focus at random from one spot to the next; instead, it can be accomplished only by the ability to concentrate uniformly and evenly on something complex—an ability developed only in meditation that can then be transferred through training to our outward eye, so that it becomes sunlike, illuminating simultaneously each and every area, large and small, on the entire image with an infinite number of light rays of equal strength and intensity, whereas the untrained outward eye is more like the roving beam of a single searchlight.

The absolute quality of the figurative sacred image's crafting proves that it is related to its functional counterpart, the linear *yantra*, which is geometric in its design. In effect, the conventionalized proportioning of their form makes these constructs independent of actual size, measured in meters or centimeters. The Vajradhara group (Plates 24, 25) is 18.2 cm in height, though it is anything but a miniature statue. In style and effect, it is akin to those gigantic Japanese Buddhas many times larger than a human body, which, rising high above the high-pitched temple roofs, can gaze out upon distant mountains, as to their equals in grandeur (Plate 46). Photographic reproductions of Indian representational works all too frequently leave the observer in the dark as to their actual size— Viṣṇu Trivikrama (Plate 28) is only 73 cm high, the dancing Kṛṣṇa (Plate 26b) only 39 cm, the dancing Śiva (Plate 15), 91.5 cm. The terms "large" or "small" are not applicable when trying to describe their size—they exist in a realm beyond small or large, as do the linear *yantras*, whose formal structure gives no indication that in fact their greatest width is a mere ten centimeters. The figure-filled Tibetan mandala paintings, when seen in photographic reproductions, could

be taken by a person unfamiliar with them for large-scale frescos or ceiling paintings as huge as those in the Sistine Chapel, whereas in reality they are just about the size of a newspaper page. The secret of this style is that the smaller examples have the effect of appearing large without being large, whereas the larger and even the largest examples, while they do appear sizeable, never give the impression of being gigantic. In absolute terms, they are neither large nor small; it is only the on-the-spot observer who sees them in relation to his own body size, who sees them in surroundings totally foreign to their original purpose, and who can assess ultimately their relative size. A photograph, on the other hand, isolates them from our own bodily dimensions and from our eye movements, which would immediately register the distance from the object as part of its dimensions. The photograph of a figurative sacred image preserves the absolute element in the scale of this style, in a way that lies beyond all "smallness" or "greatness" of actual dimensions. It is that word "beyond" that offers conclusive proof of its origin in inner vision. For the inner vision's image is indeed, as are the figurative sacred images themselves, clearly proportioned in its parts, but it is a completely self-contained composition on the mental plane and has no room for any possible secondary images against which it could be measured. Although it projects a grand or a modest style, it is itself neither grand nor modest. The canonical proportions of the craftsman's tradition preserve the technical secret of how to give the sacred image, as an external, palpable object, the same characteristic quality of the inner visualizations it serves as focal point and surrogate during the act of devotion.

The figurative sacred image's role in the devotional exercises of yoga, its interchangeability with the purely geometric construct, together with our present insight into its canonically fixed system of proportions, may serve to explain the feelings of estrangement we experience, trained as we are in different, Western habits of perception, whenever we come upon an image of this kind. Among art works, the sacred image of India is not alone in the absolute nature of its style;

it shares this self-contained style, for example, with Egyptian sculpture and with archaic Greek works (there, however, each is the product of so many different predetermining factors that a comparative approach to them could not possibly produce the same kind of conclusions reached by the more tightly focused approach attempted in this study). It was not until the beginning of the fifth century B.C., the Hellenistic Enlightenment associated with Democritus, the Sophists and their antagonist Socrates, that the epoch-making transformation of human consciousness occurred; raising man to the measure of all things, it gave birth to new rules for seeing and, consequently, reordered the world in a manner now familiar to us as classical, and presented classical art with a two-fold demand: "Be" and "Be Beautiful."

Its ontological imperative "Be Beautiful," which tempers the "terrifying" into the "darkly sublime," and the "hideous" into the "grotesquely comic," is alien to the self-dependent nature of the sacred image as an art form. If the image were to obey the imperative of beauty, it would compromise, even destroy (*aufheben*), its own highest principle: to express the essence of an absolute power. According to the *Viṣṇudharmottara*, there are in Indian representational art nine possible classifications of aesthetic taste (*rasas*), already familiar to us from poetic works: the erotic (*śṛiṅgāra*); the comic (*hāsya*); the empathetic (*karuṇa*); the heroic (*vīra*); the furious (*rudra*); the terrible (*bhayānaka*); the odious (*bībhatsa*); the marvellous (*adbhūta*), and the tranquil (*śānta*). While only the erotic and the tranquil are appropriate for the décor of the ordinary dwelling, all nine are suitable for works of art in royal palaces—and in the temples of the gods. There must be no diminution of the fearsome aspect of the Divine, before which all living things dissolve in abject terror; and though the depiction of the dreadful would be full of evil portents for the ordinary dwelling, that same image is in its proper setting where the Divine, simultaneously awesome and benign, has Its abode. Not one jot or tittle of the horrifying intensity of the pose may be omitted from the essential nature of the god's aspect, and any reduction of the measurements used in depicting the Divine

would result instead in demonic creatures.[12] Anyone attempting to capture an aspect of the Absolute in artistic representation relinquishes his freedom to modify it for aesthetic reasons, an artistic license he still retains, within traditional limits, when representing human beings.[13] For the image of the Divine serves magical purposes, and the construction of it must clearly acknowledge the primacy of faithfulness to the essence—just as that very first image, the deceased Brahman child, projected by the pious king from inner vision into external matter, was able to be open to the god's magical, galvanizing action because of the faithfulness of the reproduction. Like that image, the figurative *yantra* can be inspired with divine life through the "consignment of breath," because it is a faithful reproduction—in its awesomeness as well as in its charm—of the god's self-revelation as experienced in meditation.

The Vajradhara group (Plates 24, 25)[e] may appear odd to Western sensibilities, just as the fundamental things about the fashioning of the Indian sacred images necessarily appear strange to Western eyes; this is so because, where the image is viewed outside the context of its native cult in which it

[12] Cf. the *Citrakalṣaṇa*, [p. 104]: "if one were to set aside human figures and the gods in the study of dimensions and composition, and make room only for Piśāca, Rākṣasa, and such creatures, they would soon destroy mankind's happiness and greatly impede the most noble of human efforts." That is, wherever one departs from the canonical dimensions of the divine manifestation, one creates demonic creatures (like Piśāca, Bhūta, and so on), and if one worships figures such as these, constructed contrary to rule, one delivers oneself over into the power of the Evil Ones. There simply are no independent schemes or systems devoid of meaning that exist alongside the properly proportioned ones for gods and men; any systems that deviate are demonic and, as a consequence, dangerous.

[13] Cf. the *Citralakṣaṇa*, [p. 107]: "the ruling classes, the lords, are painted (in the same manner as) the figures of those of lowest caste; all are appraised as to length and breadth, and the respective proportions are estimated. Therefore, one is to use one's own judgement in the depiction of all those born of women. . . . Neck, head, navel, chest, loins, upper and lower thighs, knees, and both feet ought not because of their measurements to seem ugly in appearance."

[e] See also Zimmer, *Art of Indian Asia*, II, plates 610, 611.

functions as a *yantra*, we view it as we would any random piece of modern art or a remnant from the great tradition of the past in which we have our roots. For that reason, misunderstandings concerning sculpture like this were easily possible and resulted in a condemnation of what, basically, was not comprehended. Indian images of this type do not memorialize a situation; they do not render or depict a scene, any more than do the interpenetrating triangles of the Śri Yantra, as they merge into one another to signify relatedness. They are a symbol meant for solitary meditation. The intertwining of the Vajradhara's *yab-yum* figures is utter solitude—but not the intimate solitude of a happy couple's night of love, not even the solitude of elemental natural forces that, once unleashed, are oblivious to our perception of them and to their effect on us; it is rather the solitude of an existential polarity outside of which nothing may exist that exists—a polarity in whose unification is found the Whole. Unquestioned reality, compelling to anyone with the purity of vision to see it; existential expression in a piece of sculpture; a metaphor of Truth shaped by Śaivite tantrism—all these, draped in the transparent veil of Buddhism's grand idea, are exhibited here for the initiate's inward eye. The Divine Essence, which is both Being, eternally at rest, and Motion, constantly at play, exists here, fixed in totally compelling, immobile form, beyond the oscillating shimmer of some time-bound gesture and beyond the transitoriness of the moment; it lives here in a pose of love, in the face of which all things bound to time and space—the onrushing, crashing breakers of desire and the prolonged drifting, gradual ebbing of bliss—are in our beclouded consciousness but fleeting reflections.

From the eyes of these calm countenances, completely transfigured from within, their gaze steadfastly interlocked, even the uninitiated can perceive something of the compelling quality that expresses the Indian sacred images' essential nature, of the power of that imperative to meditation, that power which finds unambiguous expression in the geometric severity of the purely linear *yantras*. But when the total solemnity of the God's nearness—having captured the Divine

schematically, *more geometrico* in those *yantras*—expresses It *more figurali* in the *pratimā*, then the solemnity demands complete freedom to choose the right symbols portraying the experience of divine presence; when the Divine is depicted through those figures, human morals and conventions are not so much transgressed against as they are transcended, for they have already been fulfilled at the merely human level. The Vajradhara couple's interlocked gaze expresses an ultimate, utterly inexhaustible, complete merging of two figures who totally permeate each other that surpasses any possible metaphoric use of passionate movement. The magnificent counter-positioning of the heads of two beings who are fused insolubly into one expresses a state of a Two-in-One as no depiction of even a kiss might, since lips, searching, seeking, swelling, lingering, can never achieve a point at which they actually become one; they glide or race instead, from one movement to the next, in a naive sometimes desperate attempt to express, through finite gesture, what is infinite in nature— only to experience in the end their own insatiability, their own inadequacy. The Two-in-One of God and World, of Man and God, finds its most perfect expression in the sphere of fulfillment where space dwindles away, where time stands still, both in the entwining of the physical bodies and in the calm, collected stare of this interlocked gaze that is as unflinching or unblinking (*animiṣa*) as the eyes of the gods, or the yogi's gaze when he envisages, with his inner eye, godlike Truth.

· V ·

The Place of the Sacred Image in
the World of the Believer

AN IMPORTANT late Buddhist text, *The Unfolding of the Basket
of Avalokiteśvara's Characteristics,*[1] culminates in the recounting
of the "Six-lettered Great Doctrine of Wisdom."[2] With mag-
ical syllables this grand formulation characterizes the essence
of Avalokiteśvara, the great Benefactor who in his many
guises ceaselessly roams the worlds to guide their creatures
to Enlightenment, when he does not happen to be helping the
All-Compassionate One, Amitābha, with his labor of libera-
tion in the Western paradise. "This Six-lettered Great Doc-
trine of Wisdom is the inmost heart of Avalokiteśvara, and
whoever knows of this inmost heart, knows of release."[3] In
the realm controlled by the Lamaist theocracy of Tibet, this
"wisdom" has become the national maxim and prayer because
its supreme ruler, the Dalai Lama, is always considered to be
the most recent of the unending reincarnations of Avaloki-
teśvara; in this "wisdom," the exalted Being appears as a fe-
male figure, named the "Jeweled Lotus" (Manipadmā); in
China and Japan, too, as Kuanyin/Kwannon, Avalokiteśvara
is venerated predominantly as a female. The "Six-lettered
Great Doctrine of Wisdom" is a formulaic prayer like those
countless other mantras with which an initiate summons one
aspect of the Divine in order to worship it inwardly or to
establish it in a *yantra* for purposes of the ritual practice. Its

[1] *Avalokiteśvaraguṇakāraṇḍavyūha.* [Edition used:] *Kāraṇda Byūha: A Work
on the Doctrines and Customs of the Buddhists,* edited by Satya Bratu Samasrami
(Calcutta, 1873).

[2] *Ṣadākṣarī mahāvidyā;* a more complete formulation would add: the
"Queen": *ṣadakṣarī mahāvidyā rājñī* (see, for example, pp. 67, 74, 80, and 83).

[3] Ibid., p. 67.

words are: "*om Manipadme*[4] *hūm.*" Since it expresses Avalok-
iteśvara's nature, the *Kārandavyūha* calls it the "Essence of the
Great Vehicle"—of that later Buddhist doctrine, to the effect
that all creatures are Buddhas-in-the-Making—and attributes
to the bodhisattva "Who Removes All Obstacles" (Sarvanī-
varaṇaviṣkambhin) the following words: "Whoso giveth me
the Six-lettered Great Doctrine of Wisdom, to him I would
bequeath the four quarters of the earth, heaped high with
seven kinds of jewels. Should he find neither birch bark on
which to write, nor ink nor paper, let him use my blood for
ink, take my skin for bark, split one of my bones for a reed
pen—none of these shall harm my body. He would be to me
as father and mother, of all things venerable the most ven-
erable."

To come into the possession of the Great Royal Wisdom,
the Padmottama Buddha ("Supreme Lotus") had traversed an
infinite number of worlds. In vain. Finally he reached the
Amitābha Buddha and asked him for the sacred formula:

> Then, with a voice as soft as the cuckoo's call, Amitābha,
> who Has Come in Truth, the Holy One, the Truly En-
> lightened One, did speak to Avalokiteśvara, the Bod-
> hisattva and Great Being: "Behold, O son of noble house,
> here is the Padmottama, who Has Come in Truth, the
> Holy One, the Truly Enlightened One; he has traversed
> weary millions upon millions of worlds, all for the sake
> of the Six-lettered Great Doctrine of Wisdom—grant
> unto him, O scion of noble lineage, the Six-lettered Great
> Doctrine of Wisdom, the Queen. He who Has Come in
> Truth has wandered so far!" [No one is more able to
> reveal the most profound secret of his nature, the "inmost
> heart of Avalokiteśvara," than he himself.] Then spoke
> Avalokiteśvara to the Sublime One: "It may be revealed
> to no one who has not beheld Its mandala—how is he
> to perceive the 'lotus symbol' gesture [*padmānka mudrā*]?;
> how is he to understand the 'jewel-holding' position
> (*manidharā mudrā*)?; how is he to understand the hand ges-

[4] Vocative.

ture 'Mistress of All Kings' [*sarvarājendrā*]? How is he to understand the perfect purification of the mandala?

"This is the mandala's design. A four-point [*caturaśra*], five hands'-breadth in circumference. In the mandala's center, Amitābha should be drawn. Ground sapphire, ruby, emerald, and crystal, powdered gold and silver should be combined in the image of Amitābha, who Has Come in Truth. On the right-hand side, the Bodhisattva should be drawn, the 'Great Bearer of the Jewel' [Mahāmanidhara: evidently a male aspect of Avalokiteśvara, to whom Manipadmā corresponds as a female manifestation, just as the *manidharā mudrā* expresses his essence in its finger gesture]; on the left, is to be drawn the Six-lettered Great Doctrine of Wisdom [which appears in sign language as the *sarvarājendrā-mudrā*]: four-armed, yellow in color,[5] richly ornamented. In her left hand, a lotus should be placed, in her right, a prayer wreath of nuts. Two hands should be depicted, clasped in the gesture [*mudrā*] called 'Mistress of All Kings' [*sarvarājendrā*]. At the feet of the Six-lettered Great Doctrine of Wisdom, a [guardian] spirit should be placed, full of magical knowledge [*vidyāhara*]. In his right hand, there is to be placed an incense spoon from which smoke arises. In his left, there is to be a basket filled with many kinds of ornaments. At the four portals of this mandala, the Four Great Kings [the divine Protectors of the Earth, cf. *supra*, Chapter 3, n. 72] are to be placed, with an assortment of weapons in their hands. At the mandala's four corners are to be shown four vessels filled to the brim with all kinds of jewels."[6]

The Buddha Amitābha then asks Avalokiteśvara how an initiate is to provide all this if he is too poor to acquire the costly pigments for painting the mandala; and the response is

[5] *Śarabhakānda-gauravarṇā*, yellow, like a grasshopper's egg.

[6] See Plates 20 and 21, and the phrase concerning Gaṇeśa's image: "containers . . . agleam with pearls and rubies, and constantly raining down streams of treasures," *supra*, p. 141.

that, instead of pulverized jewels and precious metals, he is to use flowers and fragrant oils in the corresponding colors. Amitābha asks further what is to happen if even these prove too much. He hears in reply: "Then the teacher is to create a mental image of the mandala [and] the characteristics of the mantras and *mudrās* are to be demonstrated by the teacher." Only after this explanation does the Padmottama Buddha acquire the Six-lettered Doctrine of Wisdom.[7]

It is only in keeping with the great sanctity and infinite power contained in this formula for the release of all creatures that, whenever possible, its corresponding visible image should be prepared with the use of the finest materials. But if Avalokiteśvara refuses to pass on the Six Letters without a description of their related mandala, the reason is that the formula, as audible sound, is incomplete and useless unless accompanied by its counterparts: the hand sign [*mudrā*], the mental and the external images. If this formula [mantra] is to transform a person and lead him to the state of Enlightenment, then its essence, the exemplary and miracle-working character of Avalokiteśvara, has to permeate every one of the initiate's spheres of reality and activity: his language, his mental world, even his body's movements and posture. Functionally, the *yantra*—in the *Kārandavyūha*, a mandala—in any event never stands simply for itself; for the *yantra* to be at all effective, knowledge and practice of other kinds of manifestations of the divine being's "inmost heart" are required, beyond that one visible sign represented by the *yantra*. And even in the visible sphere it is not the only possible manifestation; Hindu tantrism recognizes as such a sign a person who confronts the initiate as a revelation of the Divine. In the male form this would be the teacher (guru), as the *Kulārnava Tantra* teaches:

Śiva, the omnipresent one, too exquisite to be perceived, the Ecstatic One, the Undivided, the Immortal, Like-unto-Heaven, the Unborn, the Infinite—how is he to be worshiped?

[7] Ibid., pp. 73–76.

It is to answer this question that Śiva has assumed the body of a teacher and dispenses, if he is worshiped with passion, material [*bhukti*] and spiritual release [*mukti*].

Clothed in human form, Supreme Śiva Himself walks the earth, to the delight of all true disciples.

The third eye upon my brow [Śiva himself is speaking] and the crescent moon and two of my arms I do conceal, and roam the earth in the guise of teacher [guru].

Just as "*ghata*," "*kalaśa*," and "*kumbha*" all have the same meaning [a "pot"], so too "god" [*deva*], "sacred word" [mantra], and "teacher" [guru] are used in describing one and the same thing.[8]

Similar is the teaching of the *Tantrarāja Tantra*:

Let the initiate's love of God be as his love of the sacred word; of the sacred word, as of the teacher; as of the teacher, as of his own Self: this is the ascent of love's devotion [*bhakti*].

He is not to regard the teacher as something mortal; if he does so, he will never attain perfection [*siddhi*] by means of sacred formulae [mantras] or by worship of the god [*devapūjana*].[9]

This is why the guru is given the epithet "Śiva" in the hymns chanted by the initiated disciple in honor of the guru's birthday: "He Who has Śiva's Form [*śivarūpin*]," "He Who Assumes Many Shapes," but "Who Has in Truth but One"— he is "the Sun Which Dispels the Darkness of Ignorance," "The Solidifying of Consciousness [*cid-ghana*]," and "his nature is Śiva [*śivātman*]."[10]

The guru is worshiped as God though he is not of himself God, but rather an initiate perfected in Divine Truth; whoever is guided by his hand, finds himself on the path to his own

[8] *Kulārnava Tantra*, XIII, 51, 52, 54, 56, and 64. Cf. the crescent moon in the forelock, the brow's [central] eye, and the four arms in Plate 15.

[9] *Tantrarāja Tantra*, I, 30 and 38.

[10] Ibid., I, 96–98. The five hymnic strophes are translated by Avalon in his "Introduction," p. 17, as "Hymn to the Guru." Cf. the related prayer in the *Kulārnava Tantra*, XVII, 3–5.

divinity if he worships the guru as God. Since the love of God, of the teacher, and of one's own Self basically are one and the same—as in the case of "pot," only the names are different—the deification of the teacher is the way to one's own perfection (*siddhi*): "let him know that he is ever one with his teacher and the same, that they are not two separate natures [*advaitam—na dvaitam*]. Let him show love to all creatures as though they were himself"—these are words from the twelfth chapter of the *Kulārnava Tantra*, which treats of the "Characteristics of Devotion to the Sacred Footwear of the Teacher" [v. 1—ed.].

Appearing in the last epoch still purely Indian in nature, concepts and instructions like these reveal the godlike, aristocratic attitude the *brahman* initiates in the ancient Vedic tradition had developed through self-contemplation thousands of years before: the devotees' role as "gods upon earth." A human being recognizes himself as a manifestation of the Divine. The ultimate reality at the heart of the dyad "teacher-disciple" is the oneness of the Divine Nature found in that duality; elucidation of this identity, and its indiscriminate application to everything in the world, is the goal of this dyad: these three things explain more clearly than does the sole fact of the esoteric nature of the tantra doctrine the stringent demands placed on the teacher-disciple duality. "He who needs only to indicate the Truth, and to see his disciple become Truth at that same moment, and to know his Self [*ātman*] to be released—he and he alone is guru": this is the wording in the thirteenth chapter of the *Kulārnava Tantra* (v. 96), where it characterizes teachers and disciples; but this miracle of instruction can be accomplished only with a few select disciples, as indicated in the chapter on initiation: "A teacher is to examine carefully his disciple's mind and deeds for a quarter, a half, or even a full year"[11] to determine whether he is worthy

[11] *Kulārnava Tantra*, XIV, 19, an instruction reminiscent of the ancient stories concerning disciples from Vedic times, of Satyakāma Jābāla and Dhaumya Āyoda. Cf. further v. 18, for the characterization of the teacher: "If a teacher confers initiation upon the disciple for money, or out of fear, greed, [or underservedly; in original—ed.], he will harvest the curse of the Divinity,

of and mature enough for initiation. For between the genuine
teacher and the disciple who has a vocation, initiation works
like a transformational process in alchemy: "Just as iron, per-
meated with the king of metallic essences [*rasendra*], attains
the nature of gold, so also does a Self, properly initiated,
achieve Śiva's nature."[12]

In the same way that the dual relationship between disciple
and teacher derives its meaning from their single identity as
one Divine nature, transcending the split between the I and
the Other (the Thou, the World) brought about by human
consciousness; and in the same way that this relationship, if
the initiation's aim of attaining one's own Divine Nature is
to be realized, must be expanded to embrace all creatures in
a comprehensive love, aware of itself as one with all things,
so too, the relationship between man and woman must of
necessity be the total unity of Śiva with his Śakti, the supreme
Goddess; it must be the same relationship the divine couple
have to each other, in which the One without Attribute (*nir-
guṇam brahman*) divides into primal poles in the ultimate state
of its unfolding *māyā*. The spouse is her husband's *śakti*; and
where Śiva, the male element in the highest unfolding of the
Divine into poles, appears to the initiate as a human, a teacher,
so too the divine Śakti confronts him in personalized form,
in the figure of his own wife—indeed, in all that appears in
female form; the *śakti*'s unfolding in play is both the whole
world and his very own Self. In the place of a figurative sacred
image or linear *yantra* into which the initiate inserts the Divine
slumbering within himself to worship It, once he has aroused
It through mantra, *dhyāna*, and touching (*nyāsa*), and once he
has brought this Divine completely into his consciousness, he

and that which he has done will bear no fruit." The act of initiation is not a
magic trick; it is the conferring of the teacher's internal transformation upon
the disciple who is himself mature enough for the same transformation. [Cf.
further ibid.,] XIII, 48: "[the teacher is to be] addicted neither to women nor
to money, immune to sicknesses and such evils, filled with the spiritual state:
'all is I,' devoid [*nirdvandva*] of all duality [of I and world, etc.], steadfast in
all his vows."

[12] *Kulārṇava Tantra*, XIV, 89; *rasenda*, mercury, the quicksilver of alchemy.

can, in the Kula tantra rite, worship a living female person—child, girl, or woman—as a manifestation of the divine śakti. The *Kulārnava Tantra* treats this point extensively in its tenth chapter:

> In the month of Aśvin he is to perform his devotions to nine girls; early in the day, the initiate is to extend an invitation to them, full of the love of God [*bhakti*], with a pure heart.[13]
>
> The initiate is to bathe a sweet, little, one-year-old girl, adorned with symbols of good fortune; and following this, pure in spirit he is to present before the child his devotions to the Goddess in the prescribed sequence. When the child has been purified by baths and ointments, let the initiate bear her to the seat of worship, place her where the deity is contained [*devatāsannidhi*, that is, into the linear *yantra* where the living figure is placed so that it may become its figurative content] and pay his devotions to the child. He is to delight her with perfumes, flowers and the like, with incense and lights, with sweetmeats, food, drink and more, with milk, clarified butter, honey and meat, with bananas, coconuts and other fruits.[14]

A human likeness of divine energy revealing itself with attributes in female form is suitable as a figurative *yantra* as long as the initiate does not see in it the individual human, but knows it for the deity it contains: "When he sees a little girl [*bālā*] all adorned, he is to know her as the deity of his heart; after that, he is to worship her, looking upon her as the deity [*devatābuddhi*], and then he is to let her go."[15] But this worship of the deity in the form of a living female is tied to the use of the *yantra* as a ceremonial seat for the person worshiped: "if worship takes place without a *yantra*, the deity

[13] Ibid., x, 20. The number nine corresponds to the nine-three-point figure of the design with nine triangles in the *yantra* of the Goddess. Cf. *supra*, Chap. 3, n. 45.

[14] Ibid., x, 21–23.

[15] Ibid., x, 25.

finds no favor in it"[16]—an instruction that also could serve to ensure the ritual solemnity appropriate to the act of worship. Its chief purpose is, by inserting a human figure into the linear organizational schema of the divine essence, to turn a mere child into a completely appropriate receptacle for the Divine to be worshiped.

Similarly, one is to worship, "on the ninth day of the waxing and waning moon, nine little girls, one to nine years of age," that is, each girl is to be one year older than the next; they represent nine aspects of the deity.[17] "In his belief that they are the deity [*devatābuddhi*], the initiate is to worship them.[18]. . . Or, on the other hand, for nine successive nights let the initiate [*mantravid*] worship [with the same ritual] in his love of God [*bhakti*], nine young maidens in the bloom of youth [*yauvanārūdhā pramādā*] who are beautiful."[19]

The text goes on:

> . . . on a Friday he is to invite and summon a beautiful maiden pleasing to his eye [*kāntā*], in the bloom of youth, of great charm bedecked with all the auspicious symbols . . . and just past puberty.[20] He is to cleanse her body with bathing and ointments and place her upon the ceremonial seat. He is to adorn her according to the instructions, with perfumes, flowers, garments, and ornaments, and, following this, adorn himself as well with ointments, flowers, and so forth. He is to install the deity into the maiden and offer her sacrifices through the ritual of touching [*nyāsakrama*]. Once he has worshiped her in the proper ritual sequence, and sacrificed incense and candles to her . . . in his belief that she is the deity, he is to delight her, in his loving devotion, with things to eat,

[16] Ibid., x, 109.

[17] Ibid., x, 27–33. As aspects of the deity their names are Bālā, Śuddhā, Lalitā, Mālinī, Vasundharā, Sarasvatī, Ramā, Gaurī, and Durgā (v. 27).

[18] Ibid., x, 30.

[19] Ibid., x, 34. Among these nine aspects of the deity, the following are included, according to their sequence of names: sorrow, great distress, "the Terrible One," desire, perception, and deed.

[20] *Puṣpiṇī*, one who has the flower, that is, has menstruated.

each of which possesses one of the six types of flavors,[21] with meat and other foods and sweetmeats. When he sees her delight at its peak [*praudhāntollāsasahitā*], he is to utter the Goddess' sacred formula [*manu-mantra*], himself filled with the joy of youthful vigor [*yauvanollāsasahitā*], and his thoughts totally immersed in the ritual image of the deity. Once he has with unwavering attention offered up to her the spoken formula, among other things, one thousand and eight times,[22] let him pass the night with her. Whoever worships in this way for three, five, seven, or nine Fridays receives benefits [*punya*] beyond measure deriving from his piety.[23]

The *Tantrarāja Tantra* teaches how the worship of a particular aspect of universal divine Śakti, called "Nityā Nityā," is to be performed with the aid of seven young women:

> let him through meditation see these goddesses [who are aspects of Nityā Nityā], in the manifestation described; let him worship them in the *cakras*. . . . Likewise let him place in the seven *cakras* seven young women who have the appearance of goddesses [*tad-varnā*] and are lovely to behold; let him worship them in the order described above. Let him delight them with flowers, garments, perfumes, meat, and other foods. If they are pleased, then the *śaktis* who are like them will be satisfied as well. [xvi, 89, 91–92]

Along with these appearances of divine Śakti in human form, which are used for special ceremonial purposes, she is normally found in her role as the initiate's spouse. She is called "*svaśakti*," "the personal *śakti*."[24] In the *Kulacūḍāmani Tantra*,

[21] These are: sharp, sour, sweet, salty, bitter, dry.

[22] A multiple (9 × 12 = 108) of the favorite figure used, for example, in litanies of names that attempt to comprehend all aspects of a deity, and applied here because it is divisible by nine.

[23] *Kulārnava Tantra*, x, 39–45.

[24] Cf., for example, *Kulacūḍāmani Tantra*, Tantrik Texts, IV, II, 29 (also called "*nityakāntā*"), as opposed to "*para-śakti*," "the wife of another [man] [II, 30]."

the "crest-jewel of Kula doctrine," divine Śakti finds the words for her relation to the Divine-Masculine, Śiva, illuminating the relationship of the spouses to each other with concepts and rites taken from the tantras:

I become one with Thy body; in union with Śakti, be filled with power [*prabhu*]. Other than me, there is no mother who can make manifest that which has been conceived. Therefore, whenever that which has been conceived is unfolded, son-ship is with Thee.

Other than Thee, there is no father who makes manifest that which has been conceived, so that Thou alone art [my] father and no other. At times Thou hast the form of father, at times Thou wearest the guise of teacher, at times Thou appearest before me as a son, at times Thou art my disciple.[25]

From the sexual union of Śiva and Śakti the world is unfolded. Whatever does exist in this world, it is all comprised of Śiva and Śakti. Therefore, Thou art everywhere—and everywhere am I, O Lord Most High! Thou art all, O Lord of Lords, and I too am all, Thou Eternal One![26]

In words like these, the insoluble marital bond in ancient India is exalted to become a tangible symbol of the divine essence—its "Two-in-Oneness"—that found its ultimate and most visible outward expression in the widow's death by fire: in a union which looked upon that rite, beyond the episodic nature of birth and death, as an affirmation of its immortality through the infinite course of India's countless ages.[27] The mystery of the Divine that, viewed from its female aspect, is

[25] The deity's self-revelation in the tantras takes the form of dialogues of the Divine with Itself which, separating into Śiva and Śakti, has each part take on the role of the other's teacher, alternating between the male and the female.

[26] *Kulacūḍāmani Tantra*, VII, 81–86.

[27] Ancestor worship and, therefore, the Brahman family order rest upon the assumption that the son is simply the rejuvenated father, and that family order has managed to survive the doctrine of transmigration of souls, even though negated by that doctrine's basic belief. Cf. Aśvalāyana's *Domestic*

at one and the same time father and son reflects an ancient belief in the woman's role as the womb from which the spouse came. Manu's *Book of Laws* summarizes this view in the following formula (IX, 9): "The spouse [*jāyā*] is spouse [*jāyā*] for the simple reason that the man is, in her, born again [*jāyate*]." The female spouse is the mother of the male spouse because she is the mother of his son, in whose person the man achieves new life, earthly immortality.

Everything in the world is Śiva and Śakti: in the sexual union of the spouses, the polar tension of the Divine's duality collapses into oneness; in this union, human consciousness crosses the borders of its isolation and enters a realm beyond polarities, to the point where it dissolves its polar nature—it becomes *nir-dvanda*. Eroticism in marriage is one means to the experiencing of one's own godlike nature, where the distinction between I and Thou disappears, where the world falls away, where pain and desire and all the other polar opposites are transcended (*aufgehoben*).

This understanding of marital Eros, where the spouses view each other as Śiva and Śakti, gives to our sphere of elemental drives an awareness of its inmost nature, transforms natural passion into a serene pastime of the Divine, transfigures the sensual, and makes the marital bond itself divine.[28]

With a conceptual language derived from the Sāmkhya doctrine, the *Kulārnava Tantra*, in its eighteenth chapter dedicated to the God of Love,[a] describes the sexual union of the spouses as the homecoming of the Divine from Its divided nature in human consciousness: " 'The man whose physical body is a shimmering, playful sense of Self [*ahamkāra*], whose

Customs, I, 15, 9–10: "When the father returns from his travels, he embraces his son's head and murmurs a salutation: 'Limb for limb thou has been created; thou art born from the inmost heart. Thou art my Self with the name of "son," and mayest thou live as such one hundred years.' Whereupon he kisses him thrice upon his head."

[28] Cf. *Kulārnava Tantra*, V, 111–12: "Whoever treats his spouse as *śakti* [*sevayet*], is servant to *śakti* [*saktiśevaka*] . . . the others are slaves to women [*strīnisevaka*]."

[a] There is an error here: the *Kulārnava Tantra* has only seventeen chapters.

member[29] is his sixth sense [*manas*], the abode of Delusion, should copulate with the woman, whose body is intelligence [*buddhi*], whose womb is Thinking [*cittam*].' Whoever loves his wife and interprets the act of love in this way will attain happiness in life [*bhukti*] and release [*mukti*] and will enchant the hearts of women."[30]

The Sāmkyha doctrine views intelligence (*buddhi*) as that which is the "Great" evolving, as a material derivation, from the "Undivided" (*avyaktam*); from intellect, there derives further a feeling of self; within that in turn we distinguish inner consciousness, the five senses and five modes of action; ultimately, from that feeling of self there evolves the material external world in its coarser or finer forms; there arises the Other to confront the I. In the hierarchy of Sāmkyha concepts, there is no special place for Thinking (*cittam*) as such; it is a function of intelligence (*buddhi*).

Here we are taught that the sexual union is to be performed as the definitive homecoming of the highest manifestations of the Not-Yet-Unfolded into Its own undifferentiated oneness. Intercourse is both a symbolic event and the sensual basis that assists the individual soul in experiencing its own all-embracing, godlike nature; it is a sacrament that will transform anyone who has been initiated in its meaning.[31]

Perceiving divine Śakti in all that is female, tantrism, in its "Kula doctrine," exceeds the limits of the marital relationship. "Kula," the "family" as a unit made up of man, woman, and

[29] Here the member is designated as "*śiva*," the Eternal Masculine—just as, conversely, the *linga* is the most commonly encountered representation of Śiva in the temples, and just as those *linga*-like formations found in nature are places of pilgrimage.

[30] *Kulārnava Tantra*, XVIII, 27–28.

[31] Still alive here is the millennia-old Vedic theological belief in the magical power of knowledge: "*yo evam veda*"—"who knows it in this manner," that is, whoever knows about the hidden sense of a ritual or of a profane act and practices that act with this knowledge, enters thereby into a new network of relationships, into a forceful combination of those powers that his occult knowledge understands in all its effects. This is a fact fundamental to all religious experience and education, a fact that, from its new focal point, presents the profane world with an interpretation the adept is able to follow.

their issue, as the "Three-in-One," so to speak, is the symbol for the total identity of the Knower, Knowing, and the Knowable—of "the Measuring" (*mātra*), as it is called, "Measure" (*māna*), and "the Measurable" (*meya*); that is, of "Individual Soul" (*jīva*), "Knowledge" (*jnāna*), and "All Things" (*viśvam*)—of the diversity of the phenomenal world. They are "Three-in-One" as manifestations of one and the same Śakti, which can appear as different only to a consciousness that is unknowing, ensnared in its own isolating boundaries.

The experience of this oneness is not to be gained through a mere act of reflection; a genuine assimilation of it can only be the result of a transformational process that—like all yoga—demands the total effort of the whole man. The limits of individual human existence must not only be surmounted in thought, but dissolved and eliminated in the ritual; for the return of the Divine from Its differentiation to suprapolar oneness is no flight of fancy, but an actual transformation within the realm of Being.[b] As an individual, the Hindu is bound throughout his life to sacred and moral religious systems that, since they are divinely ordained, envelop him from the hour of his birth and possess different sets of duties varying with the individual's caste and gender. In fulfilling these duties, man is constantly aware of and confirmed in the special quality of his Being; in carrying them out faithfully, he is because of his probity guaranteed happiness in this and any future existences; but this does, on the other hand, keep him bound, unreleased, in his isolation. The Kula doctrine perceives, then, a path that leads to divine suprapolarity by bursting the bonds that maintain and sustain individual existence—not through the performance of some profane, immoral acts, but through rites strictly regulated in Kula ritual practice (*Kulācāra*).

Just as deadly poisons administered at the right time and in proper dosages can save a life, so too, *Kulācāra* prescribes

[b] This paragraph represents a statement of conviction for Zimmer. He believed in the possibility of an "actual transformation" for man even in the twentieth century. As he noted in n. 48 of this chapter, he saw signs of a coming "transformation of Western man."

things forbidden in everyday life as components of its rite that will reveal to the initiate the path to his becoming divine. These ingredients are called, for brevity's sake, the "five M's" (*Ma-kāra-pancaka*): alcohol (*madya*), meat (*māmsa*), fish (*matsya*), and illicit intercourse (*maithuna*); the fifth is the positioning of the hand and fingers (*mudrā*).

All of these "are pleasing to the Deity."[32] In the profane world, the enjoyment of the first four is considered to be more or less grievously sinful. It is not so much their basic ability to intoxicate and liberate a person that makes them into sacramental elements, but rather the fact that they have the power, ennobled by rite and enshrined in ceremony, to transport the initiate beyond the moral order of his everyday existence. Dramatic contrast lends an aura of holiness to that which is morally reprehensible. Rescinded here by ritual are the ethical commands that set limits for the individual in the profane world and shape both his behavior and what is permissible or prohibited; they are abolished through the rites in order to allow for the experience of a sphere that is undifferentiated, beyond polarity. The initiate's task is to enter this world in order to experience himself in its atmosphere as someone totally other than he could know, or might know, in the everyday world. The physical pose of the Perfected One, of the suprapolar Deified One, is anticipated in ritual in order that, through experience and practice, it might become as one with the initiate's body, so that the transformation of his essence might be effected. In the ritual performance he is to anticipate the idealized pose that is his goal, so that it becomes second nature to him. Just as the Buddhist adept of the "Circle of Bliss" views himself as the combined Mahāsukha figure in the innermost part of the mandala, so too, the initiate of *Kulācāra* assumes the pose of the Supreme Śiva, who is inseparably linked with Śakti. And since Śiva and Śakti are to be found everywhere, he transcends the confining tie with his own wife (*svaśakti*) accorded to him in his own solitary, individual existence, and can unite with a *para-*

[32] *Kulārnava Tantra*, X, 5.

śakti[33] for the duration of the ritual act. In so doing, he transfers into the sensual and corporeal realm what the Buddhist adept of the *Śrīcakrasambhāra* performs during the act of meditating upon a mental image. He who actually lives a truth in truth—performing either inner or external acts—will be able to experience that it is true. There is no other path leading to it—only one path emanating from it: Divine Favor.

The secret of *Kulācāra* technique lies in its prescribing for the rite things that are shunned in the everyday world, for it is obvious that the undifferentiated, suprapolar state of the purely Divine stands in clear contradistinction to human existence, which is in so many ways determined and delimited. There seem to be no integrating links between them; the only possibility is to transcend (*aufheben*) them:

> The delight in indulging in alcohol, meat, and women is release [*mokṣa*] for initiates, mortal sin for the uninitiated.
>
> Śiva has revealed the Kula path: whatever is base in the world [of the uninitiated], is sublime; whatever is sublime there, is base. Evil [*anācāra*] is good; whatever is forbidden [*akāryam*], is the highest duty [*kāryam*].
>
> Whatever is forbidden to drink, is to become our beverage; whatever is forbidden to eat, is to be our food; she with whom one is not to copulate [*agamya*], with that very person one is to copulate [*gamya*], if one be a Kaulika [a follower of *Kulācāra*].

So that a person may experience the undifferentiated unity of all things, the text continues:

> for the followers of Kula, there is neither command nor prohibition, nor pious works, nor sin, nor Heaven nor Hell;
>
> for them, enemies are become friends, all lords of the earth will be openly known as slaves; all beings are become brothers for the followers of Kula;

[33] "*Para*," "the other" [cf. n. 24 *supra*].

for the followers of Kula, those who have turned their faces away, look upon them now in friendship; all the arrogant and the mighty show humility; those who have raised obstacles now provide assistance;

death, for the followers of Kula, is become the physician; the house has obviously become Heaven; sacred is the contact with women. . . .

The adept of *Kulācāra* is a yogi, and once he reaches his goal of suprapolar existence, he becomes an irritation, a mockery, an enigma to a world continuing in differentiation and forms:

The Released One plays like a carefree child; the master of Kula walks the earth as one without sense [*jada*, idiot]; the wise man, the yogi of Kula, speaks like a madman [*unmatta*].

If the man who has become divine lives as do other men, then he does this to adapt himself to their ways in order to aid them:

The yogi enjoys sensual pleasures in order to help mankind, not out of desire; he is at play upon the earth, delighting all men, [that is how he conceals his true nature].
. . . the yogi is all-scorching like the sun, all-consuming like the fire; he enjoys all pleasures and yet he remains without blot or blemish. He touches everything as does the wind; he permeates all things as does the air.

For he has become Śiva. Śiva says of himself: "Not upon the Kailāsa do I dwell, not upon [the World Mount] Meru, nor on [Mount] Mandara: but where the 'Adepts of Kula' dwell, there do I abide."[34]

Śiva insolubly united with Śakti is the Two-in-One. Whoever is aware of this sees two great goals of Indian speculative thought and yoga together: the One, "Without-a-Second," of the Vedanta, and the "Duality," whose proper discrimination (*viveka*) releases the soul from its entanglement

[34] *Kulārnava Tantra*, IX, 50, 55–58, 60, 61, 63, 72, 75–77, and 94.

in *samsāra* through Sāmkhya Yoga. Śiva-Śakti are one and at the same time two: they are the undifferentiated Divine at repose within itself, and they are the Divine's unfolding to the world in the play of its own *māyā*, which is Śakti: "Many aspire to the state of One-without-a-Second [*advaitam*], and others to the Duality [*dvaitam*]. My true Being [*tattva*], they never know: it is just as devoid of Duality as it is of Non-duality."[35]

This is the reason why both Being-Bound-up-in-the-World (*samsāra*) and Release are one and the same, and why the pleasures of this world (*bhoga*) are not forbidden to the yoga adept. As long as a line is drawn separating asceticism and sensuality, the nature of the Divine—the Two-in-One of Śiva and Śakti, of pure Being and the play of *māyā*—have not been comprehended. Sensual pleasure has, of course, to be understood as a component of yoga and sanctified as one integral part of religious life by the knowledge that it is precisely that element which makes humankind *śiva-śakti*-like, that is, godlike.

Śiva speaks to Śakti:

> Wherefore so many words—hear me, my life's Beloved: No conduct [*dharma*] is in fact like the conduct of Kula . . . : if the ascetic [yogi] is not at the same time a sensualist [*bhogi*]; if the sensualist [*bhogi*] is not at one and the same time an ascetic [yogi], then the state of supra-polarity will not be attained; this is the reason why the Kula doctrine, whose nature is asceticism and sensual pleasure [*yogabhogātmaka*], is superior to all others, O my love! Sensual pleasure [*bhoga*] becomes asceticism [*yogāyate*]; sin, pious deed; and *samsāra* becomes, in the Kula rite, liberation itself [*mokṣāyate*], O Queen of Kula.[36]

In the equating of yogi and *bhogi*, the age-old conflict between asceticism and hedonism is laid to rest; the gap between the Absolute and the world of *māyā* is closed: both are one in Śakti.[37]

[35] Ibid., I, 110.

[36] Ibid., II, 22–24.

[37] It is worth noting that the original Buddha doctrine, apart from its appearance in tantric form, also merged into a fusion of yogi with *bhogi* in its

The utilization of the *para-śakti* as a living component of the goddess' *yantra* is explained in the following sentence: "Two different words designate bond [*bandha*] and release [*mokṣa*]: 'my.' and 'absence-of-my' [*nir-mama*]; with the word 'my,' the individual soul is held fast; with the concept 'absence of my,' it is released."[38] The ritual sexual union with the *para-śakti* occurs in the "Śrīcakra," in the "Circle of Bliss," whose actualization for Buddhists takes place in the sphere of inner vision, for example, in the *Śrīcakra* of Mahāsukha. Mahāsukha is represented in the figurative sacred image, for example, in the images of Vajradhara, to which the Śrī Yantra, a purely linear *yantra* in the Hindu mould, corresponds with its interlocking male (*vahni*) and female (*śakti*) triangles. In "*cakrapūjā*," in the worship of the *Śrīcakra*, the worshiper himself becomes a component of the *yantra* (called here, the *cakra*). He himself, along with the *para-śakti*, becomes the significant component of the figurative content in order to experience himself in sexual union with the *para-śakti*, as Śiva-Śakti. "God shall be worshiped by none but God"[39]—the initiate does not project into a *yantra* the god of his heart, his own hidden godlike nature, toward whose suprapolar reali-

most spiritual offshoot, Japanese Zen. Cf. the original sources that August Faust, together with Shūei Ōhasama, the accepted patriarch of the Rinzai branch of Zen, brought to light in *Zen: Der lebendige Buddhismus in Japan* (Gotha and Stuttgart: F.A. Perthes, 1925): "Neither sin nor happiness, neither gain nor loss has any place here. Thou mayest not inquire nor search within the nature of perfect *Nirvāṇa*" (p. 72); "Drink and eat, as it best pleases you, once within the nature of complete *Nirvāṇa*" (p. 73). Cf. further the related, characteristic stories of Jūsze and the two monks (p. 89).

The realization of suprapolarity is the goal of all Zen practice, where traditional "tasks" are formulated in the literature as "problems"; cf. among these especially problems 2, 27, 28, 31 (2), and in Ōhasama's introduction, pp. 7–8, 25–29, and 33.

[38] *Kulārnava Tantra*, I, 111.

[39] "*Nādevo devam arcayet*" [the motto to the present study], an anonymous quotation found in Bhāskararāya (p. 277), which is followed by a text in the same vein: "having become Śiva, he is to offer sacrifices to Śiva" ("*Śivo bhūtvā śivam yajet*"). In the same text we find a quotation from the *Mystery of the Sacred Tradition* ("*Āmnāyarahasya*"): "The Godhead who is the own Self [*ātmadevatā*] is to be worshiped with perfumes and other things to which the portals of the senses are open, in the inner core of the Knowing One [who knows:] God am I [*mahāmakha*]."

zation he is striving; on the contrary, he arouses the deity slumbering within himself in order to enter the ritual circle as the Divine that he is. With his *para-śakti* he plays the role of god; he mimes him in order to transform into living Being his knowledge of his own godlike nature.[40]

In the *cakrapūjā-yantra*, whose figurative content is the initiate himself, the *yantra* attains, in terms of form, the ultimate degree of material density and corporeal reality. Represented here is the counterpart of the *yantra* in pure meditation that is constructed mentally, worshiped, and then allowed to melt away. Between these two esoteric types of *yantra*, which the uninitiated of the West know only through the literary tradition dealing with occult teachings, we find the figurative sacred images (*pratimās*), the figure-filled organizing schemas (mandalas), and the purely linear constructs (*yantras*), whose function and nature are illuminated for us by those two esoteric extremes. The place these three types assume in India's spiritual world is determined by their position mid-way between the two extreme forms, and by that ideology common to all types of *yantras*, however different each may be in material and form.

· Compared to the role of imaginative power in the act of worship, the role of the enabling instrument (*yantra*) is sec-

[40] Apart from *cakrapūjā*, where the initiate, together with a female initiate, figures as a divine couple in the *yantra*, another—not unexpected—instance can be cited where the male initiate alone takes his place on the divine throne in order to experience his own divinity. The *Nityāṣoḍaśikārnava*, II, 10–11, teaches a rite by means of which the initiate can acquire power over other creatures: "The initiate sits in the middle of the *cakra* and imagines himself completely red in color, and the object of his desires [*sādhya*] is to be imagined in the same color. By virtue of all his charms, he then becomes beautiful and the object of everyone's affection." Bhāskararāya quotes in support a verse from another tantra: "he is to imagine himself with a radiance, red as the brilliance of a thousand rising suns, and the object of his desires is to be imagined in like color." Red here, like the red body color of *Tripurasundarī*, is the symbol of desire and yearning for the phenomenal world. Related to this is the situation where the initiate puts on clothing and adornments in the deity's color in order to give a more subdued expression of his unity with it. In his commentary to the *Nityāṣoḍaśikārnava* IV, 36, Bhāskararāya offers a supporting quotation from the *Jnānārnava*.

ondary: this is why the *yantra* can appear in such radically different forms. In place of a living human *pratimā*, which might assume its seat (*pīṭha*) in a linear organizing schema, a pot with boiled water can be substituted as the container of the deity, something in which that deity is installed and worshiped.[41] In addition, any object that formally might have nothing in common with manually constructed *yantras* can become the physical basis for the inner diagram. We find that not only the mirroring water surface of a jug in the linear organizing schema but shiny objects of any sort are particularly suited for this purpose. The initiate may project his inner vision of the deity, together with the figures in its retinue, into the flame of a lamp, and may worship them there as the instructions may dictate.[42] In the course of daily morning devotions (*sandhyā*), worshiping the god of one's own heart takes place by projecting its diagram into the sun's disk just as it rises above the horizon. Together with its retinue of divinities, the deity enters the sun's shape (*sūrya-mandala*): it becomes the total figurative content filling a linear *yantra* or a mandala.[43] Finally, even the sacred act of returning to his suprapolar godlike nature that the initiate practices by unfolding and enfolding the image, or by entering into the *śrī-cakra*, can be performed also by *mudrās* (hand and finger gestures). The *Kulārnava Tantra* teaches, for example, in VI, 96: "The initiate causes the *śakti* of his own inner Being to arise and the deities of his own body to rejoice [that is, by bringing about their loving sexual union; he is himself, after all, both Śiva and Śakti.] . . . The thumb [the *linga*-like finger] is the God Bhairava [Śiva]; the middle finger [in Sanskrit, feminine in gender: *madhyamā*, 'the center-most', which is also the *yoni*]

[41] *Tantrarāja Tantra*, II, 66; cf. also II, 59 ff., and XVI, 77, where six *cakras* are to be placed in six water jugs so that the initiate may worship six enemy-destroying *śaktis* in them.

[42] *Kulārnava Tantra*, X, 75–79: "*dīpe sāvaranām devīm dhyātvā vidhivad arcayet.*

[43] Ibid., X, 55 ff. A similar projection of the deity's diagram during the course of an enchantment by love is found in the *Nityāṣoḍaśikārnava*, IV, 42–45.

is Candikā [an aspect of Śiva's Śakti]. By touching thumb to middle finger, he makes the 'family' [*kula-santati*] complete." In other words, with his fingers he performs the religious ceremony of *cakrapūjā* of the Kula doctrine.

The *yantra*'s various forms are not equal in value. There is a hierarchy ranging from anthropomorphic images down to stone, bronze, or wood images, just as there is another hierarchy for organizing schemata ranging from those containing figures up to purely linear ones. The Divine is spiritual, uncorporeal in its purest essence, but in its corporeal state the deity consists of mantra (*devatā mantrarūpiṇī*): for this reason the more mental forms of the sacred image and of worship rank above the materially coarser ones. All *yantras* are, after all, means to an end, just as offerings of physical objects— flowers, perfumes, the swinging of lamps—are unnecessary for anyone capable of performing the entire devotional act exclusively at that level which is of value and profitable—at the level of inner visions whose constant interplay is, after all, equally indispensable for outward sensible action, if this is to be more than something mechanical and unproductive. The less perceptible the pious act is to the senses, the more intensely it engages the believer's inner Being, and the greater is its effect. A clearly audible mantra is less efficacious than one whispered, but the most efficacious of all is one recited silently, inwardly.[44]

> The highest state is the inborn one [*sahajā avasthā*, man's inborn, godlike nature]; the intermediate state is the retention of the inner image [*dhyānadhāranā*]; the lower state is the recitation of formulas in praise of the deity [*japastuti*]; the lowest of the low is the presentation of offerings in worship [*homapūjā*, which requires a yantra].[45]

[44] Quotation in Bhāskararāya, to *Nityāṣoḍaśikārnava*, v, 7: clearly audible *japa* bears fruit tenfold; whispered, one hundredfold; purely inward [*japa*] one thousandfold. Recitations spoken aloud and whispered are placed on one level, but the higher rank is accorded to internal recitation. Ibid., v, 18.

[45] *Kulārnava Tantra*, IX, 34.

To-act-not [*akriyā*] is the highest form of worship [*pūjā*]; To-keep-silence is the highest recitation; Not-to-think is the highest meditation [*dhyāna*]; absence of desire is supreme fulfilment.[46]

This view restricts the sacred image's pretension to distinction and consigns it to a lower, material level where it may indeed act as an intermediary for, and guide to, the Divine; it is still in a sphere at a considerable remove from the deity. All contemplation of the Divine reflects Its illusion, Its *māyā*, not Its essence, and may be considered as an expression of essence only at the lowest level—that is, the one still visible to the eye—where the initiate's eye alone is absorbed by the Divine (which for that very reason has assumed apparitional form), though his Being is Itself not as yet absorbed into Divine Being. Not-to-think (Emptiness, undifferentiated spirituality) is the ultimate mode of meditation: this genuine paradox paraphrases the sacred image's role as a simple *yantra*.

At this point, the contrast becomes clear between the Indian sacred image and Western art, which, to the extent that our art has been fostered by certain ideas about classical art, has Platonic overtones. Just as a brief glance at classical art served as a springboard to the observations in this book, in order to make more real the enormous transitional leap necessary for entering the world of India, so too, a similar brief glance at the ideological basis of classical Western art allows us to summarize, using contrasts, what has been discovered and discussed so far. A most significant bequest of classical art to Western culture and its aesthetic theory is the number of different forms in which antiquity viewed the Divine-Absolute. For Plato, it was the realm of ideas: a world of transcendent forms that represented, vis-à-vis the phenomenal world, both the universal and the ideal type; when viewed in themselves, however, the individual forms are completely separate and clearly outlined. The Absolute is a realm of differentiated ideas. And God as spirit, as Aristotle describes Him, is neither empty spirituality, devoid of outline, nor is He suprapolar

[46] Ibid., IX, 38.

absence of content, nor a self-radiant mirror without an image; He is instead both the simultaneous omnipresence of all spiritual contents and That Which Is Spiritual, that which thinks and knows itself within the sum total of its relationships. (The form this knowledge takes is life.)[47] Aristotle's concept of God dominates medieval scholasticism and mysticism as an adequate formulation of the Divine; and in the nineteenth century, where systematic philosophy reaches its high point, it culminates in Hegel's *Encyclopedia of the Philosophical Sciences in Outline*. Next to this concept of God must be set the idea of the logos. The passage in the Gospel according to St. John, "In the beginning was the Word," is characteristic of Western understanding of the Absolute: as Word, It possesses clarity of outline, gives expression to Itself, and embodies reason. It is, therefore, diametrically opposed to the Indian notion of the pure Divine. Paralleling this contrast, there is a difference in the function of art in the two cultures, Western and Indian. Its highest aim in these cultures is to guide mankind from the world of appearance to reality. All Western art—not only that which is classically stylized—which has its roots in the classical-Christian ideology of the Absolute (note, for instance, the sculptured quality of our cathedrals), is not content simply to depict phenomena as such; it sees, in the vast store of earthly forms to which human experience is limited, the colorful refraction[c] of a pure world of ideas and ideal types.[48]

[47] Aristotle, *Metaphysics*, XII, 7. For the role of this concept in the Middle Ages, see J. Bernhart, *Die philosophische Mystik des Mittelalters* (Munich, 1922).

[c] Goethe's "*farbiger Abglanz*," (literally, "colorful reflection") at the end of the opening scene of *Faust*, Part II. Faust realizes that he cannot look at the light of the sun directly, but only indirectly, as it is refracted in a rainbow. He therefore modifies his urge to strive towards the ideal world and turns instead to its reflection in the living world around him.

[48] Impressionism is by intent free of this Platonizing attitude toward the phenomenal world; for Impressionism, the world is not "the colorful refraction" in which the True becomes visible; it *is* the True. But in this non-intellectual art, the purpose of form is still related to that of the classical school. The delight an Impressionist canvas affords our eye is the same offered by the structure of a classical composition by, for instance, Raphael. It may be that the attractiveness of color patterns has more or less supplanted or pushed into the background the guiding function of the linear framework of classical

It attempts to represent the essential nature of objects and persons, and, as the concrete result of its perception, Western art becomes a wellspring of emotion and a guide for life.[d] Side by side with the intangibles of concept and idea, this view sees art as the second magnificent form in which Truth concerning the physical and metaphysical worlds is presented to mankind. As the reflection of the essential nature of all things, and as the tangible image of ideas, Western works of art are ultimate, untranscendable (*unaufhebbare*) expressions of essence. This is precisely the quality that distinguishes them from Indian *yantras*, which are simply a means of mirroring eternal essence ensnared in the illusory world, and which represent Truth only to someone who does not yet know what Truth is, someone not yet become Truth. The spiritual eye of the Platonic soul feasts on the eternal ideas hovering around it as the soul moves along in blissful contemplation through the upper regions in the divine sphere; in the phenomenal

art. But even here our eye lingers—insatiable, blissful—over the juxtapositioning of formal elements that exist in some kind of irrational equilibrium. The immediate stimulus of the color values appeals to our eye and forces it to adjust to the proper distance so as to combine an optimal amount of clarity and unity in the picture with a maximum of orchestrated color. Then begins our eye's delighted play, moving over the irrationally balanced richness of the color values that emerge as meaning made visible, as our eye is attracted first by one and then another of the many color patterns. Here, too, our eye, though driven to see, is simultaneously filled with infinite tranquillity because it realizes it is spellbound by a maze of inexhaustible stimulation.

Apart from Impressionism, which has freed itself of classical and Christian metaphysics, while retaining the intent of their traditional forms, some of the most recent offshoots of Impressionism seem to include what may prove to be prophetic attempts, indicating that a transformation of Western man is evolving that sees itself as being completely liberated from the classical-Christian heritage.

[d] Here Zimmer echoes the last line, "Du musst dein Leben ändern" ("You must change your life"), of the well-known poem by Rainer Maria Rilke (1875–1926), "Archaïscher Torso Apollos" ("An Archaic Torso of Apollo"), written in 1908. This poem opens the famous cycle, *Der neuen Gedichte anderer Teil* ("New Poems, Part Two"), which closes with the poem Zimmer quotes below, "Buddha in der Glorie" ("Buddha in the Gloriole Enthroned"). See *infra*. p. 238.

world, it is the memory of those pure, primal images that acts as a guide for the fallen soul. India possesses no celestial realm of the visible Absolute. The Indian Absolute stands in permanent contrast to any view of the world based on extensive differentiation.

Conclusion

LIKE all images rooted in a classical tradition, the Gāndhāra Buddha (Plate 13) is solemnly festive in character. Classical art itself is in every respect solemnly festive: even death is a solemn celebration. Niobe's children "perish in beauty" (Plates 48, 49)[a]; an aura of dignity and grandeur, a glow, surrounds every classical figure. Michelangelo's Giuliano di Medici, *Il Pensieroso*, is seated, immersed in princely melancholy (Plate 50), and Saint Sebastian, riddled with arrows, represents the triumph of serenity over death (Plate 51). Like the *Praying Boy*, classical art makes a present of its own beauty, an offering in the sight of man and the gods (Plate 52); in it, life is transfigured and celebrates its own perfection.

Among later artists there is probably no one who experienced and depicted this sense of classical art more clearly than Titian in some of his portrayals of Venus: for example, the *Venus with the Organ Player* (Plate 53). Tenderly, Cupid is about to whisper in her ear as she attends to the music of the cavalier at her feet: there is a perfection that trembles in this gentle afternoon hour, awash in music, as there is in each divine curve of her milk-white, opalescent body, that the softest breeze can set aquiver in sweet commotion. Slowly, the cavalier interrupts his playing, lost in the waves of music as he was, and turns his head to his mistress as though he had suddenly sensed an emptiness about him, as if She had been abruptly withdrawn and estranged from him, whose sole desire in that perfect moment had been to couch her lustrous beauty in sweet sound. Had he perceived the merest note of lament, a sound at once smothered in her divine heart, already bursting with an excess of emotion? In her eyes, teardrops glisten: that sign of a beauty which, in self-awareness, has

[a] See also Zimmer, *Art of Indian Asia*, I, plate B15.

reached its limits. Perfect beauty is an ultimate; but on the other side of all perfection, we find death; and the joy of a perfection that knows of itself—a sublime moment of transfigured life—finds its purest resolution solely in the sweet pain of unending melancholy, in the crepe-veiled, indifferent knowledge of its own transitoriness.

Classical art is an everlasting hymn to the triumph of exalted life.

However readily from our lips the grand words might flow with which we are obliged to praise these immortal works of art—and even those of Indian gods and saints—we simply can no longer utter them. For we know that though these words are by no means out of place, that though one can, even when dealing with Indian works of art, indeed speak of luster and greatness, of dignity and charm, we are nonetheless aware that in so doing we touch upon things that in reality are but relatively incidental and peripheral; and we know too that the true essence of Indian art cannot be captured by grandiloquence. Are grace and majesty anything more than a sheen that envelopes this essence and entices the eye of the Westerner, and our soul thirsting after beauty, into straying from the essence itself? Are they anything more than a screen that deflects our impetuosity, diffusing it with its shimmering surface? Again and again our gaze slips from a beauty that at once seduces and mocks us, like the play of *māyā* wherein the Divine playfully conceals its pure essence; our attention is diverted to those more austere related forms constructed of lines alone—the *yantras*—that, in their purer, unwavering form of illusion, keep secret the same element hidden in the silence of the lustrously veiled figures—themselves concealed in the siren song of beautiful forms. In looking at the *yantras*, we see both what it is about them that holds us spellbound, and what the secret spark of life is that lies hidden within these beautiful images: the compelling necessity that meaningfully relates all parts; the tranquil effect achieved by the unforced quality of their arrangement; the religious sobriety of totally unemotional expression, and Truth, presented *more geometrico* in ever-changing, unending aspects of illusion that is *sub specie*

aeternitatis ineluctable, divinely ordained—but not a single one of these qualities is an inseparable part of the grandeur, of the allure of form that captivates us in Indian art; the place where they come alive, the stage they require, is not the grand and beautiful realm of illusion. In Indian art, there is no exalted, consciousness of life setting up memorials to its own glorification; there is no perfected earthly existence holding up a mirror to its own beauty; here, the transitoriness of life is not celebrating its victory over the forces of death, as they constantly threaten to sap its strength and hold it locked in the unrelenting grip of brute necessity and arduous self-preservation; here there is no celebrating of an ascent to the freedom of a godlike exuberance that becomes spent and crystallizes into form in beauty. In classical art, man appears as divine because his beauty is so great. Man usurps the place of the gods his spirit has vanquished and annihilated; nothing is left now but the celebration of his own Self as the most exalted form of the Divine to be found on earth. He wishes to dwell forever in the celebration of his Self, as in his most sublime moment.

For Indian art, man is god, and art is created so that he might experience this truth and need art no longer. Indian art is only beautiful because the Divine must appear beautiful as long as It observes Itself as perfection, through the human eye that is necessarily dependent upon perceiving forms. But beauty is not the essence of the Divine, and through the *māyā*-veil of the Divine's beauty in the visible image, there constantly obtrudes that irreducible core which, beyond all categories of Beautiful and Non-Beautiful, beyond all names and forms, is the essence of the Divine—the essence of the human. *Tat tvam asi!* "That art—thou!"

Classical art and the Indian sacred image are polar opposites: the one celebrates the most beautiful of the veils of *māyā*; the other displays that veil in changing, often beautiful forms, because only in Its *māyā* can the Divine appear visible. What, for the first, represents an ultimate goal and completion, is for the second a gateway and a beginning. Because their aims are polar opposites, the *māyā*'s world of forms—that raw ma-

terial for all pleasure in artistic creation—takes on a completely different appearance in each of the two arts. The polarity emphasizes the saliency of that form-encompassed, silent essence of the Indian sacred image, which is something missing, even undreamt of, in classical, expressive art. If we may borrow an ancient phrase from the Upanishads relating to *brahman*, whose *māyā* is unfolded in the sacred image, it is that essence "before which, words and even thought itself must retreat without ever having reached it."[1]

To render it into Buddhist terms: since Nirvāṇa, or Emptiness (*śūnyam*), is, in the image of Buddha, conceptualized three-dimensionally, whether in sensual or suprasensual apparitional form (as *nirmāṇakāya* or *sambhogakāya*), we might, when attempting to articulate the essence of the Buddha image (that is, the ineffable basis of its manifested form), use the same words that occur in a verse from the *Suttanipāta*, an anthology of ancient Buddhist poetry, describing the saint toward whose perfected state the sacred image embodying him is meant to guide us: "For him who [like the sun] has gone to rest, there is nothing more to which one might compare him; terms to express him are not to be found in him. Where all conceptualizing has come to naught, all figures of speech are become as nothing."[2]

Finally, in exactly the same way, the *Kulārnava Tantra* char-

[1] *Taittirīya Āranyaka*, VIII, 4, I, and VIII, 9, I; see also the *Taittirīya Upanishad*, II, 4, I and II, 9, I: "He who knows The Bliss [*ānanda*] of Brahman, whence words together with the mind turn away, unable to reach it—he is not afraid of anything whatsoever." [*The Upanishads: Taittirīya and Chāndogya*, translated by Swami Nikhilananda (New York: Bonanza Books, 1959), p. 62. The passage in the text above has been rendered by the translators.]

[2] *Sutta-Nipāta*, V, 7, 8. Translations: V. Fausböll, in *Sacred Books of the East*, X, 2 (Oxford, 1881), p. 199; K. E. Neumann, *Die Reden Gotamo Buddhos aus der Sammlung der Bruchstücke*, 2nd printing (Munich, 1924), p. 373. [The rendering in the text is the translators'. For the purposes of comparison, Fausböll's translation reads: "'For him who has disappeared there is no form, O Upasīra,'—so said Bhagavat,—'that by which they say he is, exists for him no longer, when all things (dhamma) have been cut off, all (kinds of) dispute are also cut off.'"]

acterizes the perfect adept of its teaching, who has become the Divine in the consciousness of his Self, Whose image in *māyā* is repeated in *pratimās* and *yantras* of all shapes: "Just as the celestial path of the sun and moon, the constellations and planets, is imperceptible to the everyday world, so too the course of the yogis. As the path of the birds is not to be seen in the upper reaches of the air, nor the course of the fishes in the depths of the sea, neither is the way of the yogis."[3]

For what we find marvellous about the sacred image (*pratimā*) is of material importance only for the *pratimā* as a stage, however significant it may be for us at that stage. Its raison d'être lies in the fact that it points beyond itself: it can appear as essence only to someone limited by Ignorance (*avidyā*), to the Not-yet-enlightened (*a-prabuddha*): "For the Brahman [*vipra*] versed in sacrifice and the Vedic texts, God [*deva*] is in fire; for the worshiper [*manīṣin*], in his own heart; for the Not-yet-enlightened [*a-prabuddha*], in the sacred image [*pratimā*]; but for him who is aware of the [highest] Self [for the *viditātman*, who is aware of the *ātman* as *brahman*, of his own nature as being the essence of all essences], God is in All Things [*sarvatra*]."[4]

We seem now to have come to a line of demarcation where comprehension and speech reach their inherent limits, since we are not devotees who, with most reverent heart and the deity within it, are able to breathe life into the image through *prāṇapratiṣṭhā*. We are at precisely that point where *māyā*'s veil, which has lured us into studying the image, is lifted, and where we can begin to see what the image, in essence, really is.

Whether a person born and raised in the *māyā* of classical Western art takes delight in the sheer beauty and majesty of Indian sacred images; or whether he turns away from them and rejects elements integral to their beauty, culling these out as mere iconographic or ethnological materials because the

[3] *Kulārnava Tantra*, IX, 68–69.
[4] Ibid., IX, 44.

images seem to lack what it is that his eyes and emotions would feast on: whichever his reaction, he will have to acknowledge *in fine* that all his rhetoric can disclose little more than the remoteness of his orbit from the heart and core of those images to which his own heart ever draws him.

Notes on the Plates

IN MANY of the beautiful and widely known publications on Indian art that have appeared in recent years,[a] the essential part is the illustrations, and the accompanying texts are more or less welcome supplements. In the present book, however, the plates are simply an appendage to the preceding detailed discussions; they supply the reader with a small part of the indispensable visual material. The explanation for the various types of this material is given in the text; the selection was based on the desire to present, wherever possible, unpublished material. Some borrowing from published sources was unavoidable: the photographs of Borobudur, Plates 11 and 12, come from the Ernst Osthaus Archive (at the Georg Müller Verlag, Munich) and appeared in Karl With's *Java* (Berlin: Folkwang Verlag, 1920); Plates 38 and 40 are taken from J. F. Scheltema's *Monumental Java* (London, 1912); for the Japanese Giant Buddha (Plate 46), I am indebted to the photographer, Oswald Lübeck, in Greifswald; Sundaramūrtisvāmin (Plate 9) is found in A. K. Coomaraswamy's *Vishvakarman: Examples of Indian Architecture, Sculpture, Painting, Handicraft* (London, 1913, Plate 63); the publisher acknowledges the kind generosity of Dr. William Cohn for the two dancing Śivas (Plates 15 and 16), which have been frequently reproduced, most beautifully in V. Goloubev's *Ars Asiatica*, Volume 3, 1921. The view from Borobudur out into the surrounding landscape has been taken from H. H. Karny's article in the

[a] The books on Indian art that are available since Zimmer wrote this are too numerous to list here in full. Three important titles that have appeared are: Alice Boner, *Principles of Composition in Hindu Sculpture* (Leiden, 1962); Ananda K. Coomaraswamy, *The Transformation of Nature in Art* (Cambridge, 1934; reprint New York, 1956); and Alain Daniélou, *Hindu Polytheism* (New York, 1964). As Zimmer focuses on Tantric art, three further titles on that subject should be mentioned: A . Mookerjee, *Tantra Art* (Basel, 1971); A. Mookerjee and M. Khanna, *The Tantric Way* (Boston, 1977); M. Singh, *Himalayan Art* (New York, 1971).

Zeitschrift für Buddhismus, Volume 5, 1924.[b] I include a new photograph of the often-reproduced Gāndhāra Buddha in Berlin (Plate 13) because no previous reproductions do justice to this image, which depends so much on the critical effects of light and shadow.[c] Thanks to the kindness of two curators, Professor F. W. K. Müller and Professor A. v. Le Coq, all the remaining material, from the Berlin Museum of Ethnology, is published here for the first time.[d] The selection of the objects portrayed, which are quite different as to their subject, form, material, geographic origin, and traditional school, follows the criterion of allowing the reader to understand, in condensed form, both the general and the fundamental significance of the thoughts developed in the text. In so doing I have, on the whole, instead of choosing more spectacular examples, given preference to smaller objects, which meet this aim perfectly well; this will avoid needlessly duplicating available reproductions and will allow me to keep the larger items for an extensive collection of illustrations I have planned.[e] What is innovative in the following plate section is the embedding of Lamaist painting and sculpture in the context of Hindu art and Buddhist sculpture and architecture from both the Indian subcontinent and Southeast Asia. Particularly novel is the introduction of linear organizing schemata (Frontispiece, Plates 17–19) into the realm of art which until now were terra incognita for the art historian; they had been the preserve of ethnologists and historians of religion, and were obscure even to them until Avalon's publications shed some much needed light on them. They are to be considered as keys to the understanding of Indian sacred images.

[b] This plate could not be satisfactorily reproduced for this volume. The present Plate 39 has been substituted.

[c] For a photograph showing the statue illuminated from another angle, see Zimmer, *Art of Indian Asia*, II, plate 62a.

[d] Those objects that survived the war are now in the Museum für indische Kunst, Staatliche Museen Preussischer Kulturbesitz, Berlin, and have been rephotographed through the kindness of Dr. Volker Moeller.

[e] The work finally appeared posthumously as *The Art of Indian Asia*.

Since the illustrations in the present work are meant only to demonstrate certain important principles, a detailed description of the objects illustrated is unnecessary. But for the Lamaist groups of figures it is almost superfluous to refer the reader to A. Grünwedel's basic work, *Mythologie des Buddhismus in Tibet und der Mongolei* (Leipzig, 1900), where a variant of the Mahāsukha figure (Plates 22 and 23) can be found on page 103 (Figure 84), together with a reproduction of a Vajradhara with a *vajra* and a bell in both hands, but without a *śakti* (page 95, Figure 78). The Peking discoveries of other Lamaist groups of figures in the same pose, enthroned on their mounts, are illustrated in E. Fuhrmann's *Das Tier in der Religion* (Munich, 1922), Plate 98. The same photograph can also be found in *Milaraspa*, a selection of Tibetan texts translated by Berthold Laufer (Berlin: Folkwang Verlag, 1922), Plate 14.

The figures in the mandala painting (Plates 20 and 21) require some commentary in order to identify them. Of the three *dhyānibuddhas* above the clouds, the middle one, whose right hand is pointing to the earth while his left one holds the beggar's bowl, is in Śākyamuni's pose; the Buddha on the left, holding the beggar's bowl with both hands, is Amitābha. Both of these figures are represented in these poses in a well-known Lamaist trio of figures that E. Pander has described ("Das lamaistische Pantheon," *Zeitschrift für Ethnologie*, 21 [1889], p. 51 and Fig. 4). The third member of this trio is Bhaiṣajyaguru (Manla), "The Master of All the Healing Arts," whose pose is, however, different from the third *dhyānibuddha*'s in our mandala. Pander says about him: "Manla is holding the *pātra* filled with medicinal herbs in his left hand, and in his right hand, which is hanging downward, he is holding the fruit which heals all illnesses, *gser-mdog arura*," and this is the pose also illustrated in Grünwedel (*Mythologie*, p. 93). But in our mandala, the right-hand Buddha holds his hands together in front of his breast (as does Amitāyus in Grünwedel, *Mythologie*, Figure 91) in the gesture of the Wheel of Instruction (*dharmacakramudrā*).

If we turn from these details of the mandala painting, so tantalizing for the interpreter, and direct our attention to the mandala as a whole, it would take a poet to give adequate expression to the deeper meaning of its austere, yet variegated beauty. Standing before it, we may recall some lines of Rilke which of course owe their origin to a different source of inspiration but which ring like a paraphrase of this image:

<div style="text-align:center">

Buddha in the Gloriole Enthroned

</div>

Of all centers center, of all cores core,
Almond, self-enclosing, growing sweet,—
this All that reaches all the stars
is your fruit's swelling: Hail.

See: you sense how no thing cleaves to
 you;
your shell is in the Infinite itself,
and there the potent sap is, and surges.
And from without, a radiance helps it rise,
for far above, your suns wax
full and are revolved in incandescence.
And yet within you is begun,
what long outlives, outlasts the suns.[f]

But the words and vision of yet another poet bring the heart of this image to life if we turn our gaze to linear mandalas, for example in Plate 18, where instead of a single wreath of petals, there lie several wreaths around the "center of all centers," and the number of petals is doubled with each wreath; then we may conjure up the vision of that *candida rosa* where the Christian *milizia santa*, in countless number on the rings

[f] "Buddha in der Glorie," translated from Rainer Maria Rilke, *Sämtliche Werke*, edited by Ernst Zinn (Frankfurt: Insel, 1955), I, 642. Zimmer's choice of this poem is more apt than he could have known. According to C. F. MacIntyre, Rilke's wife recalled that this poem "was written about the great statue in the Völkerkunde Museum in Berlin." *Rilke: Selected Poems*, translated by C. F. MacIntyre (Berkeley and Los Angeles: University of California Press, 1960), p. 147. The statue is reproduced in Plate 13 and is still in the museum, now renamed the Museum für indische Kunst; Zimmer describes its importance in the first chapter of the present book.

of petals, throng around the radiant God in the flower's center: the "yellow" of the *rosa sempiterna*.

Dante's journey proceeds by stages up the Mountain of Purgatory which, in the middle of the world and washed by the sea, towers into the heavenly heights and has Paradise, Eden, at its peak—just as the similarly situated world-mountain Sumeru, whose terraces, crowded with demons and superhuman creatures, are crowned by Indra's Garden of the Blessèd. Dante climbs up to the heavens that, in the cosmic architectonics of his vision, correspond to the ever more spiritual heavenly worlds experienced in Indian yoga, although the names and numbers in his vision are indebted to classical astronomy. Passing beyond the spheres of the sun, moon, and the five planets, beyond the heaven above them that rotates most quickly of all around the earth, he enters the empyrean. There, transformed by the fountain of divine light that floods his sight, he beholds the rose of Heaven, a perfect replica of those many-petaled lotuses—here reshaped by the Christian tradition—that form the center of so many mandalas and purely linear *yantras*, are the symbolic dwelling place of the Absolute, and serve as a frame for Its unfoldings into the world of illusion. The Holy Trinity floats above the center of this infinitely great flower, but each of its petals, in ring upon ring, serves as the seat for a saint or a blessèd soul. The rose is a grand amphitheater of deified essence—the *convento delle bianche stole*. The blessèd souls of the Old and New Covenant form rows encircling the Divine, filling petal upon petal of the great rose in a significantly ordered pattern, just as Buddhas and bodhisattvas and aspects of the Divine intended for the initiate's contemplation are placed on the rings of petals in mandalas and *yantras*.

In the Frontispiece and Plate 18, the pattern of the central many-petaled flower is used on a rather modest scale; but related to these mandalas is another, the Garbhadhātu mandala (Plate 36), which has survived in Japan, though it originated in India; this mandala, whose detail is greater than that of a typical large-scale topographical map, approaches the infinite quality of the Dantesque vision because of the plenitude of

its figures from the Buddhist-Hindu pantheon that are en-
throned on the concentrically arranged petals of the lotus
flower.

An organizing pattern of a similarly extraordinary quality
and having the same function can hardly be expected ever to
recur, and it is clear that the lotus, as the seat of the Absolute,
the Divine (of Brahmā or Buddha), is the source of this pat-
tern's many colorful variants that have been disseminated
throughout the Eastern and Western worlds. The phenom-
enon of Manichaeanism—the most comprehensive attempt at
synthesizing Christian, Gnostic, Persian, and Indian doctrines
of salvation or release—shows us that Persia was the leading
exchange center for religious concepts, symbols, and philo-
sophies in the early Christian era. Works from a monumental
"atlas of images," which illustrate how Persia intermingled
elements from different cultural regions, are preserved in the
art of Central Asia, which provided a channel for extending
this mélange to China and Japan. If the symbol of the lotus
flower, with its throng of saints on the petals encircling the
Divine in the center, came from India into neighboring Persia
along with other, well-known borrowings, then a botanical
metamorphosis of this symbolic motif was obviously inevi-
table, or else it would have been reduced to the level of a
meaningless ornament—for the lotus is not indigenous to Per-
sia or countries farther West. But Persia is the homeland of
the rose. A Persian's feeling for nature places this flower above
all others, as the Indian's does the lotus. Just as the rose came
to the West as the queen among flowers, as a palpable, fra-
grance-filled reality, found in highly cultivated, sixty- and
hundred-petaled varieties, it seems too that the lotus of
India—after it was transformed into the rose in Persia—then
proceeded to become a sacred symbol in the Christian Middle
Ages; as a symbol, Dante's heavenly rose must be considered
as the equal of the gleaming rose windows of the cathedrals
which (at Chartres, for example) portray Christ surrounded
by rings of saints and martyrs, and encircled by angels,
thrones, and powers (Plate 54).

Dante's description of his rose shows the Indian symbol already breaking apart in spectacular style: the Holy Trinity is not actually seated at the heart of the great flower in the way that the saints and blessèd souls surrounding It are seated on the wreath of petals; instead, the Trinity fills the center of the flower as a source of radiant light whose dazzling flood appears in the form of three rings to the eye of anyone touched by grace. (An Indian would probably have envisaged a three-headed figure seated at the flower's center.) We may also feel that another feature of Dante's description is his apparent toying with this venerable symbol, which had, after all, been imported into the Christian world, not rooted and cultivated in it. And to play with symbols means that their symbolic function is disintegrating and is a sign that the hour of their death is nigh: for Dante, the heavenly rose is purely and simply a rose, not a symbol of the Absolute and Its unfolding, as is the lotus in India; that is why he populates it with the crystalline, golden-winged, bee-like swarm of angels who spread heavenly bliss by flying to and fro, from the divine font of supreme sweetness at the center of the flower out to its petals laden with transfigured souls.

Appendix
Some Biographical Remarks about
Henry R. Zimmer

BORN on December sixth, he really should have been called after Santa Claus. His parents, too late, repented this omission. Otherwise he might have acquired the nickname "Nickel" or "Niki" after Saint Nikolaus. Saint Nicholas, the saint-bishop of Bari in lower Italy, by the way, is the favorite patron saint of all the Nordic ports, like the author's birthplace, Greifswald on the Baltic. The biggest church there is dedicated to Saint Nicholas, or was so, in the period before the Reformation.

Greifswald actually means "Griffin's wood." The griffin is the animal symbol in the arms of the old duchy of Pomerania, a white griffin in a red field. Red and white are the two colors of the ancient Holy German-Roman Empire.

Pomerania was a semi-independent duchy under the Emperor, subject only to him. The last duke of Pomerania, Bogislav XIV (a slavic name; and a more than semi-slavic population) died in the days of Gustavus Adolphus. At that time Pomerania had turned wholly Protestant. Bogislav, having no issue, bequeathed his country to Gustavus Adolphus, who, with the rise of Swedish power, would have seized it anyhow, and thus saved it from the aggression of Habsburg-Jesuit counter-reformation. With the ascendency of Prussia-Brandenburg after the end of the Thirty Years War, Pomerania and the island of Ruegen, just opposite Greifswald, were conquered and incorporated by the Great Duke-Elector of Brandenburg, the predecessor of the first king of Prussia, Frederick I (in the second half of the seventeenth century).

These—unedited—autobiographical notes, meant as a supplement to some oral information the author had given to a friend, were found among his manuscripts after his death. They were published as the first of *Two Papers by Henry R. Zimmer* (Metuchen: Van Vechten Press, 1944).

Greifswald is a small town of 24,000 inhabitants, shopkeepers, etc., in a totally rural environment made up of estates of gentry (Junkers), of wind-mills and pleasant extensive beech forests. The countryside, on a modest scale, is similar to Holstein, Denmark, the Netherlands. The town is a market-place for the peasantry all around. As a boy of four and five, before my school days, I used to watch the flocks of fat geese driven to market, around St. Martin's day in fall, my nose flattened against the cold window-pane to count their numbers. The charm of the flat wide country with straw-thatched red barns, wind-mills and village steeples, is immortalized by the greatest Romantic painter of the early nineteenth century, Caspar David Friedrich, born in Greifswald, and who lived later in Dresden. The town is linked up with a bay of the Baltic, partly closed by the south shore of Ruegen; you reach it in half an hour by small steamers along a little river. There are salt water swimming establishments at its mouth, fisher-villages, nets, a smell of tar. Along the river fisheries and fish-smokeries abound, with their unforgettable smell of smoked herring, flounder and eel. The people definitely are not teetotalers.

One of the little places at the mouth of the river is Eldena with its Gothic brick ruins of a monastery whose monks were the first teachers of the university founded as early as 1456 for the training of clergy and of government officials of the duchy. Nowadays it is the smallest university of what was Prussia before the obliteration of semi-autonomous German states, and before the recent centralization by the Nazi regime.

(The oldest German university is Prague, from which, through the secession of German students, Leipzig came into existence; next Vienna, then Heidelberg, all in the fourteenth century.)

Without the university the town would be a rather anonymous and insignificant spot in a rural atmosphere. There is much grass between the cobblestones in the quieter streets. The original statute of the university authorized professors to keep a cow and graze it in the streets.

Although the smallest university, Greifswald frequently was the starting point for splendid career-scholars: Wellhausen (bible critic), von Wilamowitz-Moellendorf (Greek philology), my father, Heinrich Zimmer, who jumped from Greifswald to Berlin University and the Berlin Academy of Sciences, to a chair, established for him as the first full professor for Celtic Philology, and the only one in Germany. He was succeeded there by Kuno Meyer, formerly a lecturer at Liverpool University, who travelled in this country during the last war, unsuccessfully, on a kind of good-will propaganda mission before the United States entered the war.

Our home atmosphere was thoroughly Lutheran. During the first nine years of my life, 1890–1900, there existed a marked antagonism between liberal and orthodox theology around us. My parents, without being too actively religious, sided with the liberals. The Protestant training in school (three years in the elementary, nine years in the high school [from the sixth to the eighteenth year], first in Greifswald and subsequently in Berlin) I liked very much. Two hours a week of Bible reading, catechism, and hymns gave me a foundation and approach to man, history and life, at least as important as the (one-sided) humanistic training with the classics, classical German poetry, and history, which practically forms the background of my education.

I learned to swim in the sea when nine; the shore, the sea, the salt water is where I feel really at home (Cape Cod, Long Island, Bailey Island).

The Royal Joachimsthal Gymnasium, one of the oldest high schools for training ministers, officials, and scholars in Prussia, was founded by Joachim, a Duke-Elector of Brandenburg, in the little town of Joachimsthal, to the north of Berlin. It was burned down by the Swedes in the Thirty Years War, and found a refuge in Berlin, where it remained until after the time I left it (1909). In my time it was attended half by boarding pupils (sons of ministers and small landowners, mostly supported by grants), half by day scholars living with their parents (as myself), sons of professors, government officials, businessmen, Jewish lawyers and doctors, military of-

ficers—altogether a rather picked set of eager and promising pupils. Latin and Greek predominated, mathematics and sciences played second fiddle, so did sports. Homer, Plato, Sophocles, Horatius, Goethe, Schiller loomed large. English was not required. I had six years of French as a minor subject. I discovered Voltaire, Balzac, Stendhal, Maupassant when a high school boy. I learned Italian as well, and read Tasso, Boccaccio, Dante eagerly when seventeen and eighteen.

A lonely boy, with but one brother, four years my senior, I was mainly interested in the humanities, and read widely. Theater, museums, art exhibitions became the major topic with my comrades. We fought the battles of Impressionism in painting, Ibsenism, Naturalism, Neo-romanticism in the theater, in novels and poetry, versus the Victorian and erratic taste of the Kaiser and the older generation; we acclaimed Reinhardt in his rise, hailed Thomas Mann, built up George, Hofmannsthal, and later on Rilke, Werfel, the great lyrical poet, then the expressionist painters Marc, Kokoschka, Nolde, Feininger, Kirchner, Heckel, etc.

I fed on the remarkable art collections: the Egyptian Department (Amenophis, Nofretete, Tell-el Amarna); the lectures of eminent scholars such as Eduard Meyer, at the university.

The most impressive figures at the Berlin University, which I attended from my second term in the winter of 1909 and until I received my Ph.D. in the summer of 1913, were Heinrich Woelfflin, the eminent Swiss art historian, who taught us to see what is represented in painting and architecture in a way nobody had done before or could do; Andreas Heusler, professor of Nordic philology, a pupil of the great Jacob Burckhardt at Basel, himself from Basel, who combined scholarship with literary appreciation, a man of genius. Besides, there was the great linguist and philologist Wilhelm Schulze, with whom I read comparative linguistics as a major subject. I only attended some of Woelfflin's lectures, and never took regular courses under him; Heusler's courses were only a sideline. I could not make up my mind to devote my whole life to the insulated Norse civilization.

I studied German philology, read the Bible in all available translations, and in clumsy early monks' transcriptions into old German dialects. I felt undernourished by medieval singers and epics, transcriptions from Chrestien de Troyes and Celtic texts; German studies somehow lost their appeal to me at that period, because of the mass training of high school teachers, and over-inflated second-rate topics.

I began Sanskrit, as a matter of course, and as part of comparative linguistics in my second term, and stuck to it. The other studies (German) faded out. Linguistics remained my second major study, together with some Iranian studies (ancient Persian texts: Zarathustra's Avesta, etc.). I did some modern Persian and Arabic, but forgot them during my five years of military service 1913–1918, and did not brush them up.

My teacher in Sanskrit, Heinrich Lueders, was an arch-craftsman in philology, in deciphering manuscripts, inscriptions, a skilled super-mechanic, one of the past masters of philological craft in the field of Indic studies. But he was not interested in Indian thought, a plain liberal citizen from the republic of Luebeck, anti-philosophic, indifferent to mysticism, and with a meager sense for artistic qualities and implications. I was brought up on a wholesome diet of stones instead of bread, but my generation could take it, thanks to a Prussian Spartan high school training. We were strictly pre-progressive in our upbringing, trained to ascetic hardship with Thucydides, Demosthenes, under philologists who scorned to be teachers and were, in part, original scholars.

During my nine terms at the University, and even after I got my Ph.D., I remained fascinated by things Indian, but I had no understanding of them. I could not have expressed what they meant to me. I did not know it myself. My teacher or guru, that master technician, operated no magic, no transference in the way of a rebirth. We stood in awe of him because of his infallible accuracy, masterly method, the true gift of which he was rather incapable of transmitting. Without knowing it, he did not even care too much for his pupils, though he was conscientious about his courses and prided

himself for having attracted and caught promising boys like me. He was essentially unconscious, projected himself on me, because he thought me of his kind, and I, at that period, was very far from realizing my own very different method. Thus I made routine progress in mastering texts of increasing difficulty, of various periods, styles, dialects and contents. It was a technical training, no more; a chance to remain unconscious and to grow underneath without realizing one's growth and goals.

Yet I felt all the while that I was not leading a double life, that of a scholar, adept, technical philologist on the one hand, and of a passionate addict of Nietzsche, Baudelaire, Wagner, Stendhal on the other hand. My dream was to read India's classics as one reads French novels: on the couch, in the railway car.

What made me abandon Western studies in my fifth term, burn the ship and set forth on the quest for the East, on the track of Alexander, the path of Julian the Apostate?

I could not stand the stale and dull atmosphere of pseudoromantic Western medievalism: this rotten and degenerated mixture of Old and New Testament, classic Humanism, German folklore, degraded and diluted for high school teacher consumption. I felt the major victories and decisions in this field of research had been won one or two generations earlier. It was a field for aftermath, ear-gleaning. I could not stand this atmosphere of monkishness and minnesingers, Biedermaennerei and philistinism in the costumes of knights and cobblers, master-singers and lute-players, Gretchens and Evchens. Imagining India, its dense deep fragrance in my nostrils, the jungle before me, unknown, perhaps unknowable, I thought of this southern sky of which I had read: studded with strange stars and bewildering asterisms: none of them familiar to us; and yet a whole civilization, many civilizations, had steered their boats looking up and orientating themselves from this totally different pattern. Life worked as well the other way round, and it was worth while embarking for this other ocean.

I had faith. Not the faith, ever to understand or to decipher the characters of the strange other script. But the faith that they contained as much truth, no more and no less, than the familiar script in which I was brought up and which was taken for *the* script of knowledge and reality all around me.

Whereas most of my student-colleagues, and later on my fellow research rivals, aimed only at ascertaining what was meant and implied by the strange script, I, continually, silently, added to every statement about its contents a little profession of faith, a deep vote of confidence, and said: "That is what they state and mean,—*and* (so I added) it is true. It is the truth, though I do not understand it as yet, and feel not any too confident that I shall ever grasp its point."

My father died when I was spiritually an infant, in my third term, in the summer of 1910. Thus I was spared the enormous struggle to come into my own against this towering representative of the older generation of scholar-titans, brought up in positivism and a philological mastership I and most of my generation never acquired. I was spared the Oedipus conflict; for my guru too, with all his knowledge and his limitations, practically was not in my line. When I awakened to my own capabilities, in 1924/5, in writing *Kunstform und Yoga im indischen Kultbild*, I simply swept him overboard; he never forgave me and did much to hinder my career. But I had been reborn, and the price paid for it was negligible, considering the fact that no wounds, no scars were left . . .

My Ph.D. thesis on the Vedic Brahmin family clans contains something that points to what was to become my real field, but not very much.

In October, 1913, I had to enter the army, to undergo my one-year peacetime training. I took it with the Second Imperial Grenadier Guards in Berlin, where my mother lived. My brother married at that time.

In 1913, I spent the summer for the first time in England, three weeks with a vacation-term at Edinburgh and in the Highlands, five more weeks in the British Museum, where Egyptian monuments and Babylonian reliefs attracted me somehow more than Indian sculpture. The values of Indian

art were disclosed to me only after the First World War, in 1922–1925, when I read Tantric texts. The Berlin Museum has good examples. The first-class collections at Paris I saw only after I had finished *Kunstform und Yoga* in 1925.

While I was deeply engrossed in Nietzsche's "Genealogy of Morals" (this is among his best books), and reading a Chinese grammar in a military camp in July 1914, war became rife. Instead of returning to my secluded, solitary existence of a budding scholar, I went into war: four years of human, sub- and superhuman experiences, initiations in the trenches, staffs, meeting more people than I ever did before and watching them in all kinds of revealing attitudes. The initiation of Life (including Death) playing its own symphony with the fullest possible orchestration.

I came home, unshocked, unwounded, having by chance spent long stretches of time with staffs because of my command of French and English. I was demobilized early, on December fourth, 1918, and returned to my studies to brush up what I had largely forgotten.

The downfall of the Empire, the humiliating and disastrous peace treaty did not affect me deeply, and still less the wave of communistic enthusiasm. I remained decidedly a hopelessly non-political, almost a-social type. I had not started the war, I did not accuse or blame anybody for it, I felt like what the French call a "revenant," Ibsen "Wiedergänger," "Gespenster," "Ghosts," for being allowed to return from an ordeal in which the best among us had disappeared. The only benefit which I derived from my participation in the war was a complete liberation from the authority of the older generation who had managed the war and managed it into catastrophe. I said to myself: "I do not criticize anybody or anything. But henceforth I shall decide what I shall take seriously, if anything at all. I am a revenant, a ghostly revenant. It is mere irony that I have come back. Many much better did not. I offered my life for the ideals and purposes of the community, and did it naively, willingly. With this life I brought back, I am free to do what I decide to do,—free as a guest from the other world. They have no claim upon me any more."

For years I submitted to the traditional pattern, worked under my teacher on boring manuscripts, fitting together fragments of paper inscribed with Buddhist texts from the sand-buried ruins of Central Asia—sheer puzzles for arch-craftsmen, athletic master-philologists. For these finds, intrinsically, did not contain much that was not already known from the Ceylonese Canon of the Pali Text Society.

Thanks to a preliminary draft of some of these texts meant for a critical edition which I never finished, I became Privat-dozent at Greifswald, under a former pupil of my father, who had eventually inherited the chair of comparative linguistics and Sanskrit, though he had an absolute inhibition against publishing anything, and was of no great account otherwise.

I chose my native university because I had no money and most of the other universities were already provided with professors and instructors. Ruinous inflation showed its first impact, but friends of my parents made life easier there, and food was cheap in this rural environment.

My only connection with Pomerania is that I was born there and spent two terms at Greifswald as a Privatdozent (the first on leave at Berlin). I have nothing in common with the somewhat clumsy, heavy, common and uncouth semi-slavic population.

My father came from the hills of the left bank of the Rhine, which from 1801 to 1815 was even under French domination: the Hunsrueck hills. Hunsrueck means "dog's back." A poor, wooded country, wind-swept, strikingly different from the gorgeous wine-growing valleys of the Rhine, Moselle, Nahe, which form a triangle in the east, north and south respectively.

His native town of Castellaun goes back to Roman and Celtic antiquity. "Castell" points to a Roman garrison controlling these heights, erected on the emplacement of a former Gallo-Celtic town: Castellaun is Castellodunum, "dunum" is the Gallo-Celtic term for town: see Lug-dunum: Lyon; Virto-dunum: Verdun. Despite all the waves of immigration, invasion and conquest these poor unattractive heights remained almost untouched down the ages. The Celts, then the Germans, then the Romans swept through the rich valleys below

and settled on their fertile, sunny riverbanks. The population up there is swarthy, stocky, of medium stature, with tanned skin; and is closely akin to the dark Irish and Scottish type. They are practically of the same stock as ancient Pre-Celtic, Pre-German population, as in the British Isles, in France, the Alps, which formed the ancient Western-European civilization and population at the period when Central Europe, Germany in the center, was covered by ice up to the Alps.

It was this Pre-Celtic origin, I suppose, which by its affinity, drew my father (who had started with Germanic and Indic studies) definitely to Celtic studies in which he became a pioneer classic scholar second to none. He travelled in Ireland and Wales for years every summer, conversing with shepherds, village school teachers and other wonderful nonanglicized inhabitants. For years he drew Irish clergymen, postgraduate students of Ancient Irish studies to Greifswald. In this out-of-the-way spot they picked up their ancient language and literature, in the course of the revival of aboriginal Irish language and tradition. Some of them I remember well. My father's memory is cherished up till today in Ireland. The National Irish University at Dublin bought his library after his death in 1910 and set it up in a seminary [sic] room as a special study for students of Celtic philology.

On this side I should be definitely of Pre-Aryan, Pre-German descent. My ancestors, when Arminius stopped the Roman conquest of Western Germany between the Rhine and the Elbe by trapping Varus' legions, evidently sided with the Romans and flirted with Roman sergeants.

My mother, on the other hand, was born near the Bohemian border in Saxony, at Zittau, an industrial town of spinning and wool weaving. It was also the birthplace of the second-rate but sympathetic composer Marschner (his opera "Hans Heiling," written early in the nineteenth century, was pushed into oblivion by Wagner's achievements, and was not a match for Carl Maria von Weber's operas). My mother was one of those gentle, charming, sweet early Victorian girls "aus Sachsen, wo die hübschen Mädchen auf Bäumen wachsen" (from Saxony where lovely girls grow on trees). She was

delicate, pre-intellectual, naively conventional, of sweet tem-
per, musical, a good singer, good at the piano, most unas-
suming, helpful and cooperative, brave without knowing it.
Her imago, in addition to all her love and care for her two
sons, was of course the most precious gift she bestowed upon
me, compensating for the towering but really grand and
deeply moving figure of my father. This sweet, harmonious
and efficient archetype of womanhood, evidently, is at the
root of my sentimental, romantic and mystic attitude towards
the fair sex, than which I know nothing more attractive and
inspiring. On her father's side she was of German-Saxon ex-
traction (the family name was Hirt). Her mother (grand-
mother was a very tiny, sweet, energetic and simple person)
was of Wendish stock (née Domsch, i.e., Dumic). This
Saxon-Wendish stock is inclined to mysticism, as are kindred
folk in Silesia: see Jacob Boehme, of the "inner light." This
may account for my predilection for mysticism, myths and
symbols, while the Pre-German, Pre-Celtic, Pre-Aryan de-
scent of my father from the ancient European matriarchal civ-
ilization explains my penchant for the corresponding strati-
fications in ancient Pre-Aryan Hindu civilization (the Great
Mother, the feminine principle in Tantrism).

· · ·

WHEN I returned from the war, I knew that I knew nothing
whatsoever of things Indian, and that, even in the period when
I took my Ph.D., I had not known anything real. I had but
acquired a philological technique of reading various kinds of
texts and of translating them in a correct way. But what they
could mean for us, or mean in themselves, lay, so I felt, be-
yond this approach and the ideas of my teachers and most of
my colleagues of whom I knew. However, I said repeatedly
to myself: I feel that now the time has come when someone
might understand something real of this Indian stuff, if he
had an archimedic point of support outside on which to base
his other leg. This point, I felt, was to be gotten, not by books,
research and libraries, but by living. The experiences of the
war had been one, very vital and enlightening, aspect of "liv-
ing";—the life of the following decades, experiences with

men and women, the magic scenery of Heidelberg and the Neckar valley, and the discovery of non-Indic values in literature, art, music, psychology, medicine, helped me to come into my own.

While I brushed up my Indic philology and worked at the Buddhist manuscript remains in the Berlin Academy, I did intensive Chinese studies for some terms with that wonderful scholar Johann Maria de Groot (a Dutchman), a perfect embodiment of the gentle wise Taoist Old Man. I acquired an extensive reading in Buddhist texts, which led to the publication of a small volume of translations of Buddhist legends with which I fell deeply in love: as much for their artistic qualities as for their deep and deeply moving meaning. The values of Hindu tradition were disclosed to me through the enormous life-work of Sir John Woodroffe, alias Arthur Avalon, a pioneer and a classic author in Indic studies, second to none, who, for the first time, by many publications and books made available the extensive and complex treasure of late Hindu tradition: the Tantras, a period as grand and rich as the Vedas, the Epic, Purânas, etc.; the latest crystallization of Indian wisdom, the indispensable closing link of a luminous chain, affording keys to countless problems in the history of Buddhism and Hinduism, in mythology and symbolism. The whole set of Arthur Avalon's writings became available in continental libraries shortly after 1918. Happily enough I could not afford to buy any of these books, thus I was forced to read them most intensely and to take notes and quotations from them for months. This helped me to integrate the Tantric wisdom. Seemingly to no concrete purpose. I was simply caught up by it. I stuck to it as does a babe to its bottle.

I had always been interested in art, from high school on, to such a degree that both of my parents expected me to take up history of modern art as my major field of university studies. But I felt, during my first terms, not sufficiently gifted for the task of interpreting art; moreover the isolating of art, esthetics, the beautiful, and dwelling upon them exclusively, appeared to me as a kind of sickening, unhealthful perversion and onesidedness, devoid of roots in real soil. While I lived

at Heidelberg, in the spring of 1924, an art-historian, specializing on Far Eastern art, Alfred Salmony, now at New York University, called on me when in search of collaborators for a periodical, *Artibus Asiae*, he had just launched. I could not promise him any contribution, having never seen the monuments of India proper, nor the collections in Paris either; travelling, by the way, being out of reach, financially and politically as well, in those years following the Treaty of Versailles, inflation, etc. Yet his visit gave me the idea of attempting a brief paper of some forty pages, doing away with the then prevailing purely esthetic approach to Indian art on the one hand, and with barren classicistic criticism on the other. As I wrote, I realized that my knowledge of Hindu Tantrism offered me some really valid foundation on which to base the understanding and study of Indian art, and I drew freely from this treasure—the more so, since I felt this wonderful esoteric matter might easily be misrepresented by some other scholar less deeply engrossed by it. Within a year I had completed *Kunstform und Yoga*. I did not write it for professionals, nor as a contribution to specialized studies. I had to write it, to realize my self and to come into my own. This book won me many friends, some of whom I know personally. Being the first study on mandalas and kindred diagrams, it drew the attention of C. G. Jung; on the other hand the excellent archaeologists of the French school sensed that something new in principle here had been offered. There is a voluminous monograph on Boro Budur by a French scholar, based on some hints contained in this book.

After having finished the manuscript, in the summer of 1925, I went to Paris for the first time. The Indian monuments, especially the Buddhist art of Cambodia, Khmer, did speak to me.

From some charming minor hunting-relief I picked up a general hint. It showed huntsmen on an elephant, the animal handing them with its trunk the deer they had killed. It gave me a pang; I felt a criticism and remorse for having dealt so exclusively with Hindu and Buddhist devotional yoga and esoteric doctrines. Here I was confronted with a scene of

everyday life. I felt the necessity of balancing my interest in transcendental Hindu wisdom by knowledge of the realistic approach to life's experiences in the Indian tradition. Thus I delved into medicine, the best representative of Hindu earthly life and wisdom, and, first of all, into Indian elephantology. I read the veterinary encyclopedia on "the Longevity of Elephants," Hastyâyurveda, more than 7600 stanzas and ample prose chapters, to acquire the background for a translation of a smaller treatise on how to keep elephants: Mâtangalîlâ, "Play about the Elephant," *Spiel um den Elefanten*. I gave a lecture on Hindu medicine, and this led, finally, to the invitation to give three lectures on Indian Medicine at the Institute of the History of Medicine at Baltimore, Johns Hopkins University, in 1940 (Hidyo Noguchi Lectureship), and to a lecture this past winter, before the New York Society for the History of Medicine on the Influence of Hindu Medicine on Greek Medicine. The Noguchi lectures will be published as a book; the manuscript is unfinished as yet.

From the very outset of my Indic studies I felt a slight, yet marked, difference in my approach to this inspiring subject from that of the majority of my colleagues, co-students, and scientific forbears. I came to realize that I was in the same boat with a few people who delighted me and whom I could accept wholeheartedly, e.g., Arthur Avalon and J. J. M. de Groot. The attitude of the great majority, the typical representatives of philological skill under the deadening spell of the logic of positivistic sciences, ultimately remained unrelated to the content of the material they handled all their lives. Their only link was their impersonal method. They posited and answered the question: What is the meaning of these terms, texts, doctrines, etc.? What are their interrelations, chronology, origin, migration? But they never asked the question: Are these sayings valid—valid for us, valid for ever and apart from the context in which they figure? While the others stopped at analyzing, dissecting, classifying, dehydrating the stuff, I accompanied, inwardly, whatever I read and fancied to understand, at least to some extent, with the refrain: "This is the meaning, and—what is more: it is the truth. I believe

it to be a most significant aspect of truth, even though I am not capable, as yet, of merging it into the context of Western accepted aspects of reality or truth. It may be that I shall never be capable of achieving this on a major scale, yet I fully believe in the intrinsic validity of this secret script."

It was, I felt, not the right solution, simply to swallow Eastern wisdom hook and sinker, as did the Theosophists, Neo-Buddhists, etc. The task was to transmute it so as to make it fit into the context of our own experiences and traditions: a process of mutual transmutation, assimilation. The spiritual food, when assimilated, assimilates him who has swallowed it. It forms and transmutes his substance.

In the course of this process, a lifelong one, I came to realize that this attitude of intrinsic, anticipatory faith in the total validity of an only partly understandable script is the basic attitude of the Indian pupil-adept: śraddhâ—faith in the words and the nature of his spiritual teacher and guide, wholehearted acceptance of the traditional classic texts, the far-reaching meaning of which will be disclosed gradually with growth and increasing intimacy.

Later on I came to know that this again is the basic attitude of the Christian philosophy-theology of the Fathers and the Roman Catholic Church: Saint Augustine's famous "Credo ut intelligam"—I have faith (in the intrinsic truth of the traditional doctrines, e.g., the mystery of the Trinity, not because I fathom their depth by understanding, but) in order that I may understand them (to an ever increasing degree).

This is the only possible attitude towards traditional esoteric wisdom and philosophy, in contradistinction to the critical, sceptical attitude of modern philosophy: Cartesius, Hume, Kant, which starts with total doubt and proceeds by careful criticism, confined to the realm of the intellect, as the only and supreme authority; while the other attitude follows the lead of a doctrine which strictly aims at transcending the faculties and limits of the intellect and the senses.

The real task of this pursuit is: how to fit, in a legitimate way, the esoteric message from afar into a proper context in our own tradition and nature, and to avoid the willed blind-

ness and infatuation of the theosophists on the one hand, and the sterilizing anatomy and dehydration of the merely intellectual approach of the sheer scientist-philologists on the other hand.

The insight that gradually unfolds on this "Middle Path" between these two extremes or pitfalls, naturally has to be fragmentary at the outset: you are allowed to write down what is given you to understand by assimilation and mutual transmutation.

All my books and articles, from *Kunstform und Yoga* (1926) on, are parts and documents of this process of assimilation and transmutation: *Ewiges Indien*, "Eternal India," the perennial leitmotives of Indian wisdom and life (1930); *Indische Sphären*, on the Hindu Myth, on Hindu doctrines of policy on forms and functions of Yoga in relation to the phenomenal and the transcendental reality, Maya, and on Buddhism (1935); the translation of an enlightening Vedânta treatise in aphorisms, *Anbetung Mir*, "Worship to me" (Ashtavakragītā); and the 500-page volume *Maya, der Indische Mythos*, "Maya, the Hindu Myth," translations from the Purânas of the principal myths about Vishnu, Shiva and the Goddess, with introductions and interpretations; my contributions to the Eranos-Yearbooks in 1933, 1934, 1938, and 1939; on the psychology of Tantra-Yoga and the Tibetan Book of the Dead; on Hindu Myths; on the symbolism of the Mother-Goddess; on death and rebirth in the Vedic tradition, as compared to Orphic and Gnostic parallels; *Weisheit Indiens*, "The Wisdom of India," containing Hindu parables with their interpretations, in the light of the psychology of the unconscious (1938); the Story of the King with the Corpse (my contribution to the sixtieth anniversary volume for C. G. Jung Festschrift, Berlin, 1935).

I must confess that the India that was offered to me by the representations of my teachers and of most books available, did not live up to the expectations and ideas I felt compelled to cherish on the Indian material. The current representation of India lacked color, depth, intensity, consistency, life. For

years I was in search of the "real" India, of "my" India, of
Schopenhauer's India.

I first gained access to it through the magnificent lifework
of Arthur Avalon: the huge series of Tantric texts, and his
most adequate introductions to their contents. At the same
time the monuments, terrible and charming, and magnificent
beyond words, began to speak to me.

Then I gained my first access to Hindu myth. I always had
suffered under the common almost total lack of understanding
prevailing in my field with regard to this foremost of all
expressions of the Hindu genius. I felt that nothing, so to
speak, was achieved, nothing availed, as long as the seals of
this book of revelation were unbroken.

I am deeply indebted to the writings of the astounding Basel
scholar Johann Jakob Bachofen ("Symbolism of Grave Im-
plements of Antiquity," "The Story of Tanaquil," and above
all, "*Das Mutterrecht,*" The Maternal Order,—Bachofen
coined this term) for my first key of how to decipher the
pictorial script of myths and symbols. I soon came to realize
that his key, though a master-key, was but one among many;
and some years later in reading Jung's great early work "*Wan-
dlungsformen der Libido*" ("Psychology of the Unconscious,"
the book translated by Dr. Beatrice Hinkle), I came to realize,
with deep delight and admiration, that there was yet another
man, and a living genius at that, who had found another mas-
ter-key to the treasure of myths and symbols. Curiously
enough, for the understanding of Jung's psychology in the
beginning, the excellent book by Frances G. Wickes on chil-
dren's psychology (which she wrote before she learned of
Jung) proved to be most enlightening.

I am utterly lacking in initiative to approach important and
impressive people; I have to leave that to chance, for I am
incapable of taking the first step. My personal contact with
Jung started in 1932. At that time, another Indic scholar, most
unreliable as a scholar and as a character as well, but endowed
with a kind of demoniac, erratic vitality made up of primitive
resistances and ambitions, drew the attention of doctor-psy-
chiatrist-psychologists to the subject of Yoga. Now, after his

long collaboration with Richard Wilhelm on Chinese wisdom, Jung was ready to take over similar stuff from Indic scholars. Hauer had a seminary [sic] on Kundalinīyoga at Zuerich, and I introduced myself at this forum with a lecture on the types of Yoga in Indian tradition, in the spring of 1932. From that time on I had lectures every year at the Zuerich club and the other Jung clubs at Basel, Munich, and Berlin. The good fortune to have Jung among those who were interested in the things I had to offer constituted one of the principal elements in the next six years which I permitted myself to spend on the continent in spite of the ever-increasing pressure and peril from the Nazi regime and the more and more stifling, deadening atmosphere growing around me in the concentration camp which Germany was to become in this period. You cannot just talk to the stars or to the silence of the night. You have to fancy some listener, or, better yet, to know of somebody whose mere existence stimulates you to talk and lends wings to your thoughts, whose nature sets a measure to your undertaking. In this respect the mere existence of Jung, quite apart from what I got out of meeting him, the mere fact that nature allowed this unique, mountainous example of the human species to come into existence, was, and is, one of the major blessings of my spiritual and my very earthly life, one of those gifts of life, not to be imagined or prayed for, but showered upon you as a secret compensation by a generous Providence.

I remember, when I came home, after my first meeting with Jung and spending a weekend with him at Kuesnacht, sailing, motoring, sitting around, that I begged my wife, who came to the railway station at Heidelberg, to excuse me, if I were curiously inflated for some days at least. For I had, so I explained, just met a specimen of human biology, the kind of which I had never encountered before in the flesh, and had never expected to meet alive in times like ours, but which was very familiar to me from Hindu tales and dialogues of sages, yogins, wizards and gurus.

January 1943

Selected Bibliography of Zimmer's Works

BOOKS

"Studien zur Geschichte der Gotras." Ph.D. dissertation, Berlin. Leipzig: G. Kreysing, 1914. [Zimmer's *Habilitationsschrift* on Buddhist texts discovered in Turfan was unpublished. See "Appendix," p. 251 above.]

Kunstform und Yoga im indischen Kultbild. Berlin: Frankfurter Verlags-Anstalt, 1926. Second edition, edited and introduced by Friedrich Wilhelm, Bibliothek Suhrkamp, 482, Frankfurt: Suhrkamp, 1976 [plates omitted].

Ewiges Indien: Leitmotive indischen Daseins. Das Weltbild: Bücher des lebendigen Wissens, 14. Potsdam: Müller & Kiepenheuer; Zurich: Orell Füssli, 1930.

Indische Sphären. Schriften der Corona, 12. Munich: Oldenbourg; Zurich: Verlag der Corona, 1935. Second edition, *Gesammelte Werke*, 5, Zurich: Rascher, 1963. Third edition, edited by Stefan Zimmer, *Yoga und Buddhismus: Indische Sphären*, Insel Taschenbuch, 45, Frankfurt: Insel, Suhrkamp [in Komm.], 1973.

Maya: Der indische Mythos. Stuttgart: Deutsche Verlagsanstalt, 1936. Second edition, *Gesammelte Werke*, 2, Zurich: Rascher, 1952. Third edition, edited and introduced by Friedrich Wilehelm, Frankfurt: Insel, 1978.

Weisheit Indiens: Märchen und Sinnbilder. Darmstadt: Wittich, 1938.

Der Weg zum Selbst: Lehre und Leben des indischen Heiligen Shri Ramana Maharshi aus Tiruvannamalei. Edited by C. G. Jung. Zurich: Rascher, 1944. Second edition, *Gesammelte Werke*, 3, Zurich: Rascher, 1954. Third edition, introduced by Günther Mehren, *Der Weg zum Selbst: Lehre und Leben des Shrī Ramana Maharshi*, Diederichs Gelbe Reihe, 7, Dusseldorf: Diederichs, 1974.

Myths and Symbols in Indian Art and Civilization. Edited by Joseph Campbell. Bollingen Series VI. New York: Pantheon, 1946. Paperback reprint, Princeton: Princeton University Press, 1972. Translated by E. W. Eschmann, *Mythen und Symbole in indischer Kunst und Kultur. Gesammelte Werke*, 1, Zurich: Rascher, 1951. Second edition, *Indische Mythen und Symbole*, Dusseldorf: Diederichs, 1972. Third edition, *Indische Mythen und Symbole: Schlüssel zur Formenwelt des Göttlichen*. Diederichs Gelbe Reihe, 33. Dusseldorf: Diederichs, 1981.

Hindu Medicine. Edited with Foreword and Preface by Ludwig Edelstein. Publications of the Institute of the History of Medecine, The Johns Hopkins University, 3rd series: The Hideyo Noguchi Lectures, Vol. 6. Baltimore: Johns Hopkins University Press, 1948. [Delivered 1940.] Reprint, New York: Arno Press, 1979.

The King and the Corpse: Tales of the Soul's Conquest of Evil. Edited by Joseph Campbell. Bollingen Series XI. New York: Pantheon, 1948. Second edition, Princeton: Princeton University Press, 1956. Translated by Johannes Piron, revised by Lucy Heyer-Grote, *Abenteuer und Fährten der Seele: Der König mit dem Leichnam und andere Mythen, Märchen und Sagen aus keltischen und östlichen Kulturbereichen: Darstellung und Deutung. Gesammelte Werke*, 4, Zurich: Rascher, 1961. Reprint, Darmstadt: Wissenschaftliche Buchgesellschaft, 1966. Second edition, Dusseldorf: Diederichs, 1977.

Philosophies of India. Edited by Joseph Campbell. Bollingen Series XXVI. New York: Pantheon, 1951. Paperback reprint, Princeton: Princeton University Press, 1972. Edited and translated by Lucy Heyer-Grote, *Philosophie und Religion Indiens*, Zurich: Rhein, 1961. Second edition, Suhrkamp Taschenbuch Wissenschaft, 26, Frankfurt: Suhrkamp, 1973.

The Art of Indian Asia: Its Mythology and Transformations. Completed and edited by Joseph Campbell. 2 vols. Bollingen Series XXXIX. New York: Pantheon, 1955. Pa-

perback reprint, Princeton: Princeton University Press, 1982.

Die indische Weltmutter: Aufsätze. Edited and introduced by Friedrich Wilhelm. Frankfurt: Insel, 1980. [Contains two previously unpublished pieces: "Die Erschaffung Adams" (pp. 64–70) and "Verkehrte Welt" (pp. 208–209).]

EDITIONS AND TRANSLATIONS

[Divyāvadāna.] *Karman: Ein buddhistischer Legendenkranz.* Translated and edited by Heinrich Zimmer. Munich: Bruckmann, 1925.

[Nīlakaṇṭha of Rajā-maṅgalam.] *Spiel um den Elefanten [Mātangalīlā]: Ein Buch von indischer Natur.* Translated with a "Prelude" and "Postlude" by Heinrich Zimmer. Der indische Geist: Texte zum Wesen der indischen Welt. Munich: Oldenbourg, 1929. Second edition, with a Foreword by Walter Höllerer, Dusseldorf: Diederichs, 1976. Third edition, Suhrkamp Taschenbuch, 519, Frankfurt: Suhrkamp, 1979.

Anbetung mir. Indische Offenbarungsworte nach der Aṣṭāvakragītā. Translated from Sanskrit by Heinrich Zimmer. Der indische Geist: Texte zum Wesen der indischen Welt. Munich: Oldenbourg, 1929.

Dunbar, Sir George. *Geschichte Indiens von den ältesten Zeiten bis zur Gegenwart* [A History of India From the Earliest Times to the Present Day (1936)]. Revised by the author and translated by Heinrich Zimmer. Munich: Oldenbourg, 1937.

Suzuki, Daisetz Teitaro. *Die grosse Befreiung* [excerpts from *Essays on Zen Buddhism* (1934)]. Foreword by C. G. Jung. Leipzig: Weller, 1939.

[Rudrabhatta.] *Zeichen der Liebe [Śṛṅgāra-tilaka]: Wie man lieben und die Liebe dichten soll: Ein indisches Lehrbuch für Liebende und Dichter.* Translated from the Sanskrit by Heinrich Zimmer. Calw and Vienna, 1948. Second edition,

Stuttgart: G. Hatje, 1949. Third edition. Insel-Bücherei, 935, Frankfurt: Insel, 1975 [illustrations omitted].

ARTICLES

"Der Name Avalokiteśvara." *Zeitschrift für Indologie und Iranistik*, 1 (1922), 73–88.

"Winke für Katzenzucht." *Der Querschnitt*, 4:6 (1924), 374–80.

"Von einem weißen Fächer. Ein Beitrag zum Problem der unbewussten Entlehnung." *Deutsche Rundschau*, 199 (April–June 1924), 295–309. Reprinted in *Hofmannsthal Blätter*, 25 (Spring 1982), 44–65.

"Perspektive." *Der Querschnitt*, 5:8 (1925), 665–67.

"Das Lächeln des Buddha." *Der Querschnitt*, 5:10 (1925), 886–89.

"Zum Mahāvastu-Avadāna." *Zeitschrift für Indologie und Iranistik*, 3 (1925), 201–11.

"Zur Rolle des Yoga in der geistigen Welt Indiens." *Deutsche Vierteljahrsschrift für Literaturwissenschaft und Geistesgeschichte*, 4 (1926), 21–57.

"Elefantologie." *Der Querschnitt*, 6:9 (1926), 674–79.

"Der Heilige und die Elefanten." *Der Querschnitt*, 6:9 (1926), 679–82.

"Der 'König der dunklen Kammer.' In drei Verwandlungen vom R̥gveda bis Tagore." *Zeitschrift der deutschen morgenländische Gesellschaft*, N.S. 8 [= Vol. 83] (1929), 187–212.

"Der indische Lebensbegriff." *Neue Schweizer Rundschau*, 23 (1930), 387–94.

"Indische Elefantenkunde." *Forschungen und Fortschritte*, 6:35–36 (December 10 and 20, 1930), 460.

"Buddha." *Der Erdball*, 5 (1931), 241–52.

"Altindisches Drama im neuindischen Roman." *Zeitschrift der deutschen morgenländischen Gesellschaft*, N.S. 10 (1931), 325–50.

"Albert von Le Coq †." *Artibus Asiae*, 4 (1930–32), 70–73.

"Der indische Mythos. Vortrag in der Bibliothek Warburg."
Corona, 3:1 (1932), 48–81.

"Altindische Politik und der Geist des Abendlandes." *Europäische Revue*, 9 (1933), 419–31.

"Zur Bedeutung des indischen Tantra-Yoga. Drei Vorträge."
Eranos-Jahrbuch 1933. Zurich: Rhein, 1934. I, 9–94.
Translated by Ralph Manheim, "On the Significance of the Indian Tantric Yoga." *Spiritual Disciplines: Papers from the Erànos Yearbooks*. Bollingen Series XXX.4. New York: Pantheon, 1960, pp. 3–58.

"Some Aspects of Time in Indian Art." [Translated by Stella Kramrisch] *Journal of the Indian Society of Oriental Art*, I (1933), 30–51.

"Yoga und wir." *Corona*, 4:3 (1934), 277–310.

"Yoga und Māyā." *Corona*, 4:4 (1934), 378–400.

"Indische Mythen als Symbole. Zwei Vorträge." *Eranos-Jahrbuch 1934*. Zurich: Rhein, 1935. II, 97–151.

"Die Geschichte vom indischen König mit dem Leichnam."
Die kulturelle Bedeutung der komplexen Psychologie: Festschrift für C. G. Jung zum 60. Geburtstag. Edited by the Psychologischer Club, Zurich. Berlin: Julius Springer, 1935, pp. 177–94. Translation, "The Story of the Indian King and the Corpse." *Prabuddha Bharata*, 43 (September–October 1938).

"Vischnu's Maya. Aus Indiens 'Alten Überlieferungen.'" *Die Neue Rundschau*, 47 (1936), 250–80.

"Arthur Schopenhauer. 1788–1860." In *Die Grossen Deutschen: Deutsche Biographie*. Edited by Willy Andreas and Wilhelm von Scholz. Berlin: Ullstein, 1936. III, 236–51. Second edition, article revised by Kurt Rossmann. Berlin: Ullstein, 1956. III, 134–51.

"Indian Views on Psychotherapy." *Prabuddha Bharata*, 41 (February 1936), 177–89.

"Abu Kasems Pantoffeln." *Corona*, 6:4 (1936), 448–72.

"Über den Umgang mit Mythen." *Europäische Revue*, 12 (1936), 378–88.

"Die vorarisch-altindische Himmelsfrau." In *Corolla: Ludwig Curtius zum 60. Geburtstag dargebracht.* Stuttgart, 1937. I, 183–86.

"Zur Symbolik der Hindutempel." *Forschungen und Fortschritte,* 13:11 (April 10, 1937), 134–36.

"Zur Symbolik indischer Tempelbauten." *Ostasiatische Zeitschrift,* 22 (1937), 254–58.

"Umrisse indischer Seelenführung." In *Reich der Seele: Arbeiten aus dem Münchener psychologischen Arbeitskreis.* Munich, 1937. II, 58–89.

"Schopenhauers Begegnung mit Indien." *Corona,* 8:1 (1938), 50–58.

"Indische Parabeln. Nacherzählungen." *Corona,* 9:2 (1938), 177–217.

"Schopenhauer und Indien." *Jahrbuch der Schopenhauer-Gesellschaft,* 25 (1938), 266–73; also in *Die Tat. Wege zum freien Menschentum,* 29–30 (1938), 817–28.

"Schopenhauer, die Hunde und die Frauen." *Velhagen und Klassing's Monatshefte,* 52 (1937–1938), 76–79.

"Die indische Weltmutter." *Eranos-Jahrbuch 1938.* Zurich: Rhein, 1939. VI, 175–220. Translated by Ralph Manheim, "The Indian World Mother." *The Mystic Vision: Papers from the Eranos Yearbooks.* Bollingen Series XXX.6. New York: Pantheon, 1968, pp. 70–102.

"Merlin." *Corona,* 9:2 (1939), 133–55.

"Kartenspiele und Kinderspiele als Sinnbilder." *Velhagen und Klassing's Monatshefte,* 53 (1938–1939), 361–64.

"Tod und Wiedergeburt im indischen Licht." *Eranos-Jahrbuch 1939.* Zurich: Rhein, 1940. VII, 251–89. Translated by Ralph Manheim in collaboration with Joseph Campbell, "Death and Rebirth in the Light of India." *Man and Transformation: Papers from the Eranos Yearbooks.* Bollingen Series XXX.5. New York: Pantheon, 1964, pp. 326–52.

"Shri Ramanas Erwachen." *Corona,* 10:1 (1940), 5–28.

"Die Inder bis zum Einbruch des Islam." In *Urgeschichte des Menschen. Frühzeit der Völker. Reiche des Altertums.* Edited

by Hans Weinert et al. Vol. I of *Die Neue Propyläen-Weltgeschichte*. Berlin: Propyläen, 1940, pp. 463–94.

"The Involuntary Creation: A Hindu Myth." *Spring* [Journal of the Analytical Psychology Club of New York City], 1941, pp. 1–11.

"Dr. Jung's Impress on My Profession." *Spring*, 1941, pp. 104–105.

"The Hindu View of World History according to the Purāṇas." *Review of Religion*, 6 (March 1942), 249–70.

"The Guidance of the Soul in Hinduism." *Spring*, 1942, pp. 43–58.

"Integrating the Evil: A Celtic Myth and a Christian Legend." *Spring*, 1943, pp. 32–66.

"Śrī-Yantra and Śiva-Trimūrti." [Transcribed from Zimmer's lecture notes by Joseph Campbell] *Review of Religion*, 8 (November 1943), 5–13.

"Some Biographical Remarks about Henry R. Zimmer [1943]," and "Address to the Analytical Psychology Club of the City of New York [1941]." In *Two Papers by Henry R. Zimmer*. Metuchen: Van Vechten Press, 1944.

"Träume eines Gottes." *Mesa* [Aurora, N.Y.], 1 (1945), 38–41.

General Index

MAIN ENTRIES and definitions for the following proper names and key concepts are indicated by boldface. Passing references to Sanskrit words have been listed only in the Index of Sanskrit Words, and our spelling of Sanskrit words is explained there. We have kept technical explanations to a minimum; where amplification is needed, the reader is urged to consult Zimmer's other books, especially the exhaustive index prepared by William McGuire for *Philosophies of India*. Rather than adding a bibliography of secondary literature, we have listed the authors, but not the titles, of books and articles mentioned in the footnotes.

Index of Sanskrit Words

THE SPELLING of the following words is in accordance with current Sanskrit scholarly conventions. The spellings in the text itself have been left in a rudimentary form, following Zimmer's practice. Errors in the original German text have been emended without comment; the reader should use the two indexes as the standard.

Page numbers in boldface indicate a major or definitive reference. All words, including those appearing only once or twice, are explained in the text. Proper names and important concepts are listed in the General Index. Entries marked with an asterisk also appear in the General Index.

The reader is reminded that passages cited from other translators (Avalon, Goswamy, Kramrisch) have been left in the original, which accounts for many of the variations in Sanskrit spelling.

Our special thanks to Jayandra Soni, of McMaster University, for his care and skill in establishing the accuracy of the Sanskrit in the indexes.

LIBRARY OF CONGRESS CATALOGING IN PUBLICATION DATA

Zimmer, Heinrich Robert, 1890–1943.
Artistic form and yoga in the sacred images of India.

Translation of: Kunstform und Yoga im indischen Kultbild.
Bibliography; p. Includes index.
1. Art, Indic. 2. Symbolism in art—India.
3. Art, Buddhist—India. 4. Art, Hindu—India.
5. Yoga. I. Chapple, Gerald. II. Lawson, James B.
1926– . III. McKnight, J. Michael. IV. Title.

N7301.Z513 1984 704.9'4894 84-42589
ISBN 0-691-07289-2 (alk. paper)

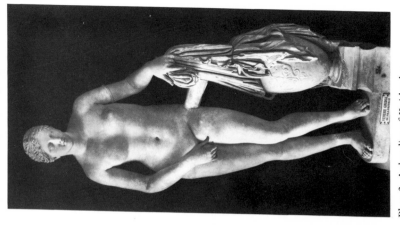

Plate 1. Doryphorus by Polykleitos.

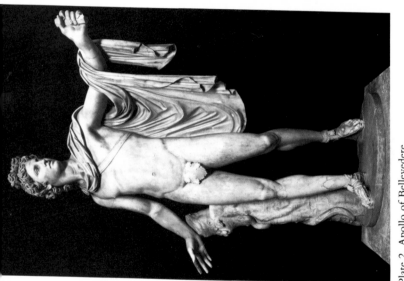

Plate 2. Apollo of Bellevedere.

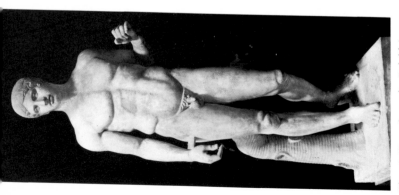

Plate 3. Aphrodite of Knidos by Praxiteles.

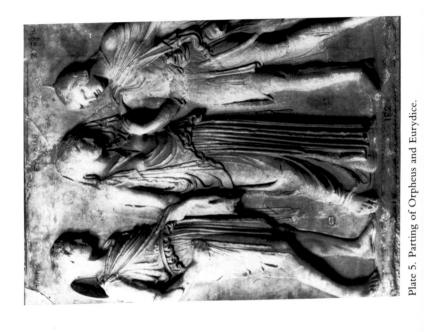

Plate 5. Parting of Orpheus and Eurydice.

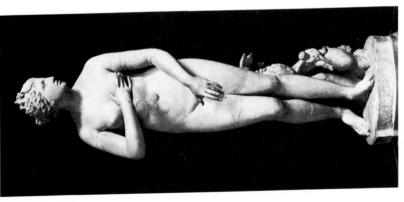

Plate 4. Medici Venus.

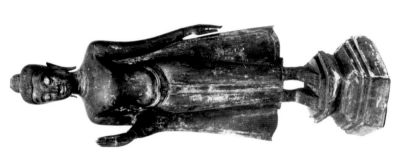

Plate 6. Standing Buddha, hand raised in the gesture offering protection (*abhayamudrā*). Wood carving, gilded and painted red. H. 52 cm.

Plate 7. Standing Buddha. Side view of Plate 6.

Plate 8. Buddha with hand raised in the gesture offering protection (*abhayamudrā*). Gilded bronze. H. 79 cm.

6

7

8

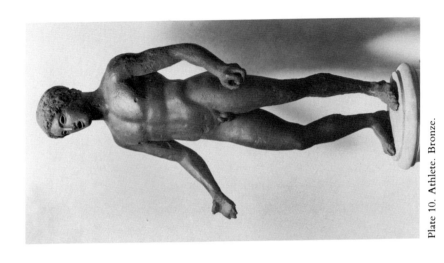

Plate 9. Sundara Mūrti Svamin, Śaivite

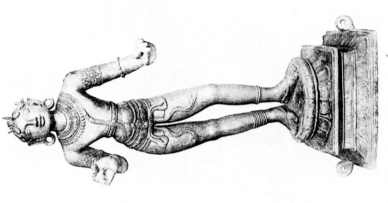

Plate 10. Athlete. Bronze.

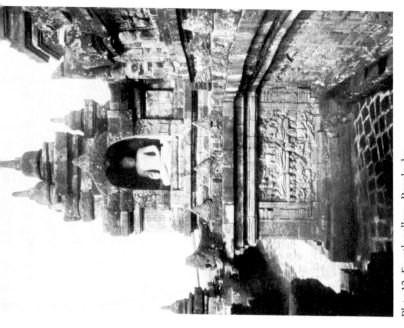

Plate 12. Fourth gallery. Borobudur.

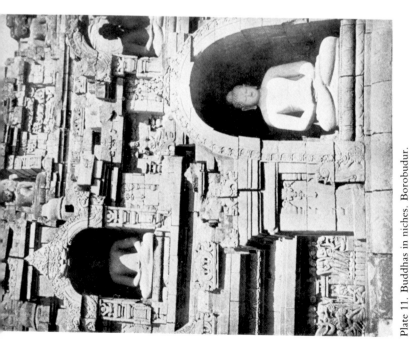

Plate 11. Buddhas in niches. Borobudur.

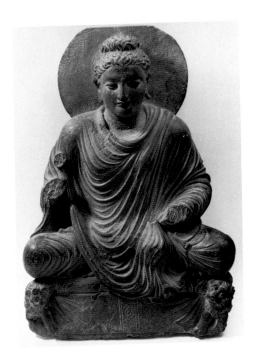

Plate 13. Buddha in the *paryanka* position (legs folded) on the Lion Throne of the Ruler of the World. H. 54 cm.

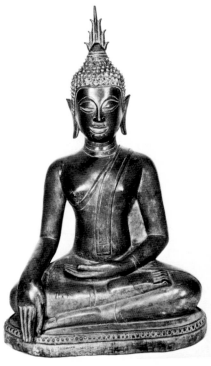

Plate 14. Buddha in the *paryanka* position, right hand extended toward the ground (*bhūmisparśamudrā*), topknot emitting rays of light. Bronze, heavy patina. H. 38 cm.

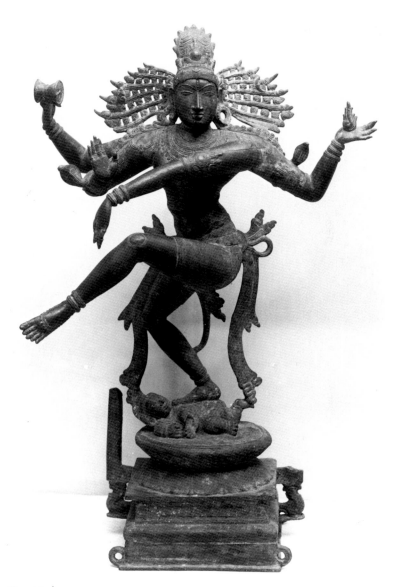

Plate 15. Śiva Nataraja. Bronze. H. 91.5 cm.

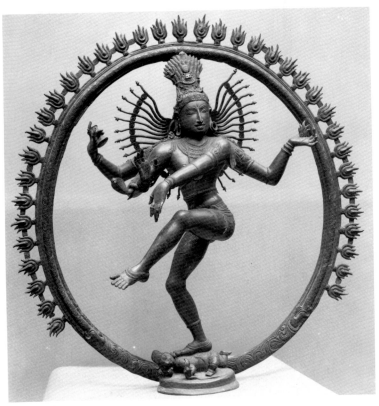

Plate 16. Śiva Nataraja. Bronze.

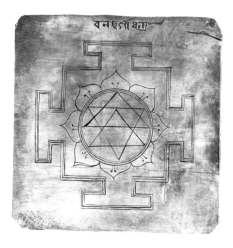

Plate 17. Vana Durgā *yantra*.
Copper plate. L. 10.2 cm.

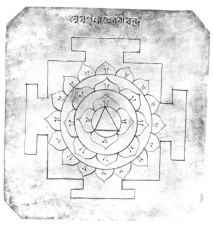

Plate 18. Annapūrnā Bhairavī
yantra. Copper plate. L. 10.4 cm.

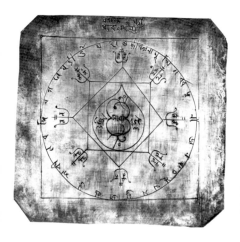

Plate 19. Bagalāmukhi Dhārana
yantra. Copper plate. L. 10.4 cm.

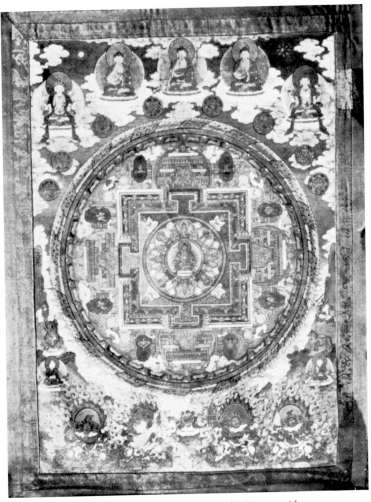

Plate 20. Lamaist mandala. Th'anka painted on silk. Picture without border, 90 x 54 cm. Tibet.

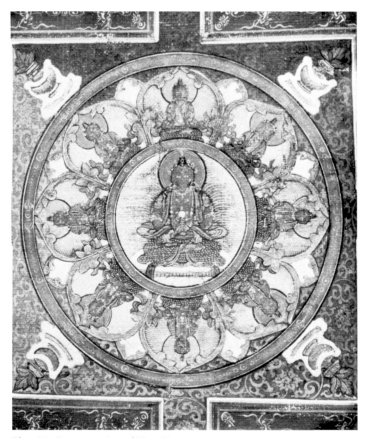

Plate 21. Center portion of Plate 20.

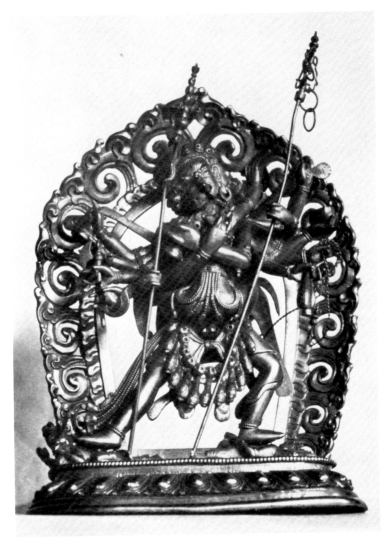

Plate 22. Mahasukha with Śakti (Tib. bDe-mchog).
Gilded bronze. H. 18.2 cm.

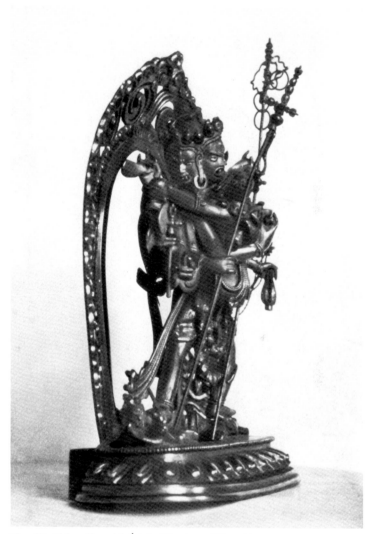

Plate 23. Mahasukha with Śakti. Side view of Plate 22.

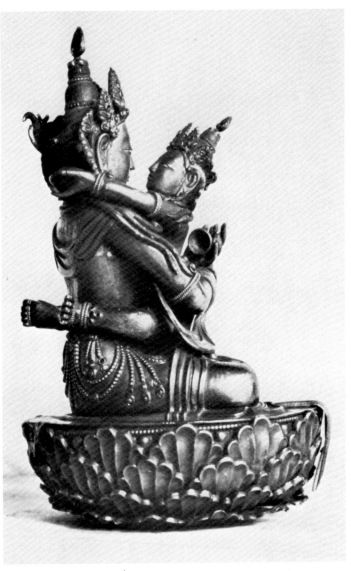

Plate 24. Vajradhara with Śakti (Tib. rDo-rje-'chang). Gilded silver. The crowns and the arm and foot ornaments are set with red and green stones. H. 18.2 cm.

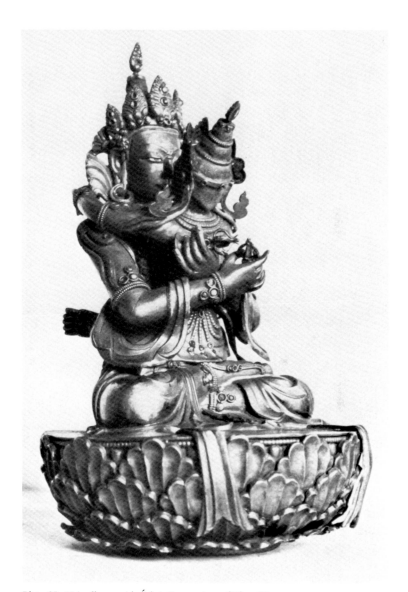

Plate 25. Vajradhara with Śakti. Front view of Plate 24.

Plate 26a. Tirujnana Sambhandha Swami, Śaivite saint. Mistakenly identified by Zimmer in the 1st ed. as Kṛṣṇa. Bronze. H. 39 cm.

Plate 26b. Kṛṣṇa dancing on the snake Kaliya. Bronze. H. 52 cm.

Plate 27. Viṣṇu Janādarna. The discus Sudarśana is in his raised right hand; the conch Pāñcajanya and the club Kaumadakī in his left hands; a lotus is in his lower right hand (damaged). Borne by his mount Garuda, he reigns from a Lotus Throne. Yellow sandstone. H. 115 cm.

Plate 28. Viṣṇu Trivikrama. He is holding the lotus and club in his right hands, the discus and the conch in his left; he is flanked by Lakṣmī and Sarasvatī and surrounded by the standard retinue for this aspect. Black basalt. H. 73 cm.

Plate 29. Viṣṇu Trivikrama. Iconography as in Plate 28. Black basalt. H. 84.5 cm.

26a

26b

27

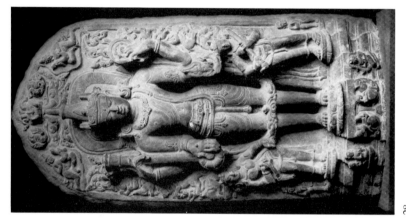

28

29

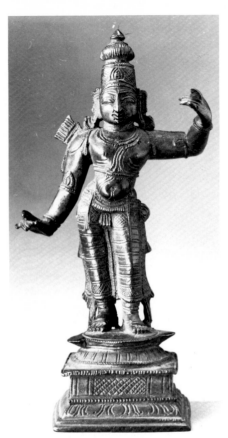

Plate 30. Viṣṇu in human incarnation as Prince Rāma. Emblems missing from both hands. Bronze. H. 13.6 cm.

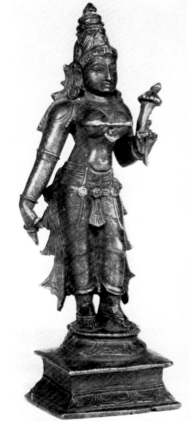

Plate 31. Lakṣmī or Śrī, spouse of Viṣṇu, goddess of happiness and beauty. Bronze. H. 11.5 cm.

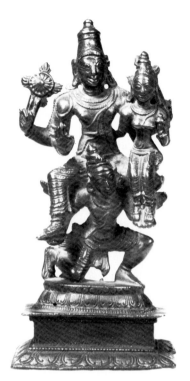

Plate 32. Viṣṇu and Lakṣmī, borne by Garuda. The upper right hand is holding the discus, the lower right hand is proffering protection. Bronze. H. 11.2 cm.

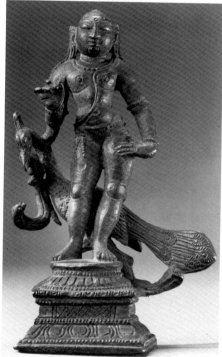

Plate 33. Skanda (Kārttikeya/ Kumāra), the god of war with his mount, the peacock, which, as the proverbial enemy of serpents, is holding a defeated serpent in its bill. Gilded bronze. H. 9.3 cm.

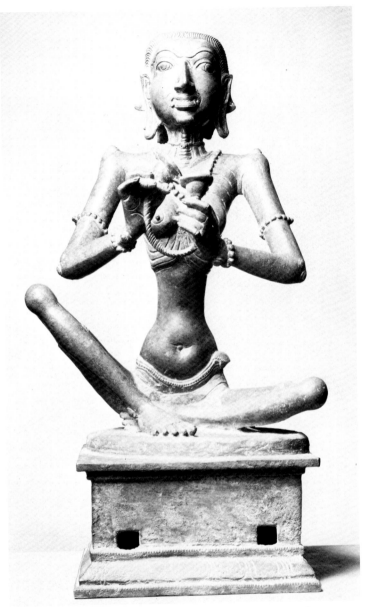

Plate 34. Karaikkalammaiyar (often identified as Kāli) worshiping Śiva.
Bronze. 14th century.

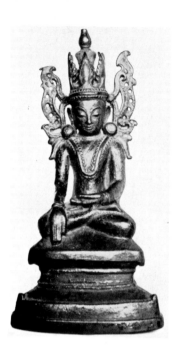

Plate 35. Buddha in the *paryanka* position with hand extended (*bhūmisparśamudrā*). The crown, decorated with fluttering ribbons, contains a *vajra* in an opening at the top. H. 21 cm. Burma.

Plate 36. Garbhadhātu mandala.

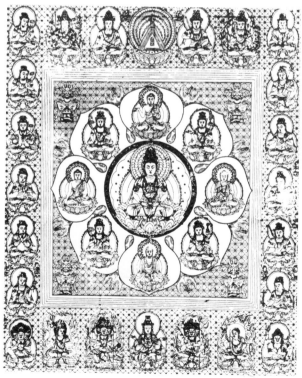

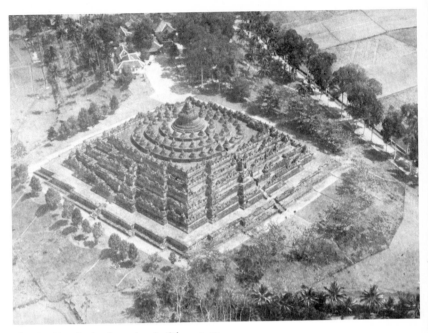

Plate 37. Borobudur from the air. 8th century.

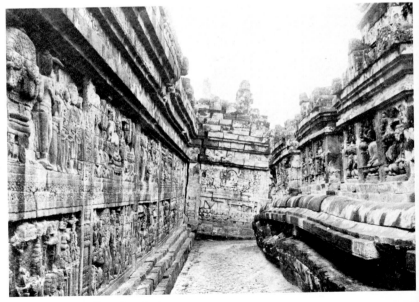

Plate 38. Lower gallery. Borobudur.

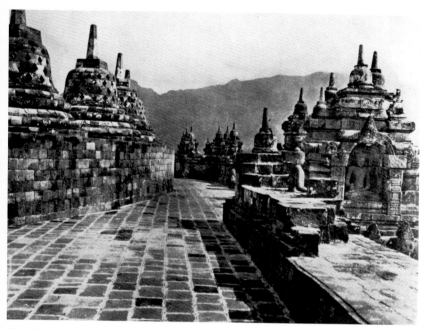

Plate 39. Plateau, first stupa terrace at left. Borobudur.

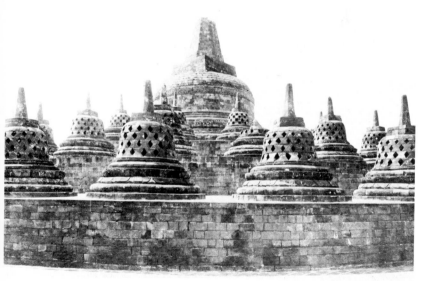

Plate 40. Upper circular terraces. Borobudur.

Plate 41. Durgā Mahiṣāsura-mardinī, Slayer of the
Titan Buffalo. Mamallapuram. Early 7th century.

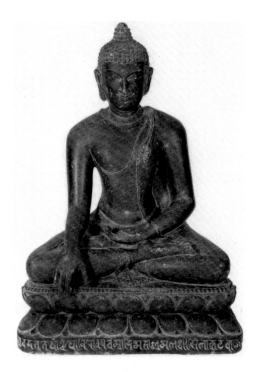

Plate 42. Buddha in the *paryanka* position with hand extended (*bhūmisparśamudrā*). The base bears the inscription "The One Come in Truth reveals the roots of the one source from which all essences come and what will bring about their dissolution: this does the Grand Ascetic proclaim." Black basalt. H. 44.5 cm.

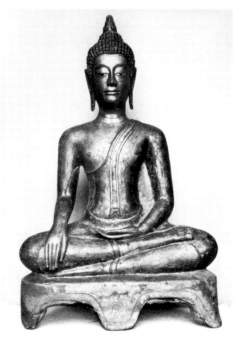

Plate 43. Buddha in the *paryanka* position, right hand extended toward the ground (*bhūmisparśamudrā*). Gilded bronze. H. 53 cm.

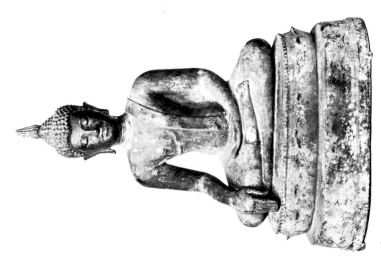

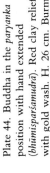

Plate 44. Buddha in the *paryanka* position with hand extended (*bhūmisparśamudrā*). Red clay relief with gold wash. H. 26 cm. Burma.

Plate 45. Buddha in the *paryanka* position with hand extended (*bhūmisparśamudrā*). Bronze. H. 40 cm.

44

45

Plate 47. Jina in the *paryanka* position, hands laid flat one over the other. Black basalt. H. 54.4 cm.

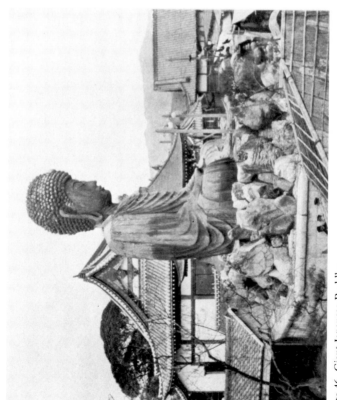

Plate 46. Giant Japanese Buddha.

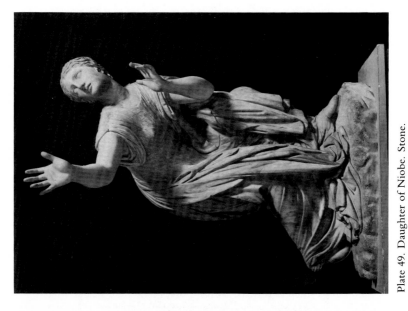

Plate 49. Daughter of Niobe. Stone.

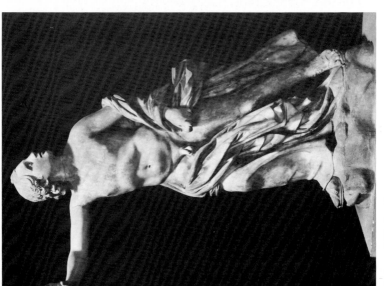

Plate 48. Son of Niobe. Stone.

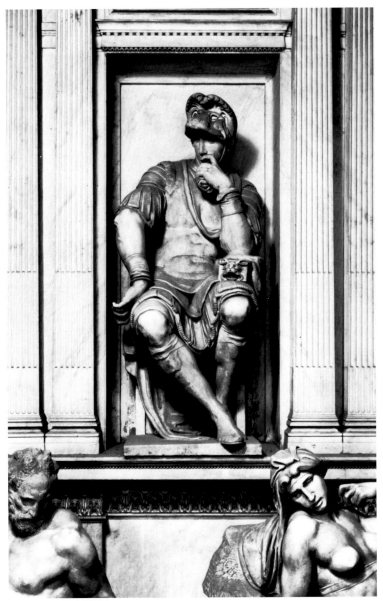

Plate 50. Giuliano di Medici, Il Pensieroso by Michelangelo. Tomb of
Lorenzo de' Medici, Medici Chapel. 1519-1534.

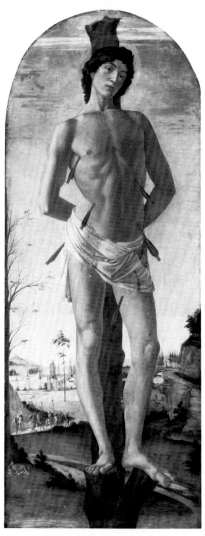

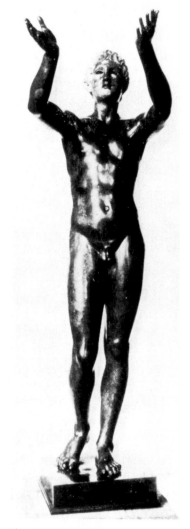

Plate 51. St. Sebastian by Botticelli.
Wood. 1.95 x .75 m.

Plate 52. Praying Boy.
Bronze. H. 128.4 cm.

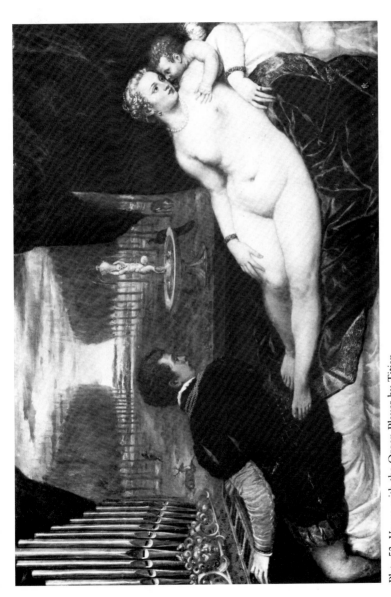

Plate 53. Venus with the Organ Player by Titian.

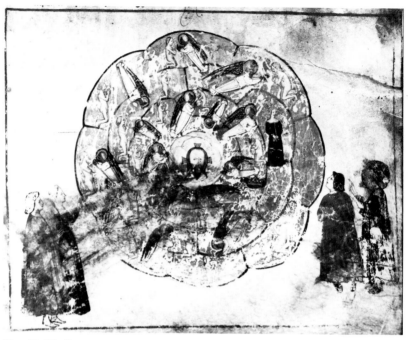

Plate 54. The Empyrean. Manuscript.